APPROPRIATING THE PAST

Philosophical Perspectives on the Practice of Archaeology

In this book an international team of archaeologists, philosophers, lawyers, and heritage professionals addresses significant ethical questions about the rights to access, manage, and interpret the material remains of the past. The chapters explore competing claims to interpret and appropriate the past and the major ethical issues associated with them, including handling the sacred; contested rights over sites, antiquities, and artifacts; the involvement of local communities in archaeological research; and the legal status of heritage sites. The book covers a range of hotly debated topics in contemporary archaeological practice, focusing particularly on the relationship between academic archaeologists and indigenous communities for whom the material remnants of the past that form the archaeological record may be part of a living tradition and anchors of social identity.

GEOFFREY SCARRE is Professor of Philosophy at Durham University and the cofounder and director of the Durham University Centre for the Ethics of Cultural Heritage. He is the editor (with Chris Scarre) of *The Ethics of Archaeology: Philosophical Perspectives on Archaeological Practice* and the author of several books, including, most recently, *Death, Mill's* On Liberty: *A Reader's Guide,* and *On Courage.*

ROBIN CONINGHAM is Pro–Vice Chancellor and Professor of Archaeology at Durham University and cofounder of the Durham University Centre for the Ethics of Cultural Heritage. Active as a field archaeologist in South Asia and Iran, he currently leads a UNESCO archaeological team that is excavating inside the temple of the Buddha's birth at Lumbini in Nepal.

D0898328

APPROPRIATING THE PAST

Philosophical Perspectives on the Practice of Archaeology

EDITED BY

GEOFFREY SCARRE

University of Durham

ROBIN CONINGHAM

University of Durham

CAMBRIDGE
UNIVERSITY PRESS

CAMBRIDGE UNIVERSITY PRESS
Cambridge, New York, Melbourne, Madrid, Cape Town,
Singapore, São Paulo, Delhi, Mexico City

Cambridge University Press
32 Avenue of the Americas, New York, NY 10013-2473, USA

www.cambridge.org
Information on this title: www.cambridge.org/9780521124256

First published 2013

Printed in the United States of America

A catalog record for this publication is available from the British Library.

Library of Congress Cataloging in Publication data

Appropriating the past : philosophical perspectives on the practice of archaeology / [edited by]
Geoffrey Scarre, University of Durham, Robin Coningham, University of Durham.
pages cm.
Includes bibliographical references and index.
ISBN 978-0-521-19606-2 (hardback) – ISBN 978-0-521-12425-6 (paperback)
1. Archaeology – Philosophy. 2. Archaeology – Moral and ethical aspects. 3. Indigenous peoples –
Antiquities – Collection and preservation. I. Scarre, Geoffrey, editor of compilation.
II. Coningham, Robin, editor of compilation.
CC72.A595 2012
930.1–dc23 2012017957

ISBN 978-0-521-19606-2 Hardback
ISBN 978-0-521-12425-6 Paperback

Contents

Contributors

TOM ALLEN is the Master of Grey College, University of Durham, and holds a chair in law at the university. His main field of interest is the intersection between human rights and property law. His current work focuses on the relationship between the rules of property law and the construction of communities and collective memories.

ALEXANDER A. BAUER is Assistant Professor of Anthropology at Queens College and the Graduate Center, City University of New York, with research interests in Old World archaeology, material culture, trade and exchange, archaeological theory, and cultural heritage policy. He maintains a particular research interest in Peircean semiotics and the ways it can be used to develop a pragmatic archaeological theory and method. He has conducted fieldwork in Greece, Israel, Jordan, Turkey, and Ukraine and is currently Associate Director of the Sinop Regional Archaeological Project in Turkey. He is the coeditor of the recent volume *Social Archaeologies of Trade and Exchange* (Left Coast Press, 2010) and has been Editor in Chief of the *International Journal of Cultural Property* since 2005.

PIOTR BIENKOWSKI is a cultural, heritage, and museums consultant; writer and researcher; and Honorary Professor in the School of Arts, Histories, and Cultures at the University of Manchester. Previously, he was Professor of Archaeology and Museology at the University of Manchester, Deputy Director of Manchester Museum, and Head of Antiquities at National Museums Liverpool. He has directed fieldwork in Jordan and has published extensively on the Iron Age in Jordan and the ancient Near East in general, on the ethics of human remains in archaeology and museums, and on community agency and sharing of authority in cultural organisations. He is Codirector of the International Umm al-Biyara Project in Petra, Jordan.

ELIZABETH BURNS COLEMAN lectures in communications at Monash University. She has held postdoctoral fellowships at the Australian National University's Centre for Cross Cultural Research and Monash University. She is author of *Aboriginal Art, Identity and Appropriation* (Ashgate, 2005) and coeditor of a series of collections on the theme of negotiating the sacred: *Blasphemy and Sacrilege in a Multicultural Society* (ANU E-press, 2006); *Blasphemy and Sacrilege in the Arts* (ANU E-press, 2008); *Medicine, Religion and the Body* (Brill, 2009); and *Religious Tolerance, Education and the Curriculum* (Sense, 2011).

DAVID E. COOPER is Professor of Philosophy Emeritus at Durham University. He has been a Visiting Professor at universities in Europe, North America, and South Asia. Much of his recent work has been in the area of environmental aesthetics. He is the author of many books, including *A Philosophy of Gardens* (2006) and a forthcoming book on Daoism and human beings' relationship to nature.

DAVID GARRARD has a background in academic philosophy but now works for English Heritage. He is interested in the intersection between aesthetic judgments and other kinds of values, particularly in the history and theory of the conservation movement. He is currently editing an anthology of architectural poetry.

PRISHANTA GUNAWARDHANA is Professor of Archaeology at the University of Kelaniya, Sri Lanka, and a board member of the Sri Lanka Council of Archaeologists. He has edited several books and journals and published more than fifty articles on archaeology. Gunawardhana is a Codirector of the Upper Malwathu Oya Archaeological Exploration Project, a collaborative project of Durham University and the University of Kelaniya. He is also Director of the Terra-Cotta Project in Sri Lanka, funded by the University of Kelaniya.

CORNELIUS HOLTORF is currently employed at Linnaeus University in Kalmar, Sweden, where he is responsible for the degree programme in heritage studies. A prehistorian by education, he has long been investigating the intersections of prehistory, archaeology, heritage, and contemporary society, and he is the author of the monographs *Monumental Past* (2000–8), *From Stonehenge to Las Vegas* (2005), and *Archaeology Is a Brand!* (2007). Holtorf is currently finishing a field project on the life history of a megalith in southern Portugal and has plans to investigate further the contemporary archaeology of zoological gardens. He is Associate Editor of the journal *Heritage and Society*.

ANNA KÄLLÉN is a Researcher in Archaeology at Stockholm University, Sweden, where she specialises in the archaeology and heritage of mainland Southeast Asia. Her main interest is in the role of archaeology and the use of the past as narratives and materiality in contemporary society. She is currently engaged in investigating the relations between archaeology and ecotourism in northern Laos.

NAYANJOT LAHIRI is Professor in the Department of History at the University of Delhi, where she teaches Indian archaeology. She has been the recipient of various fellowships including the Commonwealth Academic Staff fellowship at the University of Cambridge (UK) and the Daniel Ingalls Fellowship at Harvard University (USA). She is on the advisory editorial board of *World Archaeology* (UK) and on the editorial board of *American Anthropologist* (USA). Apart from articles in refereed international and national journals, she has authored and edited six books, including *The Archaeology of Indian Trade Routes* (Oxford University Press) and *Finding Forgotten Cities* (Permanent Black). She was co-editor of a special issue of *World Archaeology* on *The Archaeology of Hinduism*. *Finding Forgotten Cities* was a finalist for the Hutch-Crossword Award prize in 2006. She has been a member of the Delhi Urban Art Commission.

JONATHAN LEAR is John U. Nef Distinguished Service Professor in the Committee of Social Thought and Department of Philosophy at the University of Chicago. He is the author, most recently, of *Radical Hope: Ethics in the Face of Cultural Devastation* (Harvard University Press, 2008) and *A Case for Irony* (Harvard University Press, 2011). He was recently awarded the Andrew W. Mellon Foundation Distinguished Achievement Award.

GEORGE P. NICHOLAS is Professor of Archaeology at Simon Fraser University. He was founding director of the university's Indigenous Archaeology Program in Kamloops, BC (1991–2005). He is Director of the international research initiative Intellectual Property Issues in Cultural Heritage: Theory, Practice, Policy, a seven-year initiative funded by SSHRC Canada (http://www.sfu.ca/ipinch). His research focuses on Indigenous archaeology, intellectual property issues relating to archaeology, the archaeology and human ecology of wetlands, and archaeological theory, on all of which he has published widely. He is series coeditor of the World Archaeological Congress's *Research Handbooks in Archaeology* and former editor of the *Canadian Journal of Archaeology*. His most

recent book is *Being and Becoming Indigenous Archaeologists* (Left Coast, 2010).

JANNA THOMPSON is a Professor in the Department of Philosophy at La Trobe University in Melbourne, Australia. She is the author of *Taking Responsibility for the Past: Reparation and Historical Injustice* (Polity, 2002) and *Intergenerational Justice: Rights and Responsibilities in an Intergenerational Polity* (Routledge, 2009). She has also written books and articles on global justice, environmental ethics, ethical theory, and human rights.

ALISON WYLIE is Professor of Philosophy at the University of Washington. She works primarily on theoretical and ethical issues raised by archaeological practice, particularly on questions about ideals of objectivity, evidential reasoning, and accountability. Her publications include *Thinking from Things: Essays in the Philosophy of Archaeology* (2002); edited volumes such as *Value-Free Science?* (Oxford University Press, 2007, with Kincaid and Dupré), *Doing Archaeology as a Feminist* (*Archaeological Method and Theory*, 2007, with Conkey), *Epistemic Diversity and Dissent* (*Episteme*, 2006), and *Ethics in American Archaeology* (SAA, 2000); as well as essays that appear in *How Well Do Facts Travel?* (Cambridge University Press, 2010), *The Ethics of Cultural Appropriation* (Wiley, 2009), *Agnatology: The Making and Unmaking of Ignorance* (Stanford University Press, 2008), *Evaluating Multiple Narratives* (Springer, 2007), and *Embedding Ethics* (Berg, 2005).

JAMES O. YOUNG is Professor of Philosophy at the University of Victoria. He is the author of more than fifty articles on the philosophy of language, philosophy of art, and other topics. His books include *Global Anti-Realism* (1995) and *Cultural Appropriation and the Arts* (2008), and he is coeditor of *The Ethics of Cultural Appropriation* (2009).

LARRY J. ZIMMERMAN is Professor of Anthropology and Museum Studies at Indiana University–Purdue University Indianapolis and Public Scholar of Native American Representation with the Eiteljorg Museum of American Indians and Western Art. His books include *A North American Archaeologist's Field Handbook* (coauthored, 2010) and *Kennewick Man: Perspectives on the Ancient One* (coedited, 2008). Recent articles and chapters include 'Creating a translational archaeology of homelessness', *World Archaeology* (coauthored 2010); 'The premise and promise of Indigenous archaeology', *American Antiquity* (coauthored

2010); '"White people will believe anything!": Worrying about Authenticity, Museum Audiences, and Working in Native American–Focused Museums', *Museum Anthropology* (2010); and 'In the Public Interest: Creating a More Activist, Civically-Engaged Archaeology', in *Voices in American Archaeology* (coauthored, 2010).

Editors

GEOFFREY SCARRE is Professor of Philosophy at Durham University. In recent years he has taught and published mainly in the areas of moral theory and applied ethics. His latest books are *Death* (Acumen/McGill–Queens University Press, 2007), *Mill's* On Liberty: *A Reader's Guide* (Continuum, 2007) and *On Courage* (Routledge, 2010). He also edited (with Chris Scarre) *The Ethics of Archaeology: Philosophical Perspectives on Archaeological Practice* (Cambridge University Press, 2006). He is a founder and Director of the Durham University Centre for the Ethics of Cultural Heritage.

ROBIN CONINGHAM is Pro–Vice Chancellor and Professor of Archaeology at Durham University. He has conducted fieldwork throughout South Asia, directing major excavations at the Bala Hisar of Charsadda in Pakistan, the Citadel of Anuradhapura in Sri Lanka, and Tepe Pardis and Tepe Sialk in Iran, and he has participated in twelve UNESCO missions to the region. His major publications range from the excavation monographs on Anuradhapura (1999, 2006) and Charsadda (2007) and regional synthetic analyses (2005) to studies on the archaeology of Buddhism (2001, 2011) and the relationship of heritage management, identity, and archaeology. His current research includes the completion of a survey of the hinterland of Anuradhapura in Sri Lanka and directing the new UNESCO excavations at the World Heritage Site of Lumbini in Nepal, the birthplace of the Buddha. He codirects the Durham University Centre for the Ethics of Cultural Heritage.

Introduction

Geoffrey Scarre and Robin Coningham

This volume is the second in an occasional series of titles aiming to promote a constructive dialogue among archaeologists, philosophers, anthropologists, museum professionals, lawyers, and other interested parties on major ethical issues raised by the contemporary practice of archaeology. Like its predecessor volume (Scarre and Scarre 2006), it presents previously unpublished essays by several well-established writers, as well as the work of some younger scholars. The contributors come from a range of countries and disciplinary backgrounds, and they defend a variety of different, and in some cases sharply contrasting, viewpoints. It is the editors' belief that the resulting mix of perspectives makes the volume greater than the sum of its parts and that the individual chapters not only can stand alone as valuable contributions to the debates they address but acquire a new dimension of significance when read together.

Archaeologists have commonly thought of themselves as the primary custodians and the most authoritative interpreters of the material remains of past cultures. In recent decades, however, the right of archaeologists to erect 'Keep Out' signs around what they conceive as the archaeological record has come under increasing challenge from other interest groups that assert equal or superior rights to access, utilise, and manage those remains, or to determine their significance. Thus, a decorated bronze vessel that for an archaeologist is principally a source of information to be extracted by standard research techniques may be, to other eyes, a sacred or taboo object, an anchor of social or cultural identity, a work of art, or a legitimate source of hard cash. These different perceptions correspond to different modes of appropriating the past, all of which are contentious in theory and in practice. As one set of stakeholders (or claimants to a stake) among others, archaeologists need to reflect on the ethical justification of their ideals and practices and to consider how best to achieve rapprochement between their own and alternative interests: a task made harder by the seemingly incommensurable nature of those interests.

The essays in this book explore some, but by no means all, of the key ethical and practical issues raised by the competing modes in which archaeologists and others appropriate the past. These issues include (to list but a few) rights to interpret the past and tell stories about it; handling the sacred; the idea of heritage; the concepts and ethics of birthright and patrimony; local versus national versus international rights over landscapes, sites, antiquities, buildings, and artefacts; legal responsibilities of governments to defend and preserve heritage; rights to hold intellectual property; duties and rights of external intervention to defend antiquities; roles and responsibilities of museums; looting and the antiquities trade; the economic exploitation of sites and resources; duties to preserve antiquities for future generations; and the nature and legitimation of stewardship. Some readers may question the wisdom of couching these issues in the language of 'appropriation', whose use commonly reflects a mind-set more focused on contest and competition among claimants to some resource than on sharing and the harmonious resolution of differences. Indeed, accusations of 'cultural appropriation' and claims that others have taken what is rightfully ours are often employed more with the aim of guillotining reasonable debate than of advancing it. Once you identify something as your *heritage*, then anyone else's claims to or concern with it can be rejected as irrelevant and intrusive, a threat to your own rightful possession or even an assault on your identity. Writing in 1998 about the 'current craze for heritage', David Lowenthal wryly commented that although, on the one hand, 'it offers a rationale for self-respecting stewardship of all we hold dear', on the other hand 'it signals an eclipse of reason and a regression to embattled tribalism' (Lowenthal 1998: 2–3). The downside of pride in possession is that it can swiftly become jealous and exclusionary, suspicious of all external interests and unwilling to share.

It would be rash, though, to discard an otherwise useful term just because it is sometimes associated with the unwarranted assumption that any instance of cultural appropriation is, by definition, oppressive and unfair. In reality, appropriations may be just or unjust, reasonable or unreasonable. The normal form of appropriation statements is 'A appropriates B from C', but we might also speak of 'appropriation' when someone takes for his or her own use a hitherto-unclaimed resource (and thus preempts C's use of it while not taking it from C). More commonly, when A appropriates B from C, the transaction may variously resemble a borrowing or a theft, although there is an interesting intervening set of cases in which, while it would be unreasonable for C to refuse A permission to use or access B,

it would also be discourteous for A to help him- or herself to B without asking C's permission.

While appropriations in the cultural context are sometimes misappropriations, they are by no means invariably so. The history of humanity is the history of interacting cultures that appropriate from one another as a matter of course. (Why invent the wheel for yourself when you can copy the design from your neighbour?) No cultures exist as sealed units, and through their porous walls pass people, ideas, beliefs, practical techniques, artistic styles, and religious practices. Such osmosis and dissemination have been the key to human development from the most ancient times up to the age of the World Wide Web. As an associated constant, acts of cultural appropriation have been raising hackles ever since Prometheus, in Greek story, stole fire from the gods to give to mankind (thereby incidentally demonstrating that even taking without permission may occasionally be justified in the name of social utility). Reservation to one's own community of goods from which others could also benefit without leaving one's own worse off can smack of selfishness, besides being imprudent if it makes others less willing to allow one to share in their good things.

According to the *Shorter Oxford Dictionary*, to 'appropriate' is 'to take for one's own, or to oneself'. The noun 'appropriation' is defined as 'the making of a thing private property'. But the latter definition is misleading, for not all appropriations involve a claim to exclusive ownership of or access to the thing in question. To transfer another's ownership of something to oneself is to *ex*propriate it, and not all appropriations are expropriations. Appropriation can take stronger or weaker forms, some being less exclusionary than others. One variety involves 'muscling in' on what has previously been the preserve of others and demanding (or merely assuming) the right to share it with them. An example would be the act of a commercial manufacturer of pottery who 'borrows' without permission traditional artistic motifs from an Indigenous community for the decoration of its wares while leaving the community free to continue to use those motifs itself. Here the appropriation is plainly nonexclusive, albeit morally objectionable and potentially open to legal challenge. If instead the company were to copyright the motifs, depriving even their originators of the use of them without payment of a fee, then their appropriation would also be expropriation of the grossest kind.

Some appropriations are readily reversible, others less so. It has recently been announced that Yale University has acceded to the Peruvian government's request to return to Peru a large number of metal, stone, and ceramic

items removed from the Inca city of Machu Picchu in 1911. Itwould obviously be much harder to reverse the appropriation of an artistic style (e.g., the early twentieth-century cubist painters' borrowings from African sculpture), a technological or agricultural method (e.g., the wheel, the domestication of livestock), or some medical technique or religious ideology. Although in principle reversibility is not a plausible necessary condition of the permissibility of an appropriation, the difficulty (or impossibility) of reversing some appropriations may be a morally important factor to bear in mind while they are still in contemplation.

Appropriations differ from trespasses in being generally longer term in their intention or effect. Crossing a farmer's field without permission would be a trespass but not an appropriation of the owner's property, unless one attempted to set up regular residence there. Typically, where A appropriates B, A plans or hopes to hold on to B for some time to come, treating it as a resource rather than simply an immediate or passing opportunity. Note, too, that not all uses of a resource that is not one's own amount to appropriations (or trespasses). Walking in the public street is an obvious example; so too (for instances from a cultural context) are viewing pictures in a gallery or visiting an historic stately home or battlefield. None of these involves making claims to ownership or rights of control over the items at issue, or the performance of any acts aimed at preventing others from enjoying equal use or access.

In the cultural sphere, many kinds of thing are capable of being appropriated, legitimately or otherwise: not only concrete things such as artefacts, buildings, sites, and works of art but also more abstract objects such as ideas and beliefs, indigenous knowledge and stories, technology and medicine, laws and practices, artistic styles and motifs, music, and ceremonial. Appropriation is not, as it is sometimes supposed to be, 'an activity reserved for hegemonic groups, so that the idea of members of Aboriginal cultures appropriating from the dominant culture is absurd' (Walsh and Lopes, 2009); appropriation can and does go 'either way', even if the morally most problematic appropriations are usually those in which the more powerful take from the weaker.[1]

The title of this book, however, goes a stage further and suggests that the past itself can be appropriated. This requires some comment. At one

[1] It has become common to speak of members of Aboriginal or subaltern cultures 'adopting' ideas, practices, techniques, and technologies from more dominant ones. But such adoptions, where voluntary, are indistinguishable from appropriations (reminding us that appropriations are not, by definition, all morally bad or doubtful).

level, our use of the expression 'appropriating the past' is merely convenient shorthand for referring to the appropriation of specific objects, concrete or abstract, of antique origin. But 'appropriating the past' is meant, too, to have a deeper resonance, reminding us that many disputes over particular contested objects arise in a context of more general and often impassioned debates about the preservation of community identity, the integrity of cultural traditions, and the authority to interpret the past in relation to the present. When A appropriates B from C, A may also explicitly or implicitly be asserting a right to speak about C's past, to determine that past's meaning or importance (inevitably, within his or her own parameters), or to integrate C's history as part of his or her own. To cite a notorious example, when early European visitors to the deserted city of Great Zimbabwe marvelled at the sophisticated design and massive scale of the remaining structures, they refused to believe that they could be the work of Africans and blithely dismissed local traditions of their indigenous origin. Imposing their own entirely speculative history of construction by Arab or other nonnative builders, they sidelined indigenous accounts as unreliable myths, thus robbing them, at a stroke, of their own historicity.

To insist on being the sole or the most authoritative interpreter of what has happened in some particular phase of human history (or prehistory) is at best discourteous to those who take an alternative view and at worst may be auxiliary to their repression or subordination. The persistent denial, in the teeth of the evidence, of a native origin of the ruins of Great Zimbabwe became an asset in the justification of the white-supremacist government of the country arrogantly renamed Rhodesia. It is not only poor ethics but also bad science to rule out a priori the possibility that anyone but yourself, or those who share your basic assumptions, can say anything worth taking seriously about the past. Of course, not all views of the past are epistemically on a par, nor are all in some sense 'true'. Specific 'histories' may be infected by fantasy, wishful thinking, guesswork, faulty memory, prejudice, or the deliberate or innocent confusion of myth and report; or they may simply lack the evidential basis to warrant being treated as solid fact. No human group has a monopoly on the production of such flawed accounts or is immune to the temptation to 'spin' the record in its own favour. (Lowenthal remarks that '[t]he earliest common use of the past was to validate the present' [Lowenthal 1998: 369].) But care should be taken not to dismiss as inaccurate or implausible what may never have been intended as pure factual reportage. It would be inappropriate to apply to the 'just-so' stories that distil a society's sense of its identity and values, or

the allegories that express its relationship with its gods or its neighbours, the same standards of appraisal that we would bring to a newspaper report or to the testimony of a witness in a court of law.[2]

Troubles can arise when a group insists on the sole validity of its own reading of the past, whether this be the self-flattering 'histories' once produced by colonially-minded white Europeans with an ingrained sense of their racial superiority, or the occasionally encountered rejections by Indigenous groups of any alternatives offered by archaeologists or anthropologists to traditional stories of origins. Such claims are often problematic at the outset because they depend on arbitrary or unhistorical notions of group identity and the distinction between 'us' and 'them'. The continuous fusion and fission of peoples and cultures are not always acknowledged in the simplifying stories people like to tell about their tribal or national ancestries. Even where a people have a demonstrably longer association with a certain territory than newcomers or immigrants have, and may with more propriety speak of 'my country' or 'our heritage', they may have more to lose than to gain by being deaf to the voices of others. Admitting outsiders allows the entry of novel perspectives that can refresh the homegrown ones. The virtues of epistemic cooperation over competition have been notably apparent in recent years in North America, where there have been increasingly frequent collaborations between Indigenous communities and scientific researchers prepared to combine their efforts in a spirit of respectful cooperation. Wherever possible, writes Larry Zimmerman, archaeologists should '[work] with indigenous peoples to formulate both research questions and methods' (Zimmerman 1997a: 105). The collaboration between archaeologists T. J. Ferguson and Chip Colwell-Chanthaphonh and Native American researchers in the San Pedro Valley in Arizona is a striking example of how productive such joint enterprises can be (see, e.g., Colwell-Chanthaphonh and Ferguson 2004), while Nicholas and Wylie note that '[i]n a number of contexts in the USA and Canada, Indigenous groups like the Navajo and the Shuswap are now responsible for, and increasingly direct any archaeological work undertaken in their territories' (Nicholas and Wylie 2009: 30). (The same authors observe, too, that issues concerning intellectual property are also attracting greater attention 'in contexts where descendant communities are seeking access to

[2] That accounts of origins can bear multiple meanings is not a novel insight. In the preface to his *Roman History*, Livy described the stories of the events that led to the founding of Rome 'as being rather adorned with poetic legends than based upon trustworthy historical proofs'. 'It is the privilege of antiquity', he thought, 'to mingle divine things with human, and so to add dignity to the beginnings of cities' (Livy 1919: 5).

and control over their cultural heritage' [Nicholas and Wylie 2009: 31].) Noteworthy, too, is Bendremer and Richman's recommendation of the establishment of community advisory boards 'to provide an additional way for academics to hear the voices of indigenous peoples' (Bendremer and Richman 2006: 113).

Where the past is shared with others rather than appropriated, in exclusionary mode, by a specific community or interest group, the pooling of knowledge, research techniques, and material resources can facilitate a mutual enlightenment that would otherwise be unattainable. However, it is sometimes suggested that conceptions of the relationship between past and present are not cultural universals, and that the sharp separation of past and present implicit in Western notions of time is alien to some Indigenous peoples. Instead of seeing the past as dead and gone, as modern Westerners tend to do, members of some cultures consider themselves as living and acting under the eyes of the ancestors. Some anthropologists have proposed that the Western view of time is 'linear', whereas in certain other cultures time is experienced in a 'cyclic' manner (see, e.g., Pullar 1994; Walker 2000). Piotr Bienkowski remarks in Chapter 3 of this volume that '[w]hereas in the west most people are usually concerned only with a very few generations into the past – maybe as far as their grandparents – indigenous peoples and other animists regard ancestors who died hundreds of years ago as still members of the group living today'.

It is somewhat unclear how deep this difference of temporal conceptions really is. Our sense of time is intimately bound up with our experience of change, where change consists in causal processes that point for us the arrow of time. So far as the editors are aware, no human culture has thought that the past can be changed or that a completed causal process can be undone by running it backward. A society could conceivably believe that time was cyclical in the sense that what has occurred in the past will be repeated in the future (in the same way that a turning wheel will eventually come back to its starting point), but that is not to believe that literally the *same* events will happen again (as if the wheel could make its first revolution a second time). Plausibly, the phenomenon that Bienkowski alludes to depends not on some fundamental difference in the framework of experience but on a combination of (1) the belief that the spirits of the ancestors survive their death and (2) the greater sense of closeness to, and respect for, the past that is possible in more static societies that lack the restless Western appetite for change and still (in spite of all) Whiggish belief in 'progress'. But be that as it may, provided that all parties are sensitive to the different resonances that the sense of pastness (of people, objects, and places) may have for members

of other cultural groups, agreement should not be impossible on practical issues concerning the management and use of cultural heritage.

Still, it would be naive to suppose that where items of cultural heritage hold different significances for different people, any disagreements should be readily resolvable given a modicum of mutual understanding and goodwill. Some writers talk as if a mild infusion of sweet reasonableness were all that is needed to settle any dispute about the possession, treatment, or rights to interpretation of heritage objects. But people can be entirely reasonable yet still reach different conclusions when they start from disparate premises.

Is there any way of bridging the conceptual gaps that might command the allegiance of all? In an influential article, John Henry Merryman has proposed that disputes about the ownership or control of cultural property are best addressed not in terms of cultural nationalism (with their narrow focus on questions of origin) but via an 'object-oriented policy' that emphasises instead 'three conceptually separate but, in practice, interdependent considerations: preservation, truth and access, in declining order of importance' (Merryman 1994: 64). From this viewpoint it is less important where objects are located, or who controls them, than that they are properly protected and made available for study and enjoyment:

The most basic [consideration] is preservation: protecting the object and its context from impairment. Next comes the quest for knowledge, for valid information about the past, for the historical, scientific, cultural and aesthetic truth that the object and its context can provide. Finally, we want the object to be optimally accessible to scholars (for study) and to the public (for education and enjoyment). (Merryman 1994: 64)

Merryman's object-oriented approach is mainly directed against state-retentionist policies that prioritise keeping culturally significant objects on home soil, irrespective of whether they are well looked after there or open to scholarly study or public view. Such knee-jerk nationalism, Merryman argues, rarely serves anyone's real interests well, including those of the retaining states and their citizens. By contrast, the object-oriented approach is focused on the care and protection of objects themselves and recognises a wider range of interests in them; in place of narrow state or sectional interests, it places those of truth-seeking scholars and an undifferentiated general public at centre stage.

In giving primacy to the 'needs' of objects themselves, however, Merryman's object-oriented policy may sideline legitimate claims by Indigenous groups, local communities, or cultural or genetic descendants to have and

to hold, to preserve or dispose of, to keep private or make public, objects with which they have a special affinity. Indeed, despite the apparent inclusiveness of Merryman's conception of the audience for cultural objects, it effectively gives precedence to scholars whose methods are empirical and whose values are those of Western academia. In the event of a dispute between members of an Indigenous group who wish to retain some treasured sacred artefact in their own possession and archaeologists at a research institute who could give it better protection, probing scientific analysis, and ampler public exposure, the object-oriented policy would have the verdict go in favour of the latter. So an object that is, for the community of origin, an object of pride and veneration, even an icon of cultural or religious identity, would become part of a more universal commons (albeit a 'commons' to which academic 'experts' are the gatekeepers).

This is problematic not just because the Indigenous group which feels an intimate relationship with the sacred item is being treated just like any other members of the general public and denied any special privileges. If this is an affront to justice, a further difficulty is that an object-oriented policy so construed risks defeating its own intentions, by denuding objects of the meanings that they bear only while they play their designated roles in appropriate settings. The enigmatic statuette transferred from the dim depths of a temple or shrine to a shelf in a brightly lit museum, where its mysteries are unveiled by informative labelling and computer displays, has shed its sacred status through its radical detachment from context. From being a venerated item, it has morphed into a work of art or an object of study or curiosity. Loss of significance can also result from the isolated display of objects that were intended as components of larger wholes. A single terra-cotta soldier from the mausoleum of Qin Shi Huang at Xi'an is no longer a member of a mighty army but a lone warrior; a fragment of decorative stonework 'rescued' from some crumbling architectural ensemble may seem trivial and boring by itself. We could punningly say that such treatments of objects are de-meaning. Ironically, the very acts that are intended to protect objects and to make them available for study and pleasure can destroy the significances that made them interesting in the first place. The meanings of physical artefacts are often more evanescent than the objects themselves. Recontextualisation can also replace old meanings with new ones. For example, a Palaeolithic flint scraper displayed in a museum is intended not for the stripping of animal hide from flesh but to demonstrate the tool-making skills or the aesthetic tastes of our ancestors.

If Merryman is insufficiently sensitive to the fragility of the meaning of objects that are removed from their context, he is right to say that

politically motivated state policy or statute law that prohibits any move-
ment of culturally significant objects beyond national or regional borders is
unduly restrictive, being neither ethically justifiable nor practically enforce-
able. Items that are symbols of national identity or objects of national pride
may usually be best retained in their 'home' country.[3] But there is no justifi-
cation for insisting that anything created within the borders or produced by
a native craftsperson should never leave or, if removed, should be returned.
A French impressionist painting can be equally well understood and appre-
ciated in London or New York as in Paris. If someone were to claim that
the picture's Gallic origin meant that it 'belonged in' (or even 'belonged
to') France, it could reasonably be asked why others should be less entitled
to experience and enjoy what is not just a French but a human achieve-
ment. Seeking to exclude others from one's heritage may sometimes be
warranted on grounds of its sacredness, preciousness, rarity, or fragility,
but the unselfish sharing of our cultural treasures enhances our sense of
human kinship and promotes understanding and tolerance.

The chapters in this book are divided into three groups under the
headings 'Claiming the Past', 'Problems of Meaning and Method', and
'Problems of Ownership and Control'. These are only rough divisions, and
some of the chapters could have featured in more than one group. The
contributors to the first section are predominantly concerned with a range
of contested claims that people make, in a variety of contexts, to own, use,
protect, make public or keep private, explain and interpret, or determine
the significance of the things of the past (including traditional beliefs,
practices and modes of self-understanding as well as concrete objects and
physical places). While all the writers provide sensitive discussion of the
meaning of the claims at issue and the motivations behind them, they
do not always agree on how those claims should be evaluated or on the
weighting that should be accorded to different interests.

In the first chapter, James O. Young argues that focusing on the value of
finds may be more helpful in adjudicating disputes about appropriation of
the past than concentrating on ownership rights. To address in an informed
manner ethical questions about the appropriation of archaeological arte-
facts, it is necessary to know in what ways, in what degrees, and to whom
the past is valuable. Distinguishing four kinds of value (which he labels
'cognitive', 'economic', 'cultural', and 'cosmopolitan'), Young suggests that
thinking in these categories enables us to tackle rationally and fairly some

[3] However, the situation is ethically more complex in the case of items that once belonged to someone
else, such as trophies taken in war.

otherwise intractable questions about the appropriation of archaeological finds. So if one archaeological find is primarily valuable as a source of information for archaeologists while another has special cultural value for a small descendant community, the archaeologist might reasonably be permitted more access to and control over the former than the latter. The chapter particularly addresses the question of how to weigh the value of archaeological inquiry into the past against other kinds of value the past may have for descendant and Indigenous cultures. One practical implication of Young's argument is that there is not always an ethical imperative to respond positively to the requests of Indigenous communities to be regarded as the sole owners of any finds associated with their cultures. Concluding that 'we need to find the way to make archaeological finds as valuable as possible for as many people as possible', Young admits that this will be difficult to achieve but sees no satisfactory alternative to trying.

Piotr Bienkowski, in the next chapter, shifts the focus from the value of archaeological finds to the kinds of knowledge that may be had about them. Traditionally, he argues, the authority of archaeologists and museums over the retention of the archaeological heritage and the interpretation of the past has been based on a particular conception of knowledge that developed in the European Enlightenment, from which both archaeology and museums sprang. Despite the rise recently of phenomenological approaches in academic archaeology, institutionalised archaeology has, with some exceptions, not loosened its control over the archaeological heritage. Bienkowski explores the philosophy and practice of archaeological institutions (including museums) and asks how they might share or cede authority and control, working in association with groups that acknowledge different types of knowledge and challenge the authority of those institutions both to retain certain objects and to tell particular stories in a particular way. Such alternative types of knowledge, he argues, are broadly phenomenological – based on experience, emotion, social memory, and creativity – and sometimes explicitly animistic rather than 'scientific'. Often archaeological institutions, as essentially 'scientific' bodies, do not accept (or understand) the philosophical validity of such forms of knowledge, which can lead to disputes, conflicts, and feelings of exclusion by certain communities. In contrast, when archaeological institutions such as museums do 'validate' such alternative forms of knowledge and incorporate the voices of hitherto excluded groups, their established audiences often react with anger, feeling that the traditional values, knowledge, heritage, and identity – supposedly enshrined in and promoted by museums – are threatened. Clearly the conscientious museum keeper's lot is not always a happy one. Some

readers might, however, wonder whether Bienkowski's pluralist and inclusive approach to the representation of different voices by archaeological institutions is not in danger of leading to an anything-goes approach, in which no perspectives, however eccentric, are excluded and no one assumes the authority to adjudicate amongst them. Whether some form of soft sifting is possible that rejects the more outlandish viewpoints while preserving multivocality is an intriguing question that Bienkowski's discussion may prompt us to pose.

In 'The Past People Want: Heritage for the Majority?' Cornelius Holtorf argues that the attention rightly paid by heritage experts to the interest of minority groups has sometimes led to the majority's legitimate interests in cultural heritage receiving less attention that they ought. His chapter reviews the professional responsibilities of archaeologists and heritage custodians to help the general public to understand and engage imaginatively with the past. In some cases this might mean compromising on certain standards that some professional archaeologists and curators hold dear and permitting, for example, the repair and reconstruction of damaged buildings and objects that would have little, or less, meaning to a nonexpert audience if left in their distressed state. For instance, the reconstruction, in response to popular demand, of the baroque buildings of the Dresden Neumarkt that were destroyed by allied bombing in World War II is defended by Holtorf against the objections of purists that it is merely faking the past. Because such rebuilding enables people to feel a greater closeness to their past, and to grasp and appreciate more fully the achievements of their forebears, it would be undemocratic to refuse to give them what they want on the ground that the rebuilt environment they see is 'inauthentic'. In our present 'experience society'(Schulze), heritage is popular and appreciated as and when it tells good stories about the past, and heritage experts, including archaeologists, are valued in so far as they design places at which heritage can be witnessed. Holtorf suggests that archaeologists need to consider more carefully how to make the past and heritage meaningful to a broad contemporary audience and that archaeology in the future should work with, rather than against, the public's understanding and expectations of the discipline and its objects of study.

Janna Thompson's chapter 'The Ethics of Repatriation: Rights of Possession and Duties of Respect' presents a moral philosopher's appraisal of the complex debate on the restoration to Indigenous communities of human physical remains, artefacts, and other associated objects lodged in museums or research institutions. Thompson argues that there are often strong grounds for the claims of members of a culture, nation, or tribe

to the restitution of bones or artefacts that were taken from them by stealth, force, or deception. Even where the items at issue were originally obtained with the consent of the local people, requests for their restoration may well carry considerable moral force when they are now reasonably deemed to be important for the cultural or spiritual life of their modern-day descendants. Sometimes, however, it is not clear who was the original possessor of a thing or who now has the best claim to it when a community has branched, merged with or become subsumed under others, or disappeared. Drawing on examples from Australia, the United States, Iceland, and elsewhere, Thompson discusses the difficulties that arise in adjudicating requests for return where criteria for return are imperfectly satisfied or conflict. Like James Young, she is receptive to the argument that demands for repatriation may in principle be transcended where physical remains or artefacts are of outstanding scientific importance or have some other profound significance for humankind in general. But she is less willing than Young to allow that such interests can trump the property rights of local groups, where these can be clearly demonstrated.

In a lively and provocative essay, Larry J. Zimmerman challenges what he calls the 'nearly reptilian tenacity' with which some archaeologists cling to cherished ethical principles and values. Archaeologists who are convinced that scientific needs should always take precedence over other interests, or that they are the primary custodians of human heritage, or that key sites and artefacts should be preserved at all costs, draw the parameters of the discipline too narrowly and inflexibly. Rejecting the idea of ethical absolutes in archaeology, Zimmerman contends that practitioners should be ready to let go of received ideas and realise that real-world ethics must be practical and adaptable. Even those elements that seem to define archaeology as a discipline, including the very notion that archaeology is about the past, may need to be given up when we recognise that 'an archaeology of ten minutes ago' might be useful for understanding or solving contemporary social issues. So too should the ideas that archaeologists should always be free to study whatever they want, or that the past is a public heritage (contrary to the view that particular groups may have intellectual property rights to their own heritage), or that there is only one single true story to be told about the past. While carefully avoiding the trap of dismissing one set of absolutes only to replace it with another, Zimmerman suggests that the best way forward for archaeologists is to take an open-minded, pragmatic, and nonproprietorial approach to their discipline, seeing their role as one of supporting various kinds of stakeholders in the stewardship of their heritage. Rather than archaeologists being the controllers of heritage, they

do better to see themselves as agents in the service of those Indigenous or other local groups who may seek their help in researching, interpreting, and publicising their own past. Although Zimmerman's approach is attractively irenic, it may face difficulty in the case where academic archaeology and Indigenous tradition give accounts of the past that resist ready reconciliation. In such a situation the best that may be achievable is a respectful toleration of one another's viewpoint and a willingness to continue further dialogue.

The next chapter, by Anna Källén, identifies some of the things that can go wrong when archaeologists, instead of assisting the local community to tell its own story, find their services enlisted by outside interests that favour the telling of a different story. Archaeology and tourism have become steady partners in a fruitful relationship in Southeast Asia since the boom of the international tourist industry in the late twentieth century. 'Hintang and the Dilemma of Benevolence' explores the consequences of that relationship in the case of Hintang, a site high in the mountains of Laos, whose impressive standing stones have recently begun attracting ecotourists. Ecotourism is marketed as an ethically responsible form of tourism that escapes the destructive impact of mass tourism and is based on ideals of benevolent contribution to local people and endangered environments. Yet a view from within the social reality of Hintang reveals a more complicated situation. With scarce resources and economic opportunities, the people of Hintang are encouraged by the tourism industry to take part as props in staged activities that, seen in a larger perspective, will only sustain their marginalised position. Their role is to pose as primitive people in need of help so that the Western tourist, by visiting, can be made to feel caring and benevolent. Archaeology is part of the discursive tool kit that justifies such usage of local people and makes them participate in their own exploitation on a voluntary basis. To make matters worse, Källén shows how the story of Hintang presented to tourists is one of a linear pattern of human development from savagery to sophistication (of a kind beloved of nineteenth- and early twentieth-century ethnography), in which Hintang occupies a lowly place. Her essay advocates a sharpened critical focus on the ethical consequences of both popular and scientific archaeological discourse in activities such as tourism in contemporary society.

The chapters in the second part, 'Problems of Meaning and Method', take their start from an acknowledgment of the different ways in which the past can be significant for different groups of people. Their authors explore some of the methods by which disparate voices can learn to speak

to rather than past one another and consensus be reached on such practical issues as the control of information and the stewardship of artefacts.

In the first essay in the part, Jonathan Lear focuses on what kind of a loss is involved when people are deprived of the meanings by which they have traditionally lived. Expanding on themes first explored in his landmark study of the North American Crow tribe, *Radical Hope* (Lear 2006), Lear shows how profound cultural change can involve not merely an alteration of practices but also the onset of a predicament in which the old ways no longer make any sense as practical options. The Crow were driven by white settlers from their old hunting grounds, made to abandon their warlike ways, and removed to distant reservations. As a result of the loss of their traditional way of life, the concepts in terms of which the Crow had understood themselves and the values and goals that had informed their practices were no longer available to make their lives intelligible; their history had effectively come to a stop. Although the old ways could still be understood in an abstract, theoretical manner and their loss regretted, they were completely beyond reach; from a practical point of view, the concepts embedded in that way of life were dead. Suggesting that there is always more pain suffered when there is a breakdown in intelligibility than in the case of other forms of cultural assault in which intelligibility remains intact, Lear argues that Indigenous peoples who have undergone a loss of cultural meaning in the manner of the Crow can make a particularly strong claim for the return of artefacts that have been taken from them and for assistance in reviving some of their traditional practices. Although in the aftermath of historical trauma complete restoration and reinvigoration of original meanings will rarely, if ever, be possible, a people who wish to reconnect themselves with their ancestors may be able to invest old practices with new or adapted meanings, thus bridging the period of discontinuity and bringing the culture back from the dead.

How similar to present-day members of the Crow tribe who wish to reinstate such traditional rituals as the Sundance are modern self-styled Druids who demand permission to utilise the ancient monoliths of Stonehenge in Wiltshire as a ceremonial place? Not at all, one might think, in view of the lack of any connection between modern 'Druids' and those (whoever they were, and they were certainly not Druids) who erected the standing stones. However, as Elizabeth Burns Coleman observes in her chapter 'Contesting Religious Claims over Archaeological Sites', there are ethical questions about who has the right to determine the use of such heritage sites as Stonehenge, and those questions become more acute when they are linked with

issues of freedom of religious worship and expression. Coleman asks why many archaeologists, curators, and other professional bodies and institutions are much more sympathetic toward Indigenous communities' claims to have rights to access, utilise, and manage heritage sites and objects than they are toward similar claims made by contemporary Druid or New Age groups. It is often objected that these modern movements are not true religions but cases of middle-class playacting and that their pretensions to be the revived forms of ancient faiths are bogus. But as Coleman points out, it is not easy to define what a true religion is or to say when a religion is valuable, and those who profess a respect for religious freedom and civil liberties should engage with, and not merely dismiss, the demands of New Age and other modern groups to use heritage sites such as Stonehenge for purposes that are alien to the archaeologist or historian. Mere distaste for or disbelief in the ideas and practices of New Age believers is not a sufficient basis in a liberal society, thinks Coleman, to warrant an unqualified policy of prohibition.

Coleman's conclusion, though it may disturb, is indicative of a concern shared by many of the authors in this book that archaeologists should speak with and not shout down others whose understanding of and interest in the past may be very different from their own. But how can conversations be fostered in which different voices do not talk past one another but communicate? Alexander A. Bauer offers some practical suggestions in his chapter. The idea that archaeological inquiry should not be exclusively the domain of Western academicians, but should involve local and descendant communities, amateurs, artists, and many potential publics, may be seen as one way of developing a more democratic, and ultimately more ethically responsible, archaeology. But, as Bauer notes, bringing together a multiplicity of voices and perspectives raises practical and conceptual questions about how to make them mutually intelligible to one another. Leaving to archaeologists the task of synthesising the disparate voices would obviously risk undermining the democratic premise of multivocality. Bauer proposes an alternative tack that takes inspiration from the semiotic writings of the American pragmatist philosopher Charles Sanders Peirce. As a metapragmatic framework, Peircean semiotics has been increasingly recognised as a way to understand knowledge production and communication, and to find common ground among seemingly irreconcilable approaches to reasoning. What Peirce called the 'Final Interpretant' resembles what has been more humorously termed 'Wikiality', and refers to the consensus reached by a community of inquirers using any and all methods of inquiry, including guesswork. Bauer argues that new interactive modes of knowledge

formation and representation on the World Wide Web may serve as ideal vehicles for a Peircean approach to inquiry about the past. As an inclusive, nonfoundational, and community-based approach to knowledge, facilitated by new information technologies, this promises to produce an archaeology that is genuinely democratic and multivocal.

One potential danger of an unrestricted Wikiality and free flow of information is identified by George P. Nicholas and Alison Wylie in their contribution. Although all human societies have benefited from the transmission of knowledge across cultural boundaries, the unequal distribution of political and economic power means that some groups gain more than others from the open exchange of ideas. If the knowledge, objects, and images from the pasts of all cultures are considered part of a common human heritage, then it may seem unproblematic to appropriate them for current use. Unfortunately, it happens too often that such utilisation has a cost that is paid largely by Indigenous peoples, who historically have had little power to prevent the appropriation and commodification of their tangible and intangible heritage. The resultant challenge, Nicholas and Wylie argue, is to strike a balance between safeguarding the rights to their heritage of Indigenous and subaltern peoples while allowing ideas to circulate as freely as possible for the common benefit. To meet this challenge, they propose a community-based participatory research approach to identifying the impacts of cultural appropriations on Indigenous societies, which may include loss of access to ancestral knowledge and property, loss of control over the care of heritage, diminished respect for the sacred, and commercialisation of cultural distinctiveness. Community-based projects also provide an avenue to develop effective and appropriate responses to previous appropriations. For this reason, these strategies are a major component of an international collaboration, the Intellectual Property Issues in Cultural Heritage (IPinCH) project, directed by Nicholas, which documents and analyses the diversity of principles, perspectives, and responses that arise from intellectual property issues in cultural heritage. Intended to generate norms of best practice, the IPinCH project is one among a number of initiatives that have been developed in recent years to facilitate cultural exchanges of a kind that benefit many and harm none.

A different type of conflict over how to understand and value the material remains of the past is discussed in David E. Cooper's chapter 'Should Ruins Be Preserved?' Archaeologists normally take for granted that the material remains of the past should be preserved in their existing state and protected against any further deterioration. At first glance, this seems sound common sense, for where sites, buildings, and artefacts are allowed

to decay, the archaeological record disappears beyond recall. Yet as Cooper notes, there is a long tradition of taking aesthetic pleasure not only in ruins but even in the very processes of decay themselves. The archaeologist's interest is a scientific one in the information about past cultures that can be gleaned from the examination of ruins. The aesthete's is in the perceptual qualities and expressive power of ruins. Cooper raises the question of why ruins have had, and continue to have, great resonance for large numbers of people. Answers to this have ranged from an emphasis on ruins as testimonies to the vanity and hubris of individuals or civilisations, to a more recent emphasis on ruins as intriguing 'hybrids' that symbolise a dialectical relationship between human endeavour and natural processes. Cooper distinguishes two significant normative issues, which he calls the excavation and the preservation issues. The former concerns the degree to which further excavation should be allowed for scientific purposes, where this is costly to the appearance or romantic aura of a site. The latter relates to the state in which a ruin should be kept, given its vulnerability to the forces of the weather and other natural processes. In Malta a project has begun to cover the prehistoric temples with protective roofs. Cooper asks whether such artificial interference in nature's workings can be justified when it is those very workings which, some think, give ruins their charm. But he recognises that archaeologists and appreciators of ruins are likely to be on the same side in contests with entrepreneurs who want to exploit the commercial value of a site or developers for whom a ruin is merely an obstacle to be cleared out of the way.

The papers included in the third part, 'Problems of Ownership and Control', are related by their concern with cultural heritage in legal and political contexts. The first two, by Allen and Garrard, take an analytical look at aspects of contemporary property law as it relates to items of cultural heritage. The remaining chapters, by Lahiri and by Coningham and Gunawardhana, examine from a more historical perspective examples of the ways in which political and religious pressures at the state level can bring about significant dislocations in the ownership of and control over cultural heritage, with results that often benefit some at the expense of others.

In 'Legal Principles, Political Processes, and Cultural Property', Tom Allen questions the adequacy of legal principles to provide an adequate framework for resolving disputes over cultural property in view of the subtle and complex issues relating to cultural and individual identity that such disputes frequently involve. It is a core legal principle that laws must be reasonably certain, transparent, and stable over time, and property laws

are generally held to be most effective when the rights they enshrine are concentrated exclusively in the hands of one person. Where some form of group ownership is thought desirable, lawyers have the device of the artificial legal person (e.g., a corporation or public body) through which the group's interests can be recognised. Archaeologists, however, produce information that is relevant to ideas of cultural and group identity, but courts that are asked to settle disputes relating to control of or access to objects or sites of archaeological interest are not well equipped to handle questions relating to identity. In Allen's view, the attributes of identity often cannot be expressed in ways that are compatible with the core values of property law, because identity can rarely be defined with sufficient precision, is often not very transparent to observers, and is unstable over time. It can also pose a challenge to the legal concept of exclusive ownership, since an object that is important to one group's identity may also be important to the identity of others (and in ways that can change rapidly and unpredictably). Allen concludes that legal processes must therefore be supplemented by political ones and that the ad hoc responses of legislators represent a better means of responding to the shifting and often highly complex questions of identity than the principled responses of lawyers.

David Garrard's essay 'Monuments versus Moveables: State Restrictions on Cultural Property Rights' asks what kinds of cultural property the state can legitimately exert control over in the public interest. In many countries laws exist to restrict what owners may do with items regarded as having cultural significance. If I own an artistically or historically important asset such as a listed building, sculptural monument, archaeological site, notable battlefield, or designated landscape, then I may be legally prohibited from altering, damaging, or destroying it. But Garrard notes the curious anomaly that portable items typically enjoy much weaker legal protection. In the United Kingdom one is legally permitted to put one's Vermeer on the fire, yet one may not alter the fireplace of a Grade II listed building in order to make it fit. Garrard analyses the nature of the division between fixed and portable cultural property, and asks why, when items of both kinds may be of prime historical or artistic importance, the latter are less likely than the former to be subjected to forms of state stewardship (although in many jurisdictions there are legal constraints on the export of portable objects beyond the state borders). What Garrard terms 'a deep respect for proprietorial privacy' tends to inhibit the practical implementation of a concept of commoners' rights even when items are deemed to form part of the national or even the universal heritage. In Garrard's view, more could and should be done by legislators to encourage owners of cultural

property of all sorts, and particularly portable items, to allow the public opportunities to access and enjoy it.

Continuing the investigation of the interface between cultural heritage and legislation, Coningham and Gunawardhana examine the issues raised by the practice of mining ancient Buddhist monuments in South Asia to obtain relics to venerate. Presenting detailed data sets from recent field-work in northern Sri Lanka, they focus on the widespread destruction of Buddhist monuments as villagers, officials, and even Buddhist monks search for relics. Demonstrating that such activities are current in other parts of South Asia, they note that during the colonial period individuals participating in this destructive practice were referred to as 'treasure hunters', 'looters', or 'thieves' by European and Asian archaeologists. Although such activities are damaging to the cultural record and clearly criminal with respect to current South Asian legal instruments, Coningham and Gunawardhana attempt to mitigate the accusations of theft by identifying the existence of a notable tradition of acquiring Buddhist relics from earlier monuments from the third century BCE. Observing the tension between Buddhist tradition and legal restrictions, they advocate greater training and education of custodians and owners of such monuments. They conclude by suggesting that rather than criminalising these customary practices, a campaign of micro-conservation at a localised level would be a more suitable objective than the rigid enforcement of the law.

Nayanjot Lahiri's chapter tells the little-known story of the fate of monuments, religious sites, and other forms of cultural heritage during the traumatic period of the political Partition of the Indian subcontinent between India and Pakistan in the late 1940s. One ironic consequence of Partition was that the new state of Pakistan included most of the area in which the original Indus civilisation had flourished, whereas India contained many of the most important Muslim monuments, as a legacy of the Mogul Empire. Despite the best efforts of the Archaeological Survey of India (a survival from the colonial era) to protect them, massive harm, both intentional and as a result of the general social disruption and violence, was done to Muslim buildings in India. The fact that these structures represented the cultural heritage of a people now viewed by many Hindus as alien and hostile became a positive reason for some to damage or destroy them. A further ethical dilemma for archaeologists was posed when some Muslim monuments were pressed into service as schools or refugee centres, thus fulfilling urgent social needs but at considerable cost to their own preservation. At state level, the governments of India and Pakistan had to reach agreement on what to do with museums and their holdings, and particularly difficult

problems arose in the case of museums located in provinces that were now divided between the two states. Objects that had been sent away on loan and were now on the wrong side of the border were the subject of some particularly tortuous negotiations. Lahiri's historical narrative points up the acute ethical and practical questions (about ownership, control, preservation, access, repatriation, and compensation) relating to cultural heritage that needed to be faced by the Indian and Pakistani governments and their archaeological services. In Lahiri's view, many mistakes were made, some of them with the best of intentions. She cogently criticises the principle of equity that was commonly adopted as the basis for a division of items of cultural importance. This, for all its surface merits, had the frequent unfortunate result of damaging the integrity of objects, assemblages, and contexts. Yet Lahiri manages to end on an optimistic note, voicing the encouraging hope that, where goodwill is present, many previous wrong or unwise decisions about the disposition of cultural heritage items can be corrected in the future.

Earlier versions of several of the chapters in this book were presented at the inaugural conference of the Durham University Centre for the Ethics of Cultural Heritage in July 2009. The editors would like to record their gratitude to Durham University for its support of the Centre and to the College of St Hild and St Bede for hosting the conference.

PART ONE

Claiming the Past

CHAPTER 2

The Values of the Past

James O. Young

Questions about ownership of archaeological finds are often framed as questions about rights. Archaeologists claim to have a right to engage in scientific inquiry, a right that authorizes them to appropriate (at least some) finds. Indigenous people in the Americas, Australasia, and elsewhere often maintain that they have inherited a right to ownership of the finds associated with their cultures. Similarly, nations claim that they have a right to certain artifacts. We also hear that all of humanity has a right to certain archaeological discoveries. It is often difficult to discover the bases of these supposed rights to own or appropriate finds and even harder to weigh competing claims based on claims to rights. Consequently, rights-based debates have not been particularly successful in resolving questions about the ownership and appropriation of archaeological finds. In the hope of better results, I suggest that we ask about the various sorts of value that finds have and for whom. My hope is that once it becomes apparent that a particular find has great value for some group of people (and less for others), questions about possession and appropriation of the find will become more malleable. Because a universal account of how and to whom archaeological finds are valuable is likely to prove elusive, we should not expect reflection on the value of finds to result in general principles about ownership and appropriation. We can, however, hope for a methodology that will help resolve questions about ownership in a wide range of cases. This chapter takes some steps toward developing this methodology.

Each decision about possession of an archaeological find will lead to different outcomes. Some will lead to the find's having increased economic value. Other decisions about the disposition of a find will lead to its having increased cognitive value. In some cases, the value of a find for the members of some group will be greatly increased if they possess it. For example, the cognitive value of finds is greatly increased if archaeologists possess them (at least long enough to complete a thorough study). Or if some people possess archaeological finds, significant economic benefits may accrue to

them. My suggestion is that we ought to determine how archaeological finds will be most valuable and that this ought to guide decisions about possession and appropriation of the finds. The decision about possession of a find that leads it to have the greatest value is the right decision. The trick is to weigh different sorts of value against one another. Sometimes the calculation will be relatively easy. Suppose that an archaeological find has an immense amount of total value to the members of some large culture if they possess it and little value to anyone else. Likely, the large culture in question ought to have it. If a decision about the disposition of a find leads to it having a modest amount of value for a small number of people, then likely this group of people does not have a strong claim on the item. Sometimes a find has significant value to various groups. These will be the hard cases.

This chapter considers four different sorts of value. I refer to them as cognitive, economic, cultural, and cosmopolitan. The list is not exhaustive, but it includes most of the important sorts of value that are considered when the disposition of archaeological finds is under consideration. I begin (after some general reflections on value in archaeological finds) by discussing each of the sorts of value that I have identified. The importance of each sort of value is estimated. The chapter concludes with a tentative effort to provide guidelines for weighing the various sorts of value.

GENERAL REFLECTIONS

A preliminary question about the value of archaeological finds needs to be addressed. We need to ask whether they have intrinsic or extrinsic value. Some writers have maintained that at least some archaeological finds have intrinsic value. This claim is most often made about human remains. For example, Alison Wylie writes that human remains "deserve to be treated as intrinsically valuable ends, not as means (only)" (Wylie 2003: 11). The claim that some artifacts have intrinsic value could also be defended. In certain cultures, agency or personhood is sometimes attributed to artifacts. The Maori, for example, have a concept of a *taonga*, or a living treasure. Although such positions are defended, I maintain that all archaeological finds have only extrinsic value.

Let us begin by being clear about what it means to say that something has intrinsic value. To say that something has intrinsic value is to say that it is good for its own sake. G. E. Moore proposed a useful test for determining whether something possesses such value. Something is intrinsically good if, were it to exist in absolute isolation, one would judge its existence to

be good. So, for example, an archaeologist's shovel does not have intrinsic value. Without people with a desire or need to dig (or another use for shovels), a shovel has no value. Some mental states, in contrast, are valuable even in isolation. For example, pleasure, happiness, and various other states are valuable even if nothing else existed. Archaeological finds can be valuable as sources of knowledge, cultural pride, and in other ways to be enumerated here. To say that finds are valuable in these ways, as means to knowledge and so forth, is to attribute to them extrinsic value. Using the isolation test, it is hard to see how they can have intrinsic value.

We need, then, to account for the contrary opinion of philosophers such as Wylie. They appear to be using intrinsic value in Kant's sense of the term. Kant famously said that all rational beings are "ends in themselves," and are endowed with "dignity" and "intrinsic value." In making this claim, Kant is not concerned with intrinsic value in the sense of "good for its own sake." Rather, he is concerned with the question of how we ought to treat rational beings. They are, in Kant's view, deserving of respect and esteem (Zimmerman 2007). So although someone like Wylie says that certain finds have "intrinsic value," she is not contradicting my claim that they have only extrinsic value. She is simply using the term "intrinsic value" in a different way. She is saying that certain finds ought to be treated with respect and dignity, not that they are good for their own sakes.

This said, archaeological finds (even human remains) are not rational beings or persons. Some indigenous people apparently believe that human remains are persons. Sometimes, as I have noted, personhood is also attributed to artifacts and naturally occurring objects. Archaeologists sometimes speak as if indigenous beliefs about the personhood of finds were correct. The fact remains that no finds are rational beings. Consequently, they do not deserve the sort of respect and esteem accorded to such beings. This fact has to be taken into account in any determination of the value of archaeological finds – at the same time, so must the fact that some people regard finds as rational beings. A find may have cultural value to members of a culture in part because of false beliefs they have about it.

This last point is a reminder that there is a subjectivity to the experience of value. Something can have considerable value for one person (in virtue of his or her interests, tastes, or goals) and little or no value for another person (who has different interests, tastes, or goals). For example, a good performance of a Handel oratorio will have value as a source of pleasure to persons with certain musical tastes. The same performance will have no hedonic value to someone with different tastes. Different interests can also lead to the same object's being valued differently by two people.

A hotelier may regard a new bridge to an island as highly valuable. It serves his business interests. The poet, who has an interest in quiet and seclusion, regards the same bridge as worse than valueless. Sometimes generalizations can be made about what is valuable to members of a culture. For example, a pen used to the sign the US Declaration of Independence is likely to be more highly valued by an American than by a Canadian or a Chinese. A similar point can be made about archaeological finds. They may have more value (of some sort or another) to the members of one culture than they have to members of another. Some people may not value the past at all. James Cuno recently observed, "If the ancient past and antiquities are important . . . they are important to all of us" (Cuno 2008: xxxiv). This seems to be false.

One more general point remains to be made about the value of archaeological finds: we can distinguish between the value that something has and the value that it appears to have. For example, I may have the goal of living a long and healthy life. If so, any information that is means to this end has value for me. I may, however, make mistakes about the information that enables me to achieve my goal. I may, for example, believe to be worthless any research into the health benefits of exercise. That is, I regard this research as without cognitive value. In fact, given my goals, the research does have value for me. A similar point can be made about archaeological finds. I may believe that some archaeological find has little or no value, and yet (given my interests and goals) it may have substantial value for me. Note that this point does not apply to all sorts of value. At least in some cases, I cannot be mistaken about how much hedonic value some object has for me. Each of us is the best judge about how much aesthetic pleasure we derive from the contemplation of an object.

COGNITIVE VALUE

Cognitive value is the first sort of value that archaeological finds may possess. Cognitive value can be divided into two types: intrinsic and extrinsic. When a find has extrinsic cognitive value, it assists us in achieving non-archaeological ends. When a find has intrinsic cognitive value, it is valued as a source of knowledge that is valuable for its own sake. Perfectionists are among those who defend the value of pure knowledge, including archaeological knowledge. Knowledge will show up on any perfectionist list of goods, either because it makes a contribution to the development of human nature or because it is an objective good. One does not have to be a perfectionist, however, to recognize that knowledge is both extrinsically

good and good for its own sake. What holds of knowledge in general holds of knowledge produced by archaeology in particular.

A few examples illustrate this point. Archaeological finds may be a source of medical knowledge. Excavations of the graves of people who died in the Spanish influenza epidemic of 1918 and who were buried in permafrost may provide researchers with the means to combat a future influenza outbreak (Davis et al. 2000). Similarly, archaeology may assist in the identification of a gene possessed by survivors of the bubonic plague of the fourteenth century. This could be useful in the treatment of diseases in the present (Nicholas and Wylie 2009: 21). These are both cases of archaeological finds with extrinsic cognitive value. Some archaeological finds possess extrinsic value because they promote rational thought and undermine prejudice. Consider archaeological finds that undermine the hypothesis, held by Bishop Ussher, that the world was created in 4004 B.C. In other cases, archaeological finds have intrinsic cognitive value. They provide us with knowledge that simply satisfies our curiosity about the past. It is hard to see how information about the dissemination of Minoan pottery throughout the Mediterranean is anything but intrinsically valuable: we value the knowledge for its own sake.

It is important to determine how much extrinsic cognitive value archaeology can have. Everyone (including every indigenous person) has an interest in promoting medical research. Everyone has an interest in good health. If the appropriation of some archaeological find would lead to a medical breakthrough from which many people would benefit, a strong case could be made for the morality of the appropriation, even if it were against the wishes of some indigenous community. Unfortunately, only in comparatively rare cases will archaeological research have this sort of extrinsic cognitive value. This value is unlikely to outweigh other sorts of value that archaeological finds will have for indigenous people if they are unappropriated.

A defense of the appropriation of archaeological finds is likely to be more successful if it can demonstrate that appropriation will undermine prejudice and dispel ignorance. Apparently, quite a substantial number of people do not accept the view of human history supported by archaeology. Opinion surveys regularly yield the conclusion that about half of the American public believes that God created humans, in their present form, sometime in the past ten thousand years. The indigenous population is not immune to this sort of erroneous belief. Armand Minthorn, an indigenous American religious leader, has stated, "We know that our people have been part of this land since the beginning of time. We do not believe that our

people migrated here from another continent" (quoted in Owsley and Jantz 2002: 143).

Similarly, Sebastian Le Beau, a Cheyenne River Sioux, maintains: "We know where we came from. We are the descendents of the Buffalo people. They came from inside the earth after supernatural spirits prepared the world for humankind to live here. . . . I have yet to come across five Lakotas who believe in science and evolution" (quoted in Owsley and Jantz 2002: 143–4).

Although views such as these have currency, unimpeded access to the archaeological record has extrinsic cognitive value. This seems to be part of Cuno's point when he writes about the museum, qua repository of archaeological finds, as "a force for understanding, tolerance, and the dissipation of ignorance and superstition" (Cuno 2008: xxxi). At the same time, it must be admitted that there are diminishing marginal returns to be had here. Archaeology has greatly reduced the amount of ignorance and superstition in the world, but more archaeological knowledge is likely to have difficulty eliminating what remains. There is a limit to what knowledge can do against entrenched and self-satisfied ignorance.

Let's turn to a consideration of the intrinsic cognitive value of archaeological finds. Unfortunately for archaeology, not everyone finds intrinsic value in the knowledge to be had from archaeological finds. As just noted, when archaeological finds have extrinsic cognitive value, they typically have such value for everyone. Pure cognitive value is another matter. Archaeologists may be curious about the aspects of the human past that their science can reveal. Others may have no such curiosity. Consequently, the amount of intrinsic cognitive value will be lower. Indigenous people, in particular, will likely not share all of archaeologists' pure curiosity. Many of them have many more pressing concerns: substandard housing, lack of economic opportunities, and communities plagued by alcohol and drug abuse. Research with intrinsic cognitive value is something that simply does not interest them.

We need to bear in mind that many archaeological finds do not yield much knowledge. Elezar Barkan notes that only "a miniscule percentage of excavations . . . are studied, processed, and displayed" (Barkan 2002: 31). Other finds, even if studied, are typical, mundane, and unable to contribute significantly to the expansion of knowledge of the human past. When finds fall into this category, it is hard to defend their appropriation by archaeologists on the grounds that they have cognitive value. Their cognitive value to archaeologists could easily be outweighed by other sorts of value they have to descendent communities. This judgment should be

accompanied by a word of caution. It may be that archaeological finds have little or no cognitive value at present, but with advances in technology, they may yield important knowledge. Although this is possible, in many cases it will be possible to judge with a high degree of probability that certain finds are not a significant source of knowledge. In other cases, it may be clear that technological advances may enable scientists to extract more information.

These reflections may seem to have missed an important point. Some writers, inspired by the French theoretician Michel Foucault, have suggested that archaeology's pretension to being an objective science is unfounded. Such writers point to governmental use of archaeological knowledge as a tool to control and suppress indigenous populations. (These writers often actually give examples of archaeological pseudoknowledge being used for social control. For example, the false claim that North America and Australia were mainly uninhabited has been used to undermine indigenous land claims (see, e.g., Smith 2004: 18). From this Foucauldian perspective, archaeology may seem to have no cognitive value whatsoever. Such a conclusion does not follow. Archaeological knowledge, like any other sort of knowledge, can be misused. We cannot infer from this that archaeological knowledge has no intrinsic value. Clearly, for many people it does. Equally clearly, if somewhat more rarely, archaeological knowledge sometimes has extrinsic value.

ECONOMIC VALUE

Although the cognitive value of archaeological finds is of most interest to archaeologists, their economic value is what is paramount for many other people. Traders in antiquities and many collectors (those who collect for investment purposes) focus on the economic value of finds, but they are not the only ones. Some indigenous people are more concerned about the economic value of finds than any other sort. A nation (e.g., Papua New Guinea) may value development over heritage and view archaeological finds as a source of money. An indigenous culture may value finds primarily as a way to foster archaeotourism. Economic value may also be paramount for individual members of indigenous cultures who engage in subsistence digging.

The suggestion that archaeological finds have economic value, at least that they all do, may be contested. From the perspective of many cultures, certain archaeological finds ought not to be fungible. Indeed, I go further and remove the qualification. Some archaeological finds ought not to be objects of economic exchange. Given that they have such a high degree

of cognitive, aesthetic, or cultural value, certain finds ought not to be bought and sold. The noneconomic value of these finds makes them the inalienable property of some individual or, more likely, group of individuals (e.g., a culture). This said, not every archaeological find is nonfungible. The market also assigns an economic value to artifacts that ought not to be fungible. In this sense, even nonfungible items have an economic value.

Economic value is almost universal. That is, if an item has economic value, then virtually everyone will find the item valuable. This applies to archaeological finds as much as to barrels of oil and bushels of wheat. (There are rare exceptions, such as members of cultures that have not been integrated into the market economy.) The proposal in this chapter is that we determine how finds have the most value and make decisions about possession once we know how finds can be most valuable. It may seem, therefore, that consideration of economic value will provide us with no guidance when it comes to answering questions about ownership and appropriation of finds because finds have the same value for everyone. That is, it may seem that whoever has possession of a find, its economic value will be the same. In fact, just the opposite is true.

Let us begin by considering the economic value of archaeological finds to collectors of artifacts. The economic value of finds to this group will be small compared to the value of the same finds to other groups. This is a consequence of the law of diminishing marginal utility. Collectors of archaeological finds usually are, relative to indigenous people and others for whom finds have economic value, wealthy. An Aztec sculpture may be a good investment and add thousands of dollars to a collector's net worth. It may only be worth a few pesos to a Latin American peasant who digs it from his field. Nevertheless, the sculpture has more economic value for the peasant than it has for the collector, for the same reason that a £10 note is worth more to a beggar than it is to Bill Gates. Archaeological finds also have economic value for professional archaeologists. Whether archaeologists are employed by universities or museums, part of their livelihood depends on access to the archaeological record and the resulting finds. Still, because of diminishing marginal utility, the economic value of finds to archaeologists pales by comparison to their value to poor indigenous people and other disadvantaged individuals.

We should conclude from the reflections of the previous paragraph that consideration of economic value supports the claims of disadvantaged groups to own or control archaeological finds. This should not, however, be construed as a defense of subsistence digging. Subsistence digging is probably the least efficient way to generate economic value from the

archaeological record. For a start, it is a completely unsustainable practice: the archaeological record is a non-renewable resource. Consequently, whatever economic value results from the practice will be limited. Moreover, items have more economic (and other) value if they have a proper provenance, which they will lack if excavated by subsistence diggers. Perhaps most important, nothing in the practice of subsistence digging ensures that finds are controlled by those for whom they have the greatest marginal utility. Archaeological finds can have much greater economic value if a strategy completely unlike subsistence digging is adopted.

This strategy would begin by involving indigenous people and other disadvantaged groups in the archaeological process. Archaeological finds would have enhanced economic value if disadvantaged groups could benefit from income in this way. Of course, this point does not address the question of ownership and appropriation once finds are recovered. Once finds have been recovered, however, they are likely to have their greatest economic value if they can be used to encourage long-term economic activity for disadvantaged groups, such as members of indigenous cultures. An example of such an activity would be archaeotourism. In the long run, archaeotourism will have a much great economic impact than the sale of archaeological finds.

This is not to say that all archaeological finds ought to be in the custody of descendent communities when these are economically disadvantaged. Diminishing marginal utility could easily come into play again. Once a museum operated by some descendent community has a significant collection, another potsherd will have little economic value. There are also very many cases in which archaeological finds do not have economic value for indigenous persons. This is the case where finds are not used to support archaeotourism or to otherwise generate economic activity. In my judgment, the economic value of archaeological finds to disadvantaged people is the strongest basis they can have for claiming ownership. Any other outcome from archaeology pales to insignificance when compared to improvements in the quality of life of very poorly off people. Ironically, however, some indigenous cultures voluntarily forgo the economic value of archaeological finds. Some cultures given custody of finds will reinter them (as many cultures do with human remains and some artifacts) or allow them to decay in the wild (as the Zuni do with their war-god figurines). In such cases, the economic value of finds provides no support for a claim to ownership. If a find has no economic value to a culture, its claim to own the find will have to depend on its having other sorts of value to the culture.

The cognitive and economic value of archaeological finds can both be maximized. The same find can be a source of knowledge and used to generate economic activity that will benefit poorly off people. Indigenous people can participate in archaeological digs and benefit from archaeotourism. At the same time, finds can be made available for scholarly study.

CULTURAL VALUE

The category of cultural value is broad. When I say that an item has cultural value, I mean that the possession of the item contributes to the well-being of a culture, and it does so in part because the item has a history of being valued by the culture. A place of worship or important ceremonial regalia has cultural value in this sense. It contributes to a culture's ability to sustain its religious practices and beliefs. Sometimes the cultural value of an item is the result of its contribution to the cohesion, identity, and self-respect or pride of a group. Perhaps most often, the cultural value of an item is attributable to the satisfaction members of the group feel when they are secure in the knowledge that they possess something that matters to them as a culture. Objects as diverse as an original copy of the Magna Carta, the Forbidden City in Beijing, Iceland's *Flatejarbók*, a geographical site such as Uluru, and many archaeological finds (including finds of human remains) have cultural value.

It is difficult to speak in general terms about how much cultural value a find will have for the members of a culture. Only rarely will the appropriation of a find threaten the integrity of a culture. After all, a culture has usually been flourishing in ignorance of a find's existence. Moreover, as can be seen in the ability of indigenous cultures to sustain themselves under terrible duress, cultures are resilient. As I have noted, objects usually have cultural value simply because members of a culture are pleased to possess them. They feel renewed cultural pride and self-respect. This is what is at stake in the widely discussed case of the Parthenon Marbles, and this is what is generally at stake when the appropriation of archaeological finds from indigenous people is considered. It is difficult to say how this satisfaction is to be weighed. I dare say that most Greeks received more satisfaction and pride from winning the European football championship than they would from the return of the Parthenon Marbles. That said, there can be cases in which members of a culture would receive so much satisfaction (and their sense of grievance be so assuaged) that a strong case can be made for saying that a culture has a claim on an archaeological find (or some other item). For an argument to this effect, see Young (2006).

Sometimes items, including archaeological finds, acquire enhanced cultural value against a historical background of disrespect for a culture. Indigenous cultures often feel particularly strongly about controlling the past because of how they have been treated. As a result of the constant attention of anthropologists and the wholesale appropriation of archaeological finds, "Native Americans were made to feel like specimens" (Lippert 1997: 121). One indigenous Australian asked, "If we Aborigines cannot control our own heritage, *what the hell can we control?*" (quoted in Smith 2004: 26) In one widely discussed incident, Native American and white settler remains were found in the 1970s in an Iowa cemetery. The remains of the settlers were immediately reinterred while the Native remains were sent for study. In a context such as this, the ability to control what happens to archaeological finds becomes crucial to a culture. That is, finds associated with the culture's past have greater cultural value for members of the culture. For a culture to submit to indignities is for it to lose some of its self-respect and possibly some of its ability to function effectively as a culture. This point does not apply only to indigenous cultures. I suspect that the Chinese government is so strongly opposed to the export of Chinese antiquities in part because of the perceived lack of respect shown to China by the West. Against the background of this perceived lack of respect, Chinese antiquities have greater value for the Chinese. Against a background of inequity, a strong case can be made for legislation such as the Native American Graves Protection and Repatriation Act.

In certain contexts considerations concerning cultural value can lead to the conclusion that indigenous people should control archaeological finds, but cultural value does not always trump other sorts of value. Once the worst of the insensitive, inequitable appropriation of the past has ceased and cultural value been recognized as basis for claim to ownership, almost paradoxically the cultural value of finds will decrease for indigenous cultures and other descendent communities. Once this has occurred, considerations of cognitive value gain a greater purchase. At the very least, compromises such as those reached concerning Kwäday Dän Ts'ìnchi (Long Ago Person Found) seem morally indicated. Kwäday Dän Ts'ìnchi is the name given to an indigenous hunter found in a melting British Columbian glacier in 1999. He and his effects have been returned to the local indigenous people, by whom he was cremated and buried. Prior to this, however, he was carefully studied by archaeologists, geneticists, and other scientists. This is a reasonable compromise, one that can be recommended to the parties disputing the disposition of the remains of Kennewick Man.

COSMOPOLITAN VALUE

Another, more fundamental reason can be given for thinking that considerations of cultural value are not by themselves decisive. This is that items, including archaeological finds, can have value for the members of more than one narrowly defined culture. Here I use *cosmopolitan* in Kwame Anthony Appiah's sense of the word. *Cosmopolitanism* is Appiah's name for the view that all humans share, and ought to celebrate, an enormous common heritage. From a cosmopolitan perspective, humans and human achievements have value – cosmopolitan value – to everyone precisely because they are human achievements. Sometimes things are valuable (at least potentially) simply because they are the product of humans. Recognition of cosmopolitan value is found whenever people speak of something being part of the patrimony of humanity.

I have appreciated objects for their cosmopolitan value on many occasions and in many contexts. I have looked at a 1500-year-old manuscript in a language I cannot read and felt a sense of communion with the writer. Standing in an isolated medicine wheel on the Canadian prairies, I have marveled at the achievement it represents and at the people who made it. I have looked out from the battlements of a Moorish castle in Spain and imagined with a thrill what it was like to stand guard there a millennium ago. In thus valuing the products of cultures other than my own, I am not unusual. Appiah writes,

> The connection – the one neglected in talk of cultural patrimony – is the connection not *through* identity but *despite* difference. We can respond to art that is not ours; indeed, we can fully respond to "our" art only if we move beyond thinking of it as our and start to respond to it as art. But equally important is the human connection. My people – human beings – made the Great Wall of China, the Chrysler Building, the Sistine Chapel: these things were made by creatures like me. (Appiah 2006b: 135)

In this passage Appiah focuses on works of art, but many archaeological finds have cosmopolitan value. One reason that archaeologists want to study the history of indigenous people is that they value human history. Archaeological finds can have, in this way, cosmopolitan value.

WEIGHING VALUES

In the course of discussing some of the ways in which archaeological finds can be valuable, I have already made some suggestions about how to weigh competing values. Here I am more explicit about weighing values and

amplify earlier remarks. Rare circumstances can be identified in which one sort of value clearly outweighs others. In most cases, however, careful consideration of several sorts of value is needed if we are to arrive at the right conclusion about who owns or may appropriate archeological finds.

In most circumstances, extrinsic cognitive value will not be the decisive consideration when a find has a large amount of economic or cultural value. We can imagine a case (a philosophers' case, if you will) in which an archaeological find will lead to a breakthrough in medical science that will benefit millions of people. In such a case, in which many people will benefit from the extrinsic cognitive value of archaeology, archaeologists ought to appropriate the find and extract every drop of cognitive value they can. Even indigenous people (or other descendent communities) for whom the find has cultural value will benefit. In all probability, the descendent community will benefit more from extrinsic cognitive value in a case like this than it would from any cultural or economic value the find may possess. This will be true even if the descendent community does not believe that the archaeological find has (for them) cognitive value. Archaeology has an enormous amount of extrinsic cognitive value as a weapon against superstition and prejudice. As noted already, however, it is hard to see how additional archaeological investigation is going to undermine superstition any further.

Intrinsic cognitive value (for archaeologists and other interested persons) is unlikely to outweigh considerable amounts of economic or cultural value. Imagine another extreme case, one in which the integrity of a culture is at stake if some item of cultural property is appropriated. Pretty obviously, the item ought not to be appropriated, no matter how much knowledge archaeologists or other scientists may extract from it. Imagine a less extreme case, in which an archaeological find has considerable cultural value, and the members of a culture will enjoy greatly enhanced self-respect and peace of mind if they possess it. Archaeologists (and those who care about archaeological knowledge) are not numerous. Regardless of how much the archaeologists value new knowledge, in this sort of situation the cognitive value of finds is unlikely to outweigh cultural value. Similar considerations apply to the weighting of cognitive and economic value. The cognitive value of archaeological finds to archaeologists (and others) pales by comparison to economic value to seriously disadvantaged people. If considerable economic value is the consequence of vesting possession in a disadvantaged group, then that will clearly be the right course of action.

Different conclusions follow when archaeological finds have limited economic or cultural value. When this is the case, considerations of intrinsic

value (perhaps in conjunction with cosmopolitan value) will likely be decisive. Suppose that a find has severely limited economic value. Suppose moreover that some descendent community would rather have possession of the find than not, but it does not assign an especially high cultural value to it. In such a situation (and, we ought not to forget that this will be a common one) archaeologists ought to be free to appropriate the find.

In general, economic value will outweigh cultural value. This may seem to be a controversial claim when so many descendent communities are eager to reinter human remains and even other artifacts. The available evidence suggests, however, that descendent communities will tend to weigh economic value over cultural value. Economically disadvantaged cultures (think, for example, of Papua New Guinea) are quite happy to treat items of cultural property as commodities. Many individual members of descendent communities have no hesitation about engaging in subsistence digging even when their finds have considerable cultural value. The fact that members of descendent communities often place economic value before cultural value is decisive evidence that economic value outweighs cultural value.

Someone might object that some descendent communities do not place any economic value on many finds. Often items are reinterred or allowed to decay rather than being used for any economic purpose. Although this happens, I do not think that it counts against my comparative ranking of economic and cultural value. The items that are reinterred (human remains primarily) do not have significant economic value. Human remains are usually nonfungible and, except in rare circumstances, not the basis of any economic activity, such as archaeotourism. Concern about the cultural value of archaeological finds (and other items of cultural property) becomes a crucial consideration to descendent communities only when more pressing economic issues have been addressed. The weighting of economic value of finds will decline with an increase in the general standard of living of those for whom they have economic value. Descendent communities will generally put less weight on economic value when they no longer suffer from grinding poverty.

The weighting of cosmopolitan value remains to be addressed. Often, it cannot outweigh cultural value. Even Appiah, the great advocate of cosmopolitanism, recognizes that cultural value can be decisive in determining the disposition of some artifact. He writes, "If an object is central to the cultural or religious life of the members of a community, there *is* a human reason for it to find its place back with them" (Appiah 2006b: 132). Notice, however, that Appiah judges that an object has to be central to the life of

a community for cultural value to outweigh other sorts of value, including cosmopolitan value. This seems to be the right verdict here, but this is no reason to believe that cultural value will always outweigh cosmopolitan value (or other sorts of value). Likely, cosmopolitan value cannot outweigh significant economic value. The satisfaction that people feel in contemplating human achievement has to pale to insignificance compared to the value of improving the lot of seriously disadvantaged individuals.

This said, considerations of cosmopolitan value can outweigh other sorts of value in certain contexts. It is a commonplace that certain items are part of the common heritage of humanity. This is seen in UNESCO's recognition of certain places, many of them with archaeological significance, as World Heritage Sites. According to the UNESCO website, "World Heritage sites belong to all the peoples of the world, irrespective of the territory on which they are located." The reason that these sites belong to everyone is that they have a huge amount of cosmopolitan value. Cosmopolitan value in this sort of case does not limit the cultural or economic value of significant archaeological sites. A site can be part of the patrimony of all of humanity and, at the same time, of economic and cultural value to the members of a particular nation or culture.

An interesting question about cosmopolitan value is whether it is ever able to base the case for a defense of the appropriation of archaeological finds, when economic or cultural value will be decreased by this appropriation. The answer to this question is that sometimes cosmopolitan value clearly can outweigh economic or cultural value. (There is little chance that cosmopolitan value will come into conflict with cognitive value – they will likely be maximized in the same circumstances.) Many archaeological finds would, if they were returned to the nation or culture of their origin, have modestly greater cultural or economic value. Imagine that I am the member of the culture in which the find originated (or that I am the member of a descendent community). I would likely be rather pleased to read that some archaeological find was to be repatriated from another culture or country. Many other members of my community would likely feel as I would. The find might even have some modest economic value to a museum in my community. Still, reflection on cosmopolitan value could support the conclusion that its appropriation by another country is unobjectionable. The find might be rather commonplace in my community. Abroad, it could be rather unusual and striking, and possessed of much greater cosmopolitan value than it possesses in its original context. (Again, we need to consider diminishing marginal utility, although in this case the utility is not economic utility.) It could inspire admiration for members of

my community to a greater extent than it would if repatriated. An artifact can have greater cosmopolitan value in the context of a collection than it would have on its own.

In this context we need to consider the value of encyclopedic museums such as the British Museum and the Smithsonian. Many museum curators have argued that these institutions represent in themselves great cultural achievements and that to repatriate every artifact to its home culture would be an act of vandalism. A good reason for allowing (and even encouraging) the appropriation of some archaeological finds is that the dissemination of artifacts (including those found by archaeologists) throughout the world can inspire new cultural achievements. Consider, for example, Picasso's exposure to African sculpture at the Trocadero in 1907. Cubism would likely never have evolved if Picasso had not been exposed to these works. More generally, the wide dissemination of archaeological finds can cultivate appreciation of other cultures' contribution to human achievement.

My arguments here should not be regarded merely as a defense of not repatriating finds appropriated in the past. It can also be used as a defense of the practice of partage. Partage has the consequence of distributing the archaeological record in ways that maximize cosmopolitan value. More people are able to appreciate more of human achievement if museums around the world display archaeological finds from a variety of cultures. At the same time, partage (judiciously practiced) ensures that descendent communities retain control over a representative sample of the archaeological finds associated with their pasts.

A final point about weighing the values of archaeological finds remains to be made. Every decision about the possession of a find is revisable. The value that some find has for some group of people can change. New technologies may enhance the cognitive value of a find. More information can be extracted from it. The cultural value a find has for the members of a culture can change. The economic well-being of some group can improve or deteriorate with the result that the marginal utility of a find may diminish or increase. When any such change occurs, decisions about the disposition of an archaeological find need to be reviewed and potentially revised.[1]

CONCLUSION

Reflection on the various ways in which archaeological finds are valuable leads to the conclusion that various groups have a stake in the past. We

[1] I owe this point to Janna Thompson of La Trobe University.

should not expect universal principles ("Archaeologists have a right to knowledge and so a right to appropriate finds" or "Descendent communities have inherited all finds associated with their cultures") to be defensible. In making decisions about the disposition of artifacts, we ought to weigh the various sorts of value they have for various groups of people. We need to find the way to make archaeological finds as valuable as possible for as many people as possible. This will often be a difficult process, but it is the process that we ought to undertake.

CHAPTER 3

Whose Past? Archaeological Knowledge, Community Knowledge, and the Embracing of Conflict

Piotr Bienkowski

INTRODUCTION

Tackling the overall theme of 'appropriating the past' immediately raises two issues: the first is who is doing the appropriating, on what basis, and within what worldview; who is included in that appropriation and who is excluded; and what are the mechanisms and decision-making criteria and, in Foucault's terms, the disciplinary technologies or mechanisms that create and perpetuate that inclusion and exclusion (e.g., Foucault 1995 [1977]: 195–228; see also Hooper-Greenhill 1992: 190)? The second issue is, what do we mean by 'the past' – is it something that is finished and complete in a linear framework of time, something that really is 'past' and therefore can only be 'interpreted' and 'known' objectively, or is it something within which connections can still be experienced, within a non-linear or circular conception of time, and in that sense actually still subjectively 'present'? Clearly all these issues are concerned with authority: who has it, why do they have it, how do they have it, and how does it play out when those who are excluded challenge that authority? This is now a key strand in much heritage research: the tensions between 'authorised'–'hegemonic' and 'alternative'–'subaltern' forms of heritage discourse, between universal and particularist claims to heritage, or between 'expert' and 'lay' knowledge (e.g., Smith 2006, Robertson 2012).

This chapter focuses on two interlinked themes within this wider discourse: that of knowledge and that of controversy and conflict. In terms of knowledge, the chapter argues that the authority of archaeologists and museums over the retention of the archaeological heritage and interpretation of the past has traditionally been based on a particular form of knowledge – and a particular understanding of the past and the ways in which that past can be known. That form of knowledge, of course, developed in the European Enlightenment, from which both archaeology and museums sprang. I explore that type of knowledge – 'scientific',

42

measurable, curatorial – and the authority that is based on it. Increasingly, heritage institutions are being challenged by different communities who acknowledge different types of knowledge – and often, indeed, different conceptions of the past and how it can be known – and who are challenging the authority of these institutions both to retain certain objects and collections and to tell particular stories in a particular way: I refer to these different communities as 'communities of knowledge practice'.[1] Such alternative types of knowledge are broadly phenomenological and sometimes explicitly animistic rather than 'scientific'. Although the validity of such alternative forms of knowledge is acknowledged in theoretical writing on archaeology (e.g., Lilley 2009: 48–9; Byrne 2009),[2] it is less often acknowledged by heritage decision makers because heritage institutions, which wield huge institutional, scientific, and cultural authority but which are essentially a 'scientific' and 'expert' – and hegemonic – form of a community of knowledge practice, often do not accept (or do not understand) the validity of such 'alternative' forms of knowledge and therefore of those other communities of knowledge practice. This can lead to disputes, conflict, and feelings of exclusion by certain communities and often to genuine anger aimed at the institution. Conversely, when heritage institutions do 'validate' such alternative forms of knowledge and incorporate the voices of hitherto excluded and often socially marginalised groups, their established audiences also often react with anger, feeling that their traditional values, knowledge, heritage, and identity – supposedly enshrined in and represented by heritage institutions – are threatened.

[1] I have adapted this from the term *communities of practice*, originally coined by Lave and Wenger (1991) to describe learning within a process of co-participation rather than in individual minds (see also Hildreth and Kimble 2004). The term has been used in heritage situations, e.g., the long-term involvement of indigenous people in the work of the Australian Museum in Sydney (Kelly and Gordon 2002; Kelly, Cook, and Gordon 2006). In contrast, by *communities of knowledge practice*, I refer to communities who share fundamental, often culturally specific understandings of how the world works that inform the ways in which they know about things (or the processes through which they acquire knowledge, i.e., through analysis and theory or through experience and relationship), how they structure their relationships with the human and non-human world, and their actions and decisions. 'Knowledge' here is not just 'belief', which could be dismissed as ignorance: it concerns how knowledge is acquired, what values constitute it, what knowledge is regarded as culturally legitimate, and how it structures practical actions in the world. In Feyerabend's (1987: 28) words, 'knowledge is a local commodity designed to satisfy local needs and to solve local problems. . . . Orthodox "science", in this view, is one institution among many, not the one and only repository of sound information'. Benhabib's phrase 'epistemic contemporaries' has some similarity but seems to refer to fundamentally exclusive and contradictory forms of knowledge, beliefs, or worldviews (Benhabib 2002: 135–6).

[2] Byrne (2009: 84) notes the exclusion of other forms of legitimate knowledge and practice from the archaeological discourse and describes the assumption that others experience the world and the material past in the same way as do archaeologists as an 'illusion'.

These are the questions that run through this chapter: Whose voices, and whose knowledge – whose past – should be listened to, on what basis, and how? Is there such a thing as 'invalid knowledge' or an 'invalid past'? How can we better understand and deal with the conflicts that arise?

HERITAGE INSTITUTIONS AS A CULTURAL PRACTICE

Part of my theoretical framework is Pierre Bourdieu's notion of museums as a cultural practice – here broadened to encompass museums, archaeological sites, historic and archaeological landscapes, houses and ships, and, in England, organisations such as English Heritage and the National Trust, for which I use the broader term 'heritage institutions'. Although much has changed – at least in some countries, though sadly not in all – since Bourdieu's classic study of European art museums in the 1960s (Bourdieu and Darbel 1991 [1969]), there are nevertheless important aspects of his conclusions that help in our exploration of what is happening in heritage institutions today. Bourdieu's conclusion was that museum visiting was a form of cultural practice that 'consecrated' established, traditional values. The true function of museums was to reinforce for some the feeling of belonging and for others the feeling of exclusion. Museum visiting was bound up with formal, traditional learning, techniques connected with a whole attitude to the world – what Bourdieu called 'an academic culture' – and so museums were only truly accessible to those already equipped to participate in them. This 'sanctification' of culture fulfilled a vital function by contributing to the maintenance of the social order and feelings of identity and belonging.[3]

In this way, Bourdieu acknowledged that a certain type of knowledge and formal education was what characterised typical museum visitors at that time. That is not at all surprising because the emergence of museums themselves – and of all the academic disciplines contained within them (archaeology, zoology, botany, etc.) – was made possible by the development of 'objective' Science, principally expounded by Descartes in the seventeenth century (Appleby et al. 1996) and later by the Royal Society in England (Easlea 1980: 207–8; Hooper-Greenhill 1992: 145–57). This was rational knowledge based on perception and measurement and the exclusion of all 'occult' phenomena and 'natural magic' (Easlea 1980: 110–14).[4] Museums, archaeology, and all the other academic disciplines were

[3] See also Bennett (1995) for the role of museums in the formation of the modern nation-state as hegemonic educative and civilising agencies to bring order to an unruly public.

[4] Easlea (1980: 197) points out that the success of the new mechanical philosophy in the seventeenth century was not solely because it was an ingenious or self-evident philosophy but also because it

essentially about rigid order, measurement, classification, and objectification (Thomas 2004).

Crucially, that type of knowledge was based on the privileging of perception above all other senses: taste, smell, and hearing were excluded because of their lack of certainty, and touch was only narrowly employed (Hooper-Greenhill 1992: 138). Descartes regarded taste, colour, and sound as secondary qualities and not as properties of matter (Easlea 1980: 112). Colours were also little used for comparative purposes, so 'observation therefore assumed its powers through a visibility freed from all other sensory burdens and restricted to black and white' (Hooper-Greenhill 1992: 138). In museums, and in the world of learning generally, this had an effect on classification, with the separation and ordering of types of objects, and indeed of the whole empirical world – separation into the different academic disciplines and resultant growing specialisation (Hooper-Greenhill 1992: 140–4).[5]

This led in turn to the authority of the privileged expert and of the museum – and now of the heritage institution generally – as the authoritative voice offering complete knowledge for passive consumption (Hooper-Greenhill 1992: 165–8). I would further argue that this created a public *expectation* of institutionalised authoritative knowledge through the 'expert' curator, which was to be accepted passively.

This whole system of cultural practice, which continues today, is utterly dependent and contingent on that form of scientific knowledge that lies at its core. However, scientific, visual knowledge is only one way of experiencing and understanding the world. Indeed, while western Science was originally grounded in Cartesian dualism and has since become almost entirely materialist, dualism and materialism are still metaphysical *assumptions* about the fundamental nature of the world, although they lie at the foundation of most academic disciplines and institutions (Midgley 1992; Mathews 2009). Nevertheless, heritage institutions are increasingly working with communities of knowledge practice who experience and construct

was an 'establishment' philosophy that upheld the Christian religion and the social order against the perceived threat from natural magic, while at the same time legitimating the acquisition of power and control over nature. Byrne (2009: 69) comments that the rejection of the 'magical supernatural' by the mechanical philosophy, within which the archaeological discourse is constituted, prevents archaeologists today from even acknowledging the ways in which people attribute magical supernatural qualities to the material past.

5 The dominance of sight also became a moral issue, with other senses considered 'lower' than sight and the assumption by Europeans that non-westerners were more sensuous than themselves and more prone to live a life of the body than the mind. Thus the objects collected for European museums, including those retained from archaeological excavations, were valued in purely visual terms and deeply affected western assumptions about the meanings of those objects and how we apprehend them through cultural processes (Edwards, Gosden, and Phillips 2006).

the world differently and who do not necessarily acknowledge the primacy of scientific rationality (see Cove 1995: 183–90): ethnic, migrant, and refugee communities; indigenous source communities; nature-based religions; local communities with a strong relational sense of place; and artists. Although I am admittedly generalising,[6] among many of these, 'knowledge' can be broadly phenomenological and relational, that is, based on experience (including all those senses excluded from scientific perceptual knowledge, i.e., taste, smell, hearing, touch, or forms of 'perception' that cannot be measured), emotion, creativity, memory, and connection, and it is often animistic rather than scientific, and relations with the continuing personhood of the dead and with the non-human and non-animal world are also often part of their daily experience (i.e., the 'natural magic' excluded from Science). Crucially, philosophically, these are perfectly valid worldviews (i.e., no less valid than dualist or materialist Science), though they are still too often dismissed as romanticised, irrational, and suspect by those working in heritage institutions who were trained within a scientific framework and regard it as self-evidently 'true'.[7]

Many of these communities of knowledge practice experience and understand time differently from the western scientific linear model and therefore relate to the past in a different way.[8] A large part of the conceptual misunderstanding between archaeologists and indigenous peoples relates to the experience of connection between living and dead across long spans of time: how, archaeologists ask, is it possible to experience any individual or community connection with people who have been dead hundreds or even thousands of years (Zimmerman 1994: 65)?[9] Of course, this dismissal

[6] My intention is not to imply any classificatory or systemic similarity between these communities but to argue that the rationalist presuppositions that underlie the practices of heritage institutions (and of archaeology) are not universalist, and their epistemologically privileged position marginalises the alternative rich and complex worldviews and practices of communities they now need to work with and understand. For an insight into some of these different types of knowledge from a range of communities and cultures, and the problems of accommodating them from a rationalist perspective, see, e.g., Bird-David (1999), Byrne (2009), Harvey (2005: 3–95), Hviding (1996), and Lilley (2009).

[7] Lilley (2009: 57) anticipates such reactions but argues that for archaeologists to acknowledge that there are other ways of seeing the world is not 'fringe' thinking but simply good anthropology.

[8] See Janca and Bullen (2003) for one example of how other professions acknowledge such different understandings of time and take them into account in their work.

[9] Formal criteria for deciding legitimate claims in repatriation or cultural property cases, e.g., often include cutoff dates, beyond which a claim is unlikely to be considered. In the United Kingdom, the *Guidance for the Care of Human Remains in Museums*, issued by a government department, states that claims are unlikely to be successful for any remains over three hundred years old and are unlikely to be even considered for remains over five hundred years old, except in exceptional cases (Department of Culture, Media, and Sport 2005: 27). Clearly such criteria are embedded in a scientific and largely western conception of linear time, with its inability to comprehend that individual and community relationships can be maintained across long spans of linear time.

is, in part, based on the assumption by western materialist science that only measurable matter exists, and on a strict distinction between life and death – logically, therefore, it must regard the dead as no longer existing or having personhood in any sense. It must be stressed that this is not a *fact* but a metaphysical assumption or belief:[10] in contrast, for an animist, death is a transformation, not a cessation, and the continuing personhood of the dead is experienced, although it cannot be measured. The key to the misunderstanding about connecting with the dead lies in different experiences of time. Those who work closely with indigenous peoples stress that whereas western scientists see time as linear, a sequence of events linking generations of people, for many indigenous peoples, time is circular, a continuous, timeless present (e.g., Bielawski 1994). The philosopher Henri Bergson produced a critique of the scientific concept of time – which is linear and divisible into equal and measurable intervals. He argued that such a concept of time was ultimately a fiction, to be distinguished from the intuitive experience of real time (which he called 'real duration'). Scientific time, or linear measurable time, has in fact been confused with space, according to Bergson, because only in space can events can be laid out alongside another and quantified. Real duration as experienced by consciousness cannot be quantified, so past and present states form an organic interconnected whole, binding the past to the present. It is such real duration, as described by Bergson, linking past with present, linking the dead with those still living, that is experienced by indigenous peoples and by animists: and such direct experience of ancestors through consciousness by animist cultures sits outside the category of scientific linear measurable time, which is simply inapplicable to their experience (Bergson 1960: 75–139; see also Pearson and Mullarkey 2002: 1–6; Guerlac 2006: 42–105). Whereas in the West, most people are usually concerned only with a very few generations into the past – maybe as far as their grandparents – indigenous peoples and other animists regard ancestors who died hundreds of years ago as still members of the group living today (e.g., Pullar 1994: 19).

The misunderstandings and conflicts I am referring to are generally based in these different forms of knowledge and worldviews, which also often involve a different conception and experience of continuous time, creating what I have termed different communities of knowledge practice.

[10] Experiencing the dead is not irrational, in the sense that such experience cannot be falsified: it is a metaphysical worldview that cannot be dismissed simply on the grounds that some people, working within a materialist worldview, do not have such experiences and thus regard them as false (see Feyerabend 1977, 1978: 82–3, on philosophical relativism and the scientific method; see Bienkowski 2012, on animism and the dead).

Yet one of these types of knowledge has become hegemonic, wielding huge institutional authority, whereas the others are the 'alternative' or the 'subaltern'. Heritage institutions have traditionally positioned themselves as the uncontested authority on a given subject, with dominant worldviews presented as objective reality. In most cases, they are finding it difficult to relinquish that 'expert' role, even when seeking to negotiate new relationships with audiences (e.g., Smith 2006).

Many communities are now reacting angrily if they feel their voices and their perspectives are overlooked or overshadowed (Hooper-Greenhill 1997: 2; Kreps 2003: 145). There are increasing disputes about the ownership of cultural property and interpretation, not just between nations but between local communities and national heritage institutions within a country, with institutions being accused of setting the criteria that other communities of knowledge practice have to satisfy: criteria for who can be included in decision making, who has a right to be heard, who has a legitimate claim – in a sense making the rules, ensuring that institutional and national rather than local knowledge hegemony prevails. Much of this debate has involved indigenous source communities and has often been around the repatriation of ancestral human remains (see, e.g., the essays in Fforde, Hubert, and Turnbull 2002), although human remains of British provenance are also being contested by various British communities (Bienkowski 2007; Parker Pearson 1999: 179–80). Archaeologists are increasingly questioning the state's legitimacy to exclusive sovereignty and authority over cultural material (e.g., Meskell 2009: 12–17; Lydon 2009), and although most of the case studies cited involve indigenous groups, there are increasing examples from the United Kingdom in which local communities are challenging state heritage institutions over ownership and interpretation of the material past (e.g., Jones 2005).

There is also a wider dialogue with black, minority, ethnic, and refugee groups, with whom heritage institutions now work closely. In terms of interpreting the past, indeed, deciding whose past is relevant and which stories will be told and how, much of this came to the fore in the 2007 commemorations of the abolition of slavery in the United Kingdom. Although museums and universities were heavily involved in producing research and exhibitions around the topic, much of it with community collaboration and consultation, many institutions were criticised by community participants, some withdrew from projects, and some remained very angry (Lynch and Alberti 2010). Two key issues have wider relevance (Lynch 2011). The first is that, however hard institutions try, what comes across is still the assumption that traditional curatorial knowledge and approaches

are superior (see also Lagerkvist 2006). Different kinds of knowledge are still regarded as somehow quaint or exotic and not qualitatively equivalent. This is manifested in institutional decision-making processes, where the views of certain people are not taken on board: more value is given to interpretations and events led by staff or academics, and there is the accusation that the institution structures itself – maybe inadvertently – to protect itself from challenges. The second, linked point is that community interpretations and events are 'quarantined', not embedded and not taken onto the main museum galleries. The institution is accused of not integrating those different forms of knowledge into the general institutional interpretation as a valid viewpoint. This in turn leads to accusations of institutions carrying traditional British baggage of superiority, racism, and imperialism – which may be institutional legacies of prejudice, even in the most well meaning of organisations.

It is certainly true that whenever heritage institutions – usually museums – set out to challenge orthodox practice, a fierce debate often erupts about the purpose of museums. Is it their job to stir things up, to encourage and facilitate the development of visitors' critical faculties, or should they reassure and reinforce society's cultural norms? Indeed, there has been considerable research on provocation and controversy in museums from the mid-1990s.[11] But I wish to move the argument on from provocation and controversy per se to the growing issue in which heritage institutions cede their traditional authoritative voice and allow in previously unheard or marginalised voices and forms of knowledge – those alternative communities of knowledge practice – and as a result create an angry reaction among their traditional audiences.

LINDOW MAN IN MANCHESTER

As a case study, I focus on audience reaction to an exhibition at Manchester Museum, part of the University of Manchester, which brought out these issues of knowledge, controversy, and conflict.[12] *Lindow Man: A Bog Body Mystery* ran from April 2008 to April 2009. Lindow Man is the name given to a body of a man of Iron Age date discovered in a peat bog at Lindow Moss, Cheshire, in 1984 (Stead, Bourke, and Brothwell 1986).

[11] See Harris (1995) for an overview and Linenthal and Englehardt (1996), Mayr (1998), and Butler (1999) for the two most notorious cases.

[12] Although I was a member of staff at Manchester Museum during that exhibition, I rely here on the analysis in Brown (2011).

The consultations the museum had with local communities during the preparation of the exhibition on Lindow Man were an explicit acknowledgment that it was not the sole repository of knowledge; the connection these communities feel to a body discovered in their locality is a strong one that the museum acknowledged, even though there is no direct cultural or genealogical link. Manchester Museum attempted to involve, as far as is achievable, all interested groups in the consultation process, including the growing migrant and refugee communities, because it felt it is the right of everyone to feel a connection to the people who lived in the area before them (Brown 2011).

Rather than being a traditional exhibition of archaeological human remains, *Lindow Man: A Bog Body Mystery* was a consultative approach concerned with different types of knowledge and interpretation (Rees-Leahy 2008; James 2008; Brown 2011). In the resulting exhibition, seven different voices gave their own perspectives of why Lindow Man is important to them. These included perspectives traditionally aired in museums, such as the archaeological and scientific importance of Lindow Man (through the voices of archaeologists, curators, and scientists), but also included perspectives normally excluded and unacknowledged, such as the woman from Lindow Moss who talked about Lindow Man's importance to her community and her own life, and her participation in a 'repatriation' campaign in the 1980s to bring Lindow Man back from the British Museum in London to the north-west of England, or the perspective of a Druid priestess, an animist, who talked about Lindow Man as a venerated ancestor and discussed her visceral feelings that he should be reburied.

The Lindow Man exhibition was explicitly experimental, providing unexpected experiences to trigger new, perhaps uncomfortable ways of seeing and making sense of the collection and of the past. It is a philosophy that polarised staff opinion and stimulated extremely negative reactions from some visitors. The exhibition had an unconventional design and construction and included a broad consultative process, parity between the seven different interpretations, a lack of didacticism, an eclectic choice of objects, and diffusion of the authoritative museum voice – so that the archaeological and scientific stories were not presented as hierarchically more important than the others.

At first, there was informal perception and feedback that the general visitor reaction to the Lindow Man exhibition was hugely negative. There was a sustained blast of invective from the media blog *Manchester Confidential*, apparently the biggest and most long-lasting response they had ever had to a single issue: an outpouring of criticism and anger that this was political correctness gone mad, that the perspectives included were

invalid, ridiculous, and inappropriate for museums, that this was not a proper exhibition – that it was 'wicked' in its misuse of public funds, that the museum had abrogated responsibility and failed to tell the proper story. In addition, there were angry personal attacks directed at specific named members of staff, some quite vicious, including demands that they should be sacked. Specific negative comments included that leaving the interpretation open was taking the lazy way out, abdicating the museum's responsibility, as 'expert', to filter information and present the authorised version, 'the facts'. The choice of voices and perspectives was criticised, especially the inclusion of a pagan priestess and a local woman from Lindow, who were seen as providing either irrelevant or privileging minority views. There was also a negative reaction from museum staff – 70 percent said it was not what they had expected. One commented that the museum had lost its way as a university facility with 'a role and a duty to present the *facts* as researched and integrated by specialists'.

This type of blog attack to which Manchester Museum was subjected is now characteristic of our online age and has changed the parameters of what we must learn to expect in terms of audience reaction and feedback – but we should also be cautious about reading too much into such blog responses statistically because it is clear, and self-evident, that only those who are blog users (and thus have ready access to the Internet, are familiar with it, and are willing and able to spend a proportion of their time on it) will respond. We should also expect that such responses will be highly emotionally charged because their whole purpose is to criticise and stimulate an instant emotional reaction in response. In that sense, there has generally been a radical shift in the relationship of organisations with their audiences. Complaint and venting of private opinions has become a participation sport in a digital world, and by participating, the public expects to influence the outcome of events (Brown 2011).

Harris, recalling people's responses to publicly funded contemporary art in the United States in the 1930s and 1940s, notes, 'These angry reactions, remember, were not simply about art, they were about attitudes toward social reality, toward national character, official values, progress and standards of life' (Harris 1995), and we could apply the same comments to modern blog responses. Some visitors' vehement criticism of what they regarded as the 'poor' and 'lazy' design and structure of the Lindow Man exhibition may mask a broader plea to preserve the traditional place of the museum in their lives (Brown 2011).

But results from a detailed personal meaning mapping (PMM) survey of the Lindow Man exhibition showed that the informal perception concerning a majority negative audience reaction was misplaced (for details

of the sample and process, see Brown 2011).[13] Those who were extremely disappointed with the exhibition were a minority, but significantly, they were all highly educated (even describing themselves as 'expert'), experienced museum visitors, with traditional expectations: they knew what they wanted to see. Some appeared to find nothing of value in the exhibition. They were primarily looking for 'facts' and were clearly not engaged by the multivocal, open-ended approach. Some were incensed by the exhibition approach and had strongly held beliefs about the subject and museums in general. But for the majority of those surveyed in the PMM exercise – nearly 94 percent – the exhibition enabled both traditional factual transmission of information whilst also facilitating a more philosophical kind of learning experience, that is, learning in more than one category. Moreover, academic and professional journals included supportive critiques (Rees-Leahy 2008; James 2008), and the exhibition design won a national award.

PARALLEL CASE STUDIES, INDIGENOUS AND NON-INDIGENOUS

It is this visceral anger in response to exhibitions that is most intriguing. People are, of course, entitled to feel such anger, but what is the root cause of it? Why do some people get so angry about a museum exhibition that is bringing in alternative voices; why do they react so strongly, even intolerantly? As a reaction to what is only a museum exhibition, at first sight, it appears disproportionate. Yet Manchester Museum is not alone.

Exactly the same sorts of reactions occur in countries with indigenous communities. Perhaps because most of the published case studies come from the United States and Australia, it is often assumed that it is precisely the historically contingent nature of the unequal relationships between state-sponsored heritage institutions and hitherto marginalised and disempowered indigenous communities that causes controversy, conflict, and angry reactions from both indigenous participants and traditional audiences. Yet this seems not to be the case: case studies involving indigenous and non-indigenous communities create similar controversies, indicating that there are more fundamental issues that cause some people to react negatively.

The reactions to the opening of the National Museum of the American Indian (NMAI) in Washington, D.C., are a good parallel to the Manchester case and a perfect indigenous example. The NMAI opened on 21 September 2004. On the basis of extensive consultation with Native American

[13] The negative responses of the bloggers were, of course, perfectly legitimate: the key point is that by using the medium of the blog, their views gained a prominence that subsequent controlled evaluation indicated was not a typical audience response.

tribes, which directed the content development, and the transfer of agency
to the authority of Native curators, it validated Native cultural specialists as
scholars and interpreters and created exhibits that foregrounded the nature
of the sacred, human relationships with the environment and responsibil-
ity to one's community, instead of the traditional 'anthropological gaze' of
historically linear narratives about Native American tribes and their occu-
pation of the land (Erikson 2008: 68–72). Objects were displayed in terms
of their spiritual integrity and meaning and function within the commu-
nity and not as evidence of cultural, historical, or scientific phenomena
(Cobb 2008: 340). Hitherto, indigenous knowledge structures had been
marginalised in relation to 'official' versions of knowledge based on the
notion of an 'objective truth' (Erikson 2008: 45–9), with western museum
epistemologies and systems of classification defining and treating Native
Americans in 'exploitative, objectifying, and demeaning ways' (Cobb 2008:
333). Indeed, even the plan to establish the NMAI was regarded by anthro-
pologists at the Smithsonian Institution as a threat to objective, universal
science; to academic freedom; and to what constituted knowledge, enquiry,
and data (Erikson 2008: 49–56).

When the NMAI opened, many visitors were reported to be over-
whelmed, confused, and frustrated by the display techniques (Lonetree
2008: 313). Reviews, especially in the *New York Times* and *Washington Post*,
were overwhelmingly negative, even outraged: the approach of the NMAI
was perceived as being 'politically correct', departing from convention, lack-
ing scholarship, intellectually impoverished, and with no traditional sense
of order, the objects not being arranged chronologically or geographically
(Erikson 2008: 63–75; Jonaitis and Berlo 2008), demonstrating that critics
had expected western-style scholarship, the authoritative voice of academ-
ically trained curators, and traditional history and wished to disqualify
indigenous knowledge as legitimate (Ostrowitz 2008: 110–11; Archuleta
2008: 185–6). Critics saw it as representing an exclusivity that denied some
voices (Jonaitis and Berlo 2008: 231). Yet the Native curators did *not* in
fact feel complete ownership of the exhibits because agency still originated
with the NMAI, a national institutional structure; moreover, there were also
Native criticisms of the new museum, that it was homogenising, seeking
a consensus, diminishing tribal-specific voices, and giving no sense of the
struggle of Native Americans as a result of European colonisation (Chavez
Lamar 2008: 158–9; Atalay 2008). Archuleta (2008: 192–6) comments that
the NMAI deliberately decided to challenge traditional museum modes of
exhibition and to confront stereotypes of Native Americans but that the
decision had the potential to destabilize and dislocate a majority audience,
for whom the museum space is not neutral but filled with ideologies and

politics. Jonaitis and Berlo (2008: 231–2) cite Andreas Huyssen (1995: 28) in the context of the critical reaction to the NMAI that the bringing of previously marginalised groups into the museum is threatening to conservative critics 'still lodged safely within the intellectual domain of modernism that privileges the strong subject and considers only a linear passage of time'.

The similarity of the criticisms levelled at the NMAI and Manchester Museum's Lindow Man exhibition, both of which brought in previously marginalised voices and worldviews and disrupted the traditional single voice of museum authority and knowledge, demonstrates that such reactions are not an 'indigenous' issue. Other European examples underline this point. One example is the National Museum of Wales in Cardiff, which worked with the Muslim community to prepare a temporary exhibition in 2006 on Muslim cultures in Wales titled *The Muslim World on Your Doorstep*, using objects from the national collection and the work of artists in Wales to provide a current and Welsh perspective. Not only did this receive many complaints on the museum's own website, some aggressive, but it was attacked on the website of the extreme right-wing, anti-immigration British National Party – who, in 2009, were elected to their first seat in the European Parliament.[14] The attack was couched in vicious, vitriolic, and frightening terms, claiming that the museum was destroying the heritage it was supposed to protect.[15] Museum staff were taken aback and concerned for their own safety. Similar reactions have been reported from the Museum of World Cultures in Gothenburg, Sweden, where there was an angry public response from what Lagerkvist (2006) calls 'dominant culture representatives', who saw the museum's decision to remove a painting as a result of Muslim complaints a threat to fundamental rights.

What is it about doing something in a different way, particularly bringing in hitherto excluded perspectives and handing over authority to new stakeholders, that causes such a violent reaction? Andreas Huyssen (1995: 28) identifies this as a threat:

Some within the fortress of modernity will experience these changes as a threat, as dangerous and identity-eroding invasions.

So what exactly is the threat to identity?

[14] In 2006, membership of the British National Party was still restricted to white people. In February 2010, it was forced by equality legislation to widen its membership criteria.

[15] I thank Michael Tooby, formerly Director of Learning and Programmes at the National Museum of Wales in Cardiff, for discussing this with me and allowing me to refer to this example in this chapter.

AUTHORITY, CONFLICT, AND DISSENSUS

Here we must return to Bourdieu's analysis of the role of museums in feelings of identity, belonging, and social order (Bourdieu and Darbel 1991). It is true that on the whole, museums and heritage institutions have tended to work with traditional forms of knowledge; have displayed things in a particular way, which has become accepted, acceptable, and expected; and more often than not it has been the authoritative voice of the institution that has spoken through those displays. This is what regular visitors expect, are comfortable with, and see as the proper role of heritage institutions; they feel safe in this view of shared heritage – they can see where they fit in, where the institution reflects their own values. In that sense, they share the same community of knowledge practice (Archuleta 2008: 185–6). As Susan Ashley (2005: 6) puts it,

In the public mind, the museum is where history is kept; we agree that these public institutions represent us and can speak for us in matters of history and national identity.

So what happens when the heritage institution, working with other communities of knowledge practice, brings in voices and perspectives that have been hitherto excluded, silent, and unacknowledged or are in subtle ways socially marginalised? How do established audiences react when they are faced with interpretations based on types of knowledge that are alien to them, so that the heritage institution is no longer reflecting their knowledge, their values, their heritage, their identity? In a sense, the heritage institution used to reflect their monopoly over interpretation and knowledge – that shared community of knowledge practice that was unquestioned – and now that monopoly is threatened: I agree with Huyssen that it is a threat to how they see the world, to what is important, to how their past is understood, to their values, to their feelings of belonging, to their identity. In Bourdieu's words (Bourdieu and Darbel 1991: 111), it is a threat to the social order – and so they get angry and react fiercely, using easily available modern technology to 'participate' in public reaction.

Museums and heritage institutions find themselves in an interesting position. They are criticised by community groups for not integrating their perspectives sufficiently and by established audiences who no longer see their own values reflected. They are faced with the visceral reactions of those who previously had a monopoly based on knowledge and privilege – and therefore who see this as a challenge to their traditions and to the social order, the breaking of a social contract that the heritage institution's role is

to present an authoritative perspective on which the user can rely and that he or she can believe, accept, and expect.

What can heritage institutions do? Clearly this is an issue of power practices: it concerns authority and ownership – of knowledge, of interpretation, of a particular understanding of the past, and of the mechanisms by which that authority and ownership are practised and maintained, or which can, in principle, be shared. Who has the power to facilitate that sharing, or maybe to suppress one dominant perspective and introduce alternatives? If the heritage institution facilitates such sharing with alternative voices, then one can see how it could be accused of being the responsible agent in a shift of power from one set of values to another, from celebrating one identity and heritage to another, even from acknowledging the existence of one authorised 'true' story to affirming the validity of many perspectives. That may be why traditional audiences – even if they are just a vocal minority – get angry and make the now standard accusations of 'political correctness gone mad'. Of course, it is such accusations that heritage institutions are afraid of, and many directors shy away from conflict deliberately because it is their traditional audiences who often point the accusatory finger – the well-educated ones who are articulate, who know how to get their message across, and who can influence stakeholders and funders.[16] Yet there is no alternative but to become more inclusive and to include alternative perspectives. Heritage institutions, particularly museums and galleries, are arguably part of a vanishing number of 'safe' debating spaces, where democratic exchange, intercultural dialogue, and contestation about culture, memory, identity, community, belonging, and loss can take place (Karp 1992; Erikson 2008: 49). Their funding sources increasingly stress the need for diversity, difference, equality, democracy, and dialogue. Yet, among some of the public, there is a reaction against this diversity and inclusiveness, as if something else of value has been lost.

The answer is not to avoid that diversity and subsequent conflict – and institutions have many subtle practices for circumventing issues and avoiding conflict, hiding behind academia and professionalism and managing process. The answer is simply to learn how to better manage the resultant fallout by expecting it and planning for it, maybe by being proactive with those groups who might feel somehow disenfranchised, and to ignore accusations of 'political correctness gone mad', which are reflex and often exaggerated. Conflict, controversy, and lack of consensus are not necessarily

[16] For a rare exception, see Corum (2009): 'This meant we were able to give up control. . . . Giving up control is anathema for an organisation such as ours. Museums have built their reputations on their reliability and authority'.

bad things, and Lagerkvist (2006: 65), too, suggests that controversy is an opportunity to become more inclusive. Heritage institutions should strive for a postmodern 'dissensus', which is precisely the legitimising of different kinds of knowledge that accepts conflict as the standard mode of existence; for in seeking consensus and avoiding conflict, they suppress alternative or minority worldviews and continue to exercise their traditional cultural authority.

HERITAGE INSTITUTIONS AS POLITICAL AND DEMOCRATIC SPACES

What sort of processes might heritage institutions adopt to allow such dissensus? It might be argued that the cosmopolitan discourse in archaeology has acknowledged this need to bring in marginalised voices and the inevitability of occasional conflict with established audiences. After all, cosmopolitanism entails openness to divergent cultural experiences and forms of knowledge and goes beyond recognition of equal value, considering the claims of connected communities primary and, in many contexts, giving them greater weight than other stakeholders. Those stakeholders often include archaeologists, who are not the primary arbiters, should not expect to craft a consensus, and should be prepared to relinquish some of their archaeological goals, concepts, and power in favour of dialogue and acknowledgment of local worldviews (Meskell 2009: 4–16; Lilley 2009: 48–9).

But there are two problems. Firstly, the theoretical discourse often – perhaps usually – is undertaken by practitioners who are not decision makers within heritage institutions, and key decision makers remain unaware of the issues and the changing theoretical landscape. Lilley (2009: 49) is sceptical, too, about how far archaeologists are prepared to acknowledge different worldviews and share authority effectively (see also Jonaitis and Berlo 2008: 232). The second problem, already alluded to, is that the cosmopolitan discourse – unintentionally – has tended to focus on empowering and involving indigenous communities, and the published case studies (see, e.g., Meskell 2009), although acknowledging that the ethical practice of cosmopolitanism should extend to all minority communities, nevertheless report almost exclusively on work with indigenous groups. A cosmopolitan approach can thus too easily be ignored and dismissed as irrelevant outside indigenous (and postcolonial) contexts. However, as noted earlier, the wider issue of forms of knowledge and the institutional and cultural authority that is based on them affects all communities of knowledge practice, indigenous as well as those in western, urban contexts, including

black, minority, and ethnic groups and others excluded from cultural and heritage provision through ethnicity, religion, age, disability, or socio-economic factors. What is needed is a truly postmodern approach that embraces the postcolonial and the cosmopolitan but is not limited by how they are perceived. This should embrace, too, the idea that the essential, privileged, and unique role of heritage institutions in the globalised but fractured world is to promote understanding between cultures and to bring together in dialogue individuals and cultures with different perspectives, so that those institutions act as 'crucibles' in which notions of citizenship, identity, community, and nationhood are negotiated (Karp 1992; Erikson 2008: 49).

It has been acknowledged that heritage institutions, with their lega-cies of imperial and national ideologies and authority, construction of cultural identities, and privileging of hegemonic worldviews and voices at the expense of the exclusion of others, are deeply political spaces but ones that have the potential to transform into 'participatory sphere insti-tutions' (e.g., Clifford 1997; Archuleta 2008; Lynch and Alberti 2010). In retrospect, Manchester's Lindow Man process – if we include the commu-nity consultation, the alternative voices within the exhibition each given equal treatment, and the public reaction through blogging – was essen-tially an exercise in empowered participation and deliberative democracy (although if it had been recognised as such in advance, the discussion around negative reactions would have been handled more productively – much the same conclusion was reached for the NMAI; see Cobb 2008: 350). Following Benhabib (2002: 37; see also Dryzek 2000), deliberative democracy can be defined as recognition of the right to equal participation between conversation partners, that is, all whose interests are actually or potentially affected by the courses of action and decisions that may ensue from such conversation. All participants have an equal right to suggest topics of conversation; to introduce new points of view, questions, and criticism into the conversation; and to challenge the rules of the conversa-tion insofar as these seem to exclude the voice of some and privilege that of others. Deliberative democracy is not limited to representative institu-tions but embraces the unofficial public sphere, including cultural, artistic, and heritage institutions (Benhabib 2002: 21). As Habermas argues, the instrumental rationality of the Enlightenment approach has caused 'cul-tural impoverishment' through expert cultures monopolising most of our activities, but this can be balanced or even resisted through debate, reflec-tion, and talk (White 1988: 116–17; Dryzek 1990: 3–25). This seems to be both a model for what a heritage institution should be – a locus for open,

respectful, egalitarian dialogue and participation around issues of interpretation of the past, personal and group identity, and rights to ownership of culture – and a model for the process to follow, a conversation to which all those affected or even interested are invited on the basis of universal respect and egalitarian reciprocity.[17]

Agreement on or resolution of all issues is not necessarily the aim of such conversations, especially in heritage institutions. The objective is for all those affected or interested to have an opportunity to participate, to communicate, to feel they have been heard, and to listen to alternative views. As long as the criteria for decision making have been made clear beforehand (i.e., who makes a final decision and on what basis), the opportunity to participate and to be heard is usually sufficient to create meaningful dialogue, some form of convergence of views if not a consensus, and a basis for an ongoing reciprocal relationship. It is a process of understanding through familiarisation with other ways of thinking (Valadez 2001: 91). Especially for heritage institutions, which deal with past and present cultures and attempt to 'interpret' them for a wider public, and increasingly need to involve hitherto marginalised communities, the words of Kwame Anthony Appiah (2006: 8) are pertinent:

> We should learn about people in other places, take an interest in their civilizations, their arguments, their errors, their achievements, not because that will bring us to agreement but because it will help us get used to one another – something we have a powerful need to do in this globalized era. If that is the aim, then the fact that we have all these opportunities for disagreement about values need not put us off. Understanding one another may be hard; it can certainly be interesting. But it doesn't require that we come to agreement.

The possibility of radical disagreement and conflict as a result of mutually exclusive and contradictory beliefs tends to make heritage institutions shy away from creating such open opportunities for dialogue. I am often asked if, as a museum professional, I would be willing to risk the standing of an institution by inviting creationists to a consultation alongside archaeologists and scientists, where there is little scope for agreement and much for rowdy conflict. My response is yes: if the purpose is to seek mutual understanding, then a consultation must be as inclusive as possible. The 'extremists' – whether they are creationists, fascists, the BNP, Muslim fanatics, or others – still have to be heard, although their views may not sit within the broad centre ground of decision making. It is not

[17] For case studies of various mechanisms of empowered participation in deliberative democracy, see Fung and Wright (2003) and Fung (2006).

the job of museums to adjudicate and draw lines. Benhabib (2002: 135) discusses just such a case, in which we may have little doubt about the cognitive validity of the assumptions of some of the participants, but in the public sphere of a liberal democracy, 'we have to accept the equal claim to moral respect of our dialogue partners who hold such beliefs'. She adds that this 'strains to the utmost the established canons of scientific evidence and validation', but as yet another contemporary community of knowledge practice, we have to learn to live with each other and cooperate, including cooperating on cultural and heritage matters.

Ian Hodder (2009) argues that deliberative democracy is concerned largely with individual rights but minimises the rights of individuals with respect to their membership of cultural groups, and as a result, he supports state or global interventions that can provide long-term commitment to change for marginalised groups. Yet he fails to appreciate that the key role of archaeologists and heritage institutions is often more about creating understanding and familiarisation; and he misunderstands and misrepresents Benhabib, claiming that she admits that the deliberative democratic process does not address the cultural heritage of indigenous peoples (Hodder 2009: 184). In fact, she argues the opposite, that from the standpoint of deliberative democracy, 'we need to create institutions through which members of these communities can negotiate and debate the future of their own conditions of existence' (Benhabib 2002: 185). Indeed, in repatriation and cultural property claims, and in the fields of indigenous archaeology and cultural resource management, there is often huge disagreement within indigenous groups about the appropriate action to take, and in many ways, individuals within such groups carry out their own conversations in consultation workshops, negotiating the balance between culture, personal, and group identity and the need for political action (e.g., Guilfoyle et al. 2009). For heritage institutions involved in such claims, an open and transparent deliberative democratic process to resolve the claims is more beneficial than the bureaucratic and essentialist process of establishing criteria of ownership and rights, with its colonialist demands of proof and legitimacy (e.g., Cove 1995: 130). A deliberative democratic process allows many individuals to discuss, agree, disagree, challenge, come to consensus, or continue in conflict about their relationships to various collective identities and to assess their participation, non-participation, inclusion or exclusion, involvement or non-involvement in decision making with heritage institutions. Collective identities are an intrinsic part of this process: as Benhabib (2002: 61) writes, cultures are not homogenous wholes but are constituted through the narratives and symbolizations of their members.

Heritage institutions have traditionally worked with one form of 'scientific' knowledge, which has informed their whole development as centres of expertise and authority. Such knowledge acknowledges a linear understanding of time and privileges perception above all other senses. They are increasingly working with communities who acknowledge different types of knowledge, broadly phenomenological and often with an experience of a timeless present. Such forms of knowledge are often misunderstood or rejected as irrational, leading to feelings of exclusion by those communities and anger and conflict aimed at the heritage institution. Conversely, when heritage institutions do involve previously marginalised voices and forms of knowledge, their established, traditional audiences also often react with anger.

A case study of the Lindow Man exhibition at Manchester Museum explored such reactions to an experimental exhibition on archaeological human remains that attempted to dilute the authoritative expert voice of the institution and, through a consultative process, brought in alternative voices and worldviews. Although the exhibition and the staff were attacked viciously on blogs, the results of an in-depth survey demonstrated that those who reacted negatively to the exhibition were in a minority, though all were well educated and informed. Nevertheless, visceral anger in response to exhibitions is an interesting phenomenon. Although most case studies of similar reactions are in the context of indigenous reactions and counter-reactions, plenty of examples show that this is a wider issue.

Using Bourdieu's analysis of museums as a form of cultural practice, widened to include the role of heritage institutions in developing identity and maintaining social order, I have suggested that the introduction of previously marginalised voices is perceived as a threat by established, traditional audiences who expect the heritage institution to continue to reflect their own heritage, values, and identity: when it does not, and dilutes its own authority and forms of knowledge by bringing in alternative voices and worldviews, they can react negatively. Yet, to be inclusive and not suppress alternative worldviews and forms of knowledge, and as a way of sharing authority over ownership and interpretation of heritage, I have suggested that heritage institutions must embrace such conflict rather than avoid it.

I propose that deliberative democracy offers heritage institutions a practical framework for how to include different voices and forms of knowledge

and to embrace and expect conflict and disagreement: it offers a model of how to work by bringing together all interested parties in a dialogue based on universal respect and egalitarian reciprocity. The aim of such dialogue is not (necessarily) agreement but rather to foster understanding and familiarisation between individuals and cultures, which is really the crucial role of heritage institutions in today's world.

The Past People Want
Heritage for the Majority?

Cornelius Holtorf

Archaeologists are often very disappointed when the past portrayed and evoked in our daily lives appears to derive from contemporary clichés and other imaginary preconceptions rather than accurate scholarship about past realities. This is understandable to the extent that the role of the archaeological scholar is defined as re-creating past life as accurately as possible from the traces that remain today. What is the purpose of their research, such archaeologists are asking themselves, when far too many contemporaries are satisfied by reconfirming those ever-same stereotypes about, for example, the primitive Stone Age and the pillaging Vikings?

In this chapter, however, I wish to argue that archaeology should not be concerned with assessing to what extent the past portrayed or evoked in our daily lives may or may not be historically accurate on scholarly grounds. Instead, archaeologists ought to be engaging with the overall role the past plays in present society. In that view, the role of the archaeological scholar is defined in relation to a past that derives from particular social practices in the present – of which academic archaeology itself is one. Therefore, archaeologists will need to give considerable attention to larger social, political, and indeed ethical issues. Ironically, in certain circumstances popular depictions of a past that never happened may have significant benefits for present society and would thus be preferable to those that, according to current scholarship, may historically be more accurate.

In my argument, I first discuss the point and significance of historical reconstructions and historicizing architecture in present society, thus taking up topics that are relevant to the fields of urban archaeology and the archaeology of buildings. This discussion has a distinctive ethical dimension insofar as the opponents of such buildings call them lies that deliberately mislead viewers about the past, whereas advocates point to their role in making the past more widely accessible to people and to the democratic right of local communities to be listened to concerning the built environment surrounding them. I then discuss a relevant case study from

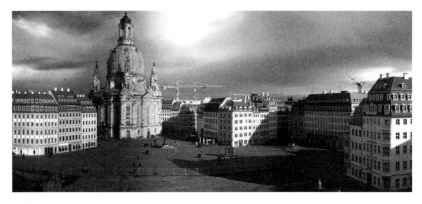

Figure 4.1. The rebuilt past at Dresden Neumarkt: misplaced nostalgic sentiment or a legitimate preference of many people? Photograph: © City of Dresden, captured by cityscope GmbH Berlin in 2009. Reproduced by permission of the City of Dresden, Department for Urban Development.

Dresden in Germany in the context of a recent German debate about the need for a democratization of state heritage management. Following from that, I consider the historical and political significance of re-reconstructing the past. In the light of the popularity of reconstructions and historicizing architecture, I argue that majority preferences should be respected by heritage professionals. Finally, I conclude with some thoughts on how my previous discussion relates to archaeological storytelling, which has become significant in present society, and to a widely perceived need to put people and the way they value cultural heritage at the centre of cultural heritage management.

THE RETURN OF HISTORIC ARCHITECTURE

In present society, a blend of restored, reconstructed, and invented cultural heritage in city centres increasingly gives the impression of a historic idyll (for an overview of this trend, see Altrock et al. 2010). One prominent example, to which I return later, is the reconstructed Neumarkt area in Dresden. Here an entire city area of eighteenth-century vernacular baroque architecture is in the process of being re-created so that it appears as if these buildings were never destroyed by the bombs of World War II (Figure 4.1). Archaeologists, historians, art historians, and architects can be quick to dismiss such buildings as resembling Disneyland, meaning that they fake history and are in parts commercially motivated. Appealing 'old' towns

not only make the locals proud of their heritage but also attract tourists and revive shopping. This discussion is not an entirely new phenomenon, though, but probably as old as the modern notion of heritage itself. Indeed, the debate on how best to conserve, restore, and indeed reconstruct historic buildings is a classic debate among art historians and conservators (e.g., Starn 2002; Muñoz Viñas 2004; Schmidt 2008; Nerdinger 2010).

The British scholars John Ruskin (1819–1900) and William Morris (1834–96) as well as the German Georg Dehio (1850–1932) famously insisted on principles summarized by the dictum 'conserve do not restore'. According to this line of thinking, a clear and always visible distinction must be maintained between the original material substance derived from the past and any modern additions that lack authenticity. In this view, complete reconstructions are not allowed, and restoration that improves on the state of the original material preserved effectively destroys historical data. At the same time – and this is worse – restoration is hiding this destruction of historic evidence by creating a seemingly improved historic impression. This school of thought has been very influential since the second half of the nineteenth century. It informed, for example, the 1964 International Charter for the Conservation and Restoration of Monuments and Sites, also known as the Venice Charter (ICOMOS 1964), which contains, among others, the following stipulations:

ARTICLE 9. The process of restoration is a highly specialized operation. Its aim is to preserve and reveal the aesthetic and historic value of the monument and is based on respect for original material and authentic documents. It must stop at the point where conjecture begins, and in this case moreover any extra work which is indispensable must be distinct from the architectural composition and must bear a contemporary stamp. . . .

ARTICLE 12. Replacements of missing parts must integrate harmoniously with the whole, but at the same time must be distinguishable from the original so that restoration does not falsify the artistic or historic evidence.

This approach is very academic and requires an educated audience that is able to appreciate the historic meaning of a historic building prominently featuring modern steel and concrete and lacking substantial parts of the original construction (Figure 4.2).

The alternative school of thought, famously represented by the Frenchman Eugène Emmanuel Viollet-le-Duc (1814–79) at Carcassonne in southern France, focuses not on the material substance but on the original idea and appearance of the building. Here the impression the building was meant to give in the past is being re-created – or indeed newly created.

Figure 4.2. Steel and glass construction built on top of the preserved foundations and corresponding to the original dimensions of the Roman baths at LVR-Römer Museum, Xanten, Germany: responsible and honest restoration or unintelligible impression that does not move any hearts? Photograph by Cornelius Holtorf, 2009.

Although such reconstructions do require interpretation and they may lead to a degree of completeness that had never existed previously, the result is not necessarily a falsification but arguably an improved view of the site that corresponds better to what was intended originally. As buildings may be used over a long time and have been altered many times during their existence, there is difficulty in deciding which historical time period to choose for restoration. But once this decision has been made, the restored building will speak to all the senses of human visitors.

Viollet-le-Duc's work has long been dismissed and even ridiculed by academics as inauthentic inventions and "almost Disney-like recreations" (Muñoz Viñas 2004: 67). But in recent years this kind of architecture has been gaining in popularity not only among citizens but also among architects and town planners. In addition to historical reconstructions, historicizing architecture has reemerged and is gaining ground, after a long period during which various modernist aesthetics dominated (Engelberg 2007; Glatz 2008; Hansen 2008). Over the past few decades, many cities throughout Central Europe have re-created or are in the process of re-creating their historical centres, even though they had not survived the bombs of World War II. Such ambitions are often controversial, but once the work is completed, they are seldom regretted. As the German art historian Jürgen Paul (1979) once remarked, if historic buildings in the

Old Town of Hildesheim in Germany had been rebuilt after the war, which they had not, partly out of respect for the authenticity of the bombed originals, experience shows that by now they would long have been accepted and appreciated as a natural manifestation of the long history of the city. Not seldom the appearance of historical reconstructions is for many people indistinguishable from that of genuinely old historical buildings, or in any case of no great significance. What some critics have ignored is the fact that this architecture is not a built manifestation of lies about the past, pretending that the buildings are of a different age than they actually are. Instead, such buildings are authentic expressions of preferences and desires of our own time (Kerkhoff 2008: 48; Karn 2008). As such they deserve our attention.

THE POLITICS AND ETHICS OF BUILDING THE PAST

In the previous section I used terms like *fake*, *falsification*, and *lies*. One ethical dimension of historicizing architecture and reconstructions of historical buildings is thus immediately obvious: for some commentators they are deliberately misleading viewers and are therefore wrong (e.g., Schmidt 2008; Hansen 2008). They argue that architecture as at Dresden Neumarkt is mainly the result of a misplaced nostalgic sentiment. It is thought to manifest an irrational and nearly pathological desire to compensate for the loss of an idealised past that was seemingly unaffected by the flaws of modern mass culture and is offering a perfect masquerade for obvious commercial interests. For this reason, we should not build like this today, they say. Indeed, it has occasionally been seen as a moral duty and a question of veracity to build in our own architectural style and avoid any historic illusions at all (Magirius 2010: 149).

Historicizing architecture and historical reconstructions acquire ethical significance also when they appear to marginalise or simply ignore other parts of the past that may, however, be very pertinent to remember. Should we really try to forget the unappealing, agonizing, but important past, such as fascism, war, national division, and state socialism in Eastern Germany (James 2004; cf. Carson 1995; Paul 1979)? Should we really try to re-create the urban face of colonial, undemocratic, and patriarchal late-nineteenth-century empires (Altrock et al. 2010: 108–9)? Knowledge of the past has power over people's minds and therefore comes with a special responsibility to honour the memory of the victims of historic injustices. For this reason, too, we should not restore and reconstruct at will; we always have to consider very carefully all its implications.

Having said all this, it has to be acknowledged that the dictum 'conserve do not restore' was formulated before the enormous destructions during the twentieth century caused, among others, by two world wars, as in the case of Dresden. Even some of the dictum's proponents, notably Dehio, accepted that it was legitimate to reconstruct historical buildings in the immediate aftermath of devastation (Schmidt 2008: 48–50). When destruction was entirely unwanted it could be undone to restore not only a building but also society as a whole. Although one could therefore argue that the circumstances of destruction determine the most appropriate response, I am taking a different view here. Even wars and other devastation occur in given historic contexts and are part of history. Arguably, they cannot, and possibly should not, be undone, but instead they might be remembered. If reconstructions are nevertheless attempted, they occur out of the same nostalgic preferences and valuation of the past as in other buildings that are given the appearance of being historical although they are not. In either case, it is the appearance of a building that embodies historic remembering, not its actual historicity (Magirius 2010: 150). Both practices most clearly merge into one when, as in Dresden, undoing war damage is carried out as much as half a century after the war has ended.

Today, buildings evoking the past are in many cases enormously popular, and their contemporary appeal is not diminished by the fact that they are not always genuinely old. There is a widespread longing for historical views that create the appearance of a historically grown town quarter or building, even when the architectural continuity in fact no longer exists. Similarly, historical buildings are increasingly being supplemented by new extensions and additions that adopt a similar, historicizing style and create a unifying impression in harmony with the original structure (Engelberg 2007). A full assessment of the role that the past portrayed and evoked by such buildings plays in present society will need to take a broader view and include a range of social, political, historical, and indeed ethical aspects in relation to the wide appeal such architecture enjoys (see Altrock et al. 2010). The yardstick against which historicizing architecture and reconstructions are to be judged cannot be solely historic accuracy, which only a small group of experts can seriously assess. Instead, we need to look at the overall effect such architecture has in society and on people. Only then can we answer the question of whether or not the heritage sector should give the people the past they want.

The main arguments in favour of comprehensive restoration, reconstruction, and other architectural evocations of the past are increased accessibility and legitimate preference. Concerning the former, there are obvious

aesthetic benefits from buildings and indeed entire town quarters appearing stylistically homogenous (see Figure 4.1). A holistic sense of place is conveyed that affects the character of the locale and the mood of the visitors in a way that a few original bits of material substance or a partial reconstruction cannot match. A fairly complete historical picture has a strong effect on our senses, making it easier to grasp and thus more accessible and more memorable. Visitors feel immersed in the past, irrespective of any historical inaccuracies in the architecture and indeed irrespective of any shortcomings in their own historical expertise. Moreover, a constructed past will often reduce the visible historical complexity that characterizes not only individual buildings but also urban quarters with long histories. The accessibility of the past to people will therefore be enhanced in this way, too. As a result, more people will enjoy the past and take home stronger impressions. This applies even though a minority is likely to be disappointed by such architecture. Increased accessibility thus has clear social benefits.

The second argument is political. Democracies presuppose competent and knowledgeable individuals that are able to apply their reason to make rational decisions that affect the conditions in which they live. Our entire state system is built on this premise. Although there may be some fields, e.g. those related to serious health and safety issues, in which special expertise will be essential and experts should enjoy some degree of elevated authority based on their special competence, the built environment is a very different domain quite far removed from questions of life and death. Here, local communities, together with other affected stakeholders, should be involved in decision-making processes, be listened to, and their preferences be respected in open-ended dialogues, even though not everybody may possess relevant specialist expertise and professional experience. Their opinions may not always be very well informed, and they may change their preferences relatively quickly. But this applies also to political decisions the electorate makes in national elections, and surely nobody would want to abolish those. On whose behalf is the Venice Charter being implemented if the majority of people affected in the present might prefer different practices and we know nothing about the preferences of people in the future anyway? Are there not good ethical reasons to respect the preferences of living human beings as much as possible?

THE BEAUTY OF DRESDEN NEUMARKT

A useful case study illustrating both arguments in favour of popular preferences concerning cultural heritage is the reconstructed Neumarkt area in

Dresden (see also Altrock et al. 2010: 112–46). Dresden, the capital of the
German state of Saxony, is famous for its baroque architecture from the first
half of the eighteenth century. Much of it did not, however, stand for very
long. During the Seven Years' War (1756–63) Prussian artillery destroyed
extensive parts of the city centre. Yet in the area of the Dresden Neumarkt,
vernacular baroque architecture had survived uniquely. The centre of this
area consisted of an irregular space made up of three squares: Jüdenhof,
Neumarkt, and An der Frauenkirche. The Neumarkt was crowned by the
distinctive dome of the Frauenkirche, built by George Bähr. In February
1945, comprehensive air raids erased the entire town, including all the
residential buildings in the Neumarkt area. After the war some historical
buildings, like the Zwinger and the Semper Opera, were reconstructed
by the authorities of the socialist German Democratic Republic, but at
the same time planning authorities demolished all but a few of the ruins
that remained in the Neumarkt area, intending to build here part of the
new, socialist Dresden. Yet the Neumarkt remained undeveloped until the
1980s, when a concrete extension of the police headquarters (pulled down
in 2005) and the Hilton Hotel were erected in the area. Following German
unification in 1990, the Frauenkirche, often described as the soul of Dres-
den and a symbol of the destruction of the city during the war, was rebuilt
from the remaining pile of rubble of the original church's ruins thanks to
private and corporate donations amounting to more than €100 million. It
reopened in 2005.

The still-destroyed Neumarkt area in Dresden broke sufficient people's
hearts to let a strong citizens' initiative arise.[1] In 1999, the foundation
Gesellschaft Historischer Neumarkt Dresden e.V. (Society for the Rebuild-
ing of the Historical Neumarkt Dresden) was founded by a group of
architects, historians, heritage managers, art historians, lawyers, and other
engaged citizens. What do these citizens want?

With the historic Neumarkt thoroughly reconstructed, Dresden could regain a
historic heart in its town centre. The Foundation will give a voice to the many
citizens of Dresden and other friends of the town. They are refusing to tolerate
modern architectural ideas at the feet of the Frauenkirche. To our horror it is now
planned to rebuild the 300 houses of the Neumarkt area in a modern way, except
for fifteen reconstructed buildings where less steel and glass will be used so that a
somewhat more old-fashioned impression will be given.

[1] See the website of Gesellschaft Historischer Neumarkt Dresden, at http://www.neumarkt-dresden.de.
Between 2004 and 2009, the Neumarkt area was part of the much larger UNESCO World Heritage
Site Dresden Elbe Valley. Neither the awarding nor the revoking of the World Heritage status stood
in any significant relation to the historical centre's being restored or the citizens' initiative.

We, on the other hand, are in favour of a different but equally realistic concept. We want the old Neumarkt to be rebuilt as one of the most beautiful old towns in Europe. We prefer an archaeological reconstruction of 70 to 80 well documented and art historically valuable old town houses, based on existing plans, sketches, original remains and photographs. There will however also be room for some modern designs in a symbiosis of reconstructed and modern elements.

We should not lose our unique chance to regain at the Neumarkt a piece of historical identity for our town, for the sake of our children and grandchildren. Let us give the new old Frauenkirche its old setting!

These days, modern architecture can and should be built in most parts of Dresden. However, on this half square kilometre, architects should consider themselves as humble servants in a historic context. We are convinced that most of the population in Dresden want it this way. (Neidhardt 1999, translation from the German modified by the author)

This agenda is clearly linked to social benefits deriving from increased accessibility of the city's past to people ("regain a historic heart . . . rebuilt as one of the most beautiful old towns in Europe . . . a piece of historical identity for our town . . . give the new old Frauenkirche its old setting!") as well as to political benefits as a result of listening to local communities ("give a voice to the many citizens of Dresden . . . most of the population in Dresden want it this way").

Both the efficiency of the people behind the initiative and the wide support it enjoyed in Dresden was born out by a petition in favour of reconstructing the historic Neumarkt area. When in 2003 the petition was handed over to the mayor of Dresden, it had been signed, within a few months, by nearly sixty-eight thousand people, including more than sixty-three thousand citizens on the electoral register of Dresden, amounting to 15 percent of the entire electorate.[2] This figure may appear small compared with levels of approval required in regular elections. However, more than one in seven is a very impressive figure for support of an independent citizen initiative. Even though the petition has had no legal significance, it indicates broad support for the aims of the initiative. Indirectly, the petition has had considerable impact both on the politicians and on the investors who are increasingly changing their plans in line with the popular demands formulated by the citizens' initiative (for a critical discussion, see Holtorf 2007b: 39, 46; Altrock et al. 2010: 122–46).

By now, large parts of the Neumarkt area have been developed, and new buildings have re-created a bit of the old atmosphere (Figure 4.1). In 2009,

[2] "Bürgerbegehren", Gesellschaft Historischer Neumarkt Dresden e. V., http://www.neumarkt-dresden.de/buergerbegehren1.html (accessed 29 May 2012).

the society won an award from the German Federal Minister of Transport, Building, and Urban Development in the category "Engagement for the City – The Civil Society and Private Initiative", recognising the exemplary commitment of many volunteers to working for the benefit of the cultural heritage, urban development, and the entire city.

The citizen initiative's popularity supporting the reconstruction of baroque architecture should give cause to consider people's possible motivations and interests. Although politicians and developers may be contemplating the benefits of a historical city centre for the development of tourism and retail, this is not the most important concern of ordinary citizens. The heritage being desired is clearly emotionally loaded. This is evident in the cited references to the desire to regain the "historic heart" of Dresden and to the opportunity to re-create "a piece of historical identity for our town". Such reconstructions by popular demand do not misunderstand heritage as some critics have it (e.g., Schmidt 2008: 73; Kalinowski 1993: 343–4) but they manifest widely shared valuations of heritage that need to be taken seriously by the heritage sector. They are expressions not of misplaced sentimental longings but of the legitimate human desire for a materialization of a sense of local belonging (Paul 1979). There are, among others, strong ethical reasons demanding to respect the preferences of fellow human beings as much as is feasible given contradicting preferences of other human beings.

Historical reconstructions like those at Dresden create places that are easily consumable for many people and thus popular. Such places please visitors by exuding prettiness. For those living locally, a particular sense of pride and belonging may be attached to them, too. Although populism in urban planning is not without its problems (Altrock et al. 2010: 84–95), these are nevertheless legitimate desires and desirable outcomes of planning and conservation. It is no coincidence that in recent years the decision-making practices of various state heritage agencies pursuing other aims than these have attracted harsh criticism. In one prominent assessment, the German architectural critic and editor Dieter Hoffmann-Axthelm (2000) argued that contemporary heritage management has alienated the population because it comes across as authoritarian, self-righteous, unpredictable, and unable to take into account the view of the owners and users of the heritage (for a full discussion, see Holtorf 2007b). Moreover, he asserted that civil servants employed in the state heritage sector have been influenced in their decisions by subjective or academic preferences for a particular kind of conservation and architecture under the pretext of what may or

may not be historically representative and thus worth protecting. Surely, in a democratic state none of this would be right, whether politically or ethically.

According to Hoffmann-Axthelm, too much has been preserved that is not worth preserving. In his assessment, it is not good enough to consider the built environment first and foremost as a historical source for coming generations and to try to leave behind a sample as representative as possible to facilitate future memory and historical consciousness. Towns and landscapes are not archives or museums. Instead, he argued, a state should preserve what its citizens and residents appreciate as worth preserving. Its value should be apparent to any resident or visitor and must not depend on written academic appraisals that fill books. Although Hoffmann-Axthelm allowed for some exceptions in the case of sites of special historical significance such as concentration camps, he argued that the most important criterion for conservation should be the aesthetic appeal or beauty of a given building. This criterion would favour older buildings, such as medieval city centres, cathedrals, or fortifications, over more recent ones, such as factories and other functional buildings constructed from the mid-nineteenth century onward. Hoffmann-Axthelm stated succinctly that we should be saving buildings "whose demise would break one's heart", for "what does not move any hearts – why should it be saved?" (Hoffmann-Axthelm 2000: 22, 33). Such aesthetic judgments, he went on, need to be made by the people concerned rather than by the state; that is, they need to be democratized. In Dresden, a citizen initiative has championed similar aims and criteria and applied them to historic reconstructions while taking on the city's Department of Urban Planning controlled by the citizens' own political representatives (Altrock et al. 2010: 138–9).

This way of thinking implies a fundamental shift in perspective the relevant experts need to take. Experts about the past, including archaeologists, historians, and historians of art, have conventionally considered themselves as accountable to the principles of scholarship on a quest for historic truth. Because the people of the past cannot represent themselves, it falls on scholars in the present, they say, to represent the past in their stead, teach contemporaries about the way past people lived, and preserve their memory for the future. This proposition can be challenged on various grounds. On a general level, historical scholarship should arguably first and foremost be accountable to present-day human beings and their legitimate interests (Burström et al. 2004). That does not imply that it does not matter how the past is represented but rather that social, political, and ethical

considerations about present-day society invariably have to take priority. Ironically, antiquarian practice is often more about protecting cultural heritage from people than it is about letting cultural heritage become a meaningful part of their lives (Burström et al. 2004: 136). Unfortunately, heritage managers usually distance themselves from newly constructed architectural evocations of the past rather than celebrating the evident significance of the past in present urban environments.

Is Dresden's reconstructed Neumarkt faking history? Not really – its buildings do not utter truth claims about the past. Instead, they appeal because of associations, emotions, and moods that correspond to widespread contemporary desires. In the contemporary experience society in which sensual experiences prevail, reconstructions and historicizing architecture fulfil successfully their role as evocations of the past. Already after a few years, surprisingly many people forget that seemingly old buildings had not always existed in their present locations (Altrock et al. 2010: 102–3).

In historic terms, these buildings, like the restorations and reconstructions of previous ages, are very clearly situated in their present. Indeed, Viollet-le-Duc's re-created fortified city of Carcassonne is today a UNESCO World Heritage Site of outstanding universal value – and certainly not because it fooled anybody about its age. The World Heritage Committee reasoned in their justification for inscription that the fortified town "is of exceptional importance by virtue of the restoration work carried out in the second half of the 19th century by Viollet-le-Duc, which had a profound influence on subsequent developments in conservation principles and practice".[3] By the same token, the Rila Monastery in contemporary Bulgaria, founded in the tenth century and rebuilt after a fire in the mid-nineteenth century, became a UNESCO World Heritage Site as a "characteristic example of the Bulgarian Renaissance (18th-19th centuries)". It symbolizes "the awareness of Slavic cultural identity following centuries of occupation".[4]

Another UNESCO World Heritage Site, the very recently reconstructed Old Bridge and Old City of Mostar in contemporary Bosnia-Herzegovina, is acknowledged as "a symbol of reconciliation, international

[3] "Historic Fortified City of Carcassonne", UNESCO, http://whc.unesco.org/en/list/345.
[4] "Rila Monastery", UNESCO, http://whc.unesco.org/en/list/216.

co-operation and of the coexistence of diverse cultural, ethnic and religious communities".[5] Similarly, the classic example of the reconstructed Old Town of Warsaw in Poland was included on the UNESCO World Heritage List because "the reconstruction of Warsaw's historical centre was a major contributor to the changes in the doctrines related to urbanization and conservation of urban development in most of the European countries after the destruction of World War II. Simultaneously, this example illustrates the effectiveness of conservation activities in the second half of the 20th Century, which permitted the integral reconstruction of the complex urban ensemble".[6] All these examples are not, then, examples of historical pretence but their outstanding universal value lies in other realms than that of age and preservation. The criteria for inscription in the World Heritage List allow inclusion of sites that are particularly significant in their influences on the historic environment (criterion 2), in their typicality for a given stage in human history (criterion 4), or in their association with noteworthy historical events or ideas (criterion 6) (Jokilehto 2008). In other words, provided they fulfil any of these criteria, popular, historical reconstructions and historicizing architecture may very well be deemed to be of outstanding universal value and thus become World Heritage Sites.

It could thus be only a question of time until Disneyland's Main Street USA becomes a protected heritage site as well. This re-created small-town scenery is not only part of a very successful twentieth-century commercial enterprise whose products have inspired many competitors and a strong expression of contemporary North American values and preferences, but, according to the American historical geographer Richard Francaviglia (1995), it has also had a profound influence on American urban architecture. Not only neotraditional and postmodern architecture, ubiquitous in American urban environments, but also the layout and character of its shopping malls and the numerous historical preservation programmes to revive the country's Main Streets owe much to Disney's Main Street USA design. Surely, this site, if any, expresses twentieth-century North American civilization.

An important factor in architecture evoking the past is often the political context. I already pointed to the political dimension of historical reconstructions in eastern Germany since 1990: there certainly is a desire to overcome an unhappy recent past by returning to a glorious distant past, redefining the national heritage (James 2004). The reconstruction of the

[5] "Old Bridge Area of the Old City of Mostar", UNESCO, http://whc.unesco.org/en/list/946.
[6] "Historic Centre of Warsaw", http://whc.unesco.org/en/list/30.

historical centre of Warsaw did have a clear political dimension as well. It was intended to signify the reemergence and indestructibility of Polish culture and the state of Poland after World War II (Kalinowski 1993). Rather than disqualifying reconstructions, the politics of this case serve to remind us that there is always a political dimension in how the past is used in each present. Given the devastating impact of the war on Poland, we should have much sympathy for a large number of Polish people collectively trying to overcome that traumatic period.

Maybe, for all the attention given to minority interests, some heritage experts have been sidelining the majority's legitimate interests in cultural heritage. So much of the ethics of archaeology and heritage is guarding the interests of humans far away in space or time, or advocating the rights of contemporary minorities. For example, there is some discussion as to which rights the dead have in the light of archaeological excavation that may involve the recovery of their belongings, their graves, or indeed their bones (e.g., Scarre 2006; Tarlow 2006). Not the least because of the enormous efforts of the World Archaeological Congress there is also a global awareness of the specific obligations contemporary societies have toward indigenous communities that may live amongst them. Although I do agree that these are legitimate concerns, I wonder at the same time whether professional archaeologists and heritage managers do not also have a responsibility to address the interests of the living majority in a given society. The overarching interests of large parts of the population, and their legitimate rights to the heritage, appear to have been insufficiently addressed by the current institutions of professional archaeology and heritage management (Burström et al. 2004; Holtorf 2007b).

It is normally assumed that the majority gets its way more or less by default and that the safeguarding of the majority's interests needs no further advocacy. Seemingly, majority interests therefore do not need to concern the ethics of archaeology and heritage in the same way as the interests of those who are in some way disadvantaged in present society. I am granting that this argument may have validity in some cases. But my previous discussion of the practices of state heritage management and their perception among the population suggests that even majorities may occasionally have interests that require to be advocated more prominently. Arguably, majorities too can become disadvantaged. This does not mean that more than half the members of a given community necessarily speak with one voice. But it does mean that a number of different interests and causes may occasionally come together behind one preference yet still lose out to the preferences of a few who might be professional heritage experts or town planers. I do not

mean to build up a false division that discredits by simplistic arithmetic important scholarly concerns or other significant issues championed by a given minority. Rather, I believe that many interests of disadvantaged or privileged minority groups in society could be subsumed under schemes that even the majority favours.

ARCHAEOLOGICAL HERITAGE SERVING THE PUBLIC

This debate on how to relate to historicizing architecture and reconstructions of historic buildings is highly relevant even for archaeologists. Urban archaeology engages with the past in town and city environments, whereas the archaeology of buildings investigates the past of built constructions. The archaeological ambition in these subfields of the discipline has conventionally been taken to be finding out about the past of the buildings and towns concerned as accurately as possible. What the present discussion shows is that this remit may be too narrow. Even urban and building archaeologists ought to be assessing the role that the past plays in present society, as represented in buildings and towns. This must include an engagement with the social, political, and ethical dimensions of historical reconstructions and historicizing architecture. The fact that these structures may physically not be very old does not alter the other fact that they evoke the past very powerfully, creating an impact in society that archaeologists need to pay attention to.

Arguably, the social value of archaeology lies in storytelling. On the one hand, archaeology excels at mystery and adventure stories about its own practices; on the other hand, it also excels at stories about the past. In both varieties of stories contemporary audiences may feature as characters in plots that give meaning and perspective to their present-day lives; it is such stories that elsewhere I called meta-stories of archaeology (Holtorf 2010a). These meta-stories may explore what it means to be human, who we are as members of a particular human group, and how we might be living under different circumstances. Crucially, in such meta-stories it is not the past as such that attracts interest and gains social significance but rather the broader issues that an engagement with the past brings up. By the same token, what often matters most is not so much the scientific accuracy and empirical richness of the story but the extent to which the story draws us, as characters, into the plot of a meta-story and ultimately touches us.

Telling stories and meta-stories about archaeology or the past is a way of making a real and widely appreciated contribution to very many people's lives. As popular culture aptly demonstrates, such stories not only entertain

large audiences but also connect with some of their most common fantasies, needs, and desires (Holtorf 2007a). Typically, this perspective takes into account archaeology's complete impact on society, including the value of the stories and meta-stories that archaeology is contributing to society. Something similar ought to apply to an assessment of architecture evoking the past. Their quality or social impact does not exclusively depend on the degree to which they correspond to scholarly values and academic truthfulness but to a large extent also on the degree to which its audience actually appreciates them. Just like many of the historical details that make up the most popular stories and meta-stories of archaeology can be fictitious, reconstructing architecture too may include a certain amount of invention to be effective. As historical novels demonstrate, stories do not need to be true in a strict scientific sense for their benefits to take effect (Wetzel 1988).

This focus on the audience's perception and appreciation in determining the quality of cultural heritage sits well with recent trends in heritage management. As the Scottish archaeologist Noel Fojut (2009) outlined in an insightful essay, the public interest in heritage has become ever more prominent since the mid-1990s. An increasing political desire for linking the cost of heritage conservation with concrete uses and benefits of heritage lead to a renewed interest in heritage values, a readiness to accept democratic input in decision making about heritage, and a return to popular identity politics coupled with a concern for social inclusion. The intention was to create conditions for heritage management that were economically sustainable.

In this overall context the Council of Europe Framework Convention on the Value of Cultural Heritage for Society was signed in Faro, Portugal, in 2005. The so-called Faro Convention (Council of Europe 2005) acknowledges in its preamble explicitly "the need to put people and human values at the centre of an enlarged and cross-disciplinary concept of cultural heritage" and "the need to involve everyone in society in the ongoing process of defining and managing cultural heritage". What is more, the preamble also states that as an implication of individual human rights "every person has a right to engage with the cultural heritage of their choice." The parties to the convention then agreed, among other things, to

- "emphasise that the conservation of cultural heritage and its sustainable use have human development and quality of life as their goal" (§ 1a)
- "recognise the public interest associated with elements of the cultural heritage in accordance with their importance to society" (§ 5a)
- "take into consideration the value attached by each heritage community to the cultural heritage with which it identifies" (§ 12a).

This agenda is rather different from that of earlier conventions such as the Venice Charter (ICOMOS 1964). They focused mostly on cultural monuments and the built heritage in its own right, as best appreciated by scholarly experts, rather than on citizens valuing these sites in their everyday lives. Whereas in the 1960s, "the definition of heritage was narrow, heritage practice was exclusive and conservation was seen as an end in itself", by the late twentieth century, the definition of heritage had been widened, the heritage expert became "increasingly seen as the servant of the public" and politicians had discovered the utility of heritage: "Rather than heritage being served by society, the new concept was that heritage must serve society" (Fojut 2009: 14–17).

This is also borne out in the Spanish conservation scientist Salvador Muñoz Viñas's (2004) account "Contemporary Theory of Conservation". He recognized that contemporary ethics in conservation have been redirecting "the spotlight from the object itself towards the people for whom the object is (and will be) useful" (Muñoz Viñas 2004: 199–200). The value of an object under conservation does not lie in some kind of inherent property and truth best accessible to a small group of experts but in the meanings and functions it has to all its human audiences. Indeed, Muñoz Viñas argued that "it is the affected people who best know what meanings the object possesses, and how it will best convey these meanings; it would not be ethically correct to impose a different point of view just because someone has expertise in art history, in organic chemistry, or in stone conservation techniques" (2004: 201–2). He acknowledges, though, that this view is not entirely unproblematic. It may be argued that some complex issues will necessarily be best known or felt by the relevant experts, and surely others must be given the opportunity to learn from them. Yet in the end, Muñoz Viñas makes it clear that conservation of the material substance of an object is not an end in itself. The aim of conservation is rather to retain or improve the meaning an object has for people, and that is why conservators always need to ask why, and for whom, some things are conserved (Muñoz Viñas 2004: 213–14).

Conservators are not merely restoring past conditions of objects and preserving them for future generations; in fact, they use heritage according to the way they see fit, within the context of the meanings of heritage in contemporary society. This is to accept that conservation essentially is a creative and subject-oriented process that alters objects to adapt them to present-day expectations and needs (Muñoz Viñas 2004: chapters 6 and 9). The meaning of both the past and its remains is always discursive and dependent on a particular perspective. The scholarly and scientific

approach to monuments is one discourse that makes the past and its remains meaningful in the present. Yet there are other discourses that are particularly appreciated or indeed advocated by local communities, town planners, businesses, and visitors. Historians, historians of art, conservators, and archaeologists compete for cultural significance with historical novels, reconstructions, and Disney theme parks, among others (Wetzel 1988).

Having said all this, it may not be surprising that some forward-looking projects in recent years experimented with celebrating a cultural heritage that is championed by local communities and consists of everything else but historical monuments as we know them. For example, in an innovative school project carried out at Malmö in Sweden, approximately fifty eleven-year-old pupils were asked what they would want to preserve for the future as heritage that is particularly significant for them (Högberg 2007). Many chose very ordinary places, like a local shop where they buy sweets and meet up with friends, a tree they used to climb, the burial place of one child's bird, or the local water tower that looks a bit like a flying saucer. Many of these children's heritage sites did not resemble monuments but were chosen because of feelings and personal associations in the present. As the Swedish archaeologist and project leader Anders Högberg (2007: 42) found, the past was actually absent, having completely merged into the present. The discussion in this chapter suggests that something very similar can also be said for at least some of the heritage that adults want.

Where does this leave archaeology? If the past is now, not then, archaeologists need to change their focus: from telling stories about past realities told in the present to telling stories about present-day realities using the past merely as a reference point (Holtorf and Högberg 2005–6; Holtorf 2010c). To achieve this, archaeologists will first of all need to understand that present-day past better than they do now. This means that there is a need to investigate in more detail both how and why the past and heritage are meaningful to various groups of people in the present and why so many of them happen to be fascinated by archaeology (see Holtorf 2007a). Future archaeology must work closely with rather than against the public's pre-understandings and existing expectations of archaeology and its object of study. Something similar can be said for the heritage sector. State heritage managers and academics in the field of heritage studies need to appreciate that even they are telling stories about present-day realities, albeit by referring to the past. For them, few things ought to be as exciting as original, imaginary, and creative depictions of the past in present societies.

Giving people the past they want is to give archaeologists and heritage professionals the past they ought to study.

ACKNOWLEDGMENTS

The discussion of Dresden Neumarkt is based on an earlier study (Holtorf 2007b). For critical comments on an earlier version of this chapter, I am indebted to Geoffrey Scarre and Anders Högberg. For facilitating reproduction of Figure 4.1, I thank Martin Potthoff.

The Ethics of Repatriation
Rights of Possession and Duties of Respect

Janna Thompson

In 1910 and 1911, a Swedish zoologist and adventurer, Eric Mjöberg, raided Aboriginal graveyards in Queensland and the Kimberleys. His purpose was to establish, by a study of their remains, that Aborigines were the missing link between apes and humans. He smuggled these remains out of Australia as 'kangaroo bones', and eventually some of his collection ended up in the Swedish Museum of Ethnography. A book recently published by an anthropologist led to a public outcry against Mjöberg's activities, and in 2004 the museum agreed to return bones to communities in the Kimberleys to which some of them were traced.[1]

This is one of a large number of cases where museums and research institutions have been persuaded or forced to surrender artefacts and human remains to those who are believed to be the rightful possessors. Demands for repatriation raise difficult moral issues that must be faced both by those curators and archaeologists who are predisposed to resist the demands and by those who are inclined to be sympathetic to the position of the claimants. There are two fundamental questions that need to be answered to arrive at a defensible position. First of all, we need to know when, if ever, claims for repatriation are legitimate (and when they are not). Who counts as the rightful possessors of the artefact or the remains, and what criteria should decide the matter? The second issue is whether other considerations – for example, the value of scientific research or respect for religious beliefs – can override legitimate claims to possession.

A good way to begin this moral inquiry is to examine a case that seems reasonably straightforward. Many people would probably agree that the Swedish Museum did the right thing by returning the bones to the Aboriginal communities: that the people of these communities had a rightful claim to them and, by implication, a right to have them returned and

[1] See the newsletter of the European Network for Indigenous Australian Rights, http://eniar.org/news/repat31.html.

to dispose of them according to their customs. But what considerations make their entitlements seem legitimate? And what objections might be advanced by those who are not so sure that repatriation was justified? If we can sort out the rights and wrongs in this case, we will be in a better position to make judgments about more difficult cases.

CRITERIA OF OWNERSHIP

Considerations familiar from discussions of the legal and moral entitlements associated with ownership can be used to make a convincing case for the return of bones to the Kimberley communities. The human remains belonged to members of these communities and were taken from their graveyards. There is good reason to assume that the people wanted their dead to remain undisturbed. Ethnologists of the nineteenth century reported that Aboriginal communities did what they could to prevent the desecration of their graveyards and complained bitterly about offences.[2] The bones were taken by someone who knew at the time that he was committing illicit acts (but even if he hadn't known, his deeds can still be described as theft). The thefts, though committed some time ago, have not been superseded by social or cultural changes that can make a past injustice irrelevant or a claim invalid. The Kimberley communities to which the bones were returned continue to exist and to maintain a connection to their ancestral traditions. They have never surrendered their entitlements to the bones or abandoned the beliefs that make the loss regrettable.

The museum directors may not have known where the bones came from when they received them as a legacy. Does this mean that the museum, as an innocent party, was not under an obligation to give them back? But leaving the question of innocence aside, this does not follow. Receivers of stolen goods, even if innocent, are not entitled to retain them. It is likely that Mjöberg, although he was aware that Aborigines did not want their graves desecrated, did not think that he was doing anything very wrong – perhaps because he thought that his scientific purpose justified his actions and/or because he thought that the opinions of Aborigines did not count. At the time that he was doing his collecting, and in the preceding century,

[2] See Paul Turnbull, 'Indigenous Australian People, Their Defence of the Dead and Native Title', in C. Fforde, J. Hubert, and P. Turnbull (eds.), *The Dead and Their Possessions: Reparation in Principle, Policy and Practice* (London and New York: Routledge, 2002): 70–1. He details a number of examples of protest and says that Aboriginal claims for the return of bones have persisted from the time that they were taken. 'Indeed, it is possible to trace the history of indigenous care for the dead up until the vigorous campaigning for the return of remains we have witnessed since the 1970s' (82).

many Europeans and Australian colonists would have agreed with him. Do the moral standards of the time make a difference to our judgment about the wrongness of the action and thus about the entitlements of Aborigines? The answer is clear. We are entitled to think that our well reasoned moral judgments about Mjöberg's activities are the right moral judgments. We do have good reasons for thinking that Mjöberg committed a wrong action, and if people at that time thought differently, then they were mistaken.

Almost one hundred years separated Mjöberg's expeditions from the time when demands for the return of the bones were made. The Aborigines who suffered the desecration of their burial grounds are no longer alive. Does the passage of time or the death of those who were injured by a wrong undermine claims to repatriation? Waldron argues that changes wrought by time make a difference to reparative entitlements.[3] Possessions are often central to the lives of those who own them, he says, and this is what makes dispossession wrong and gives those who were dispossessed a right to have their property returned. But if the possession is not returned and a long period of time passes, those who suffered the loss will have found other sources of meaning, and those who possess the property (and who are innocent of the wrong) will have come to depend on it. The historical injustice, says Waldron, has been superseded and the entitlements associated with it no longer exist. If those who were wronged are now dead, this might seem an additional reason to hold this view.

However, Waldron allows that claims to burial grounds or lands of symbolic or religious significance can remain resilient and credible for a long period of time.[4] His reason for making this exception (however reluctantly, given the thrust of his argument) is especially relevant when people are claiming the bones of their ancestors. In a group like a nation, tribe, or clan, intergenerational relationships and the fulfilment of obligations that arise from them are central to the self-understanding and self-respect of members. The duty to remember, respect, and care for their dead is a common, perhaps universally accepted, obligation for members of such groups. To resist claims made by those responsible to and for the dead is thus to disregard something that every such human group deems important: the perpetuation of a moral connection that binds the generations together and enables members of communities and kinship groups to regard themselves as participants in relationships through time. Respect for individuals and the communities they form thus requires respect for these claims. Because

[3] Jeremy Waldron, 'Superseding Historical Injustice', *Ethics* 103 (1992): 4–28.
[4] Ibid., 19.

of the importance to people of their intergenerational connections and obligations, the passage of time is not going to make a difference to their entitlements – at least so long as the intergenerational community exists.

Artefacts, as well as bones of ancestors, can be of great significance to members of an intergenerational community. They can bind generations together, be the source of intergenerational obligations, connect people with their ancestors, play a central role in their religious life, and serve as a heritage for future generations. If so, these can be the objects of reparative claims even when they were taken away many generations ago. However, not all artefacts that are the subject of repatriation claims are so essential to the life of a community; moreover, cultures change and people find new sources of meaning. It seems that Waldron's position would allow museums to retain artefacts that were taken some generations ago if those who claim them cannot prove that these things continue to have great value for their community.

However, this position fails to appreciate the kind of injustice that some communities have suffered and the way that the effects of the injustices have persisted into contemporary times. Waldron is describing a situation in which dispossessed individuals and groups are able to move on from their loss and to find a satisfactory alternative way of carrying on their existence – satisfactory enough so that in time they and their successors have no justification for dwelling on the wrong that was done to them or for demanding reparation. In the case of many indigenous communities, dispossession was only one part of an interrelated series of injustices that were designed to subjugate them, destroy their culture, and wipe out their communities. Many of these communities continue to suffer from injustice or have never had a chance to recover from the devastation that was visited on them. They have never had a real chance to find other sources of meaning. Under these circumstances, it is reasonable that those who demand the return of artefacts that were stolen from their ancestors should not have to prove that the items continue to have meaning for their cultural life. The very act of having them returned has an important cultural meaning under their present circumstances; it is a way of showing them respect as a people with a culture and a way of making reparation for the wrongs that they have suffered.[5]

[5] In some cases, indigenous people have cooperated with museums by making decisions about which items are important to their culture and which have merely a peripheral significance. See, for example, Edmund J. Ladd, 'A Zuni Perspective on Repatriation', in Tamara L. Bray (ed.), *The Future of the Past: Archaeologists, Native Americans and Repatriation* (New York: Garland Publishing, 2001), 107–15.

In such cases, those who demand reparation have a legitimate claim. The question remains whether scientific or public interest can trump rights of ownership. The return of human remains to indigenous groups is sometimes opposed by museum curators, anthropologists, archaeologists, geneticists, and others who believe that important scientific information will be lost if bones are repatriated and destroyed or buried. In some cases bones have lain in museum drawers for many years without being the objects of research or even a proper inventory, but scientists claim that new techniques, either those in existence or those that might be invented in the future, have the potential to extract important information from human remains. Because there is always a possibility of extracting yet more data from bones, this reasoning, if taken seriously, would never permit their repatriation. For similar reasons museums sometimes resist the return of artefacts, citing the loss of value that could result from their not being available to scientific research or for public exhibition.

According to common opinion, legal and moral, ownership rights can be abridged or overridden only for the sake of achieving a significant public good or avoiding an obvious harm (and then only after providing compensation). If research on Aboriginal bones were the key to finding the cure for a devastating disease, then scientists would have a reason for retaining them, whatever the rights and opinions of Aboriginal communities. But it is doubtful that scientists can justify overriding Aboriginal entitlements just for the sake of acquiring knowledge or testing theories – even if some public benefit might eventually arise from their research. If scientists want to do research on a relic possessed by a church or an heirloom owned by a family, they would naturally have to ask permission. They would have to convince the owners of the value of their research. The problem faced by archaeologists and anthropologists is that many indigenous communities are suspicious about the scientific purposes of white people. Aboriginal bones, like those collected by Mjöberg, were used to bolster a theory about race that denigrated Aboriginal people and justified their subjection.[6] Moreover, many believe that the dead cannot rest in peace until their bones are reburied in the country from which they were taken. Scientists who regard themselves as doing important research may resent being thwarted by suspicions that they regard as unjustified and religious traditions that they believe are false. But this is not a reason for overriding Aboriginal rights of possession. We must remind ourselves that knowledge

[6] The theories that motivated the collection of Aboriginal bones are detailed in Cressida Fforde, *Collecting the Dead: Archaeology and the Reburial Issue* (London: Duckworth, 2004).

is not the only value and that the 'right to know' does not necessarily trump other rights.

I have argued that repatriation of bones and artefacts is a requirement of justice when these items were illicitly taken; when the dispossessed, or their heirs and successors, still exist; and when the items in question continue to have a meaningful place in their cultural life or when they play a role in intergenerational relationships. It is doubtful that the scientific or educational benefits that might come from retaining these items can outweigh legitimate claims. Let us assume that this is right. However, when one or more of the criteria are not satisfied, then claims for repatriation are problematic and the responsibility of those who possess the objects is less clear. A claim can be problematic because it is not clear who was the original possessor of the thing in question or who, if anyone, is in the position to claim ownership; or because the object was not stolen but was legitimately acquired by a collector; or because there is no connection, communal or cultural, between those who make the claim and those who left behind their remains or their artefacts that would justify the belief that the item plays a role in an intergenerational relationship.

As time passes, communities not only change their customs and ways of life. They can also die out or change into something radically different. Suppose that during colonial times a throne decorated with precious stones was stolen from a tribal ruler by a mercenary soldier and eventually ended up in a European museum. Since that time the tribe has been incorporated into an independent state and its government insists that the throne is the possession of the nation and demands its return. Does the throne belong to the family of the former ruler, or to the tribe, or is it the patrimony of the new state? Or have political and social changes wiped away the right of any of these groups to make a claim?

How such questions should be answered depends on the details of the case, but relevant to a decision are the role that the throne played in the culture of the tribe, the way that the tribe was incorporated into the new nation, and the present identity and position of its members. If the throne symbolized the authority of the leader as the head of a people, then it is reasonable to regard it as belonging to the tribe rather than the leader's family (in the way that the Crown jewels belong to the British people and would continue to do so if the country became a republic); and if the tribe willingly incorporated itself into the new state, handing over its political authority

to the nation, then the nation through its government has a claim. In contrast, the throne may be closely connected in the minds of the tribal members with its particular history or the land it inhabits. Perhaps more than one group has an entitlement and ought to be able to have a say in how the throne is displayed and used. The important point is that decisions about ownership have to take into account the role that artefacts can play as a heritage that connects present members with the past of their society and culture. So long as this culture and heritage are valued and so long as there is an intergenerational continuum that transmits these values, political changes or even changes in the meaning of what is valued are compatible with a persistence of ownership rights.

LEGITIMATE ACQUISITIONS

If an object was illegitimately acquired, and if the group from which it was taken retain the values and connections with the past that made the object precious to them, then there is good reason to think that their entitlement continues to exist. But what if the object was not stolen but acquired in a legitimate way? What if there was no reason to believe that members of the group were opposed to its taking? In the early years of the eighteenth century a scholar travelled around Iceland – then a Danish colony – buying from farmers and villagers fragments of a thirteenth-century manuscript containing the history and sagas of the Norse people. He transported this collection to Copenhagen and bequeathed it to the university. In the course of the following century, as Iceland struggled for its independence, its people came to regard the manuscript as their cultural property and demanded it back. After much debate the Danes agreed to a transfer – an act that Greenfield refers to as a prime example of 'a successful restitution of cultural treasures from one country to another'.[7]

Restitution suggests that the Icelanders got back what rightly belonged to them. But the Danish scholar acquired the manuscript fragments by purchase from people who were entitled to sell them. There is no evidence that the Icelanders at the time regarded it as a national treasure or indeed that they valued it at all. The manuscript would probably not have been preserved if the scholar had not bought the fragments and taken them away.

[7] Jeanette Greenfield, *The Return of Cultural Treasures*, 2nd ed. (Cambridge: Cambridge University Press, 1996), 12.

Young suggests that what matters in a case like this is not history or criteria of ownership but the meaning that an object now has for those who claim it. 'When an item of cultural property has aesthetic, historical, or other value to the members of some culture, then the culture has some claim to the ownership of the property in question. The strength of the claim will be proportional to the value the property has for members of the culture'.[8]

His cultural significance principle is beset by a number of problems. We can presume that the meaning of the manuscript for the Icelanders was much greater than it was for the Danes. But what if an object has great meaning for more than one group? And why should the interest that scientists might have in studying ancient bones be of less importance than the cultural significance that the bones have for members of an indigenous group? But the most serious difficulty with Young's proposal is that it doesn't take seriously enough rights of property: the rights that people acquire through legitimate acts of acquisition. If we think that an individual or group should be able to acquire ownership rights over things through purchase or through inheritance, if being able to exercise such rights is central to the ability of people to live meaningful lives (as Waldron says), then surely ownership rights over something should not be overridden just because some group has developed a keen interest in possessing it and now regards it as central to their cultural life.

Young's principle is not acceptable as it stands, but it does point to a consideration that should play a role in the reasoning of museums and other bodies that are in possession of objects that others claim. Intensity of interest in having something may not by itself give a community right of possession, but it is not irrelevant to our views about who should have it. Denmark may not have had an obligation to return the manuscript to Iceland. But most people would judge that it was a good thing for the Danes to do, given the role that the manuscript had come to play in Icelandic identity and given the history of Icelandic and Danish relationships. From a moral point of view the return of the manuscript might have been a supererogatory act – one that neither justice nor any other moral principle required them to perform – but virtuous agents are predisposed to do good, and the good relationships that such acts promote are virtue's reward.

There is a further consideration relevant in cases in which those who make claims were subject to injustices. In the nineteenth century, totem

[8] James O. Young, *Cultural Appropriation and the Arts* (Malden, MA: Blackwell Publishing, 2008), 91–2.

poles, ceremonial masks, and other artefacts were taken from Haida villages in British Columbia and put in museums.[9] For the most part, the Haida people did not object. In some cases the artefacts were taken from villages that had been abandoned as the result of epidemics or assimilation. The collectors saved these objects from decay or destruction. However, the apparent legitimacy of their acquisitions becomes more questionable when it is put in context. The Haida people had for many years been subject to restrictions on their cultural life imposed by government regulations. They were a defeated and impoverished people. Their culture had been denigrated and undermined by the work of missionaries and government officials. They were under pressure to give up their cultural ways and assimilate. Under these circumstances it is hardly surprising that they would make little attempt to resist the taking of their remaining cultural treasures. When in the late twentieth century they had become stronger and had a chance to assert their identity as a people, they demanded the return of some of the things they had lost. In this case it seems reasonable to insist that they have a right to them. Even if we think that the collectors were justified in taking the objects to preserve them, an appropriate form of reparation for the harms that the Haida suffered as a people is to return objects that are important for the revival of their cultural life.

The demands of these Native Canadians are justified first of all because they are the cultural heirs of the people who were dispossessed and secondly because the injustices that their ancestors were subjected to rendered them incapable of resisting or objecting to the pressures put on them to surrender artefacts central to their cultural heritage. However, reparative justice may require that artefacts or bones be given to those who claim them even when the cultural connection between these claimants and those who were dispossessed are more dubious.

According to official pronouncements current up to the 1970s, Tasmanian Aborigines died out in the nineteenth century with the death of Truganini, purportedly the last Tasmanian Aborigine. Indeed, Aboriginal communities and their traditional culture were systematically destroyed by the policies of governments and the actions of settlers. Those who remained were isolated communities of people with Aboriginal blood, mostly descended from Aboriginal women who had been abducted by sealers. Some of these people today demand that they be recognized as Tasmanian Aborigines and thus as the heirs to the heritage that was

[9] For an account of what these objects mean to the Haida, see Terri-Lynn Williams (gii-dahl-guud-sliiaay), 'Cultural Perpetuation: Reparation of First Nations Cultural Heritage', *University of British Colombia Law Review* (1995): 183–201.

destroyed by colonialism. On this basis, they claim the remains of their Aboriginal ancestors, whose bones were transported to museums all over the world in the days when Tasmanian Aborigines were regarded as the most primitive race of human beings on Earth.

The cultural connection between contemporary Aborigines and the people whose bones they are claiming is tenuous. But it can be argued that obtaining these bones is appropriate reparation for the injustices that the people of these surviving communities have suffered, which include not only discrimination and neglect but also a widespread refusal to recognize them as Tasmanian Aborigines while denying them the privileges accorded to white citizens. This injustice is not merely the fault of governments and museums that preferred to think that unpleasant aspects of their history had no relevance for the present. It should be understood as one aspect of a history of injustices – which included acts aimed at wiping out a culture and a people and exploiting their remains for research. Those who identify as Aborigines are the heirs and victims of that history. The importance to them in being recognized as a people in the face of a persistent refusal to acknowledge their identity makes the return of bones an appropriate recompense for injustice. The features of this case make Young's cultural significance principle relevant – but not just because Tasmanian Aborigines strongly identify with their ancestors; because their identification is a good reason for thinking that the reparation that is owed to them ought to take this form.

ANCIENT BONES

In some cases, demands for repatriation cannot be justified by either a cultural or a historical connection to those whose remains were collected or whose artefacts were seized. In 1996 remains were found of a prehistoric man near the Columbia River in Washington in the United States. The Kennewick Man, as he came to be known, was claimed by a number of Native American tribes under the provisions of the Native American Graves Protection and Repatriation Act (NAGPRA). Anthropologists and archaeologists, who wanted to be able to study the remains, argued that they were too ancient and too unlike existing members of these tribes to be regarded as belonging to them. After a lengthy dispute, a court ruled in favour of the scientists. In a similar case in Australia, scientists were not so fortunate. Ancient bones found in the Kow Swamp in northern Victoria and kept in a museum were successfully claimed by an Aboriginal group, who took them back to their land and reburied them. The ethical question

is how such issues ought to be settled and what is relevant to settling them.

Should right of possession be determined by who possesses, or formerly possessed, the territory in which remains or artefacts are found? The Kennewick Man was found in land that was thought to have belonged to the Umatilla (although four other tribes also claimed possession), and those responsible for administering NAGPRA decided on that basis to give the remains to the members of that tribe, who intended to rebury them. In making their decision, they were apparently applying a common convention: that an artefact or resource belongs to the group who possesses the territory in which it was found. This convention is also insisted on by nation-states when they claim possession over artefacts or remains discovered in ancient graves or archaeological excavations. By recognizing indigenous groups as a people with a territory, or with a historical claim to a territory, the convention seems to require that we recognize that they can make claims to what is found in this territory – whether or not there is a cultural or genetic connection between those whose artefacts and remains are uncovered.

The convention that treats artefacts and remains that are found within a people's territory as their possession is a way of resolving questions about ownership which gives due regard to the right of people to use their land and its resources. But from a moral point of view its use as criterion for determining rights over artefacts and remains is problematic. First of all, it disadvantages those groups who do not, and perhaps never did, have a territory of their own. Second, it can fail to resolve the issue when more than one group has a claim to a territory as the result of a history of migration and conquest or overlapping rights over land. The fact that other tribes apart from the Umatilla believed that they had a legitimate claim to the Kennewick Man is an indication of the difficulties that arise when possession of territory is used to determine possession of remains and artefacts (especially when ownership is understood in a Western framework). In this case, the territory in question is also the territory of the United States, and before NAGPRA it was assumed that remains and artefacts excavated from sites where indigenous people had lived belonged to the American people. Recognizing the entitlement of indigenous people to protect their heritage was the justification for NAGPRA, and this entitlement is a moral as well as legal reason to acknowledge their right to repatriation in many cases – but not in all. Given that it is implausible to suppose that there is a special connection between remains that are eight thousand years old and present-day people, it might seem reasonable to judge, according to

the convention, that the Kennewick Man belongs to the United States, or perhaps that he belongs to all of the indigenous tribes that have had any past connection to the territory.

Should genetic relationship be the deciding factor in such disputes about ownership? The DNA tests that were performed on the Kennewick Man with the view of determining what relation, if any, he had to present-day people were assumed to bear on the question of ownership. But the relevance of genetic relationship is questionable. To be sure, if tests show that there is no genetic relationship with present members of a group, then this is a reason for thinking that the remains do not belong to someone of their tribe. But the existence of a genetic relationship does not establish the kind of connection between people of the prehistoric past and members of a present group that could give the latter an entitlement of ownership. The existence of a genetic relationship between ancient and modern Egyptians (assuming that it exists) does not give modern Egyptians an entitlement to all of the remains and artefacts of the ancient Egyptian dead (including those that are now in the museums of the world).

Transcending demands for repatriation that are made by groups on the basis of territory or genetic connection is the more general consideration of the value of artefacts or ancient remains to science or humanity in general. To treat artefacts or ancient remains as resources that nation-states or other territorial groups can use in any way that they please – even to destroy them, if this serves their purposes – wrongly ignores these other values and wrongly denies to those outside the territorial group the ability to appreciate the things that have these values.

Does this mean that the decision to give over the Kennewick Man to scientists to be studied – thus effectively preserving its value for humankind rather than allowing this value to be destroyed by reburial – was the morally correct decision? There are several considerations that might tell against this conclusion. One is that the Kennewick Man is not an artefact but the remains of a human being, and how his remains ought to be treated must surely depend on a view about what, if anything, we owe to the dead. Although we know nothing much about this individual, we can presume that he was buried by his people according to their customs, and going by what we know about other groups of people, ancient and modern, we can guess that he expected and wanted (when he was alive) that his body once buried would remain forever in its grave.

Many people believe that we have duties to the dead, and this belief has received support from a number of philosophers. Wisnewski suggests that the respect we owe to the dead might require that we leave them in their

tombs.[10] If we think that we owe it to Kennewick Man, as an individual who presumably desired to remain buried, to fulfil his wishes, then his body ought to be returned to the Umatilla – simply because they are the people who are prepared to do the right thing.

Obviously, if we take Wisnewski's suggestion seriously, this would have a devastating effect on archaeological practice – not to mention the collections of many museums. One way of defending this practice is to deny that the dead are the objects of moral duties – to insist that the common belief that they are is a superstition. But it seems to me that this is not necessary to reject Wisnewski's idea of what respect for the dead might require. The duties that we have to the dead derive either from requests that they made to their survivors before their death or from what we suppose that their wishes would be if they were aware of present circumstances (or had been informed of them while they were alive). The first we determine through historical evidence or reasonable suppositions about what those now dead requested or wanted their survivors to do. The second we determine by imagining what those now dead would have wanted if they had known or experienced what they could not have known or experienced. In my view, neither way of determining our duties to the dead requires that we rebury ancient remains.

The second does not because questions about what the dead would have wanted had they known what they could not have known cannot generally be answered – especially if they have been dead for such a long time. We cannot know what the Kennewick Man would have wanted if he had known that he would be dug up eight thousand years after his death. Imagining what he would have wanted is only going to lead to self-serving conclusions or unsupported speculations. What he requested during his lifetime is also unknown, but we can assume that he wanted to be buried according to the customs of his society and for his survivors to respect his resting place. However, any requests he made were addressed to his survivors and successors – the people of his tribe and culture who would understand the reasons for his requests and would regard themselves as obligated to respect them. But the people of his tribe and culture are long gone, and there is no one who has an obligation to fulfil his requests. This does not mean that archaeologists and others have no duties to, or in respect to, the ancient dead. Perhaps any person can request that her human survivors, however distant in time and culture, respect her

[10] Jeremy Wisnewski, 'What We Owe the Dead', *Journal of Applied Philosophy* 26, no. 1 (2009): 66.

remains. But what this respect means can reasonably be determined according to our own ideas. It does not require leaving ancient remains in their tombs.

In the case of the Kennewick Man and other similar disputes between indigenous people and archaeologists and curators of museums, the critical question is whose right or responsibility it is to determine what we owe to the ancient dead. Indigenous people commonly believe that their ancestors and the features of the land that they inhabit were created together by powerful beings, and therefore they believe that any remains or artefacts found in their traditional lands, however ancient, have to belong to their people. Their tradition thus gives them reason to believe that they are the ones who should be given responsibility for the bones. Archaeologists, in contrast, have reason to believe that the people who now inhabit the land came from somewhere else and that other waves of immigration may have preceded them.

The second consideration that might be used to challenge the decision of the Court is the requirement of respect for religious beliefs. Gerstenblith asks why the truth of scientists should be accepted when it conflicts with religious belief. 'The acceptance of only the truth that is derived from the scientists' formulation and the ability to dictate this to minority cultural groups are a form of control over the group.'[11] Her position could be interpreted to mean that the beliefs of scientists are no more valid than the beliefs of indigenous people: they are simply different ways of looking at the world, and thus scientific theories cannot be used to dictate to those who do not accept them. Or she could mean that scientific theories, though providing a better account of the nature of the world, should not be used to override the respect that we owe to the religious beliefs and practices of a people.

The relativism implicit in the first interpretation is unattractive. It implies that native and nonnative people live in different conceptual worlds and that real communication – an exchange of ideas or a discourse in which people give reasons for their beliefs that others can understand and accept – is impossible. This seems obviously false. The second interpretation of Gerstenblith's proposal seems more plausible. We ought to respect the right of people to practice a religion and live according to its beliefs. But when a conflict exists between religious believers and the interests of outsiders,

[11] Patty Gerstenblith, 'Cultural Significance and the Kennewick Skeleton: Some Thoughts on the Resolution of Cultural Heritage Disputes', in E. Barkan and R. Bush (eds.), *Claiming the Stones, Naming the Bones: Cultural Property and the Negotiation of National and Ethnic Identity* (Los Angeles: Getty Publications, 2002), 162–97.

the issue cannot be solved simply by appealing to respect for the right of
people to practice their religion. If a group of creationists demanded that
evolution not be taught in schools attended by their children (along with
others), respect for their religious belief would not require us to accede to
their demands. In resolving such issues, the institutions of a liberal state
ought to appeal to the best evidence available – even when this evidence is
rejected by some people because of their religious beliefs.

In the case of the Kennewick Man, the Court decided that the evidence
favoured the scientists. However, as we have seen, there are other consid-
erations that could be important in this and similar cases. The first is the
consideration highlighted by Young: the important role that an object can
play in the life of a people. Even if there is no duty, legal or moral, to give
humans remains to people who claim them, it might be a good thing to do.
The second consideration is the possible existence of a duty of reparation
for past injustices to a group – a duty of justice that makes it appropriate
to accede to its members' demands. Gerstenblith, like many of those who
took the side of the Native Americans in the dispute about the Kennewick
Man, seems to appeal to this idea. According to them, it is not just a respect
for the religious beliefs of the Umatilla that requires the US government to
give them the Kennewick Man but also the fact that they have suffered a
history of injustice – in particular a history in which their religious beliefs
were not respected. Their demands should be understood in terms of this
history and thus cannot be treated like the demands of the creationists.

However, even if these considerations do not justify the claims of the
Umatilla – even if in this and other cases, the rights of indigenous people
do not extend to denying the ability of scientists to study ancient remains
and artefacts – they do justify giving indigenous people a say about how
bones and artefacts found in their territory ought to be used and treated.
The problem with the way in which the ownership of the Kennewick Man
was decided was not that scientists were allowed to study the remains but
that the Court had to make a decision in favour of one group or the other.
Ideally such matters ought to be determined by negotiation – one that
acknowledges the importance of bones or artefacts for those who want
to study them but also acknowledges that indigenous people should have
a say about the treatment of the remains or about what will eventually
happen to them. Regarding and treating indigenous peoples as parties that
have a legitimate interest, even when the remains or artefacts found in their
territory are very old, is an appropriate way of showing them the respect
that they are owed as a people.

In 1969 Australian archaeologists uncovered the remains of a woman who had lived near Lake Mungo (now a dry lake bed in southern New South Wales) around twenty-five thousand years ago. Later the bones of a man were discovered which seem to be even older. It was understood from the beginning that the Aborigine people of the area, who are also now managers of the Lake Mungo National Park, should have a say in how the remains would be treated. After being studied by scientists, the remains of the Mungo Woman were repatriated. Her remains are in a vault in the National Park Headquarters which can only be opened if two keys are used: one is in the possession of archaeologists, and the other is controlled by the local indigenous people.

CHAPTER 6

On Archaeological Ethics and Letting Go

Larry J. Zimmerman

What is the nature of true morality? . . . [I]t must be a kind of ethics involving letting go of one's own interest on behalf of others, being ready if necessary to sacrifice one's own interests for them, even on behalf of an enemy.

– George Ellis (2004)

Yep, son, we have met the enemy, and he is us.

– Walt Kelly (1971)[1]

Not letting go of cherished ideas or objects can bring all sorts of trouble and can cause no small amount of pain. In this chapter, I contend that letting go is an important process in the development and application of archaeological ethics. In fact, letting go is an imperative if archaeology is to evolve as a discipline. Letting go of ethics may seem counterintuitive and somehow unethical because many of us think of ethics as morals, values, or principles to which we must hold fast instead of the tools they actually are. These days, especially with so many stakeholders to whom we are said to be accountable, many archaeologists seem to find themselves bogged down in all sorts of ethical quagmires, or they worry that they will be. A quick look at the history of archaeology, however, shows that this really isn't so new.

Our archaeological predecessors struggled hard to become a discipline, which included developing what they thought of as ethical practice. The nineteenth-century shift away from antiquarianism demanded an ethic of systematic excavation and data recording, which forced archaeology toward science, piling on additional strata of ethical practice. A peculiarly Western epistemology, science was a good fit with colonialism, which heaped on another layer of ethics. A key notion was that the Other would

[1] This famous quotation is from a classic American comic strip, *Pogo*. The comic was published on 22 April 1971 to commemorate the first US celebration of Earth Day. See the context and comic strip at http://en.wikipedia.org/wiki/Pogo_(comics) (accessed 22 May 2012).

eventually disappear, so part of archaeology's growing ethical burden was to salvage what remained of the Others' pasts. Archaeology became a kind of scientific colonialism (Galtung 1967: 13). Bolstered by technological advances, archaeologists also sought to discover and interpret the past of the Other, and in doing so, they developed an ethic of stewardship in order to protect the Others' physical remains – sites, artefacts, human remains – for all humanity. By the 1970s, the positivistic truths of processual archaeology eclipsed pasts known using other epistemologies, and cultural heritage management emerged as a sibling to archaeology. By the time the Society for American Archaeology (SAA) began discussion of what became its Principles of Archaeological Ethics in the mid-1990s, science and stewardship had coalesced, becoming the SAA's core ethical principle.[2] The problem, of course, was that the Other had not disappeared, and scientific colonialism began to unravel starting in the 1960s. By the 1980s, scientifically colonised people loudly began to demand repatriation of human remains and other cultural properties as part of their effort to regain control over their own pasts. By 1990, some archaeological organizations, most notably the World Archaeological Congress (WAC), incorporated these demands into their ethical principles, shifting away from many ideas about pasts being a public heritage and moving toward collaborative models for both investigation and stewardship of descendant community pasts.

A simplistic history of archaeology's ethics? Certainly. Resorting to casuistry? Maybe. But the point is a simple one: archaeological ethics are and always have been complicated and ever changing. If you refuse to worry for a moment about philosophical distinctions between them, consider how ethics, principles, morals, and values impinge on archaeology in the history above.[3] Notice the moments in which they shifted. If you know the history of archaeology, you likely will acknowledge that every shift required an element of letting go of the way archaeologists did many things before. This did not happen without some level of grumbling from practitioners, from relatively minor, individual complaints over small changes to skirmishes – if

[2] See Zimmerman (1995: 64) for a discussion. Although not explicitly mentioned, an assumption in the SAA's Stewardship Principle was that the best archaeology practice was the most rigorously scientific.

[3] I am aware that philosophers and ethicists may cringe at lumping these terms and some other things I'll say in this chapter. I recognise that there are differences. See a paper by Wylie (2003) specifically discussing the differences as related to archaeology. I suppose this paper fits somewhere in the meta-ethical realm, but to worry about such matters may miss the point of the chapter. With apologies to the editors and philosopher friends, I also wish to avoid references to philosophical treatises. Unless they are intellectual masochists, most archaeologists barely can keep up with their own literature and jargon, let alone want to take on that of philosophers! Poor scholarship? Maybe, but I'm afraid such avoidance is usually necessary for academic sanity and survival.

not pitched battles – between epistemological camps during paradigm shifts.

The intent of this chapter is to remind us that ethics are often as much about letting go of treasured values, morals, and principles as they are about establishing and defending them. Ethical practices almost always contain structural contradictions that echo the choices made to establish them in the first place. Thus, they can hardly be absolutes. When held to be so, they can become profoundly detrimental. When archaeologists will not let go, their obduracy can turn themselves into their own worst enemies. The discipline needs to recognise that every moral, every value, every principle – every ethic – contain loci for letting go, where practitioners should recognise the dangers of holding on. Practitioners also need to understand that letting go is something they do all the time anyway, entirely necessary and ethical. Doing so actually can be adaptive, allowing archaeology to change in ways that may benefit not only our relationships with stakeholders to the pasts we study but also our very understanding of what pasts are, how they are formed, and what they mean.

This chapter ultimately is about letting go as part of the process of archaeological ethical development in relation to collaboration with descendant – especially Indigenous – communities. My observations stem from my growing disquiet about the nearly reptilian tenacity of some archaeologists in their belief that pasts are a public heritage best stewarded by professional archaeologists. In particular, my concern derives from the manifestation of that belief in recent efforts by some North American archaeologists to fight implementation of regulations related to the repatriation of culturally unidentifiable human remains under the Native American Graves Protection and Repatriation Act (NAGPRA). I contend that holding onto a 'past as public heritage' ethic is actually maladaptive for archaeology and that we ought to let it go – or at least redefine it – in favour of an ethic of collaboration in which archaeologists support stakeholders in the stewardship of their own pasts. Before considering specific issues, however, there may be some utility in providing my take on archaeological ethics, and probably all ethics, reflecting on how I came to these opinions.[4]

[4] This means that I do not intend to present both sides of issues – as if there are ever only two sides anyway – and that I am more than willing to admit that my reasoning may be inadequate and that I may be wrong. I also note that my interests and experiences are North American, specifically in the United States with Native Americans, but I have worked enough internationally with Indigenous issues in relation to archaeology to recognise common concerns. Although some may disagree, I am a scientist, and as an archaeologist I realise that objects, including human remains, can provide extremely interesting and socially useful information about the past. I would prefer that everybody

ETHICS, SCHMETHICS

Ethics are so annoying. I avoid them on principle. – Darby Conley, *Get Fuzzy* (comic strip), 15 August 2007

Bucky Katt's quip from Darby Conley's *Get Fuzzy* comic strip humorously gets to the point: ethics can be such a bother! I make this complaint after three decades of lecturing, editing, and writing about ethics; I was intimately involved in crafting WAC's Vermillion Accord and First Code of Ethics; I have served on both the Society for American Archaeology and American Anthropological Association ethics committees; I have preached about them to others; and I have been accused a few times of being unethical. When I complained on Facebook about the trouble I was having with writing this piece on archaeological ethics, I received a number of comments and advice. From a seasoned archaeologist I received this: 'Writing about ethics is never easy, for anyone, at any time. The topic is so convoluted that there are no easy places to start'. A Native American artist I recently met asked, 'Could someone explain what archaeological ethics are? Maybe that is a good place for you to start. I actually don't know; what's the difference between, say, a scientist who is respectful and a grave robber?' A former student, starting postgraduate work in archaeology, quipped, 'If there is one thing you taught me [it] is that you can rationalize anything if you put your mind to [it]'. Finally, another Native American, a longtime friend who happens to be a trained, experienced archaeologist, reminded me of an old saw: 'Ethics backwards is scihte, if that helps'.[5]

Starting as I have should be a warning: I do not believe I could tell my artist friend what archaeological ethics are, but I do not think it probably matters all that much. At the same time, I do think that I have some understanding of what ethics might or might not be, which I hope I can present in a logical or at least understandable structure that explicates a rationale for, and perhaps the desirability of, letting go of an ethic that the past is a public heritage and that archaeologists should be its stewards.

First, we are what we do, not what we say we do. Anthropologist F. Allan Hanson (1975: 8–15) wrote about the anthropologist's difficulty in determining meaning in culture. Simplified, he observed that meaning can

agree that the past is shared heritage, and I would prefer that human remains and other objects be continually available for study. I'm also a humanist who recognises that not everyone sees things this way, and I would never suggest that I know what is best for them or what they should think about their pasts.

[5] Given the nature of Facebook communication, I fixed a few little things in the posts. I asked all four "friends" for permission to use their posts and offered either attribution or anonymity. They have my thanks for the wisdom of their comments.

be intentional (what people say their actions mean, that is, the intent of their actions), or it can be implicational (the meanings generated by the implications of their actions, that is, what they do and the impact that it has on them and their surroundings). A bit like the notions of ideal versus real and emic versus etic in culture, the intentional-implicational binary incorporates more than just the agent and includes those things and people the agent's behaviour influences.

Archaeologists almost always view archaeological ethics as intentional, but the perspectives of others about the ethical practice of archaeologists are almost always implicational. For example, in excavation of human remains, many archaeologists believe they act respectfully, or at least that is how they intend to act. They excavate remains very carefully, treat the remains well, store them carefully, and generate what they think to be historically or otherwise important data for the good of direct descendants and all of humanity.[6] In contrast, many members of descendant communities who are demanding return of ancestral remains decry the action, accuse archaeologists of acting disrespectfully, and ask why they have to dig them up in the first place, a view not too far from that expressed by my Facebook artist friend. As Colwell-Chanthaphonh and Ferguson (2006: 127) observe in their discussion of virtue ethics, 'Quite often, one could argue, both Native Americans and archaeologists offer goodwill through their actions, and only their behaviour is construed in ways not intended'.

Second, ethics are mostly about people, not things. Things do not care; people do. There is no need to worry about what things feel or think, particularly if you are a materialist, which most archaeologists are, almost by definition. Our relationship to material culture, the real core of what archaeology is about,[7] has confused archaeologists and the public from the beginning. The first questions about ethical practice in archaeology involved things and how they were used to understand the past (McGuire 2003: vii). As the shift from nineteenth-century antiquarianism happened, 'the predominant ethical principle for these early archaeologists was the need to protect sites from looting and vandalism and to excavate them in a scientific manner' (Lynott 2003: 19).

Archaeologists tend to forget the people behind the artefacts, which can be especially alienating if you somehow associate yourself with those people

[6] Ubelaker and Grant (1989), for example, discuss many of these intentional elements in an early article defending the study of human remains in the face of repatriation demands.

[7] This could be a long discussion in itself, but by definition, everything people have done is in the past. Archaeology actually studies the production, use, and distribution of material culture in the past. Time is only one dimension that we link to material culture and the past can be just seconds ago.

as ancestors. This was brought home to me forcefully early in my career. I was involved in developing a public education program called Ancient Peoples and Places of South Dakota. To promote the program we printed a beautiful poster with water rippling over cobbles and projectile points. I recall being taken aback when a Native American student asked, 'But where are the people?' Vine Deloria Jr. (1977, 1995), who was a powerful Native American critic of archaeology, often complained that archaeology dehumanises by turning people and their relationships into objects or events. Whereas archaeologists and bioarchaeologists tend to call skeletons 'human remains', many Indigenous people tend to think of skeletons as people who are still alive but living on a different plane, people to whom those living in this world have obligations (Colwell-Chanthaphonh and Ferguson 2006: 123). As an additional concern, in animistic belief systems, plants, animals, rocks, natural phenomena, and even some human-made objects may be alive, with humans having obligations to them (for a discussion, see Ingold 2000: 112–13). Thus, for animists, 'things' may care and find offence from ill treatment. Archaeologists would do well to remember that even if things do not care, there are always people associated with those things or who believe they have obligations to them.

Third, ethics tend to reflect concerns of the contemporary broader society in which a group operates. Many archaeologists might agree that they tend to be marginal to their own cultures. Others may admit that they became archaeologists because they did not want to deal with living people.[8] But archaeologists cannot escape the influences of their own societies, so their ethics reflect what is happening around them, although they sometimes are slow to recognise it. For example, archaeology started emerging from antiquarianism as a systematic and scientific discipline in the late 1700s with the age of Enlightenment (Trigger 2006: 97–105). Recent discussions about 'decolonising' archaeology came with postcolonialism and postmodernism (Atalay 2006: 290–2). That archaeological ethics should make such shifts is no great revelation, but the shifts imply that earlier ethical principles are hardly absolutes, so there is no reason that contemporary principles have to be.

Fourth, ethics are value conflicted and therefore political. Ethics imply choice between two or more possible behaviours, but sometimes a particular choice just seems obvious, logical, and beneficial. For example, stewardship of archaeological sites or long-term preservation of collections

[8] These often are said in a humorous way, but I suspect they may be truer than many archaeologists would care to admit!

might seem to be so. The reality, however, is that ethics such as stew-
ardship usually are self-referenced. Even in a group supporting the ethic
there may be a continuum of opinion about it. Archaeological ethics may
not be referenced directly to social contexts outside the discipline. They
may be seen by non-archaeologists, for example, as beneficial primarily for
archaeology, protecting the discipline's interests. Property owners, devel-
opers, or descendant communities may see archaeology's stewardship as
obstructionist and debilitating (Zimmerman 1995; Groarke and Warrick
2006: 166–7). Outsiders may see efforts to promote such ethics, especially
when archaeologists try to build them into law or regulation, as an effort to
limit their own choices and decision-making powers. Ethics thus become
political in the sense that one group seeks to gain power or authority over
others. In heritage matters, outsiders may choose to resist archaeological
efforts.

Fifth, ethics can be adaptive or maladaptive. As with everything else in
culture, ethics can be said to function as tools that help a group cope with
its environment. As a component of worldview, ethics provide cohesion,
setting a group apart from others, essentially stating, 'Here is what we
believe we should be doing and why'. At the same time, stated ethical
principles help the group to keep outsiders off their backs by being able to
tell nonmembers that the group conducts itself ethically, sending a message
that says, 'We will police ourselves, so stay out of our affairs'. Groups
may tend to see ethics as absolutes, as lines in the sand that may not be
crossed. The problem is that absolutes can decrease options for flexibility
of response to challenges from inside or out.

This is an evaluative component of ethics that drifts into the uncom-
fortable realm of cultural relativism, an idea that anthropologically trained
archaeologists would generally admit they support. Probably more con-
tentious than ethics, relativism in its simplest form suggests that the right
and wrong, morality, or efficacy of acts can be judged only by the standards
of the culture in which those acts are done, not by some outside standard.[9]
James Downs (1971: 24–5) contends 'that there is no right or wrong, that it
depends on time and place'. His argument is that the only relativistic evalu-
ation of good or bad that makes anthropological sense must be assessed on
the basis of whether some aspect of culture is adaptive or maladaptive, that

[9] I dare say that even suggesting that there can be a 'relativism in its simplest form' is probably
oxymoronic to philosophers and to many anthropologists who have worried the concept for decades.
A deeper discussion is outside the scope of the paper and, frankly, unnecessary. The point of even
raising relativism is to contextualize ethics as potentially maladaptive and not necessarily a matter of
morality.

is, whether it helps the culture to survive pressures accompanying changes in its environment. If it does, it is good, and if not, it is bad. A trait may be adaptive at one time or for one circumstance but may become maladaptive as situations change. The problem becomes one of history – time and place – because adaptivity can be assessed only in historical hindsight. Did the trait help, was it meaningless, or did it hasten extinction? By extension, one can only guess about the value of a trait for future survivability; only time will tell. A particular archaeological ethic can be viewed in terms of its probabilities for being adaptive.

Six, let go of useless, but especially of maladaptive, ethics. If evidence suggests that a particular ethic is not of benefit, there is no reason to hold onto it except for 'show' to outsiders. In contrast, if a particular ethic may be harming archaeology, letting it go might be the wiser course of action. If there is a substantial outcry from non-archaeologists regarding what we do as archaeologists, recognizing their concerns or anger as a threat is not unreasonable. Obviously, we cannot know the future for a particular ethic, whether it will be useful or harmful, but we can make some educated guesses based on the evidence at hand. This does not mean that there needs to be a wholesale letting go of an ethical system except in the most extreme circumstances. Cultural shifts usually are gradual, and letting go often may be a minor repair, essentially tweaking the system. After a long period of time and numerous tweaks the system may look substantially different from how it was at the start.

Seven, if you let go, hope for the best, but if you do not let go, you may regret it. Usually, however, the result of letting go of an ethic will not be devastating either way for archaeology. For example, with demands for repatriation and archaeology's forced acquiescence, there seemed to be numerous claims that repatriation would be the end of American archaeology and even efforts to prove it was happening. Weiss (2001, 2008), for example, examined the decline in the number of osteology articles in the *American Journal of Physical Anthropology* based on studies of Native American skeletal remains since the passage of NAGPRA. Cutright-Smith and colleagues (2010) conducted an independent study and agree that this decline happened, but their analysis looked for other markers in the more archaeology-focused journal *American Antiquity*, thus resulting in a more optimistic picture of NAGPRA's impacts. *American Antiquity* showed a post-NAGPRA increase in US-based human remains studies, engagement with tribes, and an increase in the incorporation of Indigenous knowledge in archaeological practice. Most definitely NAGPRA had an impact on the discipline (Killion 2008), but that American archaeology still seems to be

vibrant twenty years after passage of NAGPRA is worth noting, and my impression is similar in other places where archaeology's demise was predicted as a result of repatriation. Taking liberties with Mark Twain's usually misquoted witticism,[10] reports of archaeology's death are an exaggeration.

LETTING GO IS NOT UNUSUAL FOR ARCHAEOLOGISTS

The more we save, the more we become aware that such remains are continually altered and reinterpreted. We suspend their erosion only to transform them in other ways. And saviours of the past change it no less than iconoclasts bent on its destruction. – David Lowenthal (1985)

If you accept the premise of the Lowenthal epigraph, many of the things archaeologists say about stewardship seem pointless. For example, 'saving the past for the future', a tag line the SAA used during the expansion of Cultural Resources Management, actually becomes impossible for archaeologists to do. As Lowenthal would have it, pasts are multivocal and multithreaded, essentially creations that reflect the present and the agendas of the parties involved in creating them. Certainly, he understands that whatever remains of objects and their contexts, created by people of the past, can be protected from destruction, but to what end? From the moment archaeologists deal with objects and contexts, they change them, from excavation and curation to interpretations of functions and meanings. Intellectually, archaeologists know this, but not emotionally. As self-proclaimed stewards who save the past, they are reluctant to let it go, feeling that their stewardship somehow suspends time.

There are clearly evident contradictions between archaeologists' daily practice and their ethics. Archaeologists actually let go all the time but usually do not see it as a problem, let alone any kind of ethical violation. Contradictions exist because ethics are not binaries but seem to be on a continuum from unacceptable to ideal behaviour. Is there behaviour that is maybe acceptable but not best practice? Are some bad practices occasionally unavoidable or maybe even necessary to avoid harm; that is, are there little white lies in archaeology? Examples seem to be plentiful.

When archaeology became scientific it took on an ethic in which letting go was built right in as a positive. Archaeologists offer hypotheses in their interpretations of the past, and many of us realise that eventually our

[10] The usual Twain misquotation is "Reports of my death are greatly exaggerated" or some variation. In 1897 a reporter, thinking Twain was near death, inquired of his health, which Twain recounted later in the *New York Journal* (2 June 1897). No premature obituary was published.

hypotheses may be falsified, that is, demonstrated to be incorrect or inadequate to explain data. At that point we must let go, even if we championed a particular hypothesis over a career. For example, for a quarter century I have supported a hypothesis that uses poor growing conditions, competition for arable land, and internecine warfare to account for a thirteenth-century massacre of nearly five hundred people at the Crow Creek site in present-day South Dakota (Gregg and Zimmerman 1986). Competing hypotheses have unknown groups coming in from outside or a struggle between the culture of the villagers and the people they displaced. I do not think competing hypotheses account for enough of the evidence at the site, especially chronic malnutrition in many skeletons, but if researchers provide adequate evidence supporting the other hypotheses, I will let go. If we do not let go of falsified hypotheses, we risk our personal reputation and that of archaeology as a scientific field.

Similarly, we archaeologists understand that our science demands systematic recovery of spatial data from sites to retain information about context. As many of us may remember from early in our training, professors told us that the ideal would be to retain such tight control of information that we could reconstruct a site, down to the minutest detail, back in our laboratories. Then they told us it really wasn't possible, and you learned why the first day in the field. There wasn't enough time and money, you usually had to use ancient military or other surplus surveying equipment, and excavators didn't even know how to use line levels. Even these days with total stations and global navigation satellite system/global positioning system (GNSS/GPS), errors can be common if people are careless. Every archaeologist understands that no matter how hard we try to recover materials and contexts from sites and no matter the sophistication of our technology, archaeology is ultimately a destructive process. All these factors allow the ideal to slip away, and archaeologists live with letting go of potential data and precision all the time. Our research designs actually are as much built around what we are willing to let go as they are about data we hope to retrieve. In spite of a stewardship ethic, we actually let go of significantly greater amounts of information as part of cultural heritage management practice. We willingly let go of whole sites.

The genesis of a stewardship ethic was associated in the United States with societal notions about conservation of natural resources near the start of the twentieth century. For archaeological sites in particular, stewardship accompanied the assumed forthcoming demise of Native American cultures. The American Antiquities Act of 1906 (16 USC §§ 431–433) charged a nascent discipline of archaeology with investigation and collection of

information from sites: 'the examinations, excavations, and gatherings are undertaken for the benefit of reputable museums, universities, colleges, or other recognized scientific or educational institutions, with a view to increasing the knowledge of such objects, and that the gatherings shall be made for permanent preservation in public museums'. Over the years following, additional laws protecting archaeological sites promoted stewardship, and it grew to become the dominant ethic at the core of cultural resources management (CRM) by the 1970s, and indeed, at the core of American archaeological practice generally.

Educated as CRM was undergoing explosive growth, I started a contract archaeology laboratory at my first job and began a career that resulted in nearly three hundred contracts totalling nearly US $4 million by 2004. Most were related to actions done to locate sites, to evaluate their significance for eligibility to the National Register of Historic Places, and to mitigate their loss if they proved eligible. Many areas of the US Great Plains and Midwest where I worked had (and still have) vast areas that are poorly explored archaeologically. I don't think that it would be unreasonable to suggest that many CRM archaeologists working in those regions assumed that every site could be important and should be investigated, even small lithic scatters whose origins and functions we barely understood. Yet we all realised the impossibility of even locating all the sites. We wrote (and still write) research designs that survey small percentages of total areas of potential effect for construction projects. Even with excellent sampling strategies, we acknowledged that important sites probably would be missed and that projects could destroy them. We often made determination of site significance on the basis of minimal site testing, and even with sites we determined to be significant, we sometimes agreed to less-than-satisfactory (or at least less than complete) mitigation plans. We willingly let go of sites, and few archaeologists would then or now think of the practice as unethical. Letting go recognised the reality that we couldn't (and can't) save all sites and that the interests of developers are more powerful than our own.

Outsiders may have a different view. For them, our behaviours and what they imply betray our professed ethical intentions regarding stewardship. We willingly participate in the bidding process to win contracts, and we take money for the work we do. According to some of the Native Americans with whom I've worked, we are essentially selling out, not really trying to protect their heritage as we say we are. In their view we actually exploit it for our personal gain or out of our scientific curiosity and provide information they don't want or need. No small number of Indigenous people has asked how

our work is different from grave robbing (Zimmerman 1989). Indigenous queries and complaints sometimes seem to fall on archaeologists' deaf ears or appear to be tactics meant to control Indigenous heritage, especially when human remains are involved (Zimmerman 1992).

REPATRIATION AND ARCHAEOLOGY'S MALADAPTIVE ETHICS

[W]e are all the losers if for reasons of political expediency, Native Americans rebury their pasts. – Geoffrey Clark (1996)

Western cultures are preoccupied with the past. Yet, to Indians, the past is part of the present and does not need scientific study or verification. – John Wabaunsee (quoted in Anderson et al. 1980)

The epigraph from archaeologist Geoffrey Clark succinctly expresses archaeology's idea of the past as shared heritage, as well as the discipline's fixation on objects as the primary locus of information about the past and its desire to keep them. Potawatomi lawyer John Wabaunsee contrasts Indian views, rejecting the need to study the past because they already know it from their oral traditions. Perhaps because of archaeology's fixation with objects as key to the past, repatriation of human remains became a place where some archaeologists drew lines in the sand in relation to their ethics of past as public heritage, especially preservation of collections.[11] Here too, however, implications of behaviour belie good intentions.

Letting go of collections is a common-enough occurrence in archaeology; in one sense it is an extension of the inability, indeed, impossibility, of archaeologists ever to recover all data from sites. New technologies and new research questions frequently emerge that produce new insights. Before the 1960s, for example, many archaeologists didn't bother to collect faunal remains from excavations because they were thought not to provide much useful information. Bones were buried in the backfill without analysis. Today's archaeologists wouldn't think of such a thing and collect all faunal remains including those of microfauna, not to mention all sorts of other environmentally linked materials. Similarly, the paucity of time and money of 'salvage' archaeology in the years before CRM left numerous

[11] For example, the SAA's (1996) Principles of Archaeological Ethics 7, Records and Preservation, states "Archaeologists should work actively for the preservation of, and long term access to, archaeological collections, records, and reports. To this end, they should encourage colleagues, students, and others to make responsible use of collections, records, and reports in their research as one means of preserving the in situ archaeological record, and of increasing the care and attention given to that portion of the archaeological record which has been removed and incorporated into archaeological collections, records, and reports".

collections uncatalogued and unanalysed for decades, and the majority of excavated sites didn't get reported outside of site forms and field notes. Even the rapid expansion of CRM and contract archaeology resulted in poorly documented and analysed collections stored in garages, basements, and backyard storage sheds. In recent years, even catalogued and analysed collections have been treated poorly, creating a curation crisis in America (Childs 1995, 2004). Even good curation facilities sometimes consider letting go of collections because they can quickly become filled with materials from surveys and excavations. For example, after measuring weight, size, and type, some have made decisions to remove heavy, large, and often numerous pieces of fire-cracked rock left from stone boiling or hearths. The same has applied to pieces of glass, brick, and metal from historic sites. Disposal makes any restudy impossible. In essence, many archaeologists haven't seemed too concerned about letting go of collections,[12] so why should letting go of human skeletal materials be any different?

Archaeologists' extreme attachment to human remains in collections has been especially problematic and, frankly, puzzling. During the early years of controversy about repatriation, Native Americans complained bitterly that skeletal collections containing supposedly valuable scientific data sat unanalysed in museums and laboratories. For archaeologists explanations of time and money seemed perfectly reasonable; study would eventually happen. Native Americans, however, pointed out that some collections were excavated decades earlier and wondered how long it would take to get to them. If they contained such important information, why had they not been studied? Failure to study collections the first time severely undercut commonly raised arguments that remains were needed for restudy using new technologies.

The passage of NAGPRA in 1990 forced at least superficial analysis of many collections for the purposes of creating required inventories prior to possible repatriation. Interestingly, some archaeologists who fought against NAGPRA now remythologise (Zimmerman 1997b) the forced analysis as positive, using it in recent SAA (2008: 9) testimony against new regulations concerning culturally unidentifiable human remains under NAGPRA: 'Human remains and cultural items that had not been studied but simply sat on curatorial shelves were an important part of why NAGPRA came about – to trigger actual efforts to learn what we can and

[12] In fairness, many have recognised curation as ethically problematic and made efforts to draw the attention of colleagues to it. The SAA does have an ethical principle linked to proper care for, and access to, collections and records. As well, some have argued against disposing of extremely abundant and hard-to-care-for objects.

then to handle disposition respectfully thereafter'. There is no small irony, when many American archaeologists fought so hard to hold onto human remains, that letting go of collections provided the opportunity for analysis!

The war for repatriation is twenty years over but with rearguard actions of varying sizes popping up here and there since passage of NAGPRA. Certainly, Kennewick Man was a heavily publicised skirmish (Burke et al. 2008), the courts eventually deciding in favour of the right of scientists to study the remains, and current efforts on the part of some archaeologists to fight implementation of NAGPRA regulations is another. The former is already well reported, but the latter bears some scrutiny.

Without getting into too many complexities, on 14 May 2010, the US Department of the Interior, which oversees NAGPRA through the National Park Service (NPS), implemented a final rule, 43 CFR § 10.11 – Disposition of Culturally Unidentifiable Native American Human Remains (CUI). The rule clarifies how museums and other agencies subject to NAGPRA are to handle Native American human remains under their control for which no culturally affiliated Indian tribe has been identified. Under NAGPRA, institutions were required to inventory human remains, funerary objects, objects of cultural patrimony, and sacred objects, and they were to offer for repatriation those remains that could be genetically or culturally linked to contemporary tribes. Proving these linkages has been difficult at best, especially for remains older than about eight hundred years. The reasons are many but include difficulties in proving the ethnogenesis of any group, particularly when many tribal identities and even the notion of tribe came from the colonisers who didn't understand the very fluid nature of tribal identity before contact. Anthropologists realised this early on, and archaeologists in particular relied on their taxonomic labels for identification of groups that a direct historical approach couldn't document. Taxonomies created what was in essence a taxonomic landscape of clearance that had groups vanish to be supplanted by another group, even though there might have been genetic and cultural continuity in place (Zimmerman and Makes Strong Move 2008). Demonstrating cultural affiliation of remains from even deeper time has proven more difficult, which was a key element in the Kennewick Man case.

The NPS published the first NAGPRA regulations in 1995 but reserved some sections, including those for how to handle CUI for later development, so as not to delay implementation of basic regulations. Developing the CUI regulations has taken many years. The government opened the proposed rules to public comment, and controversy immediately erupted. By the time the comment period ended in early 2010, the Department

of Interior '[had] received 138 written comments from 51 Indian tribes, 19 Indian organizations, 30 museums, 12 museum or scientific organizations, 3 Federal entities, 15 members of the public, and the [NAGPRA] Review Committee' (Department of Interior 2010: 12379).

The controversy resulted from the fact that even though the skeletal remains of about 40,000 individuals have been repatriated,[13] about 124,000 remain in institutions as culturally unidentifiable along with almost a million associated funerary objects (National NAGPRA 2010). Suspicions have run high among Native Americans that the 'culturally unidentifiable' (CUI) designation was used to keep the majority of remains from being repatriated. Legal struggle over Kennewick deepened that suspicion.

Many of the CUI comments were logistical and complained about potential problems with offering return of remains to tribes that do not have government recognition; prohibitive costs of funding the research necessary to link remains to appropriate tribes; and legal actions if groups believe remains were returned to inappropriate entities. Tribes complained that even though it is important that skeletons be returned, there is as of yet no rule relating to return of associated remains. Most comments from archaeologists and related scientific organizations pointed out the difficulty of associating ancient remains with known tribes and the importance of the unidentified remains to science. They raised arguments about benefitting from new technologies, all the arguments sounding very much like the arguments against NAGPRA in the first place.[14] Many point out that NAGPRA was a compromise between Native Americans and the scientific and museum communities in the first place, allowing only those culturally identifiable remains to be returned; they assumed the CUI would not be.

Most recently, the Government Accountability Office (GAO), the investigative arm of the US Congress, conducted an audit of NAGPRA and its

[13] Also repatriated have been about 1.5 million associated and unassociated funerary objects, which includes many small items, such as beads, and about 6,000 sacred and patrimonial items. Numbers change, so see National NAGPRA 2010.

[14] Several commentaries against the new regulations have been posted on the Friends of America's Past website (http://www.friendsofpast.org/nagpra/news.html). One specific letter from forty-one members of the National Academy of Sciences (http://www.friendsofpast.org/nagpra/2010NAGPRA/Smith517.pdf) contains the use of the past as public ('shared') heritage, the need to preserve collections, the application of new technologies, and other elements that hearken back to documents written by some of these same individuals in opposition to NAGPRA twenty years ago. In relation to this letter, one younger Native American archaeologist pointed out that there is a real generational divide here, and it is his perception that Native and non-Native archaeologists of his generation 'get it'. Playing off that, another noted that because of this, most opposition to NAGPRA will be gone because people of my (Zimmerman's) generation will be dead or retired!

implementation by the NPS. Published a week ahead of the GAO's report, *Nature* (Dalton 2010: 422) reported on the supposed shortcomings of the NAGPRA national office, based on a draft of the report leaked to the journal. The overseer of NAGPRA is a seven-member national review committee comprising an equal number of members nominated from Indigenous groups, two appointees to be traditional religious leaders, and from museums and scientific organizations, with a seventh member appointed from a list developed and consented to by other members. According to *Nature*, the audit 'suggests that the NAGPRA office has manipulated the makeup of the seven-person committee, weakening scientists' voices in its decisions' and 'that the NAGPRA office inadequately screened these nominees, and passed over nominations for scientific representatives in favour of its own candidates'. It also says that the office used 'questionable efforts to recruit members of its own liking'. As the story continues, 'the [GAO] report notes that NAGPRA officials defended such practices, saying that one official "believed that the Review Committee had become too weighted toward the interests of the museum and scientific communities." The NAGPRA office did not respond to questions from *Nature* on the matter'. On 28 July 2010, the GAO released its audit report.

What is interesting is that the quotations noted in the previous paragraph do not directly appear in the final report and are the subject of only one indirect reference. There is indeed a section on the problems of the review committee selection process and a statement about how the scientific and museum communities perceive the committee as biased in favour of the tribes, but nothing about national NAGPRA loading the committee and the like. Either the final draft eliminated such statements or the author had an agenda that sought to see science and museums as victims to emphasise controversy. Doing the latter is no recent phenomenon in journalism, and as I've noted before, portraying repatriation as bipolar – us-them, archaeologists-Indians, science-religion – rather than the continuum of opinion it is has served the media and repatriation opponents well (Zimmerman 2005: 266). The bulk of the GAO report is about the lack of compliance to NAGPRA by all but three of eight federal agencies that must deal with it, yet the *Nature* report devotes a scant paragraph to it, which one National Review Committee member appointed from the science and museum side told me is by far the most serious problem in the GAO audit. My reading of the GAO report cannot see that it 'portrays a troubled organization that has failed to serve tribes well, and does not always give a fair hearing to scientists' claims' (Dalton 2010: 422). Rather, it points out both problems and successes and portrays an organization assigned a very

difficult mission, an office that seeks to address the problems and improve its performance, making recommendations to help it do so. The *Nature* article, in contrast, would appear to have a definite agenda that seeks to weaken repatriation and NAGPRA in favour of science. This did not go unnoticed by Native Americans with whom I work, and it has raised suspicions that may sour Native American and archaeologist relations as much as Kennewick has!

Some archaeologists probably would assert that they are 'standing up for science', as one of the Kennewick case plaintiffs was described (Center for the Study of the First Americans 2009), but holding onto one set of values entails rebuffing others, which usually is alienating if you hold the rejected values. Many attitudes expressed in the Kennewick case and in the opposition to the CUI regulations have been or will be damaging to archaeology. The staunch refusal of many archaeologists to let go of collections and the ethic that they should be stewards of a shared heritage have been, and will continue to be, maladaptive for archaeologists. In contrast, letting go of collections, whether forced by NAGPRA or resulting from purposeful decisions based on what archaeologists felt was ethical, provided opportunities to expand the vision of archaeology by creating opportunities for collaboration.

LETTING GO IS NECESSARY FOR COLLABORATION

And though they are with you, yet they belong not to you.
You may give them your love but not your thoughts.
For they have their own thoughts.
 – Khalil Gibran, *The Prophet* (1923)

Collaboration between Native Americans and archaeologists began well before repatriation became an issue (Colwell-Chanthaphonh 2009). The pressures for repatriation and NAGPRA, however, provided a catalyst for a more widespread discussion of how to work together. The American Indian Religious Freedom Act of 1978 required consultation with tribes in CRM projects in which access to sacred sites might be compromised by federal projects, but NAGPRA's consultation requirements were broader, relating to all archaeology done on federal or tribal lands. Consultation for some archaeologists tended to be equated with notification, but Native Americans frequently demanded a greater say in how archaeology was to be done and the role they were to play in deciding research questions, interpreting materials, releasing information, treating remains, and many additional actions.

They wanted true collaboration in which they would be treated at least as equal partners. I've written about this transition elsewhere (Zimmerman 2008), but Indigenous archaeology clearly developed out of the process. Although difficult to define precisely, Nicholas (2008: 1660) has described it as an 'expression of archaeological theory and practice in which the discipline intersects with Indigenous values, knowledge, practices, ethics, and sensibilities'. What has been encouraging is the number of Indigenous archaeologists who emerged during the process. In the United States, the fewer than five Native American archaeologists with PhDs in the early 1990s has grown nearly to twenty in 2010, with numerous MA-trained archaeologists working in CRM, and many of them doing archaeology for their own tribes. There has been a similar growth in other world regions, the process documented in the recent volume *Being and Becoming Indigenous Archaeologists* (Nicholas 2010). Indigenous archaeology goes well beyond the practice of archaeology by people who happen to be Indigenous to include many archaeologists who are not Indigenous. The development of Indigenous archaeology has seen primary intellectual and financial support from the WAC, an outgrowth of its Vermillion Accord, First Code of Ethics, and the Tamaki Makau-rau Accord, all of them dealing with concerns about treatment of Indigenous cultural heritage. A new, more inclusive draft code of ethics is in process by its ethics committee (WAC 2007), much of it driven by earlier WAC codes but including important principles from other organizations.

Developing a list of best practices for collaboration and Indigenous archaeology may be an elusive target for some time to come, but case studies are being published more frequently with a WAC-supported Indigenous archaeology series as well as monographs and journal articles from other organizations and publishers. Few archaeologists have been willing to criticize collaboration very harshly, but there have been recent challenges to Indigenous archaeology. These did not so much challenge the validity of doing Indigenous archaeology but claimed that it essentialises the concept of Indigenous and questions whether it is different from archaeology as a whole (McGhee 2008: 581). Several Native and non-Native archaeologists who support or do Indigenous archaeology have attempted to answer McGhee's criticisms (see, e.g., Colwell-Chanthaphonh et al. 2010).

Making collaboration – and by extension Indigenous archaeology – work requires letting go in some very significant ways for many archaeologists who have long found themselves in positions of colonially granted power over those they study. Some derive from academic values scholars cherish, whereas others require a deeper, epistemological letting go. The list could

be longer, and all of them do not apply in every case,[15] but here are a few important elements archaeologists need to let go of to be successful collaborators:

1. *Past as public heritage*. Collaboration, but especially Indigenous archaeology, requires admitting that a particular group has intellectual property rights to its heritage. Their past is their own and should be under their control. They may or may not choose to share it with others. This may preclude publication or limit release of findings of work done with them.

2. *Independent agency*. Collaborative relationships require working with others as at least equal partners; Indigenous people can speak and decide for themselves. Sometimes, especially doing Indigenous archaeology, archaeologists will need to see themselves as assistants or in a service capacity, and in this situation, archaeologists may have to relinquish their own agency.

3. *Academic freedom*. Closely related to independent agency, the ability of archaeologists to study what they want, when they want to, may be severely limited.

4. *An idea that there is a single past*. As noted earlier, the past is multivocal and multithreaded; positivist views about a single, knowable past may not work for Indigenous archaeology. Claiming that archaeology provides the truth may be alienating.

5. *Western views of science*. Recognition that other forms of knowledge or data may provide useful information will be important. Being able to work ethnocritically (Zimmerman 1996) at the boundaries between Western science and Indigenous ways of knowing will be imperative.

6. *Traditional field and laboratory methods*. Certain strictures may be placed on how and where to excavate, kinds of artefacts or data to retrieve, and ways of handling, analyzing or interpreting objects and information in the laboratory.

Letting go of these elements makes for a very different approach to archaeology, and some have described it as selling out science. The experience of many archaeologists who collaborate is that the methods and interpretations are not always different, varying perhaps more in style than substance.

[15] As I noted earlier, for archaeology as a discipline, letting go is not always a rapid, wholesale abandonment of ethical systems but often a series of minor shifts that eventually looks like a dramatic paradigm shift. The elements of letting go leading up to Indigenous archaeology have been going on for slightly more than four decades, by some calculations nearly a quarter of the time archaeology has been recognized as a systematic discipline. Forty years, however, is about the length of a scholar's career, so for those only now coming to terms with Indigenous archaeology, the change may appear to be dramatic and challenging.

Sometimes conclusions reached by the Indigenous people and the archaeologist can be very different, however, and may be presented as such so long as both agree to disagree or negotiate the level of confidence in particular interpretations, as happened in my first Indigenous archaeology experience as I worked with the Northern Cheyenne tribe (McDonald et al. 1990). Cheyenne oral tradition about the route used in 1879 by their culture hero Dull Knife to escape detention at Fort Robinson conflicted with military history. We archaeologists felt that evidence we found only showed the feasibility that Dull Knife used the route, but our Cheyenne colleagues felt that we had proved it, so we mutually agreed that the report would show both conclusions. The work didn't have to sell out scientific validity, and I learned a great deal about what the past meant to the Cheyenne. As from that experience, what collaboration allows is the possibility for archaeology to open itself to dramatically different understandings of how people create, view, and use their pasts and what they might want to learn from archaeological study of material culture and its contexts.

CONCLUSIONS

I throw my hands up in the air sometimes
Saying AYO!
Gotta let go!
 – Taio Cruz, "Dynamite" (2010)

Some archaeologists may not feel that doing things so differently is worth it, with too much to give up. But being unwilling to let go has a very real danger of alienating those we wish to study, and in a postcolonial world, we must seriously ask ourselves just how much power archaeology really has in relation to Indigenous or other descendant communities. Can we continue to hope that if we can just do a better job of educating them about what we do that they will rush to our support? A more realistic result of failing to let go is alienation and an unintended consequence of cutting ourselves off from people who might be natural allies for preservation of archaeological sites and collections. The difference really is that we need to redefine the 'public' in public heritage. In our current archaeological view, the public is everyone, including archaeologists, which implies that archaeologists have as much right as anyone else to study or do as they wish with the past. The definition is clearly self-serving, which is easily detected by others and undercuts good intentions.

Consider for a moment that most Westerners cherish and indeed demand a right to privacy as individuals. We denounce unwarranted

intrusions and leaks of private information, and we espouse notions that only we can truly know ourselves. When a writer releases an unauthorized, tell-all biography of a famous person, we might be fascinated, but we quickly recognize its limitations as being based on secondhand information and limited access to documents, and sometimes we even suspect an agenda. We also tend to have a degree of sympathy for the target. Really, the idea goes back to the old inside (emic)–outside (etic), intentional-implicational, and ideal-real divides discussed earlier. Can someone who is not you really know you, and can he or she do a good job telling your story? We should understand that the same values of privacy and right to self apply to groups and that they might loathe unauthorized biographies instead of telling their own stories. The key is that the project is theirs and under their control. They may ask for help from someone who provides useful skills for research, interpretation, and presentation, but the product is theirs.

A common definition of steward is 'one who administers anything as the agent of another or others'. Stewards are not the ones to declare themselves as stewards; someone else asks them or declares them to be the agents. In truth, archaeology really doesn't need to let go of the notion of stewardship. Archaeologists just need to realize who the real boss is, and archaeology will be better served when we figure out it isn't us!

CHAPTER 7

Hintang and the Dilemma of Benevolence
Archaeology and Ecotourism in Laos

Anna Källén

Archaeology and ecotourism have emerged as a rewarding global-scale relationship over the past couple of decades. To archaeologists longing for a globalizing emancipation from problematic nation-state projects and to tourism operators in need of scientific depth to satisfy an affluent academic clientele, it has appeared as a win-win relationship for all parties involved. Harmonious choirs have spoken of positive opportunities for corporate benefits and effective poverty alleviation for marginalised local communities. Few critical voices have been raised. My experiences of working with two archaeological sites in Laos that have also been target sites for ecotourism (Källén 2004a; Källén 2004b; Keosopha & Källén 2008) suggest, however, that the relationship is far from an unproblematic one. In this chapter I take you to one of these places, Hintang, for a critical inquiry into the relationship between archaeology and ecotourism in Laos. My objective is to show how, notwithstanding its positive potential, the archaeology-ecotourism match defines and establishes a structure for unequal human relations that are inconsistent with its own positive rhetoric and quite problematic from an ethical point of view.

ARRIVAL

At first you see only the stones. They are called *hin tang*, in Lao, meaning 'standing stones'. Bunches of stone planks line ancient pathways deep in the forest, like beads on a string along a twelve-kilometre mountain ridge. Among the standing stones you see large stone discs on the ground, amazingly thin and skilfully crafted from micaceous schist. Beside some of the discs are deep holes in the ground, a few with steps hollowed out or inserted into the walls. These are entrances to underground chambers, once covered by the large discs. Since long forgotten times they have been there, stones, discs, and chambers. We find them in Hua Phan Province in the northeastern corner of Laos, near the border with Vietnam. Hua Phan

is characterised by its breathtaking mountainous landscape and is famous
for its production of high-quality textiles. It is also known as the birthplace
of the Lao communist movement *Pathet Lao*, and as a consequence of that
the province was subject to heavy bombardment during the Vietnam War.
Hua Phan is today one of the poorest of Laos's fifteen provinces, and Laos
is one of the poorest countries in Asia.

Such is the setting of the Hintang stones. Silent they stand in thin cool
air among the mountaintops, as curious vestiges of bygone times against a
background of brutal wars and scarce resources. Growing trees and bushes,
grazing cattle, bombs and bullets, new road constructions, villagers, and
visitors have touched, moved, and recontexualised them into the frozen
moment where we now meet them. If you take the time to ask around,
they are surrounded by intriguing stories and are embedded in complex
and often contradictory matrices of meaning.

But arriving at Hintang as a tourist you will be given another impression.
Already at the main road, where you can stop for a Pepsi and a snack in
Ms Kiang's house, you are caught in a web of distinctive red signage leading
straight to the Hintang Archaeological Park, six kilometres from the main
road. This 'archaeological park' is the large and handsome site San Khong
Phan, which has been cleared and slightly adapted to accommodate the
visitors. Up until quite recently there was a schoolhouse adjacent to the
site, which had to close down and move when regional authorities decided
that it disturbed the tourists' experiences of the archaeological park. Since
the school moved, there are no people in the park. Only stones, standing,
lying, silently. A large Vietnamese-style hardwood picnic shelter with a
ticket booth occupies a small hill overlooking the cleared stone site. It is
empty and partly broken, and the floor is full of goat droppings. Beside
the shelter is a large sun-bleached red sign, nicely produced in distinctive
European style and protected by a little roof hat. It shows some colonial-
style photographs and drawings, a sketched map, and a text in both Lao
and English: 'At least 1500 years ago, people of whose origin and fate we
know almost nothing, erected hundreds of menhirs along ten kilometres
of summit trails atop forested mountains. . . . Until the present time these
menhirs and round-lidded tombs have held onto their secrets'.

ECOTOURISM IN LAOS

Tourism is seen as one of the major future opportunities for archaeology
and archaeologists, in times when the importance of nation-states appears
to diminish and global movement seems ever expanding. Among varying

forms of tourism, *ecotourism* is an increasingly popular branch, particularly in poor postcolonial nations like Laos. First mentioned in 1965 in an appeal by Nicolas Hetzer for a more sensitive alternative to mass tourism, it was conceived as an *alternative tourism* based on 'natural and archaeological resources such as caves, fossil sites [and] archaeological sites' (Hetzer 1965, quoted in Higham 2007: 2). In the 1980s, this alternative tourism became a veritable buzzword along with the related concepts of *heritage* and *sustainable development*. It was presented as 'alternative to large numbers, tasteless and ubiquitous development, environmental and social alienation and homogenization' (Butler 1990: 40). Ecotourism businesses continued to grow over the last decades of the twentieth century and boomed when the United Nations designated the year 2002 as the International Year of Ecotourism.

Commonly defined as 'responsible travel to areas that conserves the environment and improves the well-being of local people' (as seen, for instance, on the International Ecotourism Society website), ecotourism has been widely promoted and embraced as a particularly benign form of tourism (Higham 2007: 2). The stereotypical ecotourist is a middle-aged, well-educated, affluent, Western person who travels in a small group and is particularly interested in the nature, culture, customs, and history of the places and regions visited. Tours are often marketed as uniquely tailored experiences incorporating equal shares of adventure, education, and simple life, yet with no compromises in comfort. Famous archaeological sites and World Heritage Sites are frequently included in ecotourists' travel routes, as well as protected natural reserves and places known to be habitats of endangered floral and faunal species. The ecotourists' adventurous yet *responsible* interactions with endangered species, ancient monuments, and marginalised people along their travel routes are, according to the common definition of ecotourism above, helping *conserve* environments and monuments while at the same time *improving the well-being of local people*. Where mass tourism always threatens its own promises of virginity and freshness (Löfgren 1999: 40), ecotourism claims to provide an unthreatening alternative. The business produces strong positive images of itself based on ideals of altruistic benevolence and knowledgeable responsibility. Academic research into ecotourism tends either to adopt the business's own overwhelmingly positive message and argue for its great overall benefits (the protection and conservation of valuable environments together with the effective empowerment and poverty alleviation of marginalised communities) (e.g., Higham 2007: 3) or to be critically sceptical and portray it as a rather cynical business with an appealing rhetoric yet one that in

reality gives most benefits to the already rich and works to empower the already powerful (e.g., Duffy 2002; McLaren 2003; Hall 2007).

Once they had decided to open their country for tourism in the late 1990s, the communist government of Laos found the concept of ecotourism to be an attractive alternative to the trashier mass tourism they had long since observed across the border in Thailand. A celebrated pilot project in the northern Luang Nam Tha province called *Nam Ha*, developed with support from UNESCO and New Zealand Aid, was in 2001 awarded the UN Development Award for Outstanding Contribution towards Poverty Alleviation (McLeod 2007a). Inspired by the Nam Ha success, the Lao National Tourism Administration (LNTA) launched the National Eco-tourism Strategy and Action Plan for 2005–2010 supported by the Asian Development Bank and foreign aid agencies such as the Dutch SNV.

The strategic vision in the strategy and action plan portrays ecotourism as an entirely positive enterprise, which will 'benefit natural and cultural heritage conservation, local socio-economic development and spread knowledge of Laos' unique cultural heritage around the world' (LNTA n.d.: 4). The LNTA is directly attached to the Prime Minister's Office, and thus located high up in the government hierarchy. Ideals and beliefs that are central to Laos's national self-image as a financially dependent and capacity-needing developing country are therefore also involved in the conceptualisation of ecotourism by the LNTA. The strategic documents are formulated mainly by Western experts on ecotourism and business management (e.g., Winter 2006: 39; McLeod 2007a: 2) and signed by Lao ministers posing as front figures. Ecotourism is conceived in these strategic documents as a vehicle leading to sustainable use of natural and cultural resources at the same time that it promises to deliver 'measurable socio-economic benefits to local communities' (LNTA n.d.: 1). Put simply, ecotourism promises to help Laos develop economically and culturally in a nondetrimental way. According to these documents there are only benefits and very few, if any, problems with ecotourism (other than a few potential obstacles to a sufficiently rapid growth of the industry).

For the international market, LNTA presents Laos as a destination for ecotourism through the strategy and action plan (LNTA n.d.) and via an attractive and informative website (http://www.ecotourismlaos.com). Imagery and text work together in the strategic document, as well as on the website, to imbue the reader with a certain feel for ecotourism in Laos. This feel is communicated through images and narratives within a discourse that is common to ecotourism all over the world. It unites the business around common values and offers ecotourists a familiar surrounding to their

personae as responsible travellers, giving them a sense of belonging, wherever they are. To make my argument more concrete, I present the images and narratives used by LNTA with the help of three analytical concepts that appear to be applicable to ecotourism promotion in general: *close-to-nature aesthetics*, *benevolence*, and *adventure*. These three are interrelated, and as we will see later they signify a discursive relationship with archaeology that goes beyond and validates the ecotourists' more practical visits to archaeological sites.

Close-to-Nature Aesthetics

Beautiful pictures of lush greenery, flowers, sunsets over rivers, quiet temple yards with reading monks, waterfalls, ruins and ancient monuments, a tourist watching children play serenely at a jungle pond, village houses made of natural materials – they all match wordings such as 'Laos, the Jewel of the Mekong' (LNTA n.d.: 1; also on the LNTA website) to convey an image of Laos that not only is highly aesthetic but also represents a certain kind of aesthetic: one that omits all modern and urban aspects of Laos's territory and culture. There are no pictures or descriptions of motorbikes, townscapes, computers, jeans, or mobile phones, which are all important parts of mundane life in Laos today. Instead, it intimates that Laos is an innocent pristine land close to nature; primitive, simple, and quiet, inhabited by equally simple, beautiful, and smiling people (cf. Duffy 2002: 72). Such close-to-nature aesthetics work to create a discursive distance between Laos and the ecotourists' everyday life. This distance works in space as well as in time, and it finds expression in such favourite slogans of the ecotourism industry as 'getting away from it all' (West & Carrier 2004) and 'a place where time has stood still'.

Benevolence

The close-to-nature aesthetic corresponds with the notion of benevolence. A major message communicated in the strategy plan and on the website is that the sheer presence of ecotourists in Laos is contributing to the protection and conservation of 'irreplaceable resources' such as World Heritage Sites and 'unspoilt diverse ethnic lifestyles and traditions' (LNTA n.d.: 1). If managed properly, ecotourism 'contributes to environmental protection, the sustainable use of the natural and cultural resources and, critically, the delivery of measurable socio-economic benefits to local communities' (LNTA n.d.: 1). In the few photographs in which tourists are interacting

with Lao people, they either bring something (a camera for children to watch), they buy something (locally produced textiles), or they learn or watch something in a staged small-scale activity (e.g., rice cleaning, playing and swimming). All interaction photographs are surrounded by an air of distanced respect. The message conveyed is that ecotourists engage in a variety of respectful interactions, which always benefit the local communities of Laos. Ecotourists help, just by being there. Recent research in ecotourism has pointed to the importance of the tourists' self-images and social personae for their choices to travel as ecotourists (e.g., Crouch & McCabe 2003: 78; Duffy 2002: chapter 2). Ecotourism is accordingly presented by LNTA as an opportunity for the affluent and responsible to contribute to poverty relief and empowerment of marginalised people in Laos, via their spending and their respectful civilized presence. This responds to the needs of the typical ecotourist persona, which wants to be regarded as responsibly affluent, which includes being benevolent toward the less privileged (Duffy 2002: chapter 2). To make this logic work, the people of Laos must come through in this presentation as less able and more needy, or in other words, as unspoilt and primitive, technologically undeveloped, and gratefully smiling.

Adventure

When modern and technologically advanced paraphernalia appear in photographs in LNTA's strategy and action plan, they always belong to the tourists. Where boats and other equipment for agriculture and transportation used by Lao people are shown, they are always made of natural materials, with the exception of one picture of five schoolgirls riding bicycles. For anyone who has visited Laos the past few years and seen motorbikes, satellite dishes, cameras, and mobile phones everywhere (even in the most remote corners of the country), this stands out quite clearly as a deliberately constructed image of contemporary Laos. To some degree we may understand the portrayal of a Laos entirely made of natural materials and natural people as an expression of the general longing to 'get away from it all' to places 'where time has stood still'. Photographs of technology threaten to spoil that vision by showing the intrusion of modernity in an unspoilt paradise. Only the tourists' own aspirations can justify this alien intrusion. On closer inspection we see that apart from one video camera (LNTA n.d.: 9), all modern pieces of equipment are found in pictures of tourists involved in some kind of extraordinary physical endeavour. Among the eighty-five photographs in total, there are three of inflatable

boats in whitewater rafting, two of harnesses with ropes and carabiners on bare-chested muscular rock climbers, and one of helmeted tourists in neon-coloured kayaks on small rivers surrounded by jungle. These pictures correspond with the notion of adventure. Typical to the ecotourist's persona is the willingness to penetrate and explore unknown territories (physical and mental). Indiana Jones has emerged as a perfect icon for such adventures that are 'fun, educational and safe', and is thus frequently used in promotions and descriptions of ecotourism (InfoHub n.d.; see also Duffy 2002: 82; Algie 2006). The up-to-date equipment in the photographs is there to signal that the ecotourists' adventures are embedded in state-of-the-art safety thinking. This canny use of pictures that signal modernity and civilisation on the one hand and primitiveness and proximity to nature on the other hand fits perfectly with the general discourse of ecotourism and works to further reinforce and naturalise the division of ecotourists and the people of Laos into two clear-cut and dichotomized categories. The ecotourists are active and modern, safely penetrating the natural worlds of natural people, who are paradisal, passive, and gratefully receiving.

A strategic division of people into essential categories defined by stratified levels of development on a scale from the most primitive to the utterly modern, such as we see in LNTA's marketing products, must be seen as an appeal to the desires of ecotourists. These desires are to some extent imagined and created in the narratives and imagery that fill the general discourse of ecotourism. But through that discourse, which plays with unfulfillable desires, the same narratives and imagery generate real expectations and needs in the ecotourists. It becomes part of the ecotourist's persona to be adventurous and benevolent, and she will expect to encounter natural lands and grateful people on her travels in Laos.

INDIANA JONES AND TIME TRAVEL: ARCHAEOLOGY AND ECOTOURISM

When presented and analysed in academic texts, the relationship between archaeology and ecotourism is usually considered in terms of actual tourist visits to important archaeological sites and possible impacts on material monuments and artefacts. Here I wish instead to focus on the discursive aspects of the relationship and to emphasise the possible impacts on the human parties involved. In the case of Hintang, it is important to consider that the average Western tourist now travelling to see the standing stones has already encountered and bought into the discourse of alternative travel with key concepts like close-to-nature aesthetics, adventure, and

benevolence. The LNTA's message is tuned to a globally accepted discourse for ecotourism and other forms of responsible alternative tourism that saturates travel websites and guide books. And the same discourse is represented in the advertising and tour descriptions of the largest tour operators in Laos (e.g., Exotissimo, Indochina travels, Green Discovery), which are unavoidable by any traveller passing through cities or visiting the country's major tourist attractions. To satisfy the travellers and avoid disappointment, the meeting with the standing stones and the stories presented on the signs in the archaeological park must therefore meet with the tourists' expectations and needs. Public authorities and businesses concerned with ecotourism in Laos are quite attentive to this, and a lot of space in the strategic documents (e.g., Provincial Tourism Office Houaphanh 2007) is devoted to strategies for improvement in meeting the tourists' expectations.

The vivid interest shown by ecotourists in archaeological sites like Hintang is no coincidence. Their high level of education and historical awareness offers only part of the explanation. Further clues as to why archaeological sites (as opposed to modern art museums or university campuses) fit this scheme so well that they are standard stops on ecotourists' itineraries might be found in the discursive connections between the two. There is a rapidly growing body of academic literature offering critical analyses of heritage tourism (e.g., Bender 1998; Rowan and Baram 2004; Winter 2007). Although mainly dealing with actual visits to archaeological sites, parts of this literature also discuss what Tim Winter (2007: 22) calls 'the politics of narration', focusing on the creation and maintenance of ideas around historical heritage and tourism. Much of this discussion is also relevant to a discussion of the discursive relation between ecotourism and archaeology.

Winter's (2007: xxvi) own study of Angkor as a long-term heritage icon for politics as well as tourism is introduced by excerpts from interview transcripts. Michael, a forty-year-old British man travelling six months in Asia, says, 'We saw a program on Angkor just before we went away and the image was predominantly of you as the explorer, the archaeologist going through these completely unexplored temples, these magical mystical temples. . . . You arrive at this temple, you're Indiana Jones exploring this place'. Tasos, twenty-eight, from Greece but living in Singapore and who is in Cambodia for a three-day visit, says, 'Angkor is a place that is a very, very vivid remnant of the past. It puts you in another place, another time'.

These accounts represent two recurring and resilient themes in the global discourse of ecotourism: Indiana Jones and time travel. They are entwined with our three concepts of close-to-nature aesthetics, adventure, and benevolence. They are further rooted in Western fiction, and respond to tourists'

dreams and desires to step out of their ordinary mundane reality on their holidays (e.g., Duffy 2002). As a famous adventurous explorer Indiana Jones has, as mentioned earlier, emerged as a global icon for alternative tourism (Duffy 2002: 82; Algie 2006; Winter 2007: 101, 117–18). The fictive character Indiana Jones is an American doctor of archaeology occasionally leaving his university teaching to travel across the world in khakis with a mission to explore mythical sites and rescue hidden treasures from the threats of nature, dangerous animals, greedy competitors, and ignorant savage natives. The films are action- and humour-filled adventure movies based on the struggles between good (Jones) and evil (the others). In this fictive model, Indiana Jones, the American professional academic, represents the adventurous contribution to the rescue and knowledgeable resurrection of cultural artefacts from foreign contexts with various Other actors representing threat, greed, and ignorance.

Time travel is another strong theme in the discourse of ecotourism (Duffy 2002: 83, West and Carrier 2004; cf. Clifford 1997b: 157). We see it echoed in a current wave of heritage management programmes in the Western world based on the visitors' playful experiences of the past, often through enactments and role-plays in 'authentic' clothing at 'authentic' heritage sites (e.g., Holtorf 2010b). Time travel is a central concept in the marketing of these lived experiences of the past, just as it is in the marketing of ecotourism. Both lean heavily on the modern Western idea that cultural difference is proportionate to distance in time or space (e.g., Foucault 1970). Johannes Fabian (1983) and David Lowenthal (1985), among others, have demonstrated how this idea of distance was crucial for the nineteenth-century conception of modern anthropology and archaeology. Distance in time is here equated to distance in space, where both correspond to differences in culture and lifestyle ranging between the extreme poles of those classic modern dichotomies simple-complex, primitive-modern, and nature-culture. It goes without saying that the home of the time traveller is always at the extreme pole of complex/modern/culture, whereas the most remote 'destination' represents the other end of the dichotomy, which is simple/primitive/nature. When evoked in ecotourism or heritage theme parks, time travel responds to the Western consumer's longing to escape her own temporal context, which often also means her modern identity and the sociocultural responsibilities and restrictions that come with it (Duffy 2002).

The ecotourism business's keen use of the Indiana Jones and time-travel metaphors indicates important discursive correspondences between archaeology and ecotourism. The actual visits to spectacular and preferably

jungle-hidden archaeological sites like Hintang work as a confirmation of tourists' Indiana Jones mission to explore and secure cultural treasures. This can in many ways be regarded as a staged performance involving appropriate clothing and scenography, a reason ecotourists are often seen posing for photographs in khakis by a prehistoric monument half eaten by vegetation. The narratives communicated on signs and through guided tours around the sites reconfirm that the past is a distant destination secured by archaeologists from the messy sociopolitical present: '*At least 1,500 years ago, people of whose origin and fate we know almost nothing* . . .' The natives, whose schoolhouse was recently relocated, are seen smiling and waving at a distance, working in this context as props to reconfirm their assumed ignorance about and detachment from the heritage sites they live near by.

Now, some would say that this play with metaphors has nothing to do with 'real' scholarly archaeology, that archaeologists' responsibilities are only with the past or material remains from the past, and that archaeologists deal with truth, not fictions, when they prepare signs and other materials for tourism purposes. But another view, to which I am more sympathetic, says that scholarly or scientific archaeology can never be practically separated from the discourse that it is part of and that the discourse in this case also involves fictions such as Indiana Jones and time travel. Cornelius Holtorf (2004) has argued strongly that archaeology *first and foremost* is popular culture, and Morley and Robins (1995) along similar lines have demonstrated how the 'memory banks' of the present Western world are constituted by facts and fictions supplied by film and media. I agree with this analysis, but I am reluctant to accept these fictions as merely beneficial and as something that should be gone along with to enhance the attractiveness of archaeology and heritage management (cf. Holtorf 2004).

In relation to the often-cited aim of ecotourism 'to improve the well-being of local people', it is quite important to note that these fictions are only relevant to the Western tourists and business operators. My interviews with persons living near Hintang today reveal that Indiana Jones for them is an unknown creature of fiction, and thus one without metaphorical significance in their own context. The same goes for time travel, which has no meaning in a Buddhist and animist context in which the conception of time is quite different from the Western one (Karlström 2005). This means that communication between the well-meaning tourists and the people living near the standing stones is made impossible by the intervention of these fictions. They work to separate and create a stable distance between the actors rather than to enable dialogue. In what ways, then, is the well-being of local people improved?

I will return to that crucial question soon. But first I shall argue that the use of the time-travel and Indiana Jones metaphors (which I have just suggested create an unfortunate buffer between tourists and local people) paradoxically enhances the tourists' feeling of being helpful and contributing to the local people whom they see smiling at a distance. To clarify my argument, I need to make a brief detour to the colonial discourse of French Indochina.

Between 1893 and 1954 Laos and Hintang were part of French Indochina. At the end of the nineteenth century, during the heyday of colonial expansionism, archaeology was born as an academic and scientific discipline in Europe. Late nineteenth-century and early twentieth-century European archaeology both nourished and was nourished by colonial ideology, and archaeology (as science *and* fiction) became an important part of the colonial discourse surrounding Indochina (e.g., Norindr 1996; Cooper 2001; Winter 2007: chapter 2). It was also through the French mission to register and protect every important vestige of Indochina's past that Hintang in 1933 became an archaeological site. It was known and embedded in different matrices of meaning prior to the arrival of archaeologists. But it was the French investigation that sorted its components into the linear, vertical, and essential order that is characteristic of an *archaeological* site. The archaeologist in charge was Madeleine Colani, who represented the colonial research institute École Française d'Extrême-Orient. She worked two months at Hintang, assisted by her sister Eléonore and local villagers. The results of their excavations and surveys were compiled in scientific drawings, maps, tables, and interpretations, and these were published in an extensive two-volume report alongside their investigations of the Plain of Jars (Colani 1935). The report describes the standing stones and chambers as burial sites, remnants from a past mysterious civilisation from around two thousand years ago, when extensive salt trading networks had made the region flourish. Although there are indications throughout the report that the sites had been used and possibly even created in much more recent times, the object for interpretation is only the 'pure' and 'authentic' original moment of their creation. Everything that fell outside Colani's imagined representation of that pureness and authenticity was dismissed as pollution or looting. Through Colani's transformation, the standing stones thus came to be 'cleaned', categorised, and valorised according to a specific system for understanding both past and present, which was established as a strong part

of Western culture and society during the nineteenth and early twentieth century. Based on the scientific principles of cultural essence and difference as proportionate to distance (Foucault 1970; Fabian 1983; Lowenthal 1985; Bennett 2004), this system has survived pretty much intact to our days via reformulations in new sociopolitical contexts such as ecotourism.

In the context of colonial Indochina we also find some explanation of the relations between archaeology and tourism that have much later allowed Indiana Jones and time travel to make sense as important themes for ecotourism. French colonial ambitions in Indochina can, somewhat simplified, be divided into two phases with their juncture at the turn of the twentieth century (Cooper 2001). The discourse of the first phase can be characterised by male adventurous exploration and conquering of a passive feminized continent. The discourse of the second phase emphasised instead altruistic benevolence and developmental contribution from a responsible France driven by the liberal humanist ideals of the Third Republic (Cooper 2001). These two discourses were created and maintained first and foremost in French metropolitan society, where the French public was to be convinced of the great benefits of the colonial project whose realities it never saw. New media for display and fiction such as film, museum exhibitions, and popular magazines more or less exploded during this time in Europe (McClintock 1995; Bennett 2004). These new media were crucial for the creation and maintenance of what Panivong Norindr (1996) has called the *phantasm* of Indochina, an image with a distinctive aesthetics based on metropolitan fantasies and desires rather than the real tangible situation in the colony, which was much more ambivalent and complex (Cooper 2001). Thus Virginia Thompson (1937: 380–1) could write:

The easy-going Laotian is infectiously gay. Suddenly it seems the simplest thing in the world to be happy. Laotian family life has an archaic simplicity. The country is an earthly paradise which offers a beauty and nourishment that demands no effort for its enjoyment. ... It is a museum-piece of earthly happiness, a reply to the West's gloomy disillusionment. Even the Civilizer, with all his utilitarian baggage, hesitates to trouble its idyllic charm.

The metropolitan public consumed such images of Indochina, the Pearl of the French Empire, through the new media and through various forms of public display. One of the most successful and influential was the 1931 *Exposition Coloniale* in Paris (Olivier 1932–4; Norindr 1996; Morton 2000). In the early 1930s the French colonial project was widely questioned and criticised, so the exposition emerged out of anxiety, as a spectacular attempt to save the dream of a grand French Empire. It was marketed with the

slogan '*un tour du monde en un jour*' and attracted hundreds of thousands of visitors. In 'authentic' houses from remote colonies, 'authentic' people taken to the metropolis from the colonies lived their everyday lives as staged activities for the visitors to watch. The centre-piece of the exposition was a full-scale reconstruction of a temple from Angkor Wat, the most iconic heritage object in Indochina. Inside the Angkor replica were a number of exhibitions that displayed the colonial contributions, from a display of archaeological research results, to the latest developments in agriculture and urban planning.

The discursive essence of the Exposition Coloniale, says Patricia Morton (2000: 5–6), was found in the tension between the binary opposition of savagery and civilisation. The physical structures, the staged happenings, and the visitors' memories of their one-day tour of the world, would all be characterised by this dichotomy. 'The vast abyss of evolutionary difference' that the exposition displayed between the civilised Europeans and the primitive colonial savages justified French colonisation in the name of progress (Morton 2000: 5–6).

Archaeology contributed in two fundamental ways to the establishment of this abyss of difference in the metropolitan mind-set. First, it provided a discursive framework to the adventurous explorations and 'rescues' of monuments and sites such as Angkor Wat (Norindr 1996; Winter 2007: chapter 2). Archaeology worked in this case as the instrument by which material remains from the past were righteously appropriated by the Western colonisers and were organised in narratives proving native ignorance and oblivion. Second, archaeology contributed with an evolutionary time for humans: a linear and teleological scientific structure for classification of humans through all times. The classification was based on essential units of race (cranial types) associated with culture (artefact types), formatted in terms of higher and lower in the manner that characterises modern science from the nineteenth century onward (Foucault 1970: 274).

The exposition's marketing slogan, '*un tour du monde en un jour*', shows that tourism existed as a key attraction already in late-colonial discourse. We find the adventurous explorer playing a leading role and see that the entire exposition is saturated with what Norindr (1996:44) has called the 'rhetoric of paternalistic benevolence', portraying French colonisation as a morally superior contribution to the development of the less able. With racial and cultural distance in time and geographical space represented in the visual and narrative illustrations of archaeology and ethnography, the concept of time travel also became a possibility. The Stone Age was conceived in this discourse as equally far away as the remotest parts of

Indochina, and thus the two were metaphorically merged as one and the same. Travelling to a place representing a lesser developmental stage could hereby be understood as veritable travel in time. Here at the Exposition Coloniale, as in the language of ecotourism, the time-travel metaphor supported dreams of adventure and ideals of benevolence while at the same time reproducing strong images of human primitivity and far-away proximity to nature.

Nostalgic references to Indochina, or more correctly to the colonial phantasm of Indochina (Norindr 1996), are commonly found in the marketing products for alternative tourism in Southeast Asia today (Winter 2007: 98–102, 144). Nostalgic longings are conveyed through images with direct colonial associations, in names such as Indochina Travels, or in colonial-style descriptions of sites or tourist activities. At Hintang, the texts and photos on the big red sign that greets the visitor in the archaeological park proudly abound with references to Colani's mission of the early 1930s. The visitor can there read about ancient burial sites belonging to a glorious civilisation long since forgotten, leaving behind a mystery to be solved.

HINTANG, ECOTOURISM, AND THE DILEMMA OF BENEVOLENCE

After the Colani sisters had left with the artefacts and documentations, Hintang and the rest of Laos entered decades of political turbulence and war, and it was only in the 1990s and the 2000s that Hintang has reemerged as a site of official interest. It is represented with a diorama reconstruction at the National Museum in Vientiane, and it has been subject to a couple of minor investigations (one resulting in the red signs and the picnic shelter) initiated by the Ministry of Information and Culture in collaboration with foreign donors. In 2005, Hintang was also launched as a target site for the promotion of ecotourism. So far it has not been particularly successful, if success is counted in numbers of visitors (currently no more than a couple of hundred a year), so in that respect it is unfruitful to compare Hintang with heritage sites like Angkor that are subject to veritable tourism pilgrimages (Winter 2007).

But on a different scale, Hintang is important as an example of the workings of ecotourism. The problems of attracting larger groups of tourists are shared with most parts of Houaphanh Province and centre on the lack of transport, restaurants, and comfortable accommodation for tourists. Therefore, the province has traditionally attracted few Western tourists, with most of them being young low-spending backpackers (Provincial

Tourism Office Houaphanh 2007: 17, 29, 32). Responding to the overall aim of the Lao People's Democratic Republic to use tourism as an instrument for poverty alleviation, the stated strategy for 2007–2020 is to improve the infrastructure and thereby attract more affluent groups of tourists, preferably groups of responsible ecotourists. Hintang is in this context listed as one of the main target sites, as we see in the positioning statement of Houaphanh as a tourist destination (Provincial Tourism Office 2007: 56, my emphasis):

Houaphanh Province is an *authentic* visitor destination offering history, culture and an *unspoilt* environment. The province's product strengths include the historic Caves at Viengxay, the *mysterious* Hintang Archaeological Park, ethnic minority cultures and traditions, *pristine* protected areas, and high quality handicrafts.

The immediate measures that need to be taken at Hintang to reach the goal are identified as follows:

Conservation zones around the sites should be designated. There is also a need to fence the main site, renovate the sala, install washrooms, install interpretation materials in the sala, and facilitate local communities to provide food and beverage and handicraft sales. . . . Community-based tourism activities should be developed in selected villages near the site. (Provincial Tourism Office Houaphanh 2007: 75)

The mountains and valleys around the stone sites are only sparsely populated. Four villages with no more than a thousand inhabitants in total are close enough to have Hintang stones in their mundane living space. In the discourse surrounding ecotourism these people stand out as key actors, as a major goal is to improve the well-being of local communities. We see, however, in the strategic documents exemplified here that their involvement is considered almost exclusively in the role of the small-scale merchant of food, beverages, and handicrafts, and that is also the role they see for themselves when I have asked them about their own benefits from future tourism. As in other communist nations, members of local communities have no autonomous voices here but are controlled by the party administration on a national, provincial, regional, and local level. The structures of tourism are thus decided elsewhere and imposed on the local communities around Hintang, which are left responding to the actual occasional visits by tourists. Therefore, it may be surprising that members of the local community in my interviews express a remarkable openness toward and interest in the growth of tourism. Their own desired benefits range from getting the opportunity to sell a few Pepsis to the prospect of having a spectacle from the outer world to watch. But is this really

enough to fulfil the objective of improving the well-being of local communities?

My suggestion is that the politics of narration is of major importance here, but it is an issue rarely addressed. My interviews show that members of the local community have no knowledge of or interest in the archaeological narratives that describe the stones and discs to the visiting tourists. The text on the large red sign in the archaeological park is presented in both English and Lao, and in the villages there are still people who remember the Colani sisters' colonial excavations. Accessibility is thus not the issue. It is an active choice because, I would argue, the archaeological narrative has no meaning for them and therefore becomes uninteresting. They do care about the stones, and they incorporate them in various practical and narrative ways in their living space. In these narratives the stones are remnants from a glorious and undated past when the legendary hero Hat Ang built a city there, before he was dramatically deceived by the king of Luang Prabang and the city was destroyed. The chambers are remains of underground houses where Hat Ang and his people took shelter from enemies and tigers. These stories are mirrored in vivid memories of living in underground shelters during five years of US bombing raids during the Vietnam War. And if you just take time to look, material remains from the war are entangled with the standing stones, just as the memorial traditions of them are inseparable. Every year offerings to the spirit of Hat Ang are made deep in the forest, near one of the deserted war camps.

The lack of real interaction and communication between ecotourists and members of the local community at Hintang is in a sense both instigated and reconfirmed by the archaeological narratives presented there. New washrooms, fences, and handicraft sales are not likely to make major changes to that situation. There are good reasons to focus more on these archaeological narratives and to understand them as having strong connections to nineteenth-century colonial worldviews, carrying politicized messages of human values and of cultural development, and naturalising historically constituted categories of inferiority and superiority. Together with the general discourse of ecotourism with icons like Indiana Jones and time travel, this maintains a vast abyss of difference, similar to that of the 1931 Exposition Coloniale, between the visiting tourists and the local community (Morton 2000).

As we have already seen, one of the key principles of ecotourism is benevolence, and to me the launching of Hintang for ecotourism is a lucid illustration of the dilemma of such benevolence in our contemporary world.

On an immediate practical level, the local communities around Hintang are no doubt in need of all possible income no matter how small, and most people I have talked to express an entirely positive attitude toward having more tourists visiting the area. The tourists for their part get a rewarding feeling of responsibility for the less able and of contributing to a good cause, whereas the tourism business thrives at the same time. So on that level, all are winners. But there are academic voices of warning against such simplified claims, demonstrating that the long-term consequences may not be a winning situation for all parties concerned, given the fundamentally unequal relation it implies (e.g., Duffy 2002; Chok et al. 2007: 51; Zhao and Ritchie 2007: 21).

Thomas Scanlon (1998: 5) pursues a contractualist view in moral theory, holding that thinking about right and wrong is (or should be) thinking about what could be justified to others on grounds that they could not reasonably reject. Right and wrong are thus to be determined by reference to an implicit agreement or contract. Scanlon argues from this standpoint against the common view of well-being as a master value and claims that the concept of well-being has little importance from a first-person point of view (in our case, the local community at Hintang); rather, it has its greatest significance from the third-person point of view, 'such as that of a parent or benefactor' (Scanlon 1998: 110). And importantly, the understanding of what constitutes well-being therefore depends on the perspectives and concerns of the benefactors and the moral issues they believe to be involved (Scanlon 1998: 142). In the case of Hintang where we have 'a vast abyss of difference' between tourists and the local community preventing communication between the two, such agreements or contracts can never be established, and the idea of local well-being can thus be significant only for the tourists and the tourism business.

Altruism and benevolence are crucial but tricky concepts in moral philosophy (Driver 2007; Scott and Seglow 2007). Altruism is the apparently simple principle of taking the interests of the other as one's own, but as Scott and Seglow (2007: 2) point out, 'its implications and its associations with morality, are far from simple'. Similar to the early twentieth-century colonial discourse of French Indochina, which was also built around the ideas and ideals of benevolent developmental contribution from the modern superior metropole to the less able, the benevolent discourse of ecotourism also legitimizes and reproduces the binary opposition of savagery and civilisation, with a vast abyss of evolutionary difference in between. The short-term profit from selling a Pepsi or a piece of handicraft must,

then, be regarded in relation to what comes with it in the long term. To me it stands out clearly that the winners are not the local community around Hintang.

ALTERNATIVE TOURISM – ALTERNATIVE NARRATIVES?

In this chapter I have discussed the effects of the relationship between archaeology and ecotourism at Hintang. A key argument has been that the notion of benevolence, which was a recognised driving force in French colonial discourse and is also found at the heart of ecotourism discourse, finds a strong supporter and naturaliser in archaeology. The aim has been to demonstrate how archaeology as common sense and scientific practice has been involved in the creation of complicated ideas of benevolent contribution, where the real consequences for the lives and social realities around Hintang are not easily evaluated as entirely good or entirely bad. One conclusion to be drawn is that travelling, however carefully undertaken, renders ethical problems when the 'elsewhere' is equated with the past and becomes a fixed fetish. Homi Bhabha expresses this beautifully (in Clifford 1997b: 43):

There is another problem of travel and fixity when they then, in something like Fanon's sense, hold on to certain symbols of the elsewhere, of travel, and elaborate around it a text which has to do not with movement and displacement but with a kind of fetishization of other cultures, of the elsewhere, or of the image and figure of travel.

I cannot see why archaeology necessarily needs to be the creator of such fixed fetishes. Our traditional 'text' with its narrative format emphasising essence, authentic originality, and teleological development toward Western modernity is amazingly resilient. And therefore archaeology stands out today as a secure production site for fixed fetishes of the elsewhere. But if we agree that such fetishes are undesirable, there is a potential for change in the honest cultural interest expressed by many ecotourists, and places like Hintang can open our eyes to the possibilities of alternative narratives that can make heritage sites into sites for important cultural communication and negotiation. *Surface Collection* – Denis Byrne's (2007) eye-opening set of essays for the study of heritage and heritage sites in Southeast Asia – may serve as an inspiring point of departure as we approach Hintang. Byrne here offers a shift of focus from the deep authentic originality that we are used to look for, to the surface collection of past intermingled with present

that is there, almost too apparent before our eyes in the materials and the narratives of any important heritage site.

If we, inspired by Byrne, choose to leave aside the fetishised image of Hintang as a mysterious archaeological site that holds on to authentic secrets buried deep down, and instead approach it as a place with an outstanding surface collection of heritage objects and material fragments offering important stories of past and present (Byrne 2007), we have come some way. The broad cultural interest and the genuine desire to contribute to a better world expressed by many ecotourists (contrary to some critics of ecotourism, such as Duffy [2002], I find that this desire is genuine and heartfelt in most alternative travellers I have met in Laos) should make the travellers themselves welcome such alternative perspectives to the old fetishised ones.

Liberated from its imprisoning restriction to authentic originality and development, archaeology's sharp eye for time and materiality allows us to see things that otherwise go by unnoticed at Hintang. We see holes perforating some of the standing stones – results of shooting games played by bored soldiers some fifty years ago, resting on the way back to the war camp carrying supplies brought by American planes to the local air strip. These modest holes are entry points to meandering stories of a war that affected an entire world but happened right here. On one of the standing stones at the main visitor's site of San Khong Phan is a recently carved message, '*Hmong we love you*', demonstrating how the ethnic conflict of that war still lives on today. At the same site we find a disc with '*D32*' painted in yellow. It was painted by the Colani sisters in the 1930s and testifies to the scientific format in which they created Hintang as an archaeological site. Countless stories can be told about this, how the fascinating Colani expedition sorted the standing stones into the square and neatly dated scientific order that was essential to the French imperial project, and how Hintang moulded in this format has become an important contributor to the images that exist today of the people and cultures of Laos. And then we have, of course, the numerous places where elusive spirits will make your nose bleed if you pass wearing red clothes or will show up and scare you as a reminder of war atrocities or other immoralities from the past. All these things and places are starting points of stories in which the Hintang stones stand tall and beautiful as remnants of an intriguing past, but in which they also exist in a world of colonial domination, local values, and memories of war. An archaeological site like Hintang could, from such a surface collection perspective, become a site at which the problems of

inequality and oppression in war, colonialism, and the stigmatising imagery of ecotourism can be brought to light and discussed.

Hintang abounds with such possibilities, but they remain invisible on the other side of that large abyss of difference so long as we fail to confront the power of archaeological narration as a serious challenge and remain conveniently amenable to the (for some) lucrative metaphors of Indiana Jones and time travel, celebrating ideals of distancing benevolence.

ACKNOWLEDGMENT

This chapter is based on material from two extensive research projects in Laos funded by Sida/SAREC. It was largely written during a research period at the Department of Anthropology, University College London generously funded by Birgit and Gad Rausing's Foundation for Humanistic Research.

Problems of Meaning and Method

CHAPTER 8

What Is a Crisis of Intelligibility?

Jonathan Lear

We are creatures who, at least up to a point, seek to understand ourselves and the world we inhabit. This is not just a deep psychological or social need; it is who we are. And, essentially and a priori, we make sense of who we are in part by making sense of who we were. Obviously, we are creatures who construct historical narratives, individual and social. But even when we are not explicitly thinking about our pasts, even when we are absorbed in the present or looking toward the future, a shadow of the past illuminates self-conscious life. Thinking is paradigmatically with concepts, and the capacity to acquire and deploy a concept is in part a capacity to acquire a sense of how the concept has been used. Even when the concept undergoes change, even when the past has been significantly misunderstood, our current use of concepts carries with it a sense of the past. So, for example, to understand myself as, say, currently reading a book is to understand myself as engaged with an artifact the likes of which others have engaged with before and, indeed, to be engaging with it in similar ways. To lose that sense of the past (however inchoate or implicit it might be) would be for self-consciousness to fall apart. This is not just an empirical, psychological point; it is a logical point about the structure of self-consciousness.

Ever since the work of Hegel, Wittgenstein, and Heidegger, we have become familiar with the thought that the meaningfulness of concepts depends on their being embedded in a living form of life. Even so, there is a tendency to overlook a peculiar loss that I call a loss of intelligibility. Basically, the concepts and categories by which the inhabitants of a form of life have understood themselves – their acts, projects, and ideals – cease to make sense as ways to live. This is not a psychological claim – that when people try to make sense of their lives they fail. The claim is rather that insofar as they fail to make sense of their lives (psychologically speaking), the reason is that their lives no longer make sense. Nor is this simply a social claim – that, as a matter of social fact, it is no longer possible to live

in these ways. No doubt, the fact that there has been a breakdown in a form of life plays a crucial role in explaining the loss of intelligibility. But the phenomena are not identical: a traditional life might become impossible yet its core concepts remain intelligible. And the causality does not run in only one direction: it is not only because a form of life becomes impossible that its core concepts become unintelligible; the breakdown in intelligibility can contribute to the impossibility of a way of life. Thus, we need to get a clear view of what this breakdown of intelligibility consists of. In this chapter, I give an account of this loss, and I also offer a diagnosis of why it is often misidentified. When we speak of "appropriating the past" it is easy to conflate the theoretical and the practical demands of this task. At first, this claim might look absurd: what could be more different than thinking about a catastrophe (from a theoretical point of view) and having to live through it? But those who live through a catastrophe have to think about what they are living through, and those who think about a catastrophe (from a theoretical distance) have to think about the thinking of those who live through it. But the thinking of those who live through it is quintessentially practical thinking. And as the philosopher Elizabeth Anscombe has warned us, there is an overwhelming tendency in the modern age to treat practical thinking as though it were simply a species of theoretical thinking about a special subject matter, the practical.[1] It is only when we recognize that practical thinking is a different form of thinking that we can grasp what a loss of intelligibility is.

My imagination was captured by a series of haunting claims made by leaders of the Crow Nation after they moved onto the reservation.[2] Plenty Coups, the last great chief of the Crow, refused to speak to his biographer about his life after this move. And when repeatedly pushed, he finally said, "When the buffalo went away the hearts of my people fell to the ground, and they could not lift them up again. After this nothing happened."[3] Two Leggings, a chief of one of the clans, told his biographer: "Nothing happened after that. We just lived. There were no more war parties, no capturing of horses from the Piegans and the Sioux, no buffalo to hunt.

[1] Elizabeth Anscombe, *Intention* (Cambridge, MA: Harvard University Press, 2000), 57–58.

[2] I have written at length about these statements in *Radical Hope: Ethics in the Face of Cultural Devastation* (Cambridge, MA: Harvard University Press, 2006). This chapter is a continuation of a meditation on those themes. For a fine history of this period, see Frederick Hoxie, *Parading through History: The Making of the Crow Nation in America, 1805–1935* (Cambridge: Cambridge University Press, 1997).

[3] Frank B. Linderman, *Plenty Coups, Chief of the Crows* (Lincoln: University of Nebraska Press, 1962), 311, my emphasis.

There is nothing more to tell."[4] And Pretty Shield, a respected medicine woman, would repeatedly tell her granddaughter, "I'm living a life I don't understand." "Why has this thing come upon us. . . . I feel like I am losing my children to this new world of life that I don't know."[5]

Of course, there are many ways one might interpret these statements. And I make no claim that the one I offer is the correct one, in terms of historical accuracy or psychological insight into these particular individuals. I approach this moment not as a historian, anthropologist, or psychologist but as a philosopher. Although I have respect for the historian's task of understanding what happened and think my work should be constrained by what we do know, my primary concern is with investigating a possibility. What might they have meant? So, the form of my argument is unusual. I am not trying to argue for the truth of a particular interpretation: I am not trying to provide an account of what people actually thought or what they actually meant by what they said. Rather, I am engaged in the much more modest task of trying to make a certain possibility imaginatively robust. I want to inquire, what would it look like if they were standing witness to a crisis of intelligibility? By making a possibility robust, I am, at most, arguing that this is a genuine possibility. This, I think, is a sufficiently remarkable conclusion. This possibility is an important one for human life – it discloses a vulnerability to which we are all subject – and learning to live with it well is an ethical task.

The possibility I want to explore is that Plenty Coups, Two Leggings, and Pretty Shield were each standing as witness – first-person witness – within a form of life to the breakdown of intelligibility within it. After this, nothing happened: in the sense that nothing that had hitherto been a happening any longer made sense as something that might happen or something that one might do. And Pretty Shield's claim is not just a subjective report of her psychological state: she is reporting that the concepts and categories with which she had hitherto understood her life are no longer viable.[6] That is, her core problem is not that, psychologically speaking, she lacks confidence in how to go on, nor that, again psychologically speaking, she has been traumatized by historical events. This is not an existential crisis in the ordinary sense – a psychological breakdown in a person's ability to

4 Peter Nabokov, *Two Leggings: The Making of a Crow Warrior* (Lincoln: University of Nebraska Press, 1967), 197.
5 Alma Hogan Snell, *Grandmother's Grandchild: My Crow Indian Life* (Lincoln: University of Nebraska Press, 2000), 42.
6 One last word of warning: although I use the indicative mood, I am not making a claim about how things actually were for Pretty Shield or anyone else. The indicative only indicates how things are for Pretty Shield *within this possibility* whose shape we are exploring.

get on with her life – it is an existential crisis in an extraordinary sense: the breakdown of a form of existence. On this interpretation, Pretty Shield is reporting that, because of a breakdown in the form of life, the concepts that had been embedded in that form of life – and which depended on the viability of the form of life for their own intelligibility – can no longer be used to make her own life intelligible. Pretty Shield is reporting that she is forced to live on deprived of the concepts with which she would have hitherto understood her life. How might we understand this as authentic witness to a collapse in intelligibility?

The Crow are a tribe on the northwest plains of (what is now) the United States that flourished as a nomadic tribe for about five hundred years. In the spring of 1884, they moved onto a reservation – and their traditional way of life came to an abrupt end. The Crow had a conception of the good life: unfettered hunting in a nomadic life on sacred land that God gave them as a chosen people; participating in sacred rituals of thanks, pleas, and preparation; opportunities for behaving bravely and supporting the tribe. Traditionally, war was not itself a good, but it was inevitable, and thus behaving bravely in that context was a culturally established way of flourishing. All this became impossible when they moved onto the reservation. Intertribal warfare was forbidden and, more important, was effectively shut down by the US government, as was the nomadic way of life. Obviously, an individual or a few individuals might stray off the reservation and hunt animals, but hunting as it had traditionally been understood became impossible. Indeed, as is well known, the traditional object of the hunt, the buffalo, had, through a combination of human greed and deliberate policy, been all but destroyed. Hunting off the reservation had become impossible. There was thus no longer a way to live according to the traditional understanding of the good life. Basically, there is a breakdown in the telos of a form of life, and as a result the concepts and categories that had been organized in relation to that telos cease to make sense as ways to live.

To take an example from *Radical Hope*, by 1885 nothing any longer made sense such as planting a coup stick. In traditional nomadic life, the coup stick was used in various ways to manifest a surplus of bravery. In one paradigm, a warrior would plant it in battle to signal that he would never willingly retreat from that spot. In another, a warrior would use it to strike an enemy in battle, thereby inflicting a blow that was more symbolic than physically devastating. It was an important step en route to becoming a chief. However, with the move onto the reservation and the suppression of intertribal warfare, the act of planting a coup stick ceased to make sense.

One might take the very physical object that used to be a coup stick and stick it in the ground – but neither that nor anything else could count as planting a coup stick. Similarly, one might use that stick to hit someone, but the surrounding context in which that would have been striking him with a coup stick has vanished. At most, it could serve as a dramatic mimesis: an enactment of what warriors used to do when there used to be warriors. As a matter of historical fact, the activity of planting coup sticks fell out of existence.[7]

Similarly with the Sun Dance, a traditional dance seeking spiritual inspiration and support before battle. The issue isn't just a matter of impossibility; it is also a matter of practical unintelligibility. Obviously, the members of the tribe can still dance, and in 1885, there were still people who remembered the steps of what used to be the Sun Dance. But if someone were to get up and start going through the relevant motions, not only would it not be the Sun Dance – the surrounding context on which the institution of the Sun Dance depended for its meaningfulness had vanished – but that person would not be able to make himself intelligible to himself or others as doing the Sun Dance. As a historical indication that this might be the right way to understand the situation: the Crow themselves stopped doing the Sun Dance. Although the Sun Dance – or, rather, a Sun Dance – is now a vibrant part of Crow life, there was an approximately seventy-year gap in which the Sun Dance fell out of existence. It is this gap whose cultural and conceptual ontology I am trying to understand.

At the end of World War II, some Crow thought that it would again be appropriate to dance the Sun Dance – as a way of praying for important outcomes – but by then no one could remember the steps. It had gone out of practical memory. The tribe invited a Shoshone Sun Dance leader to teach it the steps of what had been the Shoshone Sun Dance.[8] I have Crow friends who to this day refuse to dance the Sun Dance on the grounds that it is not sufficiently Crow. Nevertheless, there is a sense in which the Sun Dance has come back. (I have lived up in the Wolf Mountains, near

7 It is heartrending to visit the massive collection of Crow coup sticks and shields in the basement of the Field Museum of Natural History in Chicago. They were sold to the curator and anthropologist Charles Simms, who made a trip to the northwestern plains at the turn of the twentieth century, because the Crow no longer had any use for them. While on the reservation, Simms did extensive interviews with Bull-That-Goes-Hunting, the second oldest tribal member at the time. See S. C. Simms, *Traditions of the Crows* (Chicago: Field Columbian Museum, 1903). I have also been helped by Donald Collier's "Crow Field Notes, December–January, 1938–39," an unpublished manuscript by another curator at the Field Museum.

8 See Fred W. Voget, *The Shoshoni-Crow Sun Dance* (Norman: University of Oklahoma Press, 1984); Michael O. Fitzgerald, *Yellowtail: Crow Medicine Man and Sun Dance Chief* (Norman: University of Oklahoma Press, 1991).

a contemporary Sun Dance ground). People will host a Sun Dance either to pray or to give thanks for a good outcome, for example, delicate heart surgery on a child. There is a place for a Sun Dance in Crow reservation life. Later in the chapter I discuss what this reintroduction of meaning consists of, but for the moment I want to concentrate on the ontology of the seventy-year period in which the intelligibility of traditional life had broken down.

Basically, if going on a hunt and going into war and going on a nomadic migration all become impossible, then there are no longer any acts that can intelligibly count as preparing to go to war, on a hunt, on a migration. Nor can anything intelligibly count as intending to perform such acts. Again, one might saddle up a horse, arm oneself, and ride off the reservation, but neither that nor any other act can be understood in these terms. But everything in traditional Crow life had been understood in terms of being oriented to hunts, migration, and battle. And thus if we think of events or happenings in traditional Crow terms – which, of course, one would do if one were a Crow – then Plenty Coups's claim 'After this, nothing happened' starts to make poignant sense. If we follow Heidegger and Aristotle as thinking that time is dateable – that every now is a now-when – then we can also see that there is a sense in which the Crow ran out of time. For they could no longer say, "Now-when we are about to go into battle," "Now-when we are planning our nomadic migration," "Now-when I am counting coup," and so on. And if one wanted to stand witness to these being the nows that really matter – these are what count as happenings – one way to do this would be to say, "After this, nothing happened." This is what it would be to witness the breakdown of intelligibility from within the form of life.

To understand why this crisis represents a breakdown in intelligibility, it is helpful to think through certain objections. So, one might object:

Just because a form of life is no longer possible, that doesn't mean that the concepts that were used within it have become unintelligible. It may no longer be possible to be a chief or a warrior as those concepts were traditionally understood; but that does not imply that the concepts have become unintelligible. After all, the Crow can look back on their past; and they can certainly understand what it was to be a chief or a warrior. This is only possible if the concepts remain intelligible. If the concepts really became unintelligible, then even when the Crow looked back on their past, they would have to do so with puzzlement and bewilderment. They would have to be unable even to make sense of their past in those terms because the terms had ceased to make any sense to them.

So the challenge is this: why should the breakdown in a form of life involve a breakdown in the intelligibility of its concepts? Even if a people are no longer able to live in certain ways – so the challenge runs – that does not imply that the concepts with which they used to understand themselves have actually become unintelligible. The plausibility of this objection stems from a conflation of theoretical and practical reason. But the point about unintelligibility as a practical concern is not that I can make no sense of my past, or my people's past, of my culture's past theoretically understood; it is that I can make no sense of my past, or my people's past, or my culture's past practically understood: that is, as a way of going forward in my deliberations, choices, actions, aspirations, and identifications. If we are thinking of unintelligibility as a phenomenon of practical reason, the past need not be incomprehensible to me as a theoretical matter. My past may be intelligible to me theoretically speaking – I can make sense of what we were all up to – but what has become unintelligible is how to live that past into this future. Again, the issue is not primarily a psychological one; it is ontological: because the culture has been devastated, I can no longer render myself intelligible (to myself or to others) in its terms. This form of unintelligibility does not imply that the past is incomprehensible to me as a matter of contemplation: it means that the concepts with which one had hitherto rendered oneself and others intelligible are no longer available to do that work. (This crucial distinction between practical and theoretical intelligibility can easily be overlooked if one confines oneself to familiar categories such as semantic meaning.)

The strands of impossibility and unintelligibility are intertwined in complex ways. I want to claim both of the following:

- It is because the traditional nomadic way of life became impossible that the central concepts, rituals, and activities within that form of life became unintelligible as ways to live, to understand oneself, and be understood by others.
- And that opened up a new way in which, say, the planting of a coup stick became impossible; it became impossible because it is had become unintelligible.

In the first case the flow was from impossibility to unintelligibility; in the second it is from unintelligibility to impossibility. In the catastrophe that confronted the Crow, the flow is moving in both directions at once. In trying to bring the polyvalence of impossibility to light I used an example in *Radical Hope* of two different senses in which one might say, "It is no longer possible to order buffalo": one in which the restaurant runs out of its supply of buffalo, perhaps because the world supply of buffalo is

exhausted; the other in which the historical institution of restaurants goes out of existence, as do all other institutions of having one group of people serve the needs of another. In the former case, it is no longer possible to order buffalo; in the latter case it is no longer possible to order. But in this latter case, the problem is not simply one of impossibility; it is one of intelligibility. In no act could I legitimately understand myself as ordering, in no act could I legitimately be understood as ordering, in no act could I make myself intelligible to others as ordering. This is a very robust sense of unintelligibility; in the first instance, it has nothing to do with my psychological state. Nothing about this kind of example need prevent me from remembering an earlier world in which ordering was not only intelligible but was a matter of course.

Note that the question of psychology – of the individual or the group – is a different question. One might recognize that there has been trauma to meaning and still not know what the psychological reaction to this trauma has been. It is true there has been a trauma to the group – in the sense of a traumatic disruption of practical reason, a breakdown of intelligibility – but it is a further question what the psychological reaction(s) to this trauma are. It might be trauma in the psychological sense – and given that these breakdowns often occur in the midst of human tragedy, one should not be surprised to find psychological trauma as well – but it might not. And the reactions might be various. The relation between trauma to meaning and trauma to psyche is not one to one.

Pretty Shield says, "I am living a life I no longer understand," and her granddaughter reports that she would often repeat this phrase, accompanied by a sigh.[9] An interpreter might hypothesize that she is sad, wistful, melancholy. Plenty Coups says, "After this, nothing happened," and an interpreter might interpret him as speaking metaphorically, perhaps about a depression or lack of orientation that has overcome the group. And there might or might not be other evidence for such claims. I have no objection to psychological interpretation per se, just so long as it does not obscure from view a different kind of possibility: that they might be standing witness to a crisis of intelligibility.

As I said at the beginning, I do not claim to know what Pretty Shield, Two Leggings, and Plenty Coups meant by their utterances. I have merely been exploring the possibility that they were standing witness. But there is reason to take this possibility seriously. Pretty Shield, Plenty Coups, and Two Leggings had a peculiar form of authority to speak for the form of

[9] Alma Hogan Snell, *Grandmother's Grandchild*, 42.

life. It is a priori that, in general and for the most part, agents can say what they are doing. That is, it is a priori that they can, for the most part, give a self-conscious account of what they are doing, using concepts that are being realized in their actions.[10] Thus, it is a priori that Crow leaders ought to be able to give an account of what they are doing in Crow terms. So when Pretty Shield says, "I am living a life I don't understand," she might be reporting that the concepts with which life would make sense – namely Crow concepts – no longer make sense in terms of possible ways she might live. Her authority is first personal and a priori: only in this case she is not only speaking on behalf of herself – that is, what she expresses by saying "I" – but she also is expressing what would be expressed by her saying "We." Similarly, when Plenty Coups says, "After this, nothing happened," I take him to be speaking on behalf of the tribe, and with the authority of the first person plural. If the Crow themselves say that Crow concepts no longer describe what we outsiders would see as unfolding events, then we ought to respect that claim, not merely as a matter of ethical courtesy, but as having genuine authority. For Crow concepts to hang on to their intelligibility, there have got to be Crow who can find ways to live understanding themselves in those terms. This is just what the Crow leaders themselves seem to have called into question. One sign, then, that there has been a genuine loss of intelligibility is that the agents themselves cannot see how to take up the concepts of their past and project them into their futures. This is what it is to take seriously the Crow's own sense of loss of intelligibility.

When we speak about the collapse of a world, there are various things we might mean, but one of them is a breakdown in intelligibility in the sense I have been trying to isolate. By way of contrast, if the Crow tribe had been devastated when the Sioux launched a massive attack in the early 1820s, with a few survivors taken into captivity, there is a sense in which though the tribe had been destroyed, the Crow way of life would have remained intelligible. The Crow who survived would understand quite well what their position was: they were then slaves, captives; maybe some of them would be adopted into the Sioux tribe. A person in that situation would not say, as Pretty Shield did, "I am living a life I do not understand." Her pain would arise from the fact that she was living a life she understood all too well. These were understandings that were part of Crow life. So too was

[10] See Anscombe, *Intention*; Sebastian Rödl, *Self-Consciousness* (Cambridge, MA: Harvard University Press, 2007).

the larger world of nomadic life on the plains, where hunting, counting coups, and doing the Sun Dance continued to be ways people could live and understand themselves. We can imagine the survivors dreaming that one day they would escape from captivity and reestablish the Crow tribe. And however wishful and unlikely those dreams might have been, they would have an entirely different status to a dream with the same content dreamt on the reservation today. In such a situation, continued Crow life might have become impossible, but it would have remained intelligible. For in the 1820s, the larger world of nomadic tribes hunting and fighting one another on the northwestern plains was still vibrant. And even if it were practically impossible for the dreamer's dream to come true, the kinds of things the dreamer would be dreaming – escaping from captivity, raising children in Crow ways – would be intelligible within the larger context of nomadic life on the plains. Even if the dreamer could not possibly pull it off, he or she would know what his next step would have to be. By contrast, when one suffers a crisis of intelligibility, the problem is not simply that one does not know what one's next step would have to be – as though this were a particularly difficult problem for practical reason – it is that nothing any longer counts as a next step.

Within classical logic the law of excluded middle is a familiar idea:

For all P, P or not P

It gives expression to our confidence that the world exists independently of us.[11]

Obviously, classical logic was formalized primarily with the aim of capturing the timeless truths of arithmetic. But if we try to capture an existential version of the law of excluded middle, that is, one that captures a shared confidence in the determinacy of a range of possibilities manifested in a living way of life, then we need a version that is directed toward the future from now. So, on an evening in the early 1820s, a young Crow warrior could think, "In tomorrow's battle, either I will be brave or I will not."[12]

The warrior's aim would be to acquit himself bravely, but his commitment would be against background knowledge of what the possibilities were. It is over this range of future possibilities that the Crow concepts for

[11] Michael Dummett, "Bringing about the Past" and "The Reality of the Past," in *Truth and Other Enigmas* (Cambridge, MA: Harvard University Press, 1978), 333–50; 358–74. See also *his Elements of Intuitionism* (Oxford, UK: Clarendon Press, 1977) and his *The Logical Basis of Metaphysics* (Cambridge, MA: Harvard University Press, 1991).

[12] The Crow word for brave is *alaxch-iaa*: see Ishtaléescgua Báchiaa Héeleetaalawe, *A Dictionary of Everyday Crow* (Crow Agency, MT: Bilingual Materials Development Center, 1987).

brave and *not brave* served as an exhaustive partition: on the eve before battle a warrior would know that any failure to be brave would be a way of not being brave. This is the background knowledge that gives content to the idea of inhabiting a world – which is open ended in the sense that various things might happen to one, and one might behave in various ways in response but all of which remained within the range of what is intelligible. But by the 1920s the intelligibility of the predicates that had hitherto been used to describe events – and thus the intelligibility of there being events – had broken down. As we have already seen, one paradigm of Crow bravery was to plant a coup stick in battle, from which point a warrior signaled that he would never willingly retreat. Within traditional Crow life, that or anything like it counted as brave. That is, in addition to having a paradigm of bravery, traditional Crow life contained a vibrant sense of similarity: a sense of what it would be like to go on in the same sort of way. This could be used to generalize their sense of what bravery required. However, with the breakdown in the intelligibility of this act of planting a coup stick, there is a corresponding breakdown in this sense of similarity. So when one now says "that or anything like it" – one fails with "that" to pick out any possible act, and one fails with "anything like it" to pick out any intelligible relation of going on in a similar sort of way.

Someone who has been exposed to classical logic might be tempted to say that classical negation is such that any failure to be brave is a way of not being brave – so the law of excluded middle holds even in the situation I have described. Again, I think the plausibility of this objection flows from imposing a demand of theoretical reason on a domain that is practical and existential. In classical logic one simply assumes a determinate range of objects over which the quantifiers range and a determinate set of predicates that either hold or fail to hold of those objects. But in the situation we are envisaging both of these assumptions come into question. What we are trying to capture is an existential version of the law of excluded middle as it manifested itself in the Crow way of life. Thus, we need to understand the quantifier as ranging over all future possibilities – as understood by and manifested in the Crow way of life. These are possibilities for living and for understanding life and the world in certain sorts of ways. This is what gives content to the idea of the world of the Crow. Thus, the possibility that we are investigating – namely that the entire range of possibilities ceases to make sense as ways to live – was not itself within that range. The Crow had a vivid idea of what it would be to be defeated in battle, decimated, destroyed, taken into slavery, and so on, but they had no idea what it would

be for their way of life to cease making sense. That possibility was not in any way manifested in their living sense of all possibilities. Moreover, the Crow predicate that we translate with the English word *brave* was one that was taught and understood in terms of the range of possibilities as understood by the Crow. We should not assume that the predicate will retain its determinacy – applying or not applying to an independently specifiable range of events – even after the form of life in which it gained its meaning becomes moribund. It is one thing for the predicate (which we translate as) *brave* not to apply to an event; it is quite another for the very idea of bravery to lose significance. When Plenty Coups said, "After this, nothing happened," I interpret him as giving voice to the breakdown of events. An event is a "now-when-X-is-happening" for some value of X. But all Crow values of X have lost intelligibility: "now-when-I-am-planting-a-coup-stick," "now-when-I-am-preparing-for-battle," and so on. So when one tries to say something like "For all X, Brave (X) or not Brave (X)," not only has the predicate "Brave . . ." lost intelligibility, so have the possible values of X.

One might well wonder how common this kind of breakdown in intelligibility is. After all, if one looks from a sufficiently high altitude, the Crow are a cultural group that suffered a massive onslaught on their identity and way of life; in some sense they endured the trauma and are even now in the process of constituting themselves as a reservation and post-reservation culture. Isn't this the stuff of history? To take some other examples about which we are today very aware: the capture and enslavement of Africans and their forced transportation to the United States, where they then constituted what we think of as African American culture; Europe's two-thousand-year assault on Jews living in their midst; the subjugation and disenfranchisement of women in cultures around the world. One might well wonder whether the difference in what befell the Crow isn't quantitative rather than qualitative?

 Although the concerns prompting this question are of great importance, the question as it stands makes no sense. Before we can discriminate quantity from quality, we need a criterion according to which we adjudicate the difference. The point of focusing on the Crow – from a philosophical perspective – was to bring to light a peculiar kind of ontological issue: the possibility that the intelligibility of concepts with which one has lived, understood oneself, others, and one's world might cease to be viable. They are no longer ways in which one can render oneself and others intelligible. In this chapter I have tried to mark this phenomenon off from other

psychological and social phenomena. The point of focusing on the Crow is not to say that they had it much worse or much easier than anyone else, but that in their case it is particularly clear that a qualitative issue – an ontological difference rather than just an ontic difference – is at stake. To put it in Heidegger's terms, it is a breakdown in the understanding of being.[13]

To what extent this has happened to other particular groups in other historical periods, I am not competent to judge. But I do think I have provided a criterion by which a sensitive historian might pursue these questions. If one can find what I have here called a crisis of intelligibility, then one has evidence of a qualitative difference from a situation in which one can only find various psychological or social phenomena. And this will be so however similar or different the social situations look on the surface. I want to emphasize this: the fact that one group suffers a breakdown in intelligibility does not thereby signify that that group has it worse (according to some absolute standard) than a group that does not. So, for instance, there is no reason to think there is always more pain suffered with a breakdown in intelligibility than with other forms of assault in which intelligibility happens to remain intact. One reason I focused on the Crow was not because their experience was qualitatively different from the experience of all other groups, but because they provide an exceptionally clear case of a breakdown in intelligibility and thus of the qualitative difference between a crisis of intelligibility and other forms of psychological or social crisis.

[13] As another illustration, consider three different ways in which marriage might become "unintelligible": (1) Standing in front of the mirror shaving, I realize I no longer love my wife. Indeed, it no longer makes any sense to me how we ever got married. It is though I am detached, looking down from a great distance, with utter bewilderment at this stranger: Whatever have we been doing all these years? We have each been living in the same house, but have we been living together? We have each been sleeping in the same bed, but have we been sleeping together? I no longer have any idea. (2) Standing in front of the mirror shaving, the very idea of marriage becomes unintelligible to me. I can see clearly that there are all these people living in pairs in houses and apartments, calling themselves married and so on, but whatever are they talking about? What *are* they doing? I no longer have any idea. Both (1) and (2) describe odd and unusual states of affairs, but they are basically psychological phenomena. By contrast, (3) this historical institution of marriage goes out of existence. The associated rituals are suppressed, the act is successfully forbidden, there is genetic intervention in population to suppress the desire to remain with any one partner, the memory of the institution becomes one of something that now seems quaint, on the level of driving chariots and wearing togas, and so on. In such a situation, there is no longer any legitimate way to represent myself (to myself or to another) as married. This has nothing to do with my psychology; it has everything to do with the viability of a form of life that I have hitherto inhabited. And in such a situation my earlier married state might well remain intelligible in theoretical terms. It is this third mode of unintelligibility that is the focus of this chapter.

Let me close with three concrete examples that I think make the point. Joseph Medicine Crow, the revered tribal historian, born in 1913, gives this account of fighting in World War II:

> Naturally, I thought about the famous warriors when I went to Germany. I had a legacy to live up to. My goal was to be a good soldier, to perform honorably in combat if the occasion should occur. I did not think in terms of counting coup. Those days were gone, I believed. But when I returned from Germany and the elders asked me and the other Crow veterans to tell our war stories, lo and behold, I had completed the four requirements to become a chief.[14]

This looks like a moment of retrospective reinvention of tradition: the leaders of the tribe are trying to revitalize the activity of counting coup – which would thus provide new routes to becoming a chief. Again, from a sufficiently high altitude this looks like one more cultural adaptation to changed circumstances. But if we leave it at that, there is a danger that we collaborate in covering over the trauma the Crow had to endure. The fact is, from the time the intelligibility of counting coup broke down, with the move onto the reservation in 1884, to the self-conscious attempts to restore a meaning to the concept, with returning veterans after World War II, there was a gap in which people could recount stories from their nomadic past, but no one had any idea of what could count as an act of counting coup in the present. One telling sign is that when the young Joseph Medicine Crow fought in that war, even he had no idea that anything he could do could possibly count as counting coup. Indeed, even as he performed the acts that would later be counted as having counted coup, he had no idea he was doing such. This is in dramatic contrast to the traditional past, when young men knew precisely what it would be to count coup – and who certainly knew, as they acted, that they were doing something with which they could later make a claim to have counted coup. Thus, unlike the continual adaptation of a culture – and concepts within the culture – to new circumstances, in this case one needed the resurrection of a concept that had fallen into a moribund state. This is a beautiful example at the social level of après coup: the retrospective decision that certain acts in the past would now be counted as having counted coup.

We should view the reintroduction of the Sun Dance into Crow life in a similar way. Obviously, traditions can change over time, sometimes quite dramatically, and we might nevertheless want to think in terms of the continuation of a tradition. Then why not just say that the Crow did

[14] Joseph Medicine Crow, *Counting Coup: Becoming a Chief on the Reservation and Beyond* (Washington, DC: National Geographic, 2006), 107, my emphasis.

the Sun Dance for a while, then they stopped doing it for a while, and then they took it up again? Why is this not just the continuation of a tradition? The reason for not going down this interpretive path is to give due consideration to the peculiar nature of the hiatus. The break is not adequately explained via recourse to a shared psychological condition, say, a collective loss of interest. Nor is it explained via some physical limitation, say, that they were all on a forced march, nor by a legal prohibition of such a dance. Insofar as there is a loss of interest, it is because the final cause of the dance has vanished. In the nomadic period, the Sun Dance was *for the sake of* victory in battle or success on a hunt. With the sudden disappearance of nomadic life the *for the sake of* relation broke down. No one could any longer say what the Sun Dance was for – because it no longer was for anything. Thus, there was a breakdown in intelligibility. In the post–World War II era, the Sun Dance was reinstalled precisely by the introduction of a new final cause (though one related by family resemblance to the previous one). Instead of being irretrievably linked to a nomadic way of life and warrior values, the Sun Dance gets linked to a successful outcome in the world of reservation life, as we have seen, with a successful medical surgery. It is with the installation of a new sense of what the Sun Dance might be for that meaningfulness is reinstalled. The idea of a breakdown in intelligibility is meant to capture the significance of the moment of discontinuity, the interim period.

Finally, it is telling that the Crow hip-hop band that recently won the Native American Music Award is Rezawrecktion – thus condensing two or three puns into its name. The music is full of references to old warrior life but also entangled in Christian themes of hope, love, and resurrection – as well as with hip-hop concerns of contemporary street life and contemporary life on the rez. It is explicit in their songs that Crow life needs to be understood in terms of death and rebirth. That is, it is part of contemporary Crow poetic culture that the Crow have come back from the dead. One might want to treat this as poetic license, but I think I have given the philosophical framework in terms of which one can understand Rezawrecktion, Plenty Coups, Two Leggings, and Pretty Shield as standing witness to something profoundly true.[15]

[15] I would like to thank my two Crow brothers John Doyle and Larry Kindness, as well as Urban Bear Don't Walk, Scott Bear Don't Walk, Sid Eastman, Tim McCleary, Carrie McCleary, George Real Bird, Veronica Small-Eastman, and Jackie Yellowtail for years of conversation. I am also deeply indebted to Gabriel Lear and Candace Vogler for years of philosophical conversation on these topics.

Contesting Religious Claims over Archaeological Sites

Elizabeth Burns Coleman

Contests over heritage may come from multiple perspectives or values. In this chapter I explore contested claims over heritage and archaeological sites that are made on the basis of religion.[1] These claims may compete with archaeological interests because they are backed by a human right, the right of religious freedom, and because the concept of the sacred is accompanied by the concept of taboo. However, in determining which groups have the strongest claims, judgments are informed by a distinction between those religions that are perceived as traditional and as having a requisite historical connection with an archaeological site, and those religious beliefs that are considered to be invented, or reinvented, traditions. The concept of authenticity informs decisions in such cases but creates numerous inequities in our treatment of religious groups.

My focus is on claims that are made over specific archaeological or geographical sites. What is distinct about these claims is their focus on what might be termed *place*. It is widely recognized that such claims over specific sites occur in a context of identity politics in a manner that connects people with land. For groups such as First Nation peoples and Aboriginal and Torres Strait Islanders, the concept of place is central to the religion. Creators and ancestors are associated with specific areas of land, and the land reflects the immanence of these creators and ancestors. Because of this, religious practice is site specific. Although in the Abrahamic traditions a place may become sacred, such as occurs with historical sites or miraculous events, the central site of worship is sanctified through ritual, such as when a church is consecrated. This implies flexibility about where worship is conducted.

[1] This chapter has benefited enormously from comments from audiences at the conference 'Appropriating the Past: The Uses and Abuses of Cultural Heritage' in July 2009, and members of the philosophy program seminar, at La Trobe University, on August 25, 2010. I thank participants at both events for their generosity.

Both the Australian Aboriginal and Torres Strait Islander Heritage Protection Act of 1984 and the US Native American Graves Protection and Repatriation Act of 1990 are concerned with the protection of places and objects of religious significance. This protection involved archaeologists' giving up a degree of authority over the protection of this heritage. As Anne Clarke has observed,

> Since the early 1970s . . . Indigenous people have demanded to be given legislative control over their own cultural heritage, in terms not only of the physical management of land and sites but also authorizing research activities. . . .
> The development of research strategies designed to meet indigenous concerns about the practice of archaeology can be seen to have two interlinked aims: first, to work towards informed consent to practices and, second, to establish meaningful processes of involvement and interaction between archaeological practitioners and indigenous people. (Clarke 2002: 250)

But indigenous groups are not the only people that claim specific connection with places. For instance, modern Druids 'treat Stonehenge as a place of religion and ritual', and have done so since the late nineteenth century (English 2002: 5, 8). Similarly, New Age followers may also seek specific sites. Barbara Bender has explored the myriad interpretations of places such as Stonehenge and argued that archaeologists should actively work with religious groups such as Druids and New Age believers to protect their rights of access. However, we treat these claims very differently from the way we treat indigenous claims. The question, I think, is, should we?

Exactly what are we attempting to do when we recognize that a site is sacred to some group? We need to ask ourselves exactly what the moral issues are here, to clarify the principles involved. Can we infer that archaeologists face the same ethical issues in both kinds of cases?

In the first part of this chapter I argue that claims by indigenous groups are treated differently from those by other religious groups on the basis of their cultural connections to specific sites and the 'authenticity' of their traditions. Following from this, when indigenous practices change, there is a tendency to treat their beliefs as 'invented' traditions that are not worthy of protection. This bears similarities to the ways in which New Age religions are dismissed. However, rights of religious freedom are quite different from claims about cultural authenticity or historical connection. Indeed, logically, the right to practice a religion requires neither.

The second part of the chapter argues that the right of freedom of religion, and the reason we think it important, presupposes a specific model of religion that privileges institutional religion over other forms of

religiosity. I argue that in fact there is no principled reason for preferring one metaphysical or sociological framework over another. It might be thought that there in fact is a principled distinction to be made between indigenous groups and other groups on the basis of the relationship between religion and the identity of the group. This argument rests on a distinction between the protection of culture that is constitutive of or instrumental for identity. However, the anthropological definition of religion that appears to be the basis of such claims has the consequence of dismissing or devaluing different forms of religiosity and leads to confusion between the value of religion and that of identity. In the end, it does not address the central issue of what rights or claims should follow from a religious connection with a specific site, and it serves as a proxy for substantive judgments about which group identities are 'acceptable'.

By way of some concluding remarks I consider our reasons for protecting religious belief. We should understand the special connection or claim of indigenous groups to be a form of respect given to groups marginalized in colonial settler societies to protect them from profound offense. This recognition is not a principled, ethical response to their claims for the control or protection of sacred sites but a more general concern for the feelings of others, and it reflects a pragmatic response to negotiation with indigenous peoples.

HISTORICAL CONTINUITY AND RELIGIOUS BELIEF

I begin by describing three controversial rights claims based on religious connections to archaeological sites. My first concerns the Pottery Mound archaeological site in New Mexico; my second is an Australian case, called the Hindmarsh Bridge Affair; and the third concerns Druid claims in relation to Stonehenge. The rights in question vary – from a right to control the representation and display of sacred objects, the rights to protect spaces because they are sacred to a group of people, to a right of accommodation of religious practice. What these cases show is that, despite the conditions, or the issue to considered, the criticisms of the claims are very similar. There is an emphasis on the idea that a historical connection between a group and a location is a necessary but not a sufficient reason for acknowledging rights. In addition, the religious belief itself needs to have the right kind of historical continuity.

The New Mexico Pottery Mound Mural

In 2003, the Acoma tribe claimed that images found on archaeological finds from an archaeological site known as Pottery Mound in New Mexico

could not be used for a mural to be painted at the University of New Mexico. The tribe claimed the murals involved depictions of cultural icons and images that were found within a sacred chamber and that the reproduction of the designs in the mural interfered with their religion. The Acoma tribe claimed that all images they produced were sacred, and hence protected under the Native American Graves Protection and Repatriation Act. However, the painters of the Pottery Mound murals were a mixture of Aztec and a local ancient Indian group who practiced human sacrifice, and there was no archaeological evidence to confirm which tribe had painted the murals. It was argued that the Acoma tribe, having no known link to the site, could not claim control over the images on the basis that they were sacred to it or part of its heritage. Despite this, the university decided not to proceed with the mural. This decision was defended by the director of the university's Museum of Anthropology, Garth Bawden, who stated:

The Native American Protection and Repatriation Act has brought into being a much heightened sensitivity to using cultural heritage that belongs to the Native American tribes of the region.... There are a lot of things that are gray in this, and legally we could do anything we could. We are part of a broad constituency that includes numerous Indian tribes. If we are doing anything that pertains to their heritage, we will consult with them. (cited in Duin 2003)

The painter of the mural, Tom Baker, pointed out that the manner in which the university had responded to the Acoma tribe's claim, which involved canceling the commission, was very different from a controversy involving a painting of the Virgin of Guadalupe. The Virgin of Guadalupe depicts an appearance of the Virgin Mary in Mexico in the sixteenth century, and the image is revered by contemporary Catholics. This religious group objected to a painting depicting her in a bikini exhibited at the state-funded Museum of New Mexico in Santa Fe, which refused to remove the painting (Duin 2003). The lack of a link between the Acoma and the site made the university's decision particularly controversial, but, as my next case shows, a group may have the right historical connection to the site and yet in the eyes of their critics lack the correct religious connection.

The Hindmarsh Island Bridge Controversy

Hindmarsh Island is a small island off the coast of South Australia. In the mid-1990s, an Aboriginal group, the Ngarrindjeri, claimed that a proposed bridge from the mainland to the island would disturb a women's sacred site. The state government had approved the bridge despite a protest from some local groups. The anti-bridge lobby looked to Aboriginal interests in the

area for support of their campaign, as there were Aboriginal archaeological sites in the area, including middens and burial sites (Kenny 1996: 31). Under the Aboriginal and Torres Strait Islander Heritage Protection Act of 1984, it was open to the federal minister for Aboriginal relations, Mr Tickner, to intervene in the state government's decision. This act 'seeks to protect places and objects of spiritual significance to Aboriginal people' (Willheim 2008: 230). The minister's office had indicated that there would need to be something 'more than archaeological' for this to occur. What would be required was that the site also possessed 'cultural significance' (Kenny 1996: 68). According to journalist Chris Kenny, the claim of women's business arose from an idea they gained from Lindy Warrell, an anthropologist acting for the Ngarrindjeri, who observed that it 'would be nice if there were some secret women's business' to provide evidence of the cultural significance of the site (Kenny 1996: 71). And according to Kenny, it was a male anthropologist who pointed out that the shape of the island was similar to a woman's reproductive organs. Following this, a claim of cultural significance was developed by a group of Ngarrindjeri women and forwarded to the minister's office. A bridge, it was claimed, would disturb the flow of waters around the island, which was culturally significant because of the meeting of the waters. Furthermore, the island was sacred to women because of 'all the little fetuses' buried there, as it is where women would go to abort. Only one woman, Doreen Kartinyeri, had knowledge of this secret sacred business, which she claimed had been passed on to her from two of her elders, both of whom had died. Other Ngarrindjeri women were surprised, yet they accepted what Kartinyeri claimed, because of the lineage of the knowledge as she presented it (Kenny 1996: 74). This application to the minister included an archaeological report prepared by Dr Dean Fergie, as well as an envelope containing documentation of the secret women's business, to be read by women only. The minister appointed Professor Cheryl Saunders to brief him. Her report concluded:

Hindmarsh and Mundoo Islands and the waters surrounding them have supreme spiritual and cultural significance for the Ngarrindjeri people, within the knowledge of Ngarrindjeri women, which concerns the life-force itself. If destroyed, the Ngarrindjeri people believe they will be destroyed. (Cited in Willheim 2008: 228)

Shortly after, however, another group of female Ngarrindjeri elders denounced the claims of secret women's business on the island as a fabrication. The claims and counterclaims raised one of the greatest controversies in the history of Australian Aboriginal land rights, including a royal commission into the existence of the religious tradition and questions about

the legal processes on which the recognition of rights was accepted. The commission found that the women's claims had been fabricated for political gain, and that Minister Tickner had erred in his decision to support the claim without looking at the evidence provided in the secret envelopes. The media represented the debate as an issue over authenticity, and of good and bad Aboriginality, with the Ngarrindjeri women making the claim variously depicted as a small splinter group, with a poor understanding of and connection to their cultural history, who were potentially fraudulently inventing claims (Muir 1996: 74). In turn, the act has been criticized for requiring disclosure of secret elements of Aboriginal religion, and similarly, the legal system has been criticized for requiring evidence of the continuing religious and cultural connections (Willheim 2008). The Ngarrindjeri women who made the claims of a secret sacred tradition refused to provide evidence to the commission, but stated through their counsel:

We are deeply offended that a government in this day and age has the audacity to order an inquiry into our secret sacred spiritual beliefs. Never before has any group of people had their spiritual belief scrutinized in this way. It is our responsibility as custodians of this knowledge to protect it.... Women's business does exist, has existed from time immemorial and will continue to exist where there are Aboriginal women who are able to continue to practice their culture. (Cited in Willheim 2008: 228)

I focus on two criticisms of the women's case.[2] The anthropologist Michael Brown was particularly concerned about the lack of scrutiny he felt was shown concerning the claim of secret women's business, in particular the idea expressed by many that it was an affront to Aboriginal people to have their traditions examined in the courts and that they should not be asked for evidence. 'Feelings matter', Brown wrote. 'No just society rides roughshod over the feelings of citizens, whatever their ethnic origin. But when heritage-protection laws move in an emotivist direction by aiming to protect the feelings of native populations from every possible indignity, they travel down a dangerous road – one that, among other things, invites similar demands from groups whose goals and values may be distasteful and destructive' (Brown 2003: 20–22). It is not clear that Australia should concede to every demand for special protection for indigenous groups' religious beliefs. And, moreover, as Brown points out, once it is conceded that

[2] In what follows I rely heavily on accounts that criticize the women's claims. I do so because I am specifically interested in the criticisms, not because I am offering an opinion on the truth of the issue. For sympathetic accounts of the Ngarrindjeri claims, see Hemming (1996); Willheim (2008); and Bell (1998).

religion is a good basis for special protection (e.g., control over a site or an image) there is an issue of consistency with how other religious beliefs are protected under law. I return to these issues later in the chapter. Of particular interest here is the demand for cultural continuity.

Kenny argued that this was a case of invented tradition. He comments, 'Anthropologists have noted that if valuable minerals are found on Aboriginal land, Aborigines sometimes assume that the site must have had special significance in their Dreaming' (Kenny 1996: 69). These assumptions point to a concern about the malleability of Aboriginal beliefs, which may be adapted to new situations. This criticism has occurred in other contexts, for example in relation to Coronation Hill mine (see Keen 1992: 8). The second criticism concerns the ongoing cultural connection with a place and the kinds of evidence required to establish that connection. Brown argued that there was insufficient evidence to consider Hindmarsh Island culturally significant: 'Even if we accept that the island and the water that surrounds it defined the Ngarrindjeri cosmos in a way that the bridge would desecrate, there was little evidence that people acted on this belief in observable ways, either now or in the recent past' (Brown 2003: 191). Therefore, Brown concluded, the building of a bridge would not interrupt the maintenance of their customs as they currently exist.

In the Hindmarsh Island case it was clear that there is an assumption that religious belief should remain constant over time and that the belief be expressed in, and maintained through, ceremony before such claims might be recognized. Even if it had not been found that that the women's business on Hindmarsh Island was invented for political gain, the fact a group had reinterpreted their tradition could be sufficient reason to consider these claims to be in some sense invalid, simply because they were different from claims made in the past. A problem of this line of reasoning, in which we protect the religion of only those indigenous groups that have maintained their tradition according to anthropological records, is that it means that precisely those indigenous groups that have been the most affected by colonization and that have lost the most of their culture are disadvantaged in relation to cultural recognition.

Inevitably, indigenous traditions are constantly in the process of transformation. Bhikhu Parekh (2002: 164–5) points out that, in the face of pressures from colonization and globalization, 'the only course of action open to such societies is to undertake the momentous task of creatively reinterpreting their culture'. However, when such groups do reinterpret their culture and beliefs, these reinterpretations are criticized for their lack of authenticity and depth. This kind of criticism is not only directed

to indigenous groups. It is particularly evident in my third example, concerning the claims made on Stonehenge.

Stonehenge

Each year, tens of thousands of people visit Stonehenge to celebrate the summer solstice. The visitors include Druids and pagans, and those following a spiritual impulse to worship the land including New Age 'travellers' (a loose group of people leading alternative lifestyles who travel from festival to festival). The solstice festival, which began at Stonehenge in the early 1970s, was not always welcome. When English Heritage took over the site, the stones were fenced, and English Heritage attempted to control access, leading to confrontations between the groups and police. After the so-called Battle of the Beanfield in 1985, public opinion was set against the festival goers (Wallis and Blain 2002). A clampdown on the festival, however, also restricted people's capacity to access Stonehenge for religious reasons (Hilary Jones, quoted in Bender 1998: 204). In 1998, after a decade of conflict with English Heritage, the Truth and Reconciliation Commission for Stonehenge was established to resolve conflicts over access to the site (English 2002: 15). Druids and pagans once again have access to the site at the solstices for ceremonies.

The claims of Druids to worship at Stonehenge as representatives of an ongoing tradition of Druidism and connection between the Druids and the site are undermined by archaeological knowledge. According to the British Museum's web page:

Modern Druids have no direct connection to the Druids of the Iron Age. Many of our popular ideas about the Druids are based on the misunderstandings and misconceptions of scholars 200 years ago. In particular, there is no link between the Iron Age Druids and the people who built and worshipped at Stonehenge, Wiltshire. This ancient monument was part of a religion that ended before the Iron Age began. (British Museum 2008)

According to this information, this is not merely a matter of 'a break' in Druidic tradition. Stonehenge was not a Druid sacred site. Moreover, it is widely felt that the Druids 'do not have a proper religion', on the basis that it is a re-creation of a past tradition. If any of the cases I have presented is most clearly an example of invented tradition, this is it.

English Heritage archaeologist Geoffrey Wainwright has commented, 'Stonehenge belongs to an era when power was exercised through ceremony and validated directly by reference to the supernatural. . . . The investment

of resources in Stonehenge was political, designed to establish a symbol of authority' (cited in English 2002: 5). As Penny English describes how the Stones are interpreted by New Agers, however, 'The ancient spiritual meaning in places [such as stone circles] became important to some groups who viewed prehistoric monuments as living places imbued with sacred energy and not as relics of a completed past' (English 2002: 8–9). This second interpretation is religious, whereas the first is not.

Legend has it that Stonehenge was initially built as a monument to commemorate the slaying of 460 British nobles, with the advice of the magician and prophet Merlin (Grinsell 1976: 5). John Aubrey's study of Avebury in 1648 used this legend as the basis for a distinctly British history, which, it was claimed, existed prior to the Roman conquest. David Harvey comments, 'By appealing to a sense of there being a common British past, Aubrey added flesh to the bones of a foundation story that suggested a natural solidarity between the people of this "island nation": an imagined nation that was legitimated through its long history, and which had suggested a common destiny' (Harvey 2003: 478). The connection between Avebury and distinctly British Druids was developed further by William Stukeley in the eighteenth century, when he set out to show that 'the Druid's Patriarchial religion was really an early and untainted version of Christianity' (Harvey 2003: 479). This is not to say that such ideas were a result of a conscious invention of tradition in the service of an ideological nationalism; rather, they emerged along with such ideas.

The first of the contemporary Druidic orders, the Ancient Order of the Druids, drew on Stukeley's claims when it was established in 1781. The order blended Druidism with Christianity, using the image of the sun as the symbol of divine light (English 2002: 8). Worship at Stonehenge began at the end of the nineteenth century, and by the First World War there were five separate sects worshiping at Stonehenge. The Druidic orders were generally regarded as respectable: Stukeley's study was dedicated to 'Valenda, Archdruidess of Kew', otherwise known as the Princess of Wales, and the Earl of Pembroke and Lord Hartfield referred to each other and to Stukeley by their Celtic Druid names (Harvey 2003: 479); Winston Churchill was a member of a Druid order; and Dr Rowan Williams, the archbishop of Canterbury, has been inducted.

The history of the New Age, and its focus, is slightly different. Throughout the 1960s and 1970s, elements of mysticism were entwined with pagan beliefs and what became known as earth mysteries. Part of this involved the reinterpretation of Alfred Watkins's theory of 'ley lines'. Initially, ley lines were thought of as the paths between archaeological monuments

and megaliths; however, they came to be understood more as spirit rather than physical pathways, as it is now popularly believed that both the sites and the lines resonate with spiritual or psychic energy (English 2002). Such beliefs are less like Druidism's transcendent Christianity than animism. These later, countercultural, groups are not considered respectable. For instance, the headlines reporting conflicts between the police and Stonehenge solstice revellers dismissed them as 'sponging scum' and 'giro gypsies', 'smellies', 'hippies', and 'ravers' (cited in Wallis and Blain 2002).

George Nicholas and Alison Wylie have pointed out that:

Archaeologists have long enjoyed considerable privilege of access and authority in determining how archaeological materials should be used, by whom, and for what purposes. The primary value assigned archaeological material as evidence underwrites scientifically driven protocols of cataloguing, storage, and analysis (including destructive analysis), and mandates controlled access for restudy by peers, often to the explicit exclusion of non-archaeologists. (Nicholas and Wylie 2009: 28)

But although the archaeological attitude toward such monuments is concerned with an understanding of prehistoric religion and worship, and controlling access for such study, contemporary worshipers treat Stonehenge as a religious site and see their activities as a reaffirmation or re-creation of the faith (English 2002: 5). This difference in perspective has often been remarked on. It should not be thought that professional archaeologists are unsympathetic to the re-creation of meaning in this way. Anthropologists such as Barbara Bender have explored the myriad interpretations of Stonehenge and argue that the meanings of heritage and landscape are never uncontroversial, as 'people engage with it, re-work it, appropriate it and contest it. [Heritage] is part of the way identities are created and disputed, whether as individual group or nation state' (cited in Harvey 2003: 495). Yet to suggest that there should be some sympathy for alternative interpretations that contest the authority of the archaeologist because the claims may be understood as an element of social identity formation is distinct from suggesting that the different perspectives can be made consistent in every instance, or to conceding that religious value should prevail over archaeological or historical value where they conflict.

Wallis and Blain (2009) report a case from the Peak District in which a stone circle was altered. Feeling the energy of the earth through dowsing, a New Age group had determined that some of the stones were incorrectly positioned. Unsurprisingly, the archaeologists had a different perspective of

what the 'correct' position of the stones was, and Wallis and Blain state that the archaeologists then 're-organised the stones into their original positions' on the basis of evidence from excavations (Wallis and Blain 2003: 310). It is unclear whether Wallis and Blain mean that the archaeologists moved the stones back to the place where they had lain or to where they had been positioned by the original creators – potentially two very different interpretations of the term *original*. It is clear that, for the archaeologists, the New Age actions were a form of vandalism of the site and that their own methods to arrive at the 'truth' about their correct position were obviously superior.

The current approach taken by English Heritage, which allows access to the site for ceremonies by recognizable religious groups (such as the Druids and pagans – so long as they do not disturb it as an archaeological site) is consistent with human rights on this issue. Article 18 of the International Covenant on Civil and Political Rights states, 'Everyone has the right to freedom of thought, conscience and religion; this right includes . . . freedom, either alone or in community with others and in public or in private, to manifest his religion or belief in practice, worship and observance'. This seems to support a right of groups to access and to practice their religion focused on place, regardless of the truth or falsity of that belief – even when the connection between groups and place is contrary to archaeological evidence.

The anthropology of religion is, appropriately, agnostic concerning the content of that religion. The issue for the anthropologist appears to be the study of religion within a social context. So it should make no difference to anthropologists whether they study a New Age or indigenous group. Despite this, anthropological and archaeological evidence may be brought to bear to undermine a group's association with a place and religious claims, regardless of the fact that rights of religious freedom do not require that religious claims be true or have any cultural authenticity. Where it is believed that indigenous people's claims are 'invented' either for political gain or romanticism, they are undermined as 'religious' beliefs and treated as without rights in postcolonial settler societies. Similarly, there appears to be even less sympathy for people with New Age beliefs, particularly if they concern ideas about animism and the power of the land. Clearly, one value judgment seems to be a judgment between 'old' and 'new' religions, as if newer religions were less valuable or their rights less important. Another distinction that is drawn is between different structures of belief. As I show in the following section, these value judgments are built into our definitions of religion.

The legal philosopher Jeremy Webber argues that we can understand why freedom of religion is a human right only if we recognize that we place a positive valuation on religious belief itself. Religious beliefs are those that are held most 'deeply', and it is in the context of the fact that people were prepared to die for such beliefs, and to kill for them, that the concept of toleration was developed (Webber 2008). Yet this associates the valuation of religious belief with an idea of religious beliefs as being inflexible and with a specific idea of the 'demands' of religion. These assumptions about what a religion is privilege certain kinds of religiosity.

Historically, toleration was necessary to counter violence associated with the religious wars – that is, violence between adherents of conservative Catholicism and fundamentalist Protestantism. Linda Woodhead and Paul Heelas have described such belief systems as 'religions of difference' (Woodhead and Heelas 2000: 27), and they state that religions of difference are characterised by a clear differentiation between the human and the divine, and attribute authority to the transcendent. Such religions demand obedience and faithfulness, and involve the highest levels of prescription in terms of behavior (Woodhead and Heelas 2000: 20–22). What is required of the believer is found in text, or the tradition that includes a 'diffuse body of teachings, laws, rituals and practices which maintain continuity between a community's past and present' (Woodhead and Heelas 2000: 27). Additionally, religions of difference stress the importance of worship, and maintaining correctly structured relations with God (Woodhead and Heelas 2000: 28). It appears as though the valuation of religious belief in Webber's account takes this as its implicit model of religion. This model presupposed the importance of tradition and authority, and it is just this lack of tradition that is criticized in re-created or New Age religions.

Importantly, there is a claim that New Age groups (including the Druids on some accounts) cannot be considered religions, with consequent claims to religious rights. There are expressions of religiosity that manifest themselves in modes that fall outside traditional 'churched' understandings of religious affiliation, such as spirituality. An argument could be developed that although spirituality may be a form of religiosity, it is not a religious practice that requires protection or equal protection.

For instance, Anthony Fisher and Hayden Ramsay argue that although such groups have particular metaphysical beliefs, the group could not properly be called a religion: 'Recently invented clubs of crystal lovers or

Stonehenge circle-dancers do not offer their members much more than the jest of Hollywood re-creations and the banality of passing fads – though they may, of course, reflect desires for community, friendship, realization etc.' (Fisher and Ramsay 2000: 162). Furthermore, although religion is a social good, New Age groups' beliefs are not: 'The contribution of such cults to the wider community is usually and often deliberately negligible. Unlike traditional religions which offer figures who have become important symbols even to those who do not acknowledge their supernatural existence (Buddha, Abraham, Christ, Mohammed . . .), such cults offer no icons of significance to outsiders' (Fisher and Ramsay 2000: 163).

For Fisher and Ramsay, one problem with such beliefs is that they lack the 'seriousness' of other religions. There are no significant teachers or leaders and no depth to their religious history, and because of this, such beliefs are not as valuable as other expressions of religiosity. A significant theme that emerges from sociological study of New Age believers is the common discursive emphasis on the self and self-authority. Matthew Wood suggests that it is the emphasis on internal authority rather than external authorities such as texts, teachers, leaders, or institutions that leads people to associate the New Age with spirituality rather than religion, as 'scholars equate religion with external authority', whilst spirituality is associated with 'individual freedom and choice' (Wood 2007: 27).

It is true that these groups lack external authority figures. Beginning with the concern with self-expression in the 1970s, when cultural developments encouraged self-exploration, the New Age developed from what has been described as self-religions such as EST, a self-improvement method based on Erhard Seminars Training. According to Paul Heelas, these religions are associated with a 'self-work ethic', actualizing 'the god within', and reflect a wider cultural movement of 'subjectification' within contemporary Western society (cited in Wood 2007: 20–22). And as Charles Taylor has pointed out, 'These features of "spirituality", its subjectivism, its focus on the self and its wholeness, its emphasis on feeling, has led many to see the new forms of spiritual quest which arise in our society as intrinsically trivial or privatized' (Taylor 2007: 507). For instance, Steve Bruce argues that the New Age is a form of religiosity suited to consumer society: instead of demanding that the believer follow a specific form of life, the New Age satisfies an elite (New Age adherents tend to be white, educated, and middle class) 'seeking uncommitted ways to consume non-material goods' (cited in Wood 2007: 30).

Taylor positions this as a social debate between those 'whose sense of religious authority is offended by this kind of quest, on the one hand,

and the proponents of the most self- and immanent-centered forms, on the other, each of which likes to target the other as its main rival' (Taylor 2007: 508–9). In short, the proponents present the battle as between a trivialized form of spiritual and traditional religious experience.

Accordingly, if one thought that what made religious belief worthy of protection was the 'deep' commitments of religious believers, in which the depth of a commitment was their preparedness to die rather than to compromise on a way of life set out in teachings and traditions associated with their religion, then one would also think that 'spiritual' beliefs of New Age believers were not worthy of protection. If this were the basis of a right to religious expression, it would privilege organized, social institutions over informal experience or gatherings, and tradition and dogma over experience or contemplation.

However, to adopt such a position is perhaps to deny that religious expression may be important as a special kind of valuing. Definitions of religion that focus on a religion's ethical nature or value structure may be developed into formal definitions – such as Tillich's (1958) belief that whatever one's religion is, it must be one's ultimate concern, or Frederich Ferré's reformulation of this as a way of valuing that is the most intensive (of ultimate value) and comprehensive (this second qualification requires that the object of the valuing be valued as pervasively important throughout all aspects of life) (Ferré 1970: 11). As Taylor characterizes the New Age, participants are looking for a direct experience of the sacred and for greater immediacy and spiritual depth. Taylor describes those who identify with spirituality, as opposed to institutionalized religion, as stressing personal integrity and unity, and a relation with the world that concerns harmony, balance, and flow (Taylor 2007: 507). Applying Ferré's account of religion, New Age valuing is both ultimate and comprehensive, and it is therefore a religious valuation. However, it seems that this approach will fall foul of the same fault for which Tillich's definition has been criticized. That is, focusing on a person's most intense (or ultimate) value does not only identify those values we might consider religious. People whose most intense, ultimate value is their football team may organize their entire life around the rituals of football games and following a specific form of life. A person may feel, most intensely, a loyalty for a football team, or for politics, and Ferré's qualification, that this valuing should be comprehensive (and not isolated) does not seem to help us isolate some activity that is specifically religious.

The value of a religious belief does not depend on whether a religion has been in existence a few years or a thousand years, has a loose or hierarchical

institutional structure, or has an explicit leader or set of teachings. This is because, as believers assure us, what is important about religion is that it is a true account of the world and the good life. Yet in the end, it appears that the protection of religion is based on whether a group has a certain kind of history and institutional structure rather than on the value of a specific kind of belief. If it is correct that the secularisation thesis is false, as many people have argued, and that there is no decline in religiosity in Western societies but only a decline in organised religion, then a right to religious freedom, where *religion* means 'the subset of religious expressions involving ritual practices with a continuous history and an institutional framework that establishes correct belief' is highly problematic.

The definition of religion as a value cannot give us a coherent explanation for our preferences, nor can it supply a principled basis for making determinations among religions. This is also true of definitions used within anthropology and archaeology. Definitions of religion in the social sciences are generally taken to be either substantive or functional. Substantive definitions identify some substantive feature or set of features that may be considered as necessary, or sufficient, to consider something to be a religion. Functionalist accounts, in contrast, are concerned with the social role that a religion plays.

In a substantive definition of religion the attributes of a religion are enumerated. For example, the *Encyclopaedia Britannica* (1994) picks out a number of features in its definition: 'Religion is commonly regarded as consisting of a person's relation to God or to gods or spirits. Worship is probably the most basic element of religion, but moral conduct, right belief, and participation in religious institutions are generally also constituent elements of the religious life as practiced by believers and worshipers and as commanded by religious sages and scriptures'. One of the earliest substantive definitions was provided by the anthropologist Edward Burnett Tylor (1832–1917), who believed that religious ideas developed out of 'primitive' beliefs in the animate nature of the natural environment. Tylor defined religion as 'belief in spiritual beings', where those beliefs are simply a mistaken attempt to explain the phenomena of the physical world (Bowie 2006: 4). Tylor's definition has been considered as inadequate partly because of its intellectualism – Tylor viewed religion as a kind of explanation of cause and effect, as though it were a variety of a scientific practice, and because it cannot account for practices that are widely believed to be religions yet do not fall within this definition, for example, in Buddhism (see Herbrechtsmeier 1993). Tylor and other evolutionist thinkers, such as James Frazer and Baldwin Spencer, who equated religion

with magic, devalued Aboriginal religions against the standard of Christianity (Charlesworth 2005: 1). Similarly, despite his unwillingness to provide a formal definition of religion, the sociologist Max Weber worked with a substantive definition concerned with the content of religion – its ethical nature that allows us to describe a religion as 'a way of life'. For Weber, a religion is a belief system that does not mirror the context in which it exists, although it may be influenced by this context and in turn influences the economic and social structures of society (Davie 2009: 174). But again, such an account emphasises a way of life established by authority and followed as a matter of orthodoxy.

The most influential functionalist account of religion was given by Émile Durkheim in *The Elementary Forms of the Religious Life* (1912). Durkheim stated, '[A] religion is a unified system of beliefs and practices relative to sacred things, that is to say, things which are set apart and forbidden – beliefs and practices which unite into one single moral community called a Church, all those who adhere to them' (cited in Davie 2009: 175). For Durkheim, the function of religion is to reinforce or sanctify the social bond. From this perspective, it is the collective rather than the sacred itself that is most important element of a religion.

The functionalist definition of religion offered by Durkheim provides a strong link between the maintenance of religion and cultural identity. On this account, the reason it is important to protect indigenous people's religious beliefs is not that the content of beliefs matters (in terms of a truth about the nature of the world); what matters is the holding of the beliefs and the ritual or ceremonial maintenance of them. Although Durkheim's theory of totemism has been rejected, it has profoundly affected the way in which people think about indigenous cultures. In particular, they are described as holistic, without a separation of religion and the state or of religion and law. It might be said of the worldview of indigenous people in particular that such groups remain 'enchanted'. Such a functionalist account of religion suggests that indigenous groups will also have the characteristics of orthodox belief, and what Mary Douglas has called the myth of primitive piety – the supposition that indigenous groups are uniformly religious (Charlesworth 2005: 2–3). But just as Durkheim's account focused on the collective rather than the substance of the religious belief, there may be a corollary that what is of greatest value is not the religion or the belief but the identity of the religious group.

It has been argued that certain kinds of groups are of greater moral significance than others. The groups that are generally considered bearers of a special right to culture are those whose membership is governed by

involuntary criteria. In addition, these groups must be structurally complex, self-perpetuating groups. For instance, the category 'Aboriginal native' was the creation of the first government of the Commonwealth of Australia to administer differential rights. As a category, it was imposed on hundreds of diverse Aboriginal groups. The National Indigenous Arts Advocacy Organization was voluntarily established by Australian Aboriginal and Torres Strait Islander peoples but was established to further collective interests. The group Yolngu, however, is for the most part a group that is involuntary (one is born into it), and the group is self-perpetuating in that the members engage in complex rule-following activity that constitutes the collective (Coleman 2005: 130–2). Frances Svernsson has argued that it is the complexity of these self-collecting groups that qualifies them for special moral consideration (Johnston 1989), whereas theorists such as Avishai Margalit and Joseph Raz (1995: 85), who deny the existence of group rights, have argued what is important about these groups is that individuals' identities are bound up with them. So, in Durkheim's account, religion is constitutive of group identity. Accordingly, the religion of an indigenous person may be held to be 'more constitutive' of his or her identity than that of a New Age believer, who is not in such structured social relations with others. Therefore, in this line of argument, the reason we give greater consideration to religions with particular institutional structures (e.g., Christianity, indigenous religions) over others is that those organized religions are constitutive of people's identity.

But in response, it may be argued that this conception of something being constitutive of identity does not really address the issue of why we might privilege certain religious groups over others. An example of this is provided by the legal theorist Wojciech Sadurski (1994) in his discussion of the distinction between constitutive and instrumental groups. A Ku Klux Klan member might be more emotionally and psychologically affiliated with his organization than many other people are emotionally and psychologically affiliated with their religions or their nations. We do not on that account either seek to protect the Klan from scrutiny of their beliefs or recognize that it has special claims over objects or places it considers sacred. Sadurski concludes that the distinction we really make in such cases is not between constitutive and instrumental identities but about which groups we consider desirable. Sadurski continues, in cases in which we are being honest about our preparedness to engage in the value judgements about whose religious sentiments are worthy of protection, 'we must face the consequences of unrestrained majoritarianism': 'For example, we will disallow Muslim claims for special protection against blasphemy because

we value their religion less than other religions. We think that their religious claims, even if genuine, are somehow less worthy in our society' (Sadurski 1994: 81).

In calling this preference unrestrained majoritarianism, Sadurski criticises the preference as lacking a principled basis. This appears correct. I have argued that anthropological definitions of religion are interwoven with judgments about which group's religions are worthy of consideration. But equally, the accounts of why freedom of religion is important seem to imply a specific model of religion. This judgment about the desirability of groups is perhaps clearest in the difference between the treatment of Druid orders, with their Christian metaphysical framework and nationalistic sentiments, and, of course, their aristocratic links, and other invented traditions associated with Stonehenge by New Age travellers. Unfortunately, in privileging a certain group structure over a certain kind of belief, we seem to end up privileging the wrong kinds of things – tradition, authority, and orthodoxy – not because we think them more important than the substantive content of religion but because there is a historical and conceptual link that encourages us to do so.

If we are to be consistent in relation to our treatment of rights based on religion, we must treat New Age claims or reinvented traditions in the same manner as we treat the claims of people whose religion is culturally authentic. Both groups should have a right of access to places they consider necessary as sites of worship. But in determining the existence of such a right, it seems necessary to hold their claim accountable in relation to some kind of scrutiny. This does not necessarily involve judging whether the belief is true, but judging the existence of traditions or behaviours that would allow us to recognise that the belief is sufficiently important to be acted on in various ways. As Brown (2003) points out, these behaviours (e.g., an annual pilgrimage) may be evidence for a belief, even when the belief itself is a secret.

SOME CONCLUDING REMARKS

The way in which liberal states promote religious freedom is through the separation of church and state. Generally, it is argued, there should be no official religion, and accordingly, a state should not officially promote or prefer one religion over another, establish religious requirements for holding public positions, or interfere with or enforce religious observance (Davies 2008: 77). However, as I have shown, New Age religions or newly re-created traditions such as that of the Druids are considered less valuable

than religious traditions that have been in existence for thousands of years and that are associated with complex institutions that authorize specific practices and dogmas. Moreover, some states have particularly strong laws that seek to protect the sites associated with specific religions and the sentiments of believers within those religions. The notion of freedom of religion, as I have shown, supports this privileging of certain religions over others, not because one religious group is more deserving than others but because this model of religion is built into our concept of why this freedom is important, and we have a tendency to make substantive judgments concerning the value of different group identities.

The protection of heritage sites because they are 'sacred' is controversial. Any such protection appears to be a form of legal moralism: the position that law may be used to prevent or punish sin or immoral acts, regardless of whether the act involves harm to others. From the perspective of religious stewards or protectors of the land, certain kinds of uses of the land are inappropriate or morally wrong; although I hesitate to call the sacrilege of sites (though inappropriate use) 'sin' in relation to earth mysteries, Druidism, or indigenous religions, since the concept of sacrilege fundamentally involves the notion of taboo, or wrongful use of land. To believe that there is harm in such situations involves assuming the truth of the metaphysical system.

Legal moralism is widely accepted as an insufficient reason for legislation in liberal democracies (Feinberg 1988: 63). At the same time, however, it is intuitively recognized in cases involving the sacrilege of any religious building or site. For instance, media reports of vandalism to a church or graveyard almost always contain an element of moralism, in recognition that what has been vandalized is not merely property but sacred. Yet what is particularly shocking about such behavior is the wanton disregard of believers' feelings. That is, the agreement that such behavior is wrong, from the perspective of someone outside the religion, depends on the recognition that the behavior is profoundly offensive to believers rather than on an emic point of view. And at the same time, it can be recognized that profoundly offensive behavior may be justified when the action has social value to others (e.g., the exploration of archaeological sites) and has not been undertaken with spiteful motives (Feinberg 1988: 26).

The reason for the legal recognition of profound offense (through heritage law) in the context of a colonial settler society, I think, is fundamentally concerned with the recognition of the profound offense experienced by indigenous peoples when their views, values, and traditions have been systematically disregarded for centuries. What this suggests is that it is not

the case that there is a moral requirement for archaeologists to accept that some sites require protection because they are sacred or that some actions are 'wrong' because they are sacrilege. From the perspective of a nonbeliever, the ethical issues concern the avoidance of offence to others. This is a general principle that is not specifically about religion. Moreover, as indicated by the University of New Mexico's response to the Acoma, archaeologists need to respond to a more pragmatic concern, the need to avoid offending people – as recognizing the depth of feelings individuals have toward that which is sacred to them may be a necessary condition for their cooperation.

CHAPTER 10

Multivocality and "Wikiality"
The Epistemology and Ethics of a Pragmatic Archaeology

Alexander A. Bauer

A major contribution of the postprocessual critique has been its advocacy of "multivocality" in archaeological practice, debate, and the construction of narratives about the past. The idea that archaeological inquiry and conclusions should not exclusively be the domain of Western academicians but should involve local and descendant communities, artists, amateurs, and multiple potential "publics" may be seen as a way of developing a more democratic, and ultimately more responsible, archaeology. Practising a truly multivocal archaeology, however, faces ongoing problems in both theory and implementation. First, how can archaeologists adequately account for and synthesize many disparate – and perhaps incompatible – views? Are all perspectives and approaches equally valid? Second, how can archaeologists present different views without privileging certain ones at the expense of others? How can we instead make available the heteroglossia and polyphony (as conceptualized by Bakhtin [1981, 1984] and rearticulated for archaeology by Joyce [2002]) to be experienced and contributed to by all interested participants?

Although critical concern regarding the constitution of archaeological knowledge has been a significant feature of archaeology for the past thirty years or more, experimentation with, and advocacy of, multivocality has really only become prominent over the past decade. First articulated as a way to include the voices of different stakeholders in interpreting and presenting the past (e.g., Bender 1998), and featuring heavily in the "reflexive" framework of the recent Çatalhöyük project (Hodder 1999, 2000, 2005), multivocality has since come to mean the inclusion of different perspectives at all stages of the archaeological process, from the construction of research design; through project organization and execution; to publication, presentation, and curation of the materials and stories produced. As Joyce (2002) has discussed, what can be seen as two main dimensions of multivocality, the inclusion of multiple voices and multiple ways of knowing,

may be better understood as corresponding to Bakhtin's (1981, 1984) concepts of polyphony (many voices) and heteroglossia (different languages), respectively.

More recent engagements with multivocality in archaeology have thus shown a commitment not only to polyphonic representation or narrating of the past but also to heteroglossic epistemologies that seek more inclusive ways of investigating and knowing the past. Multivocality is no longer just about the dissemination of results – how we talk about the past in reports, reconstructions, and museum exhibits – it is an important factor in the constitution of research design and methods. Including inquirers and investigators with different knowledges, experiences, and perspectives in formulating research questions, developing hypotheses, and offering interpretations allows for a more holistic archaeology, thus providing a richer understanding of the past in the present. This view is exemplified by numerous collaborative projects in the United States and elsewhere, and by the rise of community archaeology (Marshall 2002; McDavid 2004a) and indigenous archaeologies (Smith and Wobst 2005b; Watkins 2000) as explicit approaches alternative to what had been standard archaeological practice.

At the same time, however, notes of caution have been raised about the limits of multivocality that, as with its postprocessual forebear, if unchecked will lead to a kind of Feyerabendian anarchism. Randall McGuire (2008), for example, recently stated that "in the absence of relational criteria to distinguish one voice from another, multivocality may be harmful, because it leaves the stage open for oppressive voices." Archaeologists, he argues, "should not wish to let every voice speak" (McGuire 2008: 63) because some are dangerous or seek to disenfranchise others. To remedy this, he advocates for a "relational multivocality" that "critically examines the power relations among voices and the consequences of each voice speaking" in order for archaeologists to "retain some authority" against interpretations that are "in error or immoral" (McGuire 2008: 63).

Although allowing voices of oppression to dominate discourse about the past is a serious concern (see also Kohl 2004), if in McGuire's version of multivocality archaeologists must have authority to determine what is and is not an acceptable interpretation, it does little to address the central goal of "sharing control of the past" (Zimmerman 1994b: 67). A relational multivocality that seeks to identify the power relations among interpretations cannot exempt archaeologists from such scrutiny. And surely there is a difference between immoral interpretations, which though difficult to define

universally might be worth marginalizing, and simply those one regards as erroneous.

An alternative approach to preventing unfettered relativism is offered by Alison Wylie (2008a), who suggests that competing narratives be evaluated in terms of the dual principles of empirical and conceptual integrity. Although most claims are at least based on specific (if local) standards of adequacy, problems in evaluating, comparing, and even integrating divergent claims arise if their warrants are incompatible with each other. To avoid such incommensurability, competing interpretations should at least follow basic evidentiary standards and coherence of argument. In other words, claims should take account of the data available and be "reasonable," even if what that means exactly "must be held open to revision" in light of new data as well as through "engagement with epistemic communities that have evolved different standards of empirical and conceptual integrity" (Wylie 2008a: 208). Although Wylie's assertion may seem on the surface to be vulnerable to a similar criticism as McGuire's for privileging Western standards of evidence and argumentation over other claims, her view relies on a premise of cognitive rather than epistemic unity. And it is from this point that an invocation of the pragmatic philosophy of Charles Sanders Peirce (1839–1914) becomes valuable.

In this chapter, I wish to suggest that the semiotic writings of Charles Sanders Peirce provide a framework for how to employ and integrate multiple interpretations and seemingly incommensurable perspectives. More than this, however, the chapter provides a coherent philosophical rationale for employing heteroglossic polyphony in our attempts to understand how the world works, past and present. As a metapragmatic framework, Peircean semiotics deprivileges specific knowledge claims and instead suggests that all claims and inferences are equally effective at advancing interpretation and understanding of the past. Indeed to Peirce, all methods of inquiry, including guesswork, are equally valid and productive, and it is through expanding the overall community of inquirers and the range of ideas we consider that we can get closer to understanding the world fully. Building on this insight, this chapter argues that new interactive modes of knowledge formation and representation such as wikis – websites that allow anyone to create or edit them – may serve as ideal vehicles for a Peircean approach to inquiry about the world. As an inclusive, nonfoundational, and community-based approach to knowledge, Peircean pragmatism, mediated by new information technologies, may thus provide a way to bring together multiple participants and perspectives to produce a democratic, multivocal archaeology.

GUESSES, REASONING, AND PEIRCE'S FINAL INTERPRETANT

In a now-well-known unpublished paper, probably written in 1887, titled "A Guess at the Riddle," Peirce declared his goal to develop a theory of knowledge "so comprehensive that, for a long time to come, the entire work of human reason . . . shall appear as the filling up of its details" (Peirce 1992: 247).[1] His semiotic, or theory of signs, has served as the basis for recent discourse-based analyses in linguistic studies, but its influence on other fields such as logic, mathematics, music, physics, and literary criticism, as well as other subjects more closely related to archaeology – architecture (Broadbent 1980, 1994; Eco 1980), sociology (Gottdeiner 1995), and anthropology, among others (Sebeok 1978) – suggests that its applicability might indeed be as broad as he had thought, in spite of the density of Peirce's writing and the fact that most of his papers were never finished or published. In archaeology its utility is becoming increasingly apparent since its introduction a decade ago (Preucel and Bauer 2001), and it has been applied to a range of archaeological problems (see, e.g., Agbe-Davies 2010; Aldenderfer 2011; Cipolla 2008; Crossland 2009; Joyce 2007; Watts 2008). It may be particularly useful as a method of interpretation in archaeology because it neither suffers from the positivist universalizing tendencies of functionalism or structuralism nor follows the unanchored relativism of the deconstructionists (Bauer 2002; Preucel 2006).

The details of Peirce's sign system, most famously his trichotomy of icon-index-symbol, and its application to archaeology, have been explained at length elsewhere (Lee 1997; Parmentier 1994, 1997; Preucel 2006; Preucel and Bauer 2001), and it is not necessary to repeat here. What I wish to focus on instead are Peirce's ideas about argumentation and his notion of the *Final Interpretant*. I argue that not only does Peirce's framework allow us to bridge and synthesize alternative conceptions and claims about the past (Bauer and Preucel 2000; Preucel 2006), it also provides a clear rationale for multivocality as a method of inquiry. Finally, I want to discuss a possible method for representing that multivocality in narratives about the past, which has been an area of concern for archaeologists, which I believe follows a Peircean model.

A key feature of Peirce's semiotic is his focus on methods of argumentation. In broad terms, he rejected both induction and deduction as only partially describing how people actually interpreted the world and instead

[1] For interesting discussions of the development of Peirce's philosophy, see Fisch (1978) as well more biographical accounts by Brent (1998) and Menand (2001). Menand in particular explores the relationship of pragmatism to democracy, which is also relevant to the present discussion.

coined the term *abduction* for the process by which people developed understandings of the world through their experience of it (Peirce 1998). Not unlike Wylie's (1993) discussion of "tacking back and forth" between theory and data, or Hodder's (1999) notion of fitting theory and data to each other, abduction is the process of reaching a conclusion based on reasoning that is mediated between the observed phenomena with respect to the prior chains of signification that shape it. As with many of Peirce's ideas, abduction is a meditative (third) position that incorporates both inductive and deductive reasoning: like induction, abduction suggests deriving a conclusion based on previous observation and experience, and like deduction, it is "predictive" as a probabilistic explanation of phenomena. It largely follows what Hanen and Kelley (1989) have called "inference to the best explanation." What Peirce illustrated through his exploration of abduction is that all reasoning, no matter the explicit epistemological claim being made, is developed through abduction.

In our very own unpublished paper, Robert Preucel and I explored the universalism of Peirce's model with specific reference to archaeological reasoning (Bauer and Preucel 2000). In our analysis, we scrutinized Binford's (1981) methodology of middle-range theory with Hodder's (1990) hermeneutics and concluded that regardless of the particular claims being made, both methods relied on a meditative process of semiosis akin to Peirce's abduction (see also Fogelin 2007; Kosso 1991). Although disunity of interpretation might exist among the specific claims being made, it is clear that unity operates on the level of reasoning. The implications of this are significant for multivocality: if divergent claims nevertheless share methods of reasoning – and the claim here is that cognitive unity exists in all human interpretation – there is increased potential for us to engage with and integrate multiple, if conflicting, views in our understandings of and inquiry into the past.

Peirce himself explored at length the implications of his conclusion that all argumentation and interpretation about the world followed abductive reasoning. If all inference is abductive, then any and all methods of inquiry are equally valid and potentially productive for advancing knowledge. In fact, one of the interpretive methods most ardently defended by Peirce is guesswork, which he regarded as vital in several stages of the interpretive process. In an 1895 paper on logic titled "Of Reasoning in General," Peirce (1998: 25) writes that "knowledge must begin somewhere as well as it can" and to narrow the interpretive possibilities for what something means, "we have to begin with some guess." But more than simply acknowledging that guesswork has its necessary place in the process of inquiry, he goes on in later work to provide a philosophical rationale for why guesses, as a type

of inference, are legitimate forms of reasoning. For Peirce, interpretation is a matter of determining which inferences seem "reasonable" and which don't, on the basis of prior knowledge and inquiry. Following notions of probability, when offering new "reasonable" explanations as new knowledge is discovered and old explanations are cast aside, "any decided tendency to guess right ... will get at the truth at last" (Peirce 1998: 250).

This idea of eventually getting at the truth, which Peirce called the "Final Interpretant," is one that he elaborated on in a series of letters to William James in 1909 (Peirce 1998), and it stems from his main theory of the semiotic process. Within his general theory of semiosis, the interpretant is the understanding of a sign in the mind of the interpreter of that sign. Because for Peirce all interpretation is mediated and one cannot directly access the external world beyond one's experience of it, the interpretant in fact is our understanding of a sign as we perceive it to be. The Final Interpretant in turn results from the repeated and cumulative inquiry into the meaning of something, and it may be defined as its generally agreed-on ("true") meaning after sufficient inquiry by the community of inquirers – a concept not unlike the ideal speech community central to Habermas's (1984) communicative action theory (see Bernstein 1985: 3). In a sense, then, the Final Interpretant represents the end of inquiry, an ideal but likely never attainable moment when the understanding we have about something in the world perfectly agrees with its actual existence "out there" beyond our cognition of it.

Philosophically, the concept of the Final Interpretant raises two issues that require clarification here. First, its ontological necessity within Peirce's philosophy as a consensus view in the end does not imply that the interpretive process itself is or should be convergent and consensus driven rather than divergent and pluralistic. On the contrary, Peirce's semiotic and other writings foreground the importance of exploring and engaging with a variety of perspectives and possibilities of meaning (in fact, his thinking largely derives from his interest in variation and chance), recognizing that each individual instance of interpretation is context dependent and "situated" (see Haraway 1988). As such, even a single person's understanding of a single sign in the world is crucially dependent on that person's many different engagements with and interpretations of that sign through his or her lived experience, and it represents less a "consensus" understanding than a cumulative one.

Take, for example, a single sign such as a kite flying. Even for a single individual, such a sign might fairly be interpreted to represent the object it resembles and/or mimics (say, a bird), or it may indicate the presence of a person flying it (if, for example, it was flying off in the distance, one

might surmise that a person was below it holding the string), as well as the presence of the wind to hold it aloft. More abstractly, the flying kite might mark the advent of summer, or good weather; or going further, it might represent family outings, particular memories, or even childhood in general. If a single individual with a specific cultural perspective might legitimately interpret the kite in such a diversity of ways – none of which is better or more accurate than the others – then certainly a more complex object, idea, or history will have that many more meanings for a wide range of people whose backgrounds and experiences are different. For Peirce, the Final Interpretant was a way to conceptualize "truth" through encouraging dialogue and divergent interpretations, but he always recognized that all signs have multiple meanings, each of which cannot be privileged over the others.

Related to that last point, Peirce's view of truth should be distinguished from those of other pragmatists, and Peirce himself might be more appropriately called a realist than a pragmatist in the sense advanced by William James and developed by Dewey, Mead, and later Rorty and others. Although they were friends and correspondents, and James attributes the idea of and term *pragmatism* to Peirce, Peirce felt that James misunderstood his views (for a nice discussion of their relationship, see Menand 2001). Fundamentally, although James emphasized internal coherence of argument and felt that discovering some sort of external truth was impossible and thus irrelevant, Peirce felt that it was important to acknowledge that there was an external world out there constraining interpretation, even if we could not access it outside of our own mediated experience of it. The understanding of the world encapsulated in Peirce's Final Interpretant is necessarily a socially mediated one, rather than one warranted through reference to an external world, which Peirce believed was impossible (a core point of all pragmatic approaches). Where Peirce departs from other pragmatists is in his concern with the existence of a physical world beyond our experience of it. Although later pragmatists may have regarded the external world as irrelevant or nonexistent, Peirce felt that although such externalities cannot be accessed beyond our experience of them (and like other pragmatists, he rejects the objective-subjective dualism; Peirce 1992), the world does present constraints for our interpretations, and thus in the end, interpretation is not purely a matter of internal coherence or usefulness.[2]

[2] For archaeology, Peirce's approach thus seems similar to what Shanks and Tilley (1987: 104) called the "network of resistances" to interpretation, and the more recent approach called symmetrical archaeology, which acknowledges the importance of the material world (alongside the cognized one) in shaping understanding and experience (see Witmore 2007).

The concept of the Final Interpretant has important implications for evaluating and promoting multivocality as both a goal and a method. As has already been recognized, collaborative, community-based, and indigenous archaeologies have provided us with a richer understanding of the past (and as discussed here and elsewhere [e.g., Bauer 2002], a Peircean model of knowledge provides a way to integrate such multiple and different interpretations and perspectives). The idea in Peirce is that that richer understanding of the past, made possible by the expansion of the community of inquirers and the inclusion of more claims and ideas about the past, whether derived through hypothesis testing, guesswork, collaborative experimentation, phenomenology, storytelling, and so on, will drive inquiry and lead us to develop a better understanding of the world and come closer to a "true" representation of what the past is all about.

A Peircean view thus gives philosophical and scientific legitimacy to the aim and goals of multivocality. It deprivileges Western scientific reasoning and disabuses it of its claim to be uniquely rational, as for Peirce all methods of reasoning are essentially abductive, and all forms of inquiry contribute to the eventual discovery of truth. In addition, the expansion of the community of inquirers and the inferences made will serve to increase our chances of getting at the truth. In other words, multivocality is not just good ethical practice, although it may be, because it democratizes and opens up discourse the way Hodder (2008) and others consider vital. From a Peircean perspective, multivocality is in fact good science as well.

MULTIVOCALITY IN NARRATIVE AND PRACTICE

A major issue in contemporary theorizing about multivocality is the problem of how to provide space for multiple and often competing claims that do not privilege any one view and that can present such claims explicitly and in narrative form. In her 2002 book *The Languages of Archaeology*, Rosemary Joyce focuses on the issue of multivocality in narrative and, following Bakhtin (1981, 1984), unpacks multivocality into two constituents of heteroglossia and polyphony. Although *polyphony* means "many voices" and may be equated with the immediate association of multivocality as being the inclusion of many speakers, *heteroglossia*, according to Bakhtin (1981), is "multiple languages," and the distinction is an important one. To employ multivocality in a way that is productive for advancing knowledge in the Peircean sense, we want to expand the community of inquirers to include as many different perspectives and ways of knowing as possible (see also Bauer 2002).

How to do this both practically and in a way that avoids privileging some views over others (or silences unwanted views) is where things get difficult. In an important early experiment with multivocal exhibit curation, Barbara Bender (1998) presented Stonehenge through the different perspectives of the several interest groups that had made claims to it, including free festivalers, Druids, archaeologists, and the British government, devoting separate panels of the display to each group's views. In addition, she left room at the end for visitors to add their own comments and reactions, which were subsequently incorporated into additional panels of the exhibit as it traveled.

Although experiments such as Bender's present multiple perspectives, they still treat the viewer of the exhibit as largely passive (except in soliciting feedback at the end). As an alternative, some have experimented with nonlinear methods of presenting materials as a way of both recognizing and encouraging that people actively create their understandings of the world as they experience it (Bauer 2002; Pearce [1990] 1994). Recent advances in computer technology have led to the development of hypertext (and by extension to media sources beyond text, hypermedia) as a way to organize, present, and navigate among data and other information sources. Hypertext enables cross-referencing and linking to other materials and information in a nonlinear "branching and responding" manner impossible in traditional, linear text formats (Nelson 1993). The most commonly known example of hypertext and hypermedia organization is the World Wide Web itself, where linking among web pages and other media is easily navigable by simply clicking on hypertext links.

Rosemary Joyce presents a discussion of the possibilities offered by hypertext for organizing and presenting archaeological information through the hypermedia presentations described in her book by Lopiparo (2002) and Joyce, Guyer, and Joyce (2002). If museum displays themselves are inherently nonlinear because of their spatiality – Joyce, Guyer, and Joyce (2002: 114) in fact call them a "nonelectronic form of hypertext presentation" – hypermedia, the computer-based interface that allows for linking and moving between multiple ideas in nonlinear and unranked ways, Jeanne Lopiparo (2002:78-9) argues, achieves Barthes's (1975:45) ideal of the "triumphal plural" text, in that it explicitly allows for the reader-visitor of a text to take part in producing it as well as consuming it.

The potential of hypermedia for multivocality is not limited to museum presentations; it has even been explored with regard to the presentation of more academic arguments. Long before hypertext had become commonly known as a building block of the World Wide Web, Stutt and Shennan

(1990) suggested using artificial intelligence and other computational forms of metatext to present the structures of arguments and the metadiscourse of disagreement among participants. And before this, Jean-Claude Gardin (1980) had proposed using computer-based expert systems to represent archaeological reasoning. Gardin's work, heavily influenced by the structural semiotics of Saussure and Eco, aimed to systematize archaeological argumentation to make arguments more explicit and thus comparable, but it did not explicitly address multivocality or disagreement in the way Stutt and Shennan did.

In the late 1990s, Cornelius Holtorf and Carol McDavid developed PhD dissertation projects that sought to explore the potential for hypermedia for representing archaeological research (Holtorf 2000–8; McDavid 2002). Holtorf proposed and completed his thesis, substantively on prehistoric megaliths in Germany, as a hypertext document both to look at the potential of the medium for archaeological research and to highlight the nonlinearity and intertextuality of research, inference, and writing. McDavid's thesis, using her archaeological project at the Levi Jordan Plantation in Texas as a case study, was more focused on how hypermedia and the Internet in particular could be used to transform archaeological engagements with communities outside the discipline and encourage discussion and feedback, similar to Bender's experiments with the Stonehenge exhibit. A website developed alongside her thesis aimed to present her research in a way that was accessible to interested readers and that solicited responses through an online questionnaire and feedback form.[3]

Although these experiments with hypermedia represent important advances in the construction of multivocal narratives and presentations of data, two problems remain largely unresolved. First, these examples, even the more strictly academically oriented one of Stutt and Shennan (1990), focus on the potential for hypermedia to present contrasting or multivocal interpretations of data, which for archaeologists is the past as we understand it. But as discussed earlier and by Hodder (2008) and others, multivocality is not simply about presenting multiple narratives; it is about opening space for diverse perspectives at all stages of the archaeological process, including research design and hypothesis construction. Second, there remain problems of inclusiveness and control of discourse: who controls what gets included in the narrative, the data presented, and the links made? Even if the experience is nonlinear, allowing viewers to play a role

[3] Carol McDavid, "Levi Jordan Plantation Home Page," at http://www.webarchaeology.com/html/ Default.htm (last accessed July 9, 2010).

in constructing their experience of the data, there is in this format still limited opportunity for feedback and contribution to the narrative (see Landow 1997). As Lopiparo (2002: 77) asks, is a hypermedia presentation "elaborately constructed" by a single author "*really* polyphonic or merely 'multiple instances of the same language'"?

WIKIALITY AND THE FINAL INTERPRETANT 2.0

Since the publication of Joyce's (2002) book, new developments have taken place on the Web that have effectively transformed it from being a place for information storage and dissemination to one facilitating interaction and information creation. These new applications – collectively referred to as Web 2.0 – include blogs; wikis; social-networking and media-sharing sites; and other technologies for interactive, user-generated discourse and the development of networked social forms (O'Reilly 2005). Although a comprehensive discussion of the interactive possibilities of Web 2.0 is beyond the scope of the present chapter, it is worth noting that it is already having an impact on archaeological and museum practice (Webmoor 2007, 2008; Wong 2011).

Perhaps the best known of the Web 2.0 media is Wikipedia, the self-proclaimed "free encyclopedia" whose entries, following the typical structure of wikis, may be written and edited by anyone interested in doing so. Begun in 2001 by Internet developer Jimmy Wales, philosopher Larry Sanger, and others, as of June 2012, Wikipedia exists in 285 languages, and the English-language version boasts almost 4 million articles.[4] New entries are added by users every day.

Because Wikipedia entries may be altered and edited by anyone almost instantaneously, the accuracy or "truth" of information contained in the entries is a common concern. In academic practice – as many of us tell our students – citing Wikipedia for information is not appropriate because it is not a scholarly source, and the information in each entry may change from moment to moment as users add to and modify existing entries. What satirist Stephen Colbert has termed *wikiality* refers to the ever-changing and changeable "reality" of the world according to Wikipedia because its content can continually be manipulated.[5] To illustrate his point, he

[4] See "Wikipedia:About – Wikipedia, the free encyclopedia," at http://en.wikipedia.org/wiki/Wikipedia:About (last accessed June 7, 2012).

[5] See "Wikipedia in culture – Wikipedia, the free encyclopedia," at http://en.wikipedia.org/wiki/Wikipedia_in_culture#Wikiality; "Wikiality: The Truthiness Encyclopedia," at http://wikiality.wikia.com/Main_Page (last accessed June 8, 2012).

reported the good news that the population of the endangered African elephant had tripled in the past year, according to its Wikipedia entry – data that he claimed to have changed himself in the entry moments before reporting it. Because Wikipedia's content can be altered by anyone and does not have "experts" to act as gatekeepers to check and edit entries (although some users have been given administrator status), it is largely considered an unreliable source.

And yet if it is so unreliable, why do so many people, myself included, routinely turn to Wikipedia for information? Although this may be because of the economy of the truth it offers – the speed and ease of getting "an answer," regardless of whether it is the "right" answer – I don't think such an explanation is sufficient.[6] If its content were routinely found to be inaccurate, Wikipedia would quickly lose its audience. Rather, there are features built in to Wikipedia that allow visitors to assess for themselves how much they will trust the information in each entry, thus giving users a sense that they can distinguish the reliable from the unreliable.[7]

As with many other encyclopedias and secondary sources, most Wikipedia articles contain multiple citations for the information they contain and bibliographies for further reference. These sources may include other web-based media as well as academic works that have gone through peer review. Unlike print encyclopedias, though, the citations often provide links to the source material so that a reader can immediately access it and read it for him- or herself, a feature that online academic databases and journal publishers have recently begun to implement as well.

But it is the collective authorship of Wikipedia that provides additional and unique mechanisms for ensuring reliability and that has particular salience for the present argument about multivocality. First, as easily as changes to the text can be made, they can be undone, so that when incorrect or unsourced information is added to an entry, such as in the case of Colbert's elephants, other users will quickly undo or correct the text, in a kind of collective policing of content. A 2009 study showed that 50 percent of all Wikipedia "vandalism" was corrected within four minutes of its appearance (Cobb 2009). Second, wikis often contain metatext and/or metapages, where commentary on the entries themselves may be added

6 This point was made to me by Matthew Johnson during discussion at the Theoretical Archaeology Group conference at Brown University in 2010. Although the issue of the economics of truth in Wikipedia is an important one deserving further exploration, I do not think that it is central to my argument here.

7 In fact, a 2005 study by the journal *Nature* found that Wikipedia was comparable to the well-respected *Encyclopaedia Britannica* in the accuracy of its science entries: see Giles (2005).

and viewed by users. In Wikipedia, entries with undersourced or disputed content may be flagged as such so that readers will see notes warning them that the content has not been universally agreed on by other users.[8] In addition, metapages exist for many entries, thus allowing users to read and take part in discussions and debate about content (for example, when the contributions of multiple authors in a single entry conflict with one another), as well as see all prior versions of the entry itself, to see what changes have been made to it over time.

Because of the collective authorship, the interactive features, and the potential lack of gatekeepers, the wiki format (if not Wikipedia itself) is promising as a truly democratic and inclusive vehicle for multivocality, and it may allow for precisely what Peirce argued regarding the Final Interpretant. A core problem in producing multivocal texts and knowledge is how to provide space for different voices to speak and be heard in a way that doesn't, from the start, privilege certain voices over others (Joyce 2002). Because wikis may allow any users to generate content, an unlimited number of participants may contribute to a wiki-based narrative or multiple or complementary narratives on the same wiki page. In fact, given the open-endedness of wiki software, users may be creative in how their narratives are structured and represented in relation to other narratives: one could choose to add text to a single entry or instead could create multiple, parallel entries that intersect with one another at different points in the texts. At the same time, the collective authorship allowed by wikis can promote consensus building (in which users wish to work toward consensus) as unacceptable narratives can be removed, leaving only those elements generally agreed on by the community of participants (see Habermas 1984) in the final text.

Wikis are thus an almost perfect manifestation of Peirce's Final Interpretant, as through the involvement of a broad community of inquirers, using any and all manner of inquiry, we may get closer to understanding the world as it really is (even if we get off course along the way). And although Colbert defined *wikiality* as "truth by consensus" – he satirically called it "bringing democracy to knowledge"[9] – the wiki structure does promote a nonfoundational approach to inquiry and knowledge, much in the way that Peirce (and other pragmatists) envisioned. It thus offers promise for advancing competing multivocal understandings of the world in a way that

[8] See "Wikipedia:Policies and guidelines – Wikipedia, the free encyclopedia," at http://en.wikipedia. org/wiki/Wikipedia:Policies_and_guidelines (last accessed June 9, 2012).

[9] "Wikiality" was presented as "The Wørd" on Stephen Colbert's show of Monday, July 31, 2006. See "Wikiality: The Truthiness Encyclopedia" at http://wikiality.wikia.com/Wikiality (last accessed June 8, 2012).

many archaeologists have been seeking, as both a better method of representing the cacophonous and nonlinear archaeological process itself and as the integration of archaeological knowledge with other ways of knowing the past (see also McDavid 2004a).

WIKIS AND MULTIVOCALITY IN ARCHAEOLOGY

It should not be surprising that experiments with using wikis in archaeology have already begun. Two broad, collaborative, and interactive archaeology projects began in 2008, the Open Archaeology Collection based at the University of California, Berkeley,[10] and WikiArc, the Wiki Archaeological Information Resource, based in the United Kingdom.[11] Although only the latter is a wiki, both are meant as repositories to facilitate information sharing for teaching about archaeological research and practice. Similarly, the Working Group on Open Data in Archaeology has a new wiki, launched in 2010, which is meant as a place for archaeology professionals to discuss and exchange ideas about data sharing and how to make archaeological research "open."[12] Although this wiki is mainly a place for professionals to discuss a particular method of archaeological practice, and is not itself about presenting knowledge about the past, it is set up to facilitate the inclusion of multiple voices in an open exchange of ideas, as wikis are meant to do.

In an almost inverse way, the ArchaeoWiki, set up in 2005 by Paul James Cowie, a graduate student at Macquarie University, features entries on archaeological sites and topics in a classic wiki format, presenting current knowledge about the past in each entry and complete with cross-references and bibliographies, similar to Wikipedia.[13] Because it is written by a single individual, the wiki is understandably limited in scope (to sites in the ancient Near East and Egypt). But also because it is a single individual's, the site is not really a wiki at all, except in its format. Rather it is little more than a web-based, single-authored encyclopedia that is limited in scope. In fact, Cowie explicitly states on his "Community Portal" page of the site, "Archaeowiki.org is not open to contributions or editing by the

[10] See Open Knowledge and the Public Interest group, "Open Archaeology Collection," at http://okapi.berkeley.edu/openarchaeology (last accessed May 17, 2010).

[11] See "WikiArc/ The Wiki Archaeological Information Resource," at http://www.wikiarc.org/ (last accessed May 17, 2010).

[12] See Working Group on Open Data in Archaeology, "Working Groups/Archaeology – Open Knowledge Foundation Wiki," at http://wiki.okfn.org/wg/archaeology (last accessed May 17, 2010).

[13] See James Paul Cowie, "Main Page – ArchaeoWiki," at http://www.archaeowiki.org/Main_Page (last accessed May June 9, 2012).

general public – this feature, common to many wikis, has been deliberately disabled in order to protect the veracity of information offered on the site."[14] As a result, this project, though admirable for other reasons, does not advance the kind of multivocality about the past I am arguing for here.

More in line with a pragmatic multivocality is the wiki Timothy Webmoor, at the time a graduate student at Stanford University, set up in 2004 for his dissertation project on Teotihuacán (Webmoor 2007).[15] A core component of his dissertation was to explore the potential of new media in processing, accessing, and controlling data information in archaeology, and in fact, his dissertation was presented "digitally" in the form of a wiki-based website, replete with the open editing capacity for anyone who wished to contribute. As he explains in the introductory page,

[This dissertation] will not solely attempt a collaborative approach to my project – with input from archaeologists and interested community members from the Valley of Teotihuacan (6 local communities) – but will attempt to render the textual grist of the dissertation in a multiple-media format through this wiki forum. Importantly, two concepts of mediation are employed: one . . . will critically reconfigure the debilitating framework of "Multivocality"/"Pluralism" for archaeological research. The other idea of "mediation" derives semantically from the "media" you are engaging with right now, in that the digital "wiki" forum augments and renders interactions with archaeological subjects in a different and specific manner than other technologies, . . . the past is mediated (active verb) in and for the present in various ways depending not solely upon the informing epistemology, but upon the modes of assembling the past in media for argumentation and visualization in contemporary pursuits.[16]

Although the authorship of the dissertation text remained his own, Webmoor did use the functionality of the wiki platform for its ability to enter and store information remotely on a continual basis (so from the field, he could modify his page hosted at Stanford) and to make the wiki open to comments and editing from other users.[17]

[14] See James Paul Cowie, "ArchaeoWiki:Community Portal – ArchaeoWiki," at http://www.archaeowiki.org/ArchaeoWiki:Community_Portal (last accessed June 9, 2012).

[15] The dissertation pages remain online. See Timothy Webmoor, "Reconfiguring the Archaeological Sensibility: Mediating Heritage at Teotihuacan, Mexico" at http://humanitieslab.stanford.edu/Teotihuacan/Home (last accessed June 8, 2012).

[16] Timothy Webmoor, "Reconfiguring the Archaeological Sensibility: Mediating Heritage at Teotihuacan, Mexico: Home," at http://humanitieslab.stanford.edu/Teotihuacan/Home (last accessed June 8, 2012).

[17] In my own exploration of the site, I was easily able to comment on or even edit the pages themselves, following Webmoor's instructions on how to do this. But few users seem to have contributed comments, however, and only in the context of the "Cuestionario" page. Webmoor (personal communication, June 1, 2010) speculates that this is because most visitors learned of the

In many ways, then, Webmoor's project stands out as productive model with the wiki format, and it suggests important new directions for experimentation with both knowledge construction and representation in archaeology.

A second wiki worth mentioning is the interesting wiki-based archaeological research report of a project at South Aniakchak Bay Village, Alaska, developed by faculty and students at Hamline University.[18] This research report developed out of a laboratory analysis course at Hamline in which students researched and analyzed materials from Aniakchak and then posted their results to the project's wiki. As with other wikis, the report represents the collaborative work of the many individuals taking part in the project, and the wiki structure allows for the direct input of multiple users as well as comments and input from outside participants. Like Webmoor's dissertation, it is not clear that many outside users have in fact contributed (the "discussion" section on each page is empty), which is too bad, especially given the potential connections between the Aniakchak site and native Alaskan communities. But as an example of an open and collaborative archaeological research project, the Aniakchak wiki provides an interesting model.

For all the promise that wikis may hold as vehicles for both heteroglossia and polyphony in archaeological research and writing, they are not without their methodological and theoretical pitfalls. On a superficial level, any website that allows contributions from any user may be overrun by nuisance or prank contributions, which make productive and open discourse difficult.[19] Of course, what constitutes nuisance participation may itself be open to interpretation and may be dealt with in different ways. Webmoor, in his dissertation wiki, allows anyone access to comment or edit the pages, but he requires users to key in a password he makes available on the site itself to prevent spam and other automated Internet activity from disrupting the site. In contrast, and as mentioned earlier, Cowie prevents all users from making their own changes and instead asks visitors to send potential edits and comments to him directly, so that he can "protect the

website through the questionnaire survey and so may have felt more inclined to post there, and he acknowledged that the lack of a clear discussion or commentary page was a flaw.

[18] See Brian Hoffman, "Introduction to the Aniakchak Archaeology Wiki," at http://aniakchak. wikispaces.com/Aniakchak±Introduction (last accessed June 9, 2012).

[19] Carol McDavid (2002b) discusses many of the issues raised by discussion forums and other feedback mechanisms in her PhD dissertation, in which she examined the feedback posted on her own project's website as well as that of the new Çatalhöyük project, the archaeology pages of the online informational website About.com, and the discussion forums of the BBC television series *Time Team*.

veracity of information" presented. Although "open" sites may of course be hijacked by users with unsupported, bizarre, and even malicious views, the line between unacceptable and acceptable contributions can become murky when competing versions of the past are at stake. As illustrated by the Kennewick Man case,[20] non-Western ways of understanding history may be deemed "unreliable" sources of evidence, echoing sentiments about Wikipedia, and thus unwelcome in an archaeological database, whereas privileging data gathered through Western scientific methods may be considered another instance of the symbolic violence wrought by the West's hegemony over other people's lives.

How wikis are then moderated or policed for content raises related issues. In sites run by an individual or small group of collaborators, final determination of what constitutes acceptable multivocality will be only as broad as that individual or group conceives it. Although such a structure may not be limiting, as long as the group decides to conceive of the concept broadly, the power to control discourse still resides in, and depends on, a small number of executives. On the other end of the spectrum, the community-policing or truth-by-consensus strategy of Wikipedia and other community-based fora allows for potentially limitless contributions and voices, without being funneled through any gatekeepers, thus opening up the possibility that ideas never conceived of by an entry's creators will emerge for consideration. As McDavid (2002) has pointed out, following Rorty (1986), broadening the number of participants in the conversation is also an effective defense against malicious participation, for rather than silencing disagreeable views, this approach allows all voices to be heard, with the best ideas effectively rising to the top. Such is the approach taken by the progressive political website DailyKos, in which user-authored "diaries" and even individual comments can be "recommended" by other users, so that the highest-rated contributions earn more visibility on the site.[21]

At the same time, such community-based structures, though seemingly democratic, risk reinforcing the hegemonic authority of the majority over narratives and silencing dissent (Harrison 2010). Differential wealth and power, including differential access to the Internet (e.g., those who own or can use computers, who have access to bandwidth and connectivity), can greatly undermine diversity and skew the resulting "consensus" discourse in such media. In Wikipedia, this problem was brought into relief when it was

[20] See *Bonnichsen v. United States*, 357 F.3d 962–979 (9th Cir. 2004).
[21] See "DailyKos: News Community Action," at http://www.dailykos.com (last accessed June 9, 2012); see also "DailyKos FAQ – dKosopedia," at http://www.dkosopedia.com/wiki/DailyKos_FAQ (last accessed June 9, 2012) for details about how the site works.

discovered that some corporations had hired staff specifically to edit entries to present the corporate interests in a more favorable light.[22] As elaborated by Habermas (1996), in order not to silence disenfranchised or weaker voices that may critique and challenge the majority, the community must actively seek the representation and collaboration of a diversity of partici-pants in social action.

CONCLUSION

As critical, postcolonial, and indigenous archaeologies continue to raise awareness about the idea that there are multiple ways of engaging with and knowing the past, so archaeologists must continue to seek better strategies for including and building on those different, and sometimes incompatible, views in research and representation. This entails not only including "alter-native" voices in archaeological research but also acknowledging that the discipline is at its core polyphonic. Dissent and debate over the ambiguity of archaeological reasoning has long been a central feature of archaeological research and interpretive practice (see Tilley 1991), which suggests that the inclusion of additional voices in those debates should not be problematic. Newly challenging is the goal of representing and weaving together dis-parate and conflicting narratives in an effort to recognize that ambiguity, a goal that to some cannot but lead into an unsecured relativism.

In response, an increasing number of archaeologists are turning to prag-matism as providing a potentially productive model for structuring archae-ological inquiry into a past that cannot be accessed directly and thus remains to some extent unknowable (McDavid 2000, 2002; Preucel and Bauer 2001; Preucel and Mrozowski 2010; Saitta 2003). In this chapter, I have argued that the pragmatist philosophy of Charles Sanders Peirce is particularly useful in dealing with multivocality in scholarly discourse, bringing together divergent research agendas, and providing a rationale for why including multiple perspectives and voices is not antithetical to scientific inquiry but is in fact necessary for advancing knowledge about the world. In particular, Peirce's concept of the Final Interpretant sug-gests that a full understanding of the world is both socially mediated and best achieved through the engagement of the broadest possible commu-nity of inquirers. To advance such a goal, I have suggested that inclusive, community-based fora, made possible through Web 2.0 applications such

[22] Katie Hafner, "Corporate Editing of Wikipedia Revealed," *New York Times*, August 19, 2007, http://www.nytimes.com/2007/08/19/technology/19iht-wiki.1.7167084.html (last accessed May 20, 2010).

as wikis, may offer new opportunities for promoting the kind of nonfoun-
dational, multivocal, and pluralistic understanding of the world envisioned
in Peircean pragmatism and vital for the future of archaeology.

ACKNOWLEDGMENTS

This chapter benefited from the critical insights and assistance of a number
of people. First, I thank Geoffrey Scarre and Robin Coningham for inviting
me to contribute to this volume and for encouraging me to explore the
topic of this chapter. I also thank the students in my Writing Archaeology
course in the spring of 2010 at Queens College, City University of New
York, who both humored and challenged me as I worked through some of
these ideas with them. A preliminary version of this chapter was presented
at the meeting of the Theoretical Archaeology Group at Brown University
in May 2010 in a session on pragmatism organized by Bob Preucel and
Stephen Mrozowski, and both their comments and the discussion following
the papers were a great help to me in clarifying my ideas. Finally, I thank
Geoffrey (again), Tim Webmoor, and Carol McDavid for offering me their
thoughtful criticism and suggestions as I was pulling the chapter together.

"Do not do unto others…"
Cultural Misrecognition and the Harms of Appropriation in an Open-Source World

George P. Nicholas and Alison Wylie

Human societies have a long history of incorporating elements of the past into the present; never has this been the case more than today. For centuries, if not millennia, creative artists and writers, architects and fashion designers, publicists and advertisers, have borrowed freely from the tangible and intangible heritage of other times and places (Figure 11.1). There is plentiful evidence of how fundamentally human achievement has depended on the transmission of knowledge across cultures. The technologies that shape our world are a case in point. Consider just one example: concrete, a technology we think of as distinctively modern – literally the building block of twenty-first-century society – was developed by both the Egyptians and the Romans thousands of years ago. In the context of increasingly rapid and global diffusion of tradition-specific images, ideas, and material culture, it is often a default assumption that ancient objects and images are elements of a shared legacy of humanity.

In this spirit, a growing contingent of scholars and activists aggressively defends the free flow of ideas, images, and knowledge – within and between societies, ancient and modern – on grounds that this is essential to innovation and creativity. Proponents of the Open Access and A2K (Access to Knowledge) movements speak of the importance of sharing the world's vast knowledge, whereas scholars such as Laurence Lessig, James Boyle, and Kembow McLeod (among others) point to the stifling effects of restrictions on open exchange. Frequently, the advocates of open access draw attention to benefits that flow to the source communities and cultures (or their descendants), as well as to the recipients who draw inspiration from the cultural heritage of others. Even if economic benefits don't flow equitably, so the argument goes, the open exchange of tradition-specific objects, practices, ideas, and knowledge may play an ambassadorial role, fostering cross-cultural understanding and respect.

At the same time, even the most enthusiastic advocates of open exchange recognize that those who create new products, new music, new literature

Figure 11.1. Egyptian motifs and replica antiquities are found throughout Harrods
department store in London, but they are showcased in the opulent Egyptian Room,
designed for Mohamed Al-Fayed, then owner of Harrods. The question of appropriation is
complicated by the fact that Al-Fayed is Egyptian by birth. Photo credit: George Nicholas.

have rights that deserve recognition and protection, whatever their source
of inspiration. Certainly, in Western society, unauthorized use of origi-
nal work is prohibited, or at least limited, by copyright, patents, trade-
marks, and similar conventions that allow the creators to obtain benefit
for a specified length of time.[1] Despite the diversity of (conflicting) inter-
ests that figure in the contestation of these rights of ownership and fair
use, there is shared understanding of what rights are at issue and broad
recognition that they warrant protection; the challenge here is to find a
balance between facilitating the flow of ideas and protecting the rights of
creators.

A much different type of challenge comes into focus when we consider
the question of who should have access to or benefit from the tangible
and intangible heritage of Indigenous societies both past and present, in

[1] Efforts to protect these may clearly (and sometimes unnecessarily) hinder the development of new
creative forms in music, art, and beyond (e.g., Aoki et al. 2008; Gaylor 2009; K. McLeod 2007).

which the values and interests at issue may be fundamentally different from those that find eloquent defense in the open-access debates. In the Americas, Africa, Australia, and many other regions, the lives and material culture of Indigenous peoples have long been the object of widespread public fascination. Once disparaged as primitives on the lowest rung of the evolutionary ladder, these neo–'noble savages' have been a rich source of creative inspiration. Often emulated, commodified, and otherwise appropriated, their distinctive cultures have greatly enriched dominant societies in any number of senses, not just economically but also intellectually, technologically, culturally, and spiritually (e.g., Deloria 1998; Meyer and Royer 2001; Owen 2008; Rose 1992).[2] And as the libertarian advocates of a global commons argue, this has not only opened up new creative possibilities in the borrowing society – innovative art forms and cultural practices that could only flourish in a context of cultural exchange – but has also brought various benefits to the source communities (e.g., Young and Brunk 2009; Young and Haley 2009). Most tangibly, indigenous art production has become a crucial source of revenue in some contexts; we explore here examples drawn from the giftware industry in the American Southwest (e.g., Bsumek 2008; Mullin 2001) and from the traditions of African sculpture and Australian Aboriginal painting that are highly prized objects of international trade and connoisseurship (Comaroff and Comaroff 2009; Isaacs 1992). More intangibly, when objects created for utilitarian and/or spiritual purposes in their original cultural setting are today exhibited as art of the highest caliber, the processes of trade and exchange that bring them to international attention foster an intercultural appreciation of cultures that had all too often been presumed to lack any serious artistic accomplishment.

While acknowledging the benefits of cross-cultural exchange, it is important to recognize that they often come at a cost and that this cost has largely been borne by Indigenous peoples who have had little power, historically, to determine what uses are made of their cultural and intellectual property or to ensure that the benefits of exchange are reciprocal.[3] There are any number of cases in which elements of indigenous culture – art, music,

[2] There are, of course, many examples of cross-cultural borrowing in which dominant cultures have been significantly shaped and, indeed, transformed by the traditions of those they have invaded, ruled, colonized, settled, or traded with. This is well documented in the Old World, where, for example, Egyptian culture influenced Greek culture, which in turn influenced Roman society, and where the Roman Empire took shape through a complex dynamic of exchange with subjugated indigenous cultures.

[3] Indeed, our chapter is weighted toward the effects of appropriation on Indigenous peoples for this reason.

technical knowledge, spiritual practices, medicinal and culinary traditions – have been appropriated in ways that members of these cultures regard as inappropriate or unwelcome and that have caused harm of various kinds. Often enough, members of the appropriating culture have difficulty recognizing the harm they do; they may intend no harm, or indeed, they may operate with the best of intentions (e.g., Brown 2004; Johnson 1996; Nicholas and Bannister 2004a). But the fact remains that whatever their goals and sensibilities, their actions sometimes threaten cultural values and identity or undermine the economic interests, social relations, and other core elements of the communities whose cultural heritage they admiringly appropriate.

In this chapter we explore two important questions that we believe should be central to any discussion of the ethics and politics of cultural heritage: What are the harms associated with appropriation and commodification, specifically where the cultural heritage of Indigenous peoples is concerned? And how can these harms best be avoided? Archaeological concerns animate this discussion; we are ultimately concerned with fostering postcolonial archaeological practices. But we situate these questions in a broader context, addressing them as they arise in connection with the appropriation of Indigenous cultural heritage, both past and present.

We begin by sketching a spectrum of harms, ranging from manifestly and sometimes deliberately harmful types of appropriation – cases of theft and dispossession, recognized as such by members of the appropriating culture – through to types of cultural exchange, emulation, and celebration of Indigenous cultures that typically are not considered pernicious forms of appropriation but may nonetheless cause harms of more subtle and inadvertent kinds. We then consider four cases that illustrate in concrete terms the interplay of harms and benefits and that bring into view a variety of responses to cultural appropriation, ranging from acceptance to protest. Our purpose is to identify (some of) the economic, social, cultural, and spiritual costs of cultural appropriation in cases in which one dimension of the problem is that the interests and sensibilities of members of the source community are systematically misrecognized by those who appropriate elements of their cultural heritage. In developing this analysis we presuppose that there may be fundamental differences in the worldview, legal regimes, and cultural norms that underpin Indigenous conceptions of heritage and those characteristic of the dominant (Euro-American-derived) Northern and Western societies that have displaced and colonized them. In particular, many Indigenous and non-Western societies

do not recognize the distinctions between tangible and intangible heritage presupposed by much (Western) legal and philosophical discussion of cultural appropriation. The material elements of heritage, such as artifacts, archaeological sites, or places, cannot be separated from the knowledge, beliefs, and stories associated with them; ancestral beings and supernatural forces may be understood to reside in material things and places, not only in the past but also still today. In these cases a lot more than economic value, or historical and archaeological significance, is at stake for Indigenous peoples when heritage sites are threatened or when traditional objects, images, and knowledge are used in inappropriate and unwelcome ways. The challenge is not just to balance competing claims but also to understand claims predicated on conceptions of value and harm that may diverge quite fundamentally.

In our concluding section, we turn to the question of how such harms can be avoided or mitigated. We focus, in particular, on one approach – community-based participatory research (CBPR) – that creates a context in which source communities can identify and convey their appreciation of the harms associated with the appropriation of their cultural heritage, and a process that may enable researchers to engage in more ethical and responsible practices in relation to these communities.

"DO NOT DO UNTO OTHERS . . . ": KINDS AND DEGREES OF HARM

In a general sense, *appropriation* may be defined simply as the use and retention of something without permission. We use the term in this generic sense; the questions of whether a particular instance of use is appropriative and whether (or to what degree) it is harmful or beneficial must be adjudicated on a case-by-case basis with attention to the contexts and history of cultural exchange in which it occurs. Central to this conception of appropriation is the insight that it involves intentional decontextualization (Meurer and Coombe 2009: 21). In some cases, the repurposed use of images and ideas has morphed into familiar tropes in the literary and artistic traditions or cultural discourse of the recipient society; what was once appropriated has been recontextualized. A particular instance of appropriation becomes problematic when "a cultural text is *improperly* recontextualized, to the outrage or injury of those who have serious attachments to its repositioning in specific worlds of social meaning" (Meurer and Coombe 2009: 21, emphasis in original). Recognizing that what counts as injury and what occasions outrage may vary widely is vital to characterizing the harms that can be done by appropriation, especially when cultural heritage is central

to a person's (or a society's) well-being.[4] There are various ways in which elements of cultural heritage may be (and have been) appropriated – by purchase or trade, through discovery (accidental or otherwise) and indirect influence, as well as through forcible alienation – all of which may prove enriching for one or both parties but may also cause harm depending on history and context.

The starkest and, in a sense, the most straightforward cases of harm are examples of theft or forcible appropriation that are acknowledged as harmful by the appropriating community or, indeed, may be deliberately intended to harm. For example, in the nineteenth century, the British Army led retributive raids in Benin and Ethiopia, capturing large collections of antiquities and other items of cultural significance (Waxman 2008; Young 2008: 19–21). In the early twentieth century, ceremonial regalia and masks of Northwest coastal tribes were confiscated by the Canadian government in an effort to prohibit the potlatch[5]; these items of cultural patrimony subsequently became the foundation for a number of major museum collections (Cole and Chaikin 1990; Simpson 2001). Such instances are, sadly, not uncommon in the history of the colonial enterprise worldwide. Adding insult to injury, the harm done by the forcible removal of highly prized antiquities was often compounded by colonial programs of archaeological research that purported to demonstrate that the ancestors of local populations could not possibly have produced such cultural treasures (e.g., Zimbabwe in southern Africa; the mounds and earthworks of eastern North America). Indigenous source cultures were thus stripped of tangible cultural heritage in a way that both reinforced entrenched prejudices about their cultural sophistication or technological capacity and provided a retrospective justification for appropriation.

[4] Here we invert the questions that frame James Young's (2005, 2008) philosophical argument that, although some appropriations may be harmful or "profoundly offensive," they are not inherently wrong, particularly where creative artistic production is concerned. We share Young's appreciation that a categorical condemnation of cultural appropriation cannot be sustained, but where the focus of his analysis is on defending cultural appropriation (in the spirit of those mentioned earlier who defend open access), we are concerned with exploring the range of harms and offense, the burdens imposed by appropriative practices, of which those engaged in appropriation should be mindful.

[5] In 1885, the Canadian government revised the Indian Act to ban the potlatch (Canada 1885); the so-called potlatch law was rescinded only in 1951: "Every Indian or other person who engages in or assists in celebrating the Indian festival known as the 'Potlatch' or the Indian dance known as the 'Tamanawas' is guilty of a misdemeanor, and shall be liable to imprisonment for a term not more than six nor less than two months in a jail or other place of confinement; and, any Indian or other person who encourages, either directly or indirectly an Indian or Indians to get up such a festival or dance, or to celebrate the same, or who shall assist in the celebration of same is guilty of a like offence, and shall be liable to the same punishment." The Sun Dance was also made illegal in 1895 by another amendment to the act (Canada 1895), also rescinded in 1951.

A short step from outright theft or wartime appropriation are the various strategies, well documented by Indigenous scholars, by which the members of dominant cultures have subverted or manipulated their own legal and political conventions to justify acts of appropriation that would otherwise have been clearly judged unjust and/or illegal. Consider, for example, Laurie Anne Whitt's (1998a, 1998b) classic assessment of the ways fictions of absence have been used to legitimate legal manipulations by which Indigenous peoples have been dispossessed of their land, and then their material culture, intellectual property, and medical and/or biogenetic resources (see also Whitt 1999). Whitt argues that appropriation turns on two reinforcing claims, especially clearly articulated in connection with territorial rights:[6] first, a declaration that the land Europeans encountered in the Americas, Australia, and elsewhere was unoccupied – that it was *terra nullius* – usually accomplished by fiat of European definitions of what counts as occupation and/or by forcible displacement of Aboriginal peoples; and second, a conversion of this definitionally public property into private or individual property. She makes the point that "the politics of property has never been confined to land" and considers how the same strategies structure conflicts over the ownership of indigenous music and, "genetic wealth and pharmaceutical knowledge," and, indeed, the archaeological debates about repatriation (1998b: 149, 153). These are replete with examples in which the age of items, uncertainty about their attribution to living cultural traditions, or their affiliation with specific descendant communities are used to establish the claim that valued elements of these traditions – everything from spiritual traditions, rock-art designs, and artifact styles to technical knowledge and human remains – can be treated as "public domain" (Nicholas in press), available for the taking to anyone enterprising enough to make use of them.

A different scenario arises when, in retrospect, the ostensibly legal purchase or trade of heritage items proves problematic: the conditions of sale were coercive; the seller did not have a right to alienate the items either because he or she did not own them, or they were items of group patrimony and there was no consensus empowering the sale or consensus changed. One of the best-known examples of this was the removal of major architectural elements of the Parthenon in 1802 by Thomas Bruce, the Seventh Earl

[6] We thank one referee for noting that the legal doctrine of terra nullius was not extensively used in North America; as Banner (2007) argues, the process was a complex one that turns on the imposition of a legal framework that legitimated land ownership and land transfer on terms set by European Americans. For purposes of this argument we take Whitt to be outlining a strategy of justification (moral and political) that figures in a number of contexts of appropriation, the logic of which is made explicit by the legal doctrine of terra nullius.

of Elgin. Although it appears that Bruce greatly overstepped the intent of the permit he obtained from the Ottoman sultan to "remove some pieces with inscriptions or figures" (Browning 2008: 11), and his actions were contested at the time in Britain (in parliamentary committee hearings) as well as by the local Athenian population, the so-called Elgin Marbles have been a centerpiece of the British Museum for almost two hundred years. The official stance of both the museum and the British government continues to be that these marbles were legally obtained.[7] Comparable issues arise in connection with the purchase from Indigenous peoples of the extensive inventories of masks, regalia, carvings, and other secular and sacred items still housed in museums in Australia, Canada, the United States, and elsewhere (e.g., Coles 1985).[8] In recent decades, following the success of several high-profile repatriation cases, many museums are increasingly responsive to repatriation claims and explore options for sharing ownership, developing collaborative programs of exhibition.

Issues relating to the appropriation and repatriation of Southwestern ethnographic materials are particularly interesting in this context, ranging from the issues surrounding the Ahayu:da (war god) carved by ethnographer Frank Cushing, who was an initiated member of the Zuni Priesthood of the Bow (Isaac 2011: 218), to the information collected by Elsie Crews Parsons at Laguna Pueblo later "fictionalized" by Leslie Marmon Silko, herself Laguna (Nelson 2001), to concerns over the use of photographs of Zia Pueblo in museums and other contexts (e.g., Holman 1996). Gwyneira Isaac's (2011) recent examination of Zuni principles relating to the intangible aspects of cultural patrimony and the reproduction of the knowledge contained therein is essential reading here. Notable is William Merrill's statement (cited in Isaac 2011: 219) regarding the authenticity of "replicas," such as Cushing's: "From the Zuni perspective the fact that Cushing might have produced the Ahayu:da is irrelevant to its authenticity. Their position is that anything produced on the basis of Zuni knowledge (and especially Zuni religious knowledge) ultimately belongs to the people of Zuni, even if produced by non-Indians; for them there is no such thing as a 'replica' or 'model.'"

Beyond these are cases in which appropriation seems uncontroversially legal in the terms set by dominant Western legal conventions but harm of

[7] However, as Hitchens (2008) notes, there were several occasions when the marbles were almost returned. See Young's (2008: 72, 103) discussion of this case and his critique of the standard rescue argument defenses for their retention.

[8] Questions of ownership may be complicated by issues of private versus communal property, as well as by the fact that ownership of some items sold willingly in the nineteenth and twentieth century is today challenged.

various kinds is done to the source communities nonetheless. There are numerous cases in which medical and genetic researchers have obtained permission from Indigenous peoples to record traditional knowledge and collect biological samples but have exceeded the bounds of the original study and agreements associated with it. Well-publicized examples include the Nuu-chal-nuth blood study in British Columbia (Cybulski 2001) and the case of the Haghai of Papua New Guinea in which researchers sought patents on cell lines (World Intellectual Property Organization 2006).[9] Even when there are legal mechanisms, like copyright or patents, that Indigenous communities could use to protect elements of their traditional heritage that have value in the dominant culture, until recently Indigenous communities have made little use of them. This should not be surprising; the nuances of intellectual property law are daunting even for those who are familiar with it,[10] but often enough Indigenous communities do not share the conceptions of property or commoditized value that underpin this legal regime.[11] Their music or art or, indeed, land and biogenetic profile, never seemed the kind of thing that should require legal protection.

Increasingly, Indigenous peoples are interested in the information that can be derived from the genetic analysis of ancestral remains and modern samples, and from archaeological studies of heritage sites and artifacts (e.g., Nicholas et al. 2008), to take just two examples. But they want to be involved in decisions about what will be studied, how research will be conducted, and how the resulting information will be used. One of the central challenges they face is that historically they have lacked the means to ensure that they will benefit from the use of their heritage by others; they do not have the means to institute the necessary legal protections, and they may not be in a position to realize the benefits of such protection. A case in point from British Columbia concerns ethnobotanist Kelly Bannister (2000) and

[9] In these and other similar cases, such as the controversy surrounding James Neel's research on the Yanomami (see Tierney 2000; also Kaestle and Horsburgh 2002), harm was clearly done to the communities involved. The reputations of those conducting the studies have been widely questioned, although often long after the event, but lingering concerns about the need to protect the interests of Indigenous peoples ultimately brought an end to the Human Genome Diversity Project (see Reardon 2005; also Hollowell and Nicholas 2009; Marks 2010).

[10] Protection of biological materials is sometimes based on complex legal principles, with sometimes surprising results. A famous case in which what would seem to be protected property is not is that of John Moore, who unsuccessfully claimed an ownership interest in a patent related to a cell line derived from his spleen (Boyle 1996).

[11] Several years ago, one of us (GN) was told by a very upset First Nations man from Alberta that "someone videotaped our Sun Dance and copyrighted it," expressing great concern that the intellectual property of his people had been appropriated. This illustrates how incomplete or incorrect lay knowledge of intellectual property law may be but also that even the perception of appropriation can cause harm.

her doctoral research on the role of plants in traditional medicine, and the biochemical and pharmacological properties of balsamroot (*Balsamorhiza sagittata*). To protect the traditional knowledge of the Shuswap Nation Tribal Council with whom she was working, Bannister codeveloped a protocol with the Skeetchestn Indian Band that governed aspects of her work. Because of the potential economic interests and commercial applications of her research results, she subsequently obtained from her university a five-year restriction on public access to her dissertation; this was designed to ensure that the Secwepemc Nation would have the opportunity to pursue proprietary interests in applications of these results, if they so desired. Although this afforded some protection from bioprospecting – this is a case in which the Indigenous community could establish a right to control and profit from its traditional knowledge in terms that have legal standing in the dominant community – the time and resources required to develop viable products were far beyond their means.

By contrast, there are cases in which the heritage in question is not recognized in the dominant culture (or legal system) as a type of property that could be legally protected,[12] or more prosaically, its significance for the source community presupposes values and concepts that have no cultural salience or legal standing in the dominant, appropriating community. Especially troubling are cases in which harm is done, even by those who operate from the best of intentions – for example, artists who admiringly emulate Indigenous design traditions; collectors who are deeply appreciative of Indigenous material culture; archaeologists who painstakingly investigate sites and artifacts with the aim of understanding Indigenous cultural traditions – because they lack the understanding necessary to know what it is they're appropriating and what the impact is of their appropriation. These include examples of harm done by appropriation that is meant to honor Indigenous peoples (see Aldred 2000; Brown 2004; Meyer and Royer 2001; Nicholas and Bannister 2004a, 2004b). Clearly specifying and communicating what is at stake across these kinds of cultural divide becomes especially challenging when Indigenous peoples are themselves divided on questions of appropriate use. To draw an example from the American Southwest, a central element of traditional Navajo healing ceremonies is the practice of creating elaborate paintings of holy people and other supernatural entities using colored sand on the ground. These sand paintings become "impermanent altars where ritual activities can take place," but most important, they are also full of power, and for that reason, they are erased after the

[12] This point is central to Banner (2007).

healing ceremony is concluded (Parezo 1983: 1). This practice continues today, but alongside other far more secular uses of sand paintings, which include the creation of permanent versions for sale to tourists:

Although some Navajos were upset at first when individuals violated religious taboos by making sandpaintings in a permanent form outside their ceremonial context, the Navajo community was never totally united against their production. By the late 1970s many Navajos recognized the existence of both sacred and secular sandpaintings. But the road to acceptance of this dichotomy had many twists and turns. From the first, reaction ranged from indifference to violent opposition. Reasons for the opposition varied widely. Some felt that a sacrilege was being committed and the paintings were bring treated irreverently; some feared supernatural repercussions, for to break a rule is to disrupt harmonious relationships with the deity which would probably, but not necessarily, cause trouble. Others did not fear for themselves but objected because the uninitiated could see the paintings or view them in the wrong season. Still others feared for the Anglo recorders who were unprotected but in continued contact with concentrated power. (Parezo 1983: 63)

Finally, even when Indigenous peoples freely share aspects of their culture with others, recipients may be unwilling to accept that these gifts come with important limitations (Irwin 2000; Owen 2008). Admiring outsiders who draw inspiration from Indigenous spiritual traditions may not realize the harm they do when enacting or representing these traditions, and they may be surprised and offended when objections are raised. For example,

At a 1986 benefit concert staged to raise funds to support the efforts of traditional Navajos resisting forcible relocation from their homes around Big Mountain, Arizona, one non-Indian performer took the opportunity between each of her songs to "explain" one or another element of "Navajo religion" to the audience. Her presumption in this regard deeply offended several Navajos in attendance and, during an intermission, she was quietly told to refrain from any further commentary. She thereupon returned to the stage and announced that her performance was over and that she was withdrawing her support to the Big Mountain struggle because the people of that area were "oppressing" her through denial of her "right" to serve as a self-appointed spokesperson for their spirituality. "I have," she said, "just as much right to spiritual freedom as they do." (Churchill 1998: 103)

In short, when considered from the perspective of the source culture, significant harm may be done by cultural appropriation even when no harm is intended or recognized in the dominant culture. This brings home the prosaic wisdom that the golden rule, in its conventional form,[13] is

[13] Standard formulations are both prescriptive and proscriptive: "do unto others as you would have them do unto you," and "do not do unto others what you would not have done to you."

not necessarily a good guide to action in contexts of cultural exchange or appropriation. Given the cultural differences that may be involved, especially where the relationship between tangible and intangible property is concerned, it is dangerous to assume that your sensibilities about what constitutes respect and appropriate use will be a reliable guide to whether or not a given instance of cultural appropriation is harmless. It is especially dangerous to ignore the possibility that what you regard as an innocuous, acceptable, or even laudable use of elements drawn from another's cultural tradition, may, in fact, be profoundly offensive; may undermine economic well-being and social relations in tangible ways; or may threaten identity and cultural integrity. It is crucial, then, to consider the significance of objects of appropriation in the context of their source traditions, which, in turn, requires a commitment to respectfully learn about Indigenous worldviews, customary laws, and values.

A CONSIDERATION OF FOUR CASES: WHEN APPROPRIATION HARMS AND WHEN IT DOES NOT

As the spectrum of harm outlined in the previous section makes clear, cultural appropriation is by no means a unified phenomenon, and neither are its benefits or its harms.[14] Indeed, because not all uses of heritage (without permission) constitute appropriation in a negative sense, it is important to explore examples that illustrate the complicated interplay of good intentions and inadvertent harm. The cases presented in this section further illustrate why we need to move beyond appeals to good intentions and the constraints of legality in assessing the harms and benefits of cultural appropriation; the first set of examples are ones in which inappropriate or unwelcome uses of cultural heritage cause various kinds of harm, and the second set draws attention to cases that seem to be appropriative in a negative sense but on closer examination may not be. They are chosen to illustrate common themes that arise in contexts ranging from entertainment to economics, and from cultural tourism to ancestor celebration, and to suggest strategies by which we might more effectively recognize and constructively respond to harms that are not necessarily salient in our home culture.

[14] This point is central to Young's (2008) analysis of the ethics of cultural appropriation in the arts, and is evident in the diversity of viewpoints represented in Young and Brunk's (2009) edited volume *The Ethics of Cultural Appropriation*. See also Brown (2004); Nicholas and Bannister (2004a, 2004b); Nicholas and Hollowell (2006); and others.

When Appropriations Harm

Wanjina-Wunggurr Rock Art

One of the most widely appropriated aspects of cultural heritage is rock art, which not only garners attention from both academics and the public for the insights it provides into ancient and/or exotic worldviews but also serves as a source of images for a variety of commercial products, from T-shirts and mugs to high-end designer clothing and art. However, the inappropriate use of these images has had a direct and negative impact on these indigenous communities precisely because the tangible image cannot be separated from its intangible associations. Not only do they represent clan property; they may quite literally embody ancestral spirits, and in this they are not "of the past" but have a timeless significance; they are a vital part of a living cultural tradition, constitutive of the identity and spirituality of these communities.

This is the case in Australia, for example, where rock art has been widely commercialized and has also been prominent in cultural tourism. Customary law has long served as the means to limit access to (indeed viewing of) various images, thus ensuring their protection, but this is challenged by outside interests. As Janke and Quiggin (2005: 8) note, "Within Indigenous Australian groups, there are consistent principles underlying the ownership, cultural integrity and consent procedures. However, the Australian legal framework limits the ability of Indigenous people to adequately protect their [Indigenous cultural and intellectual property] from exploitation by outsiders."[15]

In the rock-art-rich Kimberley region of northern Australia, the Wanjina-Wunggurr people find themselves challenged by the rapidly expanding cultural tourism industry. Here, their concern is for the well-being of renowned *wanjina* pictographs, which they consider animate; the paintings are the embodiment of the creator beings who formed the land, the laws, and customs of these people. These images continue to be "freshened up" by repainting to keep the world right. As Graber (2009: 18) observes,

The rapid expansion of tourism in this region is considered to be a new threat to the sacred rock art sites. Many tourists travel to the area expecting to see the Wanginas as promised in the advertisements. The Wanjina-Wunggurr people, however, fear that unauthorised visits may offend the Wanjinas [ancestral beings]

[15] See Anderson (2005); Coleman (2005); Janke (2003), and Johnson (1996) for discussions of the types of impacts, and over prominent legal cases to restrict unauthorized use of rock art images, including the Brandl/Deaf Adder and *Bulun Bulun v R & T Textiles Pty Ltd* (1998) 157 ALR (193) cases.

and that tourists will vandalize the sacred sites. The Wanjina-Wunggurr people are thus interested in legal remedies that prevent the Wanjina from being visited and reproduced, and sacred rituals from being disturbed by people who have not received their prior consent. Consequently, during the [native title application] proceedings, the applicants put forward a claim for a right to prevent inappropriate viewing, hearing or reproduction of secret ceremonies, artwork, song cycles and sacred narratives.

The significance of these concerns is illustrated by an incident that occurred in a session on intellectual property that one of us (GN) co-organized at the 2008 World Archaeological Congress conference in Dublin. One of the participants gave a presentation on her research on rock art in the Kimberley region that included photographs of the sites and images she was describing (including those she took while accompanied by local Aboriginal community members and from published sources). In the question period an Aboriginal man from that region who was in the audience strenuously objected that this violated fundamental cultural guidelines of access: "How dare you show these images! I could be killed by my community for having seen these!" Although Indigenous peoples may welcome scholarship that recognizes the richness of their cultural traditions and are involved with or themselves undertake to develop cultural tourism for a variety of reasons, including economic benefit (see Mortensen and Nicholas 2010), the Wangina-Wunggurr example makes it clear that some aspects of their cultural heritage may need to remain off-limits to avoid harm to themselves, to visitors, and to ancestral beings.

The 2010 Winter Olympics

The Vancouver Organizing Committee (VANOC) of the 2010 Winter Olympics ostensibly went to great lengths to include Canadian First Nations in various events, including the opening ceremonies. Their participation was considered a vital element in presenting and promoting Canadian heritage, and many First Nations individuals and groups also saw this as a celebration of their culture; the four host First Nations[16] – Lil'wat, Musqueam, Squamish, and Tsleil-Waututh – were official partners of VANOC and had, at least nominally, a role in decision making involving Aboriginal issues. At the same time, the games were marked by protest and controversy by other First Nations groups and persons who objected to

[16] See VANOC's press release on this, at http://fourhostfirstnations.com/a-historic-protocol-for-the-four-host-first-nations-and-vanoc. For a critical review of this initiative, written in advance of the event, see O'Bonawain (2006).

the games as a whole or to what they considered exploitative use of First Nations presence to showcase the games, with little or no meaningful participation in decision making (e.g., O'Bonawain 2006). Three examples of how indigenous heritage was incorporated into the games make it clear that there were economic and other benefits to First Nations, but these were accompanied by various harms.

Inuksuit (singular, *inukshuk*) are the standing stone arrangements, sometimes anthropomorphic in form, found across the Arctic landscape that have been created by Inuit hunters likely for millennia. A stylized version of an *inukshuk* was adopted by VANOC as the logo for the 2010 winter games, with permission granted from Nunavut premier Paul Okalik. However, not all Inuit were in agreement. As a result of the use of the widespread use of the image, particularly on thousands of Olympics-related products, the *inuksuit* have lost much of their cultural specialness and have become both common and emblematic of Canada and the Vancouver Olympics in the public imagination rather than of Inuit culture. The stylized Olympics image has also, as noted by Solen Roth, "contributed to crystallizing one particular kind of rock formation as the archetypical *inukshuk.*" Finally, the choice of the symbol was puzzling to many, as it had nothing to do with British Columbian First Nations: as noted by O'Bonawain (2006: 389), "Squamish hereditary chief Gerald Johnston publicly condemned the [International Olympic Committee's] selection of the *inukshuk* logo by declaring that its choice was in bad faith, a deliberate act of assault on Northwest Coast sovereignty, and the symbol of a foreign indigenous nation." These examples reveal that a variety of harms may occur when a cultural item becomes a popular icon, as well as concerns over the production of, and benefits from, the giftware. At the same time, many Inuit felt pride in the recognition of their heritage, especially the arts and crafts. In addition, some carvers and communities benefited directly from the manufacture and sale of handmade *inuksuit* through an agreement made between the Nunavut Development Corporation and VANOC (Canadian Broadcasting Corporation 2010).

Another cultural controversy erupted during the Olympics when the Russian figure-skating team performed their routine wearing costumes based on traditional Aboriginal Australian body painting and faux didgeridoo music. Bev Manton, of the New South Wales Land Council, stated, "I am offended by the performance and so are our other councilors." Seeming bewildered by this hostile response, Maxim Shabalin, one of the Russian skaters, defended this appropriation of Aboriginal heritage with

the statement: "We researched a lot of information on the Internet."[17]
The suggestion seems to be both that they intended no disrespect and
that what they appropriated was nonproprietary – available in the most
public of public domain contexts. Beyond controversy about what is or
is not public domain, and what constitutes fair use of publicly accessible
information, what Manton points out is that, from the point of the source
community, this was clearly an instance of appropriation in the negative
sense: it involved use without permission in which elements were taken
out of context and inappropriately recontextualized. It was, moreover, an
instance of harmful appropriation, threatening the integrity of Aboriginal
culture by transforming it into a form of popular entertainment.

A final example is the marketing of First Nations culture at the Olympic
Games and issues of economic harm. In one case, a lucrative contract
was awarded to a leading department store to produce sweaters initially
described as "Cowichan-like," in relation to the regionally distinctive style
of the Cowichan people; these sweaters were to be worn by the Canadian
Olympic team and sold to the public. This decision was a stunning upset
for the Cowichan First Nation, who have long produced these sweaters and
had submitted a bid that was lower than that of the department store. This
immediately elicited the threat that the Cowichan First Nation and their
supporters would stage high-profile protests in the lead-up to the Games.[18]
In the end, a settlement was negotiated that provided the Cowichan First
Nation a contract to sell their sweaters in the department store, alongside
the official Olympic ones, by then described as "Canada's answer to the
Nordic sweater."[19] This was, however, just one of a number of cases that
mobilized protests from the First Nations about the practice of outsourcing
the production of "Authentic Aboriginal Products" endorsed by VANOC.
In response, a group of First Nations artists and artisans created their
own authenticating mark to identify their creations (Brown and Nicholas
2010).[20]

[17] See online coverage of these stories: Lisa Wade, "Russian Ice Skaters Impersonate Aboriginals,
 Win Gold": http://thesocietypages.org/socimages/2010/01/23/russian-ice-skaters-impersonate-
 aboriginals-win-gold/; Sonia Oxley, "Plushenko Marks His Territory with Gold": http://
 www.reuters.com/article/2010/01/21/us-figure-skating-european-idUSTRE60K46320100121?type=
 sportsNews.
[18] Numerous newspaper articles are available documenting both the reaction of First Nations
 communities (e.g., http://www.cbc.ca/canada/british-columbia/story/2009/10/07/bc-olympic-
 cowichan-sweater.html) and the resolution of the sweater controversy (e.g., http://www.cbc.ca/
 canada/british-columbia/story/2009/10/28/bc-cowichan-tribes-olympic-sweater.html).
[19] "2010 Olympic Team Apparel is Hot," available at: http://shinypackages.wordpress.com/2009/10/
 16/2010-olympic-team-apparel-is-hot/
[20] See Damian Inwood (2009).

When Appropriation Does Not Harm

Although the use of another's culture without permission and in inappropriate ways may be profoundly harmful, as the previous examples make clear, not all cultural borrowings constitute appropriation in this negative sense. As we acknowledged at the outset, cultural sharing and exchange may be enormously enriching; insights drawn from lives lived in different ways, at other times and in other places, are a rich source of inspiration on any number of dimensions. In the cases that follow, we consider how one society has benefited from unattributed archaeological heritage and how the commodification of archaeological heritage in another honors its ancestors.

Mata Ortiz Pottery

The appropriation of various elements of Puebloan and other indigenous heritage of the Southwestern United States has been an established practice from the time of contact, for several hundred years. Images or representations of katchinas, wooden figurines that represent supernatural beings, and of Kokopelli, the flute player, adorn mailboxes, jewelry, clothing, and other products.[21] At the very least, the popularity of indigenous motifs, coupled with the cheaper prices for replicas, continues to foreground issues of authenticity and economic loss.

But by contrast to the appropriation of the sun symbol from the pottery from Zia Pueblo,[22] the example of Mata Ortiz is a case in which an ancient pottery style has inspired a new artistic movement that benefits Indigenous peoples economically and culturally. In the mid-1950s, a young man from Nuevos Casas Grandes in Chihuahua, Mexico, was inspired by pottery sherds from the archaeological site of Casas Grandes (Townsend 2005). Juan Quezada taught himself to produce pottery inspired by this ancient ceramic tradition. What resulted was a new, community-wide pottery movement that has gained international attention.[23] Quezada and the ceramic artists he inspired set out to create an innovative, consistent visual language that was distinct from that of their predecessors or contemporaries, while incorporating some similar, recognizably Southwestern decorative and symbolic elements. The resulting ceramic style (Figure 11.2) reflects a conscious effort at self-determination, articulating the identity of

[21] Zena Pearlstone (2000) and others have examined issues of commodification associated with these forms of commercialization.
[22] Zia Pueblo launched legal challenges to the State of New Mexico and Southwest Airlines over their use of the image (see Nicholas and Bannister 2004a).
[23] The economics of Mata Ortiz pottery, and its competition, are discussed by Medina (2008).

Figure 11.2. Inspired by ancient ceramics from Casas Grandes, Mata Ortiz pottery developed through the efforts of a single individual in the 1950s and subsequently become a community-wide "revival" in the 1970s that blends old and new forms. Top photo: (*Left*) Fourteenth-century hooded effigy jar from Casas Grandes compared with (*right*) contemporary hooded effigy jar from Mata Ortiz. Bottom photo: Contemporary Mata Ortiz polychorme jar that incorporates design elements from both ancient Mimbres and Casa Grandes ceramic design. Private collection. Photo credit: Gordon Nicholas

a new polity but in visual terms that would be accessible to and under-standable throughout the region; those working in this style are moving beyond traditional forms to experiment with new pottery designs and other media. In this case there are no Southwestern groups who make specific claim to Casas Grandes, apart from the recognition that it falls within the general culture region (Maccallum 1978); it is an instance of inspira-tion in which Indigenous peoples derived direct benefit, initially creating beautiful and highly desirable replicas of ceramic designs associated with earlier (and likely unrelated) traditions, and then expanding in new artistic directions.

Tollund Man

One of the most haunting images found in archaeological publications is of the Tollund Man, a two-thousand-year-old individual whose body was extraordinarily well preserved in a wetland environment in Denmark. Photographs of this individual are widely available in archaeological publi-cations and other sources, including being featured in the British comedy series *Blunder*. In an earlier publication, one of us (GN) had suggested that descendants might be offended by the use of his image in advertising, such as for "Moor Mud" facial cleanser and other products.[24] This concern reflected experience with Indigenous peoples and the concerns that they and others raise about cultural sensitivity regarding human remains,[25] but it proved unfounded in the case of the Tollund Man.

Recent conversations and correspondence with Danish colleagues, Ulla Odgaard and Mille Gabriel, shed important light on the broader context in which these uses of the image of Tollund Man take place. In response to a query about this case, Odgaard, of the Danish National Museum, wrote,

The Danish people are proud of the Tollund man. Novels have been written about this peacefully looking person, who died a (probably) ritual death in the moor. I asked Mille Gabriel [curator at the Ethnographic Department, who recently fin-ished a PhD on repatriation and first people's rights[26]] about her feelings towards this commercial. She answered that in her opinion "this commercial is not delib-erately making fun of the Tollund man, but rather appropriates him as evidence for the apparently good influence of the mud on his skin. The conservational

[24] http://www.torfspa.com/about_moor.html.

[25] See, for example, the Tamaki Makau-rau Accord on the Display of Human Remains and Sa-cred Objects (http://www.worldarchaeologicalcongress.org/about-wac/codes-of-ethics/169-tamaki-makau-rau-accord).

[26] See Gabriel (2010).

qualities of the mud are presented in an almost natural scientific manner, which is something Danes generally can relate to and appreciate." In Denmark, we are used to see dead bodies on display in the museums, and the most famous of those are our most important links to the past – they are our ancestors. From childhood we learn about the Tollund man (on display at Silkeborg Museum), the Gravballe man (on display at Moesgård Museum) and the Egtved girl (on display here at the museum). They give prehistory more "presence." (Personal communication 2011)

This example illustrates the central point that context matters; the fact that the appropriation of Tollund Man involves explicit commercialization of his image does not necessarily entail it being disrespectful. Substantial and perhaps surprising variability exists in the manner in which societies approach and utilize their heritage, including the bones and bodies of their ancestors. Whether an instance of appropriation is harmful depends on the sensibilities of both the source and the recipient culture, where these establish norms of significance that determine the propriety of a recontextualization.

HOW CAN HARM BE AVOIDED?

A necessary starting point for avoiding harm is to understand how and why cultural appropriation can cause harm. In the previous sections we have identified examples of appropriation that illustrate some of the ways in which it can cause social, spiritual, or economic harm, especially to Indigenous peoples for whom tangible and intangible heritage may be indivisible. We now turn to consider the potential of community-based heritage research as a process through which affected communities and concerned researchers can develop the kind of intercultural understanding that will put them in a position to recognize and avoid the kinds of harm we have highlighted here.

Generally, responses to cultural appropriation are reactive; those who perceive or experience harm attempt to block the uses of their heritage they find insulting or injurious and, in some cases, to seek restitution (e.g., Howes 1995). The challenges here are exacerbated by the limited protection available for many aspects of cultural heritage. A proactive approach is likely to be more effective because it focuses on preventing harm rather than repairing the damage. And a community-based collaborative approach is especially promising because it builds into the core of a heritage management or research program questions about how participating and

affected parties conceptualize potential benefits and harms, and how these might best be addressed.

Community-based participatory research (CBPR) developed out of social- or participatory-based research methodology that not only engages the community fully in the process but also works to ensure that they are primary beneficiaries (Wadsworth 1998). Well established in fields as diverse as public health, forestry, sociology, and anthropology, CBPR is making inroads in heritage studies as a way to ensure that the research is, from the start, designed to be relevant, respectful, and beneficial (Atalay 2012; Hollowell and Nicholas 2009: 147). Although CBPR takes many different forms, an integral aspect of such projects is a commitment to learn about core community values and concerns through consultation, interviews, focus groups, ethnographic study, and ongoing consultation; this is the basis for defining research goals and designing a research process that puts the concerns of affected communities there at the center of the process (e.g., Bell and Napoleon 2008).

A CBPR methodology is utilized in a series of community-based research initiatives being undertaken by the Intellectual Property Issues in Cultural Heritage (IPinCH) project.[27] This international consortium is investigating how and why concerns and harms about intellectual property emerge, and how best they can be avoided or resolved. The case study component of the project involves community-designed studies to investigate local issues from the ground up. Here are two examples of projects that target cultural harm.

One IPinCH study developed in northern Canada by the Avataq Cultural Institute is organized around the question, how can Inuit language and culture be preserved in the context of cultural tourism? The indigenous Nunavimmiut people understand the need to strengthen their identity and develop a strong economic basis for the region. However, there is a danger that increased economic benefits of cultural tourism will have a negative impact on their cultural identity. The ultimate objective is to make sure that tourism is not developed without community involvement and that it corresponds to what the Inuit want to share about their lives and their land (Gendron et al. 2010).

[27] This seven-year international collaboration consists of more than fifty archaeologists, lawyers, anthropologists, museum specialists, ethicists, and other specialists from eight countries, along with twenty-five partnering organizations. The project is funded by the Social Sciences and Humanities Research Council of Canada. For more information, see http://www.sfu.ca/ipinch.

Another study focuses on *ezhibiigaadek asin* (Sanilac Petroglyph Site), a historic park containing more than one hundred petroglyphs that is administered by the state of Michigan. For Saginaw Chippewa people, this is a sacred place. As project leader Sonya Atalay notes,

One of the petroglyphs at the Sanilac site depicts an archer. Oral traditions tell us that this archer depicts our ancestors shooting knowledge into the future for later generations to benefit. These images were recorded on stone because our ancestors knew a time would come when our language, traditions, and practices would be threatened by colonization – carving knowledge on stone ensured permanence. Caring for this place and for the knowledge held there are both part of traditional knowledge stewardship practices. (Atalay et al. 2008: 2)

The challenge for the Saginaw Chippewa Ziibiwing Cultural Center is to develop a comanagement plan with the state of Michigan that recognizes the inseparable tangible and intangible aspects of this place. They would like to share this traditional place with multiple public audiences while protecting the knowledge and images from being co-opted and appropriated. Concerns about avoiding harm to this place are revealed in community values. For example, the roof erected over the petroglyphs to "protect" them is considered damaging because the rain can no longer cleanse the images; tribal women now do this so the power that resides in these images is renewed (Figure 11.3), and they encourage their children to crawl on the images. Also, two tribal members who sought permission to use the image of the archer (noted earlier) for the logo of their sporting goods store were told that such use was inappropriate.

These two examples make it clear, first, that local and Indigenous communities are often interested in engaging with the wider world but on their own terms and in ways that preserve cultural values and, second, that what counts as heritage and what constitutes its proper use or protection may vary widely. In particular, there are fundamental differences in how Western and non-Western societies conceptualize cultural heritage that affect how they use or protect tangible and intangible property. Understanding this is the necessary starting point for effective and satisfying heritage management.

In the absence of effective legal mechanisms to protect intangible cultural heritage, emphasizing cross-cultural understanding of community needs and concerns may be the only option available. The legal protections that exist typically only extend to those aspects of cultural heritage having equivalents in Western society (e.g., registering tribal designs to limit unauthorized use). There is currently little protection for traditional

Figure 11.3. At the Sanilac Petroglyph site (ezhibiigaadek asin) in Michigan, the rock face containing more than one hundred images, or "teachings," is cared for by Anishinabe women. A roof erected by the Michigan Park Service prevents rain from cleansing the images. Photo courtesy of Sonya Atalay and the Ziibiwing Center of the Saginaw Chippewa Indian Tribe.

knowledge, such as is embodied in stories or clothing design (see Brown and Nicholas 2010). Some Indigenous groups have developed policies and protocols that identify their concerns to outside researchers and others, thus providing practical protection for their heritage. One example of this is the Protocol for Research, Publication and Recordings developed by the Hopi Nation.[28] Another is the IPinCH project under way with the Penobscot Indian Nation of Maine that combines the tribal community voice and knowledge with ethnographic, archaeological, and legal information to create policies, procedures, and protocols that protect the Nation's intellectual property associated with their cultural landscape, while maintaining compliance with state and federal historic preservation and cultural resource management laws and regulations. Included in this plan are

[28] HCPO Policy and Research, Hopi Tribe: http://www.nptao.arizona.edu/research/docs/Hopi_Cultural_Preservation_Office.pdf

intellectual property and cultural sensitivity training workshops for out-side archaeologists and researchers. The Penobscot Nation has established a community-based Intellectual Property Working Group to identify aspects of their heritage that are particularly sensitive and is creating a formalized tribal structure to address these and other research-related issues.

DISCUSSION AND CONCLUSIONS

In the context of archaeological practice, there has been growing awareness of the legacy of colonialism, manifest in the limited meaningful participation of descendant communities, and the outflow of cultural capital from descendant communities (Denzin et al. 2008; Hollowell and Nicholas 2009). One response has been to develop more culturally appropriate and meaningful research methods (Atalay 2012; Denzin et al. 2008; Smith 1999), including Indigenous archaeology and related community-based archaeological approaches (Colwell-Chanthaphonh and Ferguson 2008; Nicholas 2008; Smith and Wobst 2005b). To ensure that research not only causes no harm but also is relevant and beneficial to the communities, these initiatives emphasize the need for ongoing negotiation and draw inspiration from virtue ethics and debate in other contexts about the implications of concepts of stewardship and various formulations of the precautionary principle.[29] They are predicated on an appreciation that we must learn to recognize the limitations of our own conceptual frameworks; the harms of appropriation can be identified and avoided only if the insularity of the golden rule is counteracted by robust cross-cultural communication.

We identify three promising theoretical, philosophical resources that may be useful in addressing the challenges. One is recent discussion of the demands of cross-cultural communication in the literature on deliberative democracy, where, for example, Brandon Morgan-Olsen (2010) suggests that conventional (Rawlsian) requirements of public deliberation put considerable burden on those whose values, reasons for action, or justification for a policy recommendation derive from a minority culture; they are put in the position of translating their insights into terms that are legible in the dominant culture. Morgan-Olsen argues that there should be explicit recognition of the responsibilities of listeners, not just speakers; listeners

[29] There are several compilations of essays on archaeological practice that identify methodological, ethical, and other helpful resources, as well as provide examples of their application (e.g., Bell and Napoleon 2008; Bell and Paterson 2009; Hollowell and Carr 2009; Nicholas et al. 2009, 2010; Rizvi and Lydon 2010). Also see Bannister and Barrett's (2006) relevant discussion on the precautionary principle.

should be accountable for extending themselves, finding ways to understand and translate reasons, interests, and concerns that are not familiar. We see in this discussion resources for characterizing the obligations of dominant culture interlocutors (e.g., researchers, heritage managers) and strategies by which culturally sensitive questions about the harms and benefits of cultural appropriation may be addressed.

Related insights come from the feminist and critical race theory literature on epistemic violence and epistemic injustice (e.g., Delgado and Stefancic 2001; Spivak 1998; Fricker 2007; Wylie 2005, 2011). Members of minority cultures or people who are marginal in other ways routinely confront systematic patterns of misrecognition of at least two kinds (as characterized by Fricker 2007): testimonial injustice, by which they are not recognized as credible knowers and/or speakers; and hermeneutical injustice, by which they find the dominant culture lacks the conceptual resources to articulate key elements of their experience. Recent analyses detail a range of related mechanisms by which the distinctive experience, analysis, and insights of marginalized knowers are silenced (e.g., contributors to a *Hypatia* cluster on epistemic justice, edited by Wylie [2011]: Dotson, Lee, Mason, Gilson). Just these sorts of mechanisms are at work in the persistent denial or misrecognition of the harms of cultural appropriation; the strategies for counteracting epistemic silencing and misrecognition that are explored in this literature may be a rich resource for developing constructive, proactive responses to the challenges of cultural appropriation.

Finally, the work of James Tully on intercultural constitutional negotiation converges on, and would seem to capture, the underlying rationale of practices that have been instituted by archaeologists and Indigenous peoples who are engaged in productive collaborations. Tully (1995: 116) observes that negotiation should begin with a recognition of difference, not the presumption that difference obscures an underlying (rational, universal) framework that is neutral with respect to diverse cultural values. One of us (AW) has summarized key aspects of Tully's work that seem applicable in archaeology in these terms:

The need for this kind of communication – for the kind of sustained engagement necessary to build trust and understanding, [mutual recognition,] sometimes across acrimonious differences – is pivotal to virtually every recommendation for collaboration that has been made by Native Americans and archaeologists alike. Beyond this, Tully outlines a process by which negotiating parties articulate for one another just what identity-significant values are at stake in the conflict under negotiation; he characterizes this as a matter of establishing "continuity." This many Native Americans do as a matter of course when entering negotiations with archaeologists,

and it is, in essence, what archaeologists recommend when they insist on the need to communicate clearly and publicly exactly what their goals are as archaeologists – what their interests are in archaeological sites and material. (Wylie 2005: 24)

Mutual recognition and arguments of continuity provide a framework in which priority is given to understanding the harms, and the benefits, that may be associated with cultural appropriation in terms that matter to the affected parties. This is the basis for then designing a process for negotiating accommodations that take account of, even if they do not fully satisfy, the interests of all involved, subject to the principle that "what touches all should be agreed to by all" (Tully 1995: 122).

To conclude, our aim in this chapter has been to draw attention to the harms that cultural appropriation may cause, even when they are well intentioned. We have noted that controversy about appropriation arises in connection both with tangible objects that have recognized economic value in the context of the appropriating culture and with intangible elements of cultural heritage that are more typically objects of appreciation or connoisseurship (e.g., performance and art practice, spirituality). In cases that most starkly illustrate the types of misapprehension with which we are centrally concerned, often what is at issue are fundamental differences in the conception of what counts as cultural heritage, what its significance is, and therefore how it should be treated. They key point here is that in many traditional societies there is no sharp separation of tangible from intangible property (as is typical in Western contexts); indeed, tangible heritage has no value or significance independent of the intangible heritage that gives it meaning. The salience of this distinction goes a long way toward explaining why, for example, the commodification of rock-art images on T-shirts and mugs is problematic not only (or primarily) because it represents an economic loss but because it also threatens to undermine cultural identity and well-being. An economic calculus of harms and benefits, reinforced by dominant (Western-Northern, Euro-American) conceptions of property rights and their legal protection often works to obscure the dimensions of harm felt most acutely by indigenous communities, even when extended to the forms of intangible property recognized as having value under intellectual property law.

Collaborative research is one means to address these challenges. Almost invariably it requires considerable investment of time and energy, and challenges practitioners to think outside the conventional horizons of their home disciplines and cultures, but the results can be enormously beneficial and mutually satisfying. Rather than treat collaborative work with

descendant communities as a threat to the integrity of scientific research, as have some of its prominent detractors in archaeology, we join a growing number of colleagues who argue that it stands to greatly enrich archaeology epistemically and conceptually (e.g., Atalay 2010; Colwell-Chanthaphonh et al. 2010 [in response to McGhee 2008]; Wylie 2009).[30]

In this spirit we suggest that the key to understanding the value(s) of cultural heritage and to mitigating the harms of appropriation is to make respectful, mutually enriching cross-cultural exchange an integral part of cultural heritage research practice.

ACKNOWLEDGMENTS

We are grateful to Geoffrey Scarre for his invitation to contribute and for his remarkable patience, and to two anonymous reviewers for their thoughtful feedback at several stages in the process. We also thank Ulla Odgaard and Mille Gabriel for sharing their thoughts on Tollund Man and related topics, and Solen Roth for insights on the Olympics and Northwest coastal giftware industry. Kasia Zimmerman assisted with compiling the references. The photograph of the Mata Ortiz pot is courtesy of Roy and Maureen Carlson, photographed by Gordon Nicholas. Support for some aspects of the research reported on here was provided by the Intellectual Property Issues in Cultural Heritage (IPinCH) project.

[30] We acknowledge the potential of the growing literature on cosmopolitanism (Appiah 2006b) as a resource for identifying a variety of ways to negotiate the space between the end points of the spectrum of heritage valuation – cultural distinctiveness and cultural unity (e.g., Colwell-Chanthaphonh 2009; Meskell 2009), but adequately addressing its promise (and problems) is beyond the scope of this chapter.

CHAPTER 12

Should Ruins Be Preserved?

David E. Cooper

Early in May 2009, I was flying back to the United Kingdom from Malta. Shortly after takeoff, I looked downward out of the aeroplane window and saw on the ground an object that has been described as resembling a giant hang glider or crashed UFO. It was the enormous Teflon-covered tent that had just been erected to protect one of the Maltese megalithic temples. Since the unearthing of these temples in the nineteenth century, their soft globigerina stone has, apparently, been deteriorating. The tent quickly generated a lively e-mail correspondence in the newspapers. Most of the letters either denounced the ugliness of the cover or praised its benefits for tourism. Some correspondents, however, addressed the question of the appropriateness of erecting a cover at all, irrespective of its charms or utility. 'Let Mother Nature do its bidding', wrote one correspondent, 'If they [the temples] have to fall, so let it be'. In response to such e-mails, another correspondent, while conceding that 'ruins abandoned to the natural elements have their fascination', argued that important archaeological remains could no more be allowed to 'deteriorate completely' than a sick old person could be abandoned to die (*Times of Malta On-line*, 11 May 2009).

COMPETING PRIORITIES

The tension between preservation and other priorities that this correspondence illustrates is a familiar one. A well-known instance in Britain was the debate that surrounded the fate of Seahenge, the ancient timber circle that was exposed on the Norfolk coast when the sea receded. In 1999, English Heritage removed the wooden pillars from the site and had them restored and placed, eventually, in a museum in King's Lynn. Many people protested against this action – so vociferously, in fact, that another exposed timber circle, Holme II, was left in situ and open to the elements that will eventually destroy it.

English Heritage's policy toward Seahenge has been described as a victory of 'the academic value' of 'conserv[ing]' its constituent timbers' over

the '"aesthetic" and "symbolic" value of its limited survival as a whole monument *in situ*' (Coningham et al. 2006: 271). It is too narrow, perhaps, to suppose that it is only 'academic value' that attaches to preserving threatened stones or timbers. There is, for example, the value for tourism in preserving ruins, whether in situ or not, for tourists to visit. It is true, however, that the most vigorous voices in support of preserving ruins against deterioration tend to come from within professional, academic archaeology. And it is true, as well, that people who emphasize values – aesthetic, symbolic, or whatever – that might compete with those served by preservation are not usually academic archaeologists.

This association between the priority of preservation and the profession of archaeology means that debates on whether or how to protect ruins are germane to a wider debate on the degree to which archaeologists may 'own', 'appropriate', or be 'stewards' of, the past. Ruins, evidently, refer us to the past, and how they refer us will influence understanding of and attitudes towards the past. An Egyptian statue, replete with a trunk and head, that had been carefully protected against sandstorms would, one suspects, have aroused in Shelley different sentiments from those he expressed in 'Ozymandias'. Crumbling chimneys and warehouses on deserted industrial estates encourage a perspective on the recent past that their total disintegration – or replacement by gleaming shopping malls – would not. To hold that archaeologists should be the primary custodians of built testimonies to the past is, in effect, to hold that their priorities of preservation should hold sway and significantly shape people's sensibilities towards the past. To maintain that preservation is not a main priority, or that priorities of preservation different from the archaeologist's – those of the tourist industry, say – should prevail, is therefore to challenge the stake in the ownership of the past that archaeologists sometimes profess.

The purpose of this chapter is critically to examine the case for the priority of preserving ruins that archaeologists have advanced. Although my concluding remarks have a more conciliatory tone, the main thrust of the chapter is to challenge the archaeologists' case, and thereby to question whether archaeology should enjoy the degree of ownership of the past that is sometimes assigned to it.

PRINCIPLES OF PRESERVATION

Before proceeding to the main arguments deployed in favour of the priority of preservation, it is useful to remind ourselves how entrenched this priority is within the profession of archaeology. (This is not, of course,

to deny that there are some dissenting voices within the profession that speak against this priority.) One way in which this entrenchment is manifested is in principles formulated and proclaimed by professional bodies and organizations. The Society for American Archaeology, for example, advances a 'principle of archaeological preservation'. This obliges members of the Society to 'work for the long-term conservation and protection of the archaeological record' (cited in Groarke and Warrick 2006: 172). According to the National Heritage Act of 1983, preservation of sites and buildings for which it has responsibility should be the very first objective of English Heritage. Reflecting on the practice of public archaeology in contemporary Europe, one author calls attention to the so-called PARIS principle. This is an acronym for 'Preserving archaeological remains in situ' (and where that's impossible, as in the case of Seahenge, preserving them elsewhere). This principle, he remarks, encapsulates 'the overarching philosophy guiding archaeological resource management' in our times (Darvill 2004: 421).

Those archaeologists, anthropologists, and others professionally concerned with heritage who subscribe to such principles usually concede that, under special circumstances, they can be overridden, that another priority – a moral or religious one, typically – can trump the priority of preservation. The Zuni people of the American Southwest object to the poles they have carved being preserved in museums or private collections, on the grounds, apparently, that the sculptures, when left to decay naturally, return to the earth the strength of the war gods whom they depict. Several writers agree that, in cases like this, 'the interests of contemporary indigenous people . . . outweigh the value of archaeological preservation' (Groarke and Warrick 2006: 173).

The prevailing view among archaeologists, however, seems to be that although principles of preservation may be overridden in special circumstances, there nevertheless exists a presumption in favour of preservation. A principle of archaeological preservation articulates an obligation, even if it is only a prima facie obligation.

My challenge is the more radical one as to whether, with respect to ruins, there is even a presumption in favour of preservation, even a prima facie priority attaching to preservation. I am agreeing, therefore, with a trio of authors – though on rather different grounds – that it is at least 'problematic' automatically to conclude that sites should be preserved simply because they are 'valuable' ones (Coningham et al. 2006: 260). The shakiness of this conclusion is suggested by analogies with examples of other 'valuable' objects or places where, rather obviously, their value does not entail an imperative of preservation. It is integral to the conception of

certain works of environmental or landscape art, for instance, that these should be allowed naturally to deteriorate and perhaps disappear. One thinks, say, of Any Mendieta's series *Silueta*, which includes works made with snow that will eventually melt and are of course intended to do so. Again, it was surely neither perverse nor unintelligible for the great Sri Lankan architect and landscape designer Geoffrey Bawa to want the garden he had made over the course of forty years 'to let the jungle creep back in' after his death (Robson 2008: 100). Ephemerality may, for a certain sensibility, be key to a place's value.

The short answer to the question of whether things and places of value should be preserved is that it depends on the kind of thing or place in question and on the grounds for its being valued. There can therefore be no entirely general presumption in favour of preserving what is of value. If there does exist a presumption of preservation in the particular case of ruins, this needs to be argued for. Ruins must be the kind of thing whose value is grounded in considerations that speak strongly in favour of preservation. Let's turn to some arguments that attempt to secure this claim.

PRESERVATION, HERITAGE, AND THE ARCHAEOLOGICAL RECORD

Many different arguments may be used, according to circumstances, to defend the preservation or restoration of a building, or part of a building, that has been ruined. In the case, for example, of the south transept of York Minster, which was badly damaged by fire, it could reasonably be argued that, as an important part of a functioning building, the transept should be rebuilt. But I am concerned, in this section, with two more general arguments – ones characteristically advanced by archaeologists – in support of a presumption of preservation. They are not arguments that draw on such overtly 'practical' considerations as those that are relevant in the York Minster case.

Two main arguments have been deployed by archaeologists in support of a presumption of the preservation of ruins. I shall call them the 'heritage' and the 'archaeological record' arguments.

The heritage argument is not an argument in favour of a presumption of preserving all ruins, but of affording 'special protection' to ruins that are deemed to have 'exceptional qualities' and, in virtue of these, 'outstanding value'. These words come from a 1972 UNESCO World Heritage Convention statement that gives as the reason for this special protection the fact that the sites' 'deterioration or disappearance . . . [would] constitute a

harmful impoverishment of the heritage of all nations of the world'. Similarly dramatic and hyperbolic statements, invoking the idea of humankind's heritage, are routinely made by other organizations with a responsibility for historic sites.

What concerns me about this argument is not the hyperbole – although one may legitimately wonder how the disappearance of any site, however iconic, could constitute an impoverishment of *everyone's* heritage. My concern is that the statements like the UNESCO one serve only to reiterate, rather than to ground, the presumption in favour of the preservation of ruins. Unless there is a prior commitment to this presumption, it is unclear why it would be an 'impoverishment' of a heritage if a building naturally deteriorates. It seems from such statements that the very possibility is being excluded that, at least in part, a site has 'exceptional qualities' – and, therefore, 'outstanding value' – precisely because it is subject to natural elements. For some of the people who protested against the covering of the Maltese temple or the removal of Seahenge to a museum, the special quality and value of the ruin owed in part to its location and unprotected communion with the forces of wind, sun, or sea.

The point is one that will become clearer once we have considered different kinds of value that ruins may have for people, but it is already sufficiently clear to respond to a line of thought sometimes followed in support of the heritage argument. The thought is that we have a moral obligation not to deprive people in the future of the same experience of ruins that we enjoy and value today. The first point to make in response is that in cases like those of the Maltese temple and Seahenge, it is not possible to enable people in the future to enjoy the same experiences as our own. If a temple seriously deteriorated by the end of this century, those who then view it will not experience just what we now do. But nor, of course, will they if the temple has been protected by being been encased in a bubble and roped off from close attention by visitors – or, more radically, by being moved, stone by stone, to an air-conditioned museum.

So, given that the 'same experience' is no longer available, the question is whether – and under what conditions – future experience of a ruin is of less value than present-day experience of it is. Now it is not obvious that, simply because a building has been allowed to deteriorate further, the later experience is of less value. I was looking recently at some photographs taken of a Gozitan temple in the 1880s. I find no compelling reason to think that, when I visit this temple – which has yet to receive its Teflon cover – my experience is a lesser one than the experience enjoyed by visitors at the time of the photos. The temple has altered – some stones, presumably,

have crumbled away, but there has also been some sprucing up. Have these changes enhanced or diminished experience of the temple? I don't know, and nor do I know if the experience of the same temple in another hundred years' time will have been enhanced or diminished by leaving the building relatively untouched. It begs the question in favour of the heritage argument to assume that the value of our descendants' experience will be a diminished one.

Or consider the Seahenge case. Suppose the timbers had been allowed to disintegrate in situ, with an engraved stone commemorating the place where they once stood and a replica of the henge erected a little further inland. Would the experience of visitors be of less worth than that of those who presently look at the preserved timbers in King's Lynn? Even if one accepts that there is a moral obligation to ensure that the experience of heritage in the future is not diminished, such examples suggest that further reasons are required before concluding that this obligation is only discharged through preservation.

The second main argument for the presumption of preservation – the archaeological record one – is also very familiar. In the words of the 1992 Malta Convention on the Protection of the Archaeological Heritage, sites should be protected from deterioration and damage because they are a major 'instrument for historical and scientific study' (Council of Europe 1992). A 2000 statement by the Ethics in Archaeology Committee of the Society for American Archaeology, which I quoted earlier, insists that 'it is the responsibility of all archaeologists to work for the long-term conservation and protection of the archaeological record'. Such declarations are evidence in support of one author's claim that the truly 'important service' which sites have in the minds of most professional archaeologists is 'the creation of new knowledge about the past'. Although the preservation of ruins may have several aims, including the attraction of tourists, the importance of preservation is seen by archaeologists primarily 'in terms of the potential for knowledge and understanding' (Darvill 2004: 422–3). In short, it is the value of ruins as resources for knowledge – as components of the record or archive on which archaeologists may draw – which is the basis for the presumption of preservation.

In the case of many ruins, one might doubt the relevance of this argument. Some sites, surely, have been done to death by archaeological researchers, while other sites are very similar to ones that have been intensively investigated. Either way, it is unlikely that their preservation for the archaeological record is going to yield new knowledge about the past.

There is a larger concern, however, that the argument provokes. There are many different constituencies of people for whom a ruin might be of value – for archaeologists, as resources for a certain investigation into the past; for tourism managers, as attractive destinations for their clients; for new-age enthusiasts, as locations for ceremonies; for the homeless, as a place to find some shelter; and so on. But as some of these examples make obvious, the value the ruin has for some people is not a value it possesses *as* a ruin.

The question of the value of ruins as ruins is one that is apt to be ignored or marginalized through the reluctance of archaeologists to speak of ruins at all. The Malta Convention, for example, refers to structures, constructions, sites, resources, and records, but not to ruins. This reluctance is understandable. At one time, 'ruins' had too pejorative a flavour to be used by people with a professional mission to encourage the study of places to which the word refers. Later, the term acquired a more positive, but romantic, ring that was equally unwelcome to professionals who were intent on emphasizing the scientific importance of engaging with these places. But although the reluctance is understandable, it nevertheless has the unfortunate consequence of deflecting attention away from the interesting question of the significance of ruins as ruins. One reason this is unfortunate is that, by ignoring the value or significance of ruins as ruins, the presumption in favour of preserving them as archaeological record is made to look more compelling than it is. At the very least, a serious rival conception of why ruins matter will have entered the ring.

THE APPRECIATION OF RUINS

There once flourished a considerable literature on the appreciation of ruins, on what German Romantics called *Ruinenlust* and *Ruinenempfindsamkeit* (pleasure in and sensitivity to, or a 'feel' for, ruins) – and there are welcome signs of a renaissance of interest in why ruins are appreciated. (Recent books that explore this question are Woodward 2002 and Hell and Schonle 2010). Many of the reasons that authors, old and new, have given for why people enjoy the experience of ruins were summarized in Rose Macaulay's popular but erudite book *Pleasure of Ruins*. They include 'admiration for the ruin as it was in its prime', 'pleasure in its present appearance', interest in its historical and literary associations, 'morbid pleasure in decay', 'righteous pleasure in retribution', and 'mystical pleasure in the destruction of all things mortal and the [contrasting] eternity of God' (Macaulay 1966: xv–xvi). Fashion changes, of course, and some of these considerations

have seemed more or less compelling than others at different times. Few people in the West, I imagine, would today advance the last of the reasons Macaulay mentions, whereas pleasure in retribution for what is often seen as humanity's technological hubris helps explain the fascination that ruined mines, mills, warehouses – the 'ruinscape of the modern world', as Martin Jay calls it – have for many people.

I shall focus on two broad, and intimately related, reasons for *Ruinenlust*, for appreciating ruins as ruins – reasons that perhaps embrace some of those listed by Macaulay. Ruins qua ruins, I suggest, matter to, and are appreciated by, people because they evoke and cultivate both a certain aesthetic sensibility and a certain sense of history. In this section, I discuss the first of these.

Whether or not, as Christopher Woodward (2002: 31) puts it, 'the artist is inevitably at odds with the archaeologist', aesthetic considerations about ruins – just like the word 'ruins' itself – are notably absent from the recent literatures of professional archaeology and of heritage organizations. Indeed, it has been said that government-sponsored agencies concerned to assess the 'character' of sites that are candidates for protection 'deliberately eschew aesthetic value judgements' (cited in Brady 2003: 233). In his frequently quoted list of the values that sites of archaeological interest may have, Timothy Darvill (1995) includes their 'use-value' to artists – but that is a different matter from the aesthetic aspects of the sites themselves. Norham Castle may have had use-value for J. W. M. Turner, as did a steam train in a snowstorm and a burning ship, but it is not in virtue of this service to art that the castle possesses its aesthetic appeal.

There may be several reasons aesthetic concerns rarely figure in debates about the preservation of ruins. The main one, I suspect, is the characteristically modern view that aesthetic concerns are at once irremediably subjective or personal and really rather superficial. This chapter is hardly an appropriate place for launching a full-scale criticism of this view, so I shall content myself with remarking that it is a view that reflects a very thin conception of aesthetic appreciation. According to this conception, roughly, aesthetic appreciation of ruins consists in little more than the enjoyable sensations elicited by the sight of the ruins. Judgments of the place's beauty, in this conception, reduce to exclamations of pleasure when perceptually experiencing it.

By way of contrast, consider some remarks of Arthur Schopenhauer's on 'ruins of great antiquity'. These, he says, excite an 'impression of the sublime'. In their presence, 'we feel ourselves' – as mere individual human beings – 'reduced to nought'. At the same time, however, we feel

ourselves to be 'one with the world and are therefore not oppressed but elated' when experiencing the immensity, both spatial and temporal, of these ruins (Schopenhauer 1969: 206). I cite these remarks of Schopenhauer's not because I want to endorse them, but because they nicely exemplify a much richer conception of aesthetic experience than the thin one more fashionable today. For Schopenhauer – rightly, in my judgment – aesthetic experience may be complex and significant, indicative of a certain understanding of ourselves and our relationship to the world. Serious judgments of beauty, for example, are not mere reports of agreeable sensations but expressions of profound human yearnings and, thereby, of people's visions of the good and fulfilled life (see Cooper 2010).

One rich account of aesthetic experience with particular application to the appreciation of ruins appeals to the significance of an interplay or 'dialectic' between cultural and natural processes. Ruins, of course, are not the only objects to provoke an experience of this dialectic. Gardens, environmental artworks, outdoor theatrical performances, and much else are enjoyed, in significant part, because of an interplay between artefact and nature, between human and nonhuman contributions, that they display. But ruins, too, are certainly a good example. For a suitably responsive person, it has been said, 'The perceived resistance of ruins to forces of time is the counterpoise to the visible effects of natural forces destroying architectural order'. For this reason, among others, 'ruins have a richly layered aesthetic' (Crawford 1983: 55).

On this approach to the aesthetic appeal of ruins, it is no accident that poetic descriptions or paintings of ruins typically emphasize the vegetation – the ivy, say, or the lianas – that is visible on or among the ruined structures. The vegetation is not, as it seems to be for some archaeologists, mere 'picturesque fluff' that can and should be removed from the site (Woodward 2002: 69). Rather, it is an integral feature of a ruin, making salient the dialectic between a human creation and the processes of nature. Looking through some photographs I took during a visit, some years ago, to Dryburgh Abbey in the Scottish Borders, I found that I had focused the camera as much on the moss and spring flowers on or among the buildings as on the buildings themselves. A testament, I imagine, to a sense I must have had that these living things were part of the ruins, not excrescences. A 'good ruin', observes Midas Dekkers in a remarkable book written 'in celebration of decay', is an 'eco-system', which is why it is able to become 'a symbol of the harmony' – and tension – 'between nature and culture' (Dekkers 2000: 32, 40).

I do not claim that the only aesthetic appeal of ruins is to a sensibility that responds to this dialectic between human artefact and natural process. And

it is worth stressing that the dialectical account itself is compatible with there being a range of different experiences evoked by ruins, each of which constitutes an appreciation of ruins. This is because people are affected differently by the spectacle of human constructions at once resisting yet succumbing to natural disintegration. Rose Macaulay's 'morbid pleasure in decay', for example, is different from a sense of a unity between the human and the nonhuman domains that objects at the interface of culture and nature may intimate to some observers. The filmmaker and nature writer Roger Deakin loved ruins because, as he saw it, they do 'what everything really wants to do . . . [,] returning themselves to the earth, melting back into the landscape' (Deakin 2008: 5). This is an intelligible yearning, one that may well be implicit in a person's appreciation of the beauty of ruins. But there are other yearnings, and it may be one or other of these that is implicit in a different person's responsiveness to the interplay of culture and nature that ruins enact.

Two things should be clear. First, the kind of aesthetic appreciation I have been describing is one that goes deep with people. It is not the superficial, idiosyncratic enjoyment of sensations that some archaeologists seem to have in mind when they expel aesthetic considerations from debates on the treatment of ruins. Rivalry between the preservationist priorities of archaeology and the aesthetic significance of ruins should not, therefore, be presented as one between serious and trivial interests, between scientific advance and a predilection for 'fluff'.

Second, it is clear that certain strategies for preserving ruins from further deterioration cannot be reconciled with the ruins remaining appropriate objects of the kind of appreciation described here. For some interventions – including the Teflon tent above the Maltese temple and the removal of the Seahenge timbers to a museum – obstruct or entirely prevent any further dialectic between the buildings and natural processes. Such, indeed, is the very purpose of preservationist interventions of this sort. Not only, then, is there a serious rivalry between spokesmen for the aesthetic significance of ruins and champions of preservationist principles; it is also a rivalry liable all too frequently to flare up.

A SENSE OF HISTORY

I turn to the second of the two broad reasons, in my judgment, that ruins matter for many people – namely a sense of history that ruins are able to evoke and cultivate. This reason is not unrelated to the aesthetic considerations just discussed. Indeed, it is something shared by all versions of the 'dialectical' account of aesthetic sensibility toward ruins that this is

intimately involved with a historical sense. Christopher Woodward supports his contention that the vegetation that grows among ruins is not simply 'picturesque fluff' by stressing how this growth is a powerful reminder of 'the hand of Time' (Woodward 2002: 69). Midas Dekkers prefers to look at old, decommissioned trains in a 'locomotive graveyard', where the machines 'stand and rot in their own time'. In a railway museum, by contrast, 'the links with the past have been polished out of existence'. 'History', Dekkers adds, only 'comes alive . . . [in] ruins' (Dekkers 2000: 29, 32).

But isn't the importance of ruins as places that provide access to the past at the core of one of the main arguments – the archaeological record argument – used in support of the presumption of preservation? Admittedly, not just any item of specialist historical knowledge that examination of a ruin might yield would contribute to or enhance people's sense of the past in which the ruin is set. A carbon test showing that, say, a temple was originally constructed three years earlier than archaeologists had previously supposed is unlikely to revise anyone's sense of an ancient people's history. But the preservation of ruins for scientific study is often defended on the grounds that it will yield knowledge of a kind that certainly would be germane to cultivating a sense of history. Perhaps with her country's megalithic temples in mind, Sandra M. Dingli, a Maltese writer, argues that 'stringent measures' should be taken to 'conserve' ruins, precisely because of their capacity 'to tell us more about who we are and where our roots lie' (Dingli 2006: 21). Experience of ruins with this capacity might reasonably be described as enhancing a sense of history, of a past to which people recognize the debt of their present condition.

Again, isn't the importance of ruins as historical sites central to recent trends in public archaeology – to, in particular, the way in which carefully preserved or renovated ruins are presented to visitors? It is becoming rare, these days, to visit the remains of a famous castle or abbey without being filtered through an information centre, with its DVD that dramatizes the place's story, and being equipped with headphones through which one learns, at each point during the tour, just what happened here and when.

Why, then, should the value of ruins in the evocation and cultivation of a sense of history be pitted against the preservationist presumptions of both professional archaeologists and the agenda of public archaeology? The first part of the answer is that the sense of history that people experience in the presence of ruins is not typically provided either by the expert knowledge that archaeologists pursue or by the information communicated at sites through headphones and DVDs. The second part of the answer is that the preservation of ruins required by scholars in pursuit of expert knowledge

or by curators intent on informing the visiting public may compromise the capacity of ruins to evoke a sense of history.

A sense of a place's history is a sense, primarily, of how things were for the people whose lives were involved with the place – people who, perhaps over many centuries, worked, worshipped, loved, fought, and were otherwise engaged there. An understanding of this, after all, is surely what may 'tell us more about who we are and where our roots lie', to recall Dingli's words. For, it is the narrative that runs from past lives to present ones that enables history to cast a light on people's present condition. Acquisition of a sense of how things were for people in the past demands the exercise both of the imagination and of empathy. 'A ruin', it has been said, is 'a dialogue between an incomplete reality and the imagination of the spectator' (Woodward 2002: 139) – and a dialogue, too, between what stands before the spectator and his or her feel for the lives, moods, ambitions, and disappointments of people in the past.

These exercises – these dialogues – are delicate ones, for they are sensitive to the character and condition of a ruin. Walking alone in the Cheviot Hills of Northumberland, I often come across small, deserted, derelict buildings – the stone huts or cottages, in the main, of shepherds who once worked in the hills. The ruins are open to the elements and are unencumbered by signs and notices giving me names, dates, and so on. I am less equipped, therefore, to glean factual knowledge from these ruins than from ones that have been restored and provided with sources of information about their history. On the other hand, my ability to imagine the lives of the men who ate and slept in these cottages, to have a feel for their hopes and fears, to sense their subjection to but respect for their harsh environment would be reduced by restoration and by the putting up of intrusive signs. It would be reduced even more by the erection over the ruins of protective tents or the removal of the stones to a 'Museum of Cheviot Life'. In such a museum, as in Dekkers's railway museum, there would be too much 'polish', and a degradation therefore of the links with the past that a rawer experience of the places and things that people once occupied and used may cultivate.

Where imagination and empathy fail, it is unlikely that a sense of the past might instead be provided through expert knowledge. W. G. Sebald visited the spooky disused weapons research establishment at Orford Ness on the Suffolk coast. As he walked around, he found that, to him, 'the beings who had once lived and worked here were an enigma' – but not because he lacked knowledge and information about their work. It would, he recognizes, be through an exercise of imagination provoked by this

ominous relic that the existence of these people might become less alien to him (Sebald 2002: 237).

There are some ruins, it seems to me, whose preservation – whose freezing in time – would necessarily conflict with the sense of history that they are apt to evoke. I am thinking especially of buildings, such as derelict factories, barns, and mines – or, indeed, the installations at Orford Ness – which belong to 'the ruinscape of the modern world'. Precisely because these buildings were constructed in the relatively recent past, and were abandoned not very long after, they testify to the fast pace, the ephemerality, of the modern world – to the technological imperatives of an era in which the new very soon becomes the old, the obsolescent, and therefore the dispensable. Ruins, remarked Roger Deakin, 'have a special life of their own' (Deakin 2009: 245). The very brevity of the lives of these relics of modern industry or agriculture is indicative of the main moods and tendencies of our times. It can be enjoyable to visit immaculately preserved Victorian villages and similar 'attractions'. But it would be unfortunate – an occlusion of a proper sense of history – if too many of the places that testify to the experience of modernity were similarly manicured.

PRESERVATION: CONTEXT OR CONSTITUENTS

In this chapter, I have been calling into question the presumption of preservation that suffuses professional archaeological statements on ruined sites – the presumption that ruins should be protected from deterioration. The main argument in support of this presumption, voiced in various principles of archaeological practice, is that ruined sites constitute part of the archaeological record that is essential to disciplined investigation of the past. The problem with the presumption is that it ignores the legitimate interest in ruins of other stakeholders, notably the large number of people who appreciate ruins as ruins – for the aesthetic sensibility and the sense of history that ruins evoke and cultivate. When the importance of this appreciation in people's lives is properly taken into consideration, it becomes unclear how a presumption in favour of preservation can remain. For there is a genuine tension between serious but, arguably, incommensurable concerns – one that should be honestly recognized and debated when the future of this or that ruin becomes a matter for dispute and decision. Put differently, the appropriation of the past through the control of the destinies of the places and structures that provide access to it is a legitimately contended issue – and a deep issue, because the access to the

past enabled by archaeological research and the access enhanced through the appreciation of ruins as ruins are of fundamentally different kinds.

But perhaps there is a more conciliatory way of articulating the confrontation. Maybe both parties to the debate can agree that preservation is essential – in which case the dispute becomes one over what, exactly, it is most vital to preserve. The bitter debate about Seahenge illustrated, according to one group of authors, a 'tension between the value of [preserving] the context and the value of [preserving] the constituent parts' of the structure (Coningham et al. 2006: 272). Save the ambience of the place and the timbers will eventually disintegrate; save the timbers, by removing them to a museum, and the place loses its whole atmosphere as the context of the monument. Material and immaterial heritage, in other words, cannot always be simultaneously honoured. To preserve what inspires both a sensibility to a dialectic of nature and culture and an imaginative feel for history, ruins may need to be left alone so that they may lead that 'special life of their own'.

To describe the debate as one between two different ambitions of preservation – context or constituent parts, material or immaterial heritage, expert knowledge or empathetic understanding – does not, of course, erase the differences. But it does place the archaeologist and the appreciator of ruins on the same side in contests against those without any preservationist concerns at all – entrepreneurs, say, who want to turn the ruin into a 'fun for all the family' attraction, or planners for whom the ruin is an annoying obstacle in the way of progress. One would like to think that today's archaeologists, artists, and appreciators of ruins might all sympathise with the spirit at least of a moving statement made in 1945 by some of their precursors. It comes from a celebrated manifesto contributed to by, among others, Kenneth Clark and Hugh Casson, whose message is clear from its title, *Bombed Churches as War Memorials*. The authors write,

Preservation is not wholly the archaeologist's job: it involves an understanding of the ruin as a ruin. . . . A ruin is more than a collection of debris. It is a place with its own individuality, charged with its own emotion and atmosphere and drama, of grandeur, of nobility, or of charm. These qualities must be preserved as carefully as the broken stones which are their physical embodiment. (Cited in Woodward 2002: 214–15)

Problems of Ownership and Control

Legal Principles, Political Processes, and Cultural Property

Tom Allen

This chapter asks whether legal principles provide a satisfying framework for resolving disputes over control or access to an object or site of archaeological interest. It is concerned with situations in which individuals or groups feel that specific sites or objects have a special value in maintaining their identity and that archaeological work may affect that value. For example, they may feel that archaeological study would subject objects or sites to physical disturbances that are prohibited on religious or cultural grounds. Or they may fear that archaeological methods may produce results that undermine religious or cultural beliefs, or that they cannot get access to sites or objects as needed for important religious or cultural practices. In these situations, the lack of control over archaeological activity may threaten identity in some way. In such cases, one would hope that the parties could reach agreement. Indeed, the Society for American Archaeology has stated, in its *Principles of Archaeological Ethics*, that "responsible archaeological research, including all levels of professional activity, requires an acknowledgment of public accountability and a commitment to make every reasonable effort, in good faith, to consult actively with affected group(s), with the goal of establishing a working relationship that can be beneficial to all parties involved."[1] One would hope that there is a basis for cooperation. However, if agreement cannot be reached, the individuals or groups may turn to the law for support.

Numerous laws already reflect concerns over identity and cultural property. For example, in the United States, the Native American Graves Protection and Repatriation Act imposes duties on federal agencies regarding the return of human remains and cultural objects. The UN Declaration on the Rights of Indigenous Peoples puts the ratifying states under an obligation to protect the cultural property of indigenous peoples. Many states also have legislation for the protection of cultural heritage, with restrictions on

[1] Society for American Archaeology, *Principles of Archaeological Ethics*.

the destruction of historic buildings and the export of culturally significant art and artefacts. There are also many other laws that can be used to protect cultural identity, even if not enacted specifically for that purpose. Land-use planning and environmental protection laws are examples.

This chapter asks how far the values that underpin these laws are internal to the legal way of thinking. It is an example of a broader question: when should principles developed by a professional or specialised group resolve issues of broad social importance? An example from a different field relates to euthanasia and other end-of-life decisions. Should principles for resolving these issues be developed solely by medical professionals or by the broader community through the political process?

I argue that, in general, legal processes and legal principles are not sufficient to resolve issues relating to identity and cultural property. Such laws are products of political processes rather than legal processes. The legal process, in this chapter, refers to the development and expression of rules and principles in disputes resolved by the courts. It is differentiated from the political process, by which the legislature makes rules and principles through statute law. The key difference, for our purposes, relates to the manner in which various interests are considered in the formulation of principle. In a sound political democracy, all interest groups have the opportunity to participate in the process of developing statutory rules and principles that affect them. Of course, interests groups are not necessarily allocated their own representatives in the legislature. However, elected representatives would look ahead to the next election, and hence they would normally wish to survey the full range of public opinion before proposing or voting on statutes. To do this, they would normally wish to be aware of and consider the views of all interested parties. This does not mean that the final version of a statute would suit all interest groups in every case, but all groups should feel that they have at least had the opportunity to participate in the formation of policy and principle.

By contrast, the legal process provides a narrower forum than the political process. Ordinarily, only the parties to the specific case are entitled to make arguments to the court. Hence, interest groups may be denied a voice in the process of developing policy and principle. For that reason, groups often turn to the political process when the development of legal principle has not taken their interests into account. Instead of making legal arguments within a carefully controlled procedure, they engage in the political process: lobbying representatives, bargaining with opponents, and attaching and detaching themselves from other causes as needed to secure a favourable result. Given the potential for rapid shifts in public opinion, and

the vagaries of lobbying and bargaining, the democratic political process can produce ad hoc, expedient responses to specific issues. Judges in a well-functioning democracy are not subject to the same pressures. The judgment in a specific case should not be the product of a political bargain. Instead, the judgment should be justified by reference to general principles, which should provide "an intellectually coherent statement of the reason for a result which in like cases will produce a like result, whether or not it is immediately agreeable or expedient."[2] The political method does not require such justification. Of course, there may be situations where politicians feel it is important to justify their policies by reference to general principles, but we accept that they may well respond to public opinion. The primary difference is that the outcomes of legal processes are determined by the specific values and principles of legal professionals, where emphasis is placed on ensuring that decisions are consistent with general, high-level principles of those professionals.

This leads to the question raised in this chapter: Do legal principles include sufficient recognition of importance of culture and identity in property cases to satisfy claimants that their interests are being fully considered? If not, one would expect frequent recourse to the political process and frequent use of statutory law as the regulating factor.

I begin by discussing the core legal values that arise in disputes over the control of sites and objects. For lawyers, such disputes normally involve the law of private property. This leads to an examination of arguments in favour of incorporating principles relevant to identity in the law of property. This leads to the conclusion that, even when it is recognised that the protection of identity is valuable and should receive some form of legal recognition, such forms of recognition are not compatible with the core legal values of property law. Hence, they receive recognition only through the political process.

CORE LEGAL VALUES

In discussing the core values of lawyers, I am referring to high-level criteria relating to the rule of law. These criteria are concerned with the form or structure of law rather than the different activities that are regulated by law. For example, most lawyers would identify (at least) three related criteria concerning the form of law that every law should satisfy. To begin with, the law must be reasonably certain, so that people can determine the legal

[2] Bickel, *The Least Dangerous Branch*, 59.

consequences of their actions. This means that the law must be precise enough to allow them to determine their rights and responsibilities, and it must be applied in a reasonably predictable manner. Laws must also be transparent, in the sense of being public rather than secret; a law that is not made public would not satisfy the basic requirements of the rule of law. Finally, laws must be reasonably stable over time. A law may be certain and public, and yet if it is changed frequently and unpredictably, it would not meet the standards of most lawyers. There are disputes around the edges of these values, but the majority would agree that any law that lacks these features would not qualify as a sound law. This leaves aside the objectives of the law: you may well disagree with the social purpose or effect of legislation but recognise that it has the certainty, transparency, and stability that satisfy the basic criteria of the rule of law. For example, a law that is intended to improve road traffic safety may be judged against the legal value of certainty: if the law were so imprecise that no one could be expected to understand it, it would not be a good law. However, legal values would not provide a standard for judging whether the law contributes to road safety. Such questions would properly fall to safety experts, and lawyers would be guided by the experts' opinions.

In this chapter, I am particularly concerned with competing claims to control access to sites and objects. For lawyers, such claims involve the law of private property. Other areas of law may also apply: heritage laws, planning laws, export laws, and environmental laws may all be relevant. Those laws may be produced by a local authority, or a national legislature, or through an international process, but the law of property would be relevant in any case. Indeed, it is property law that makes other laws necessary. For example, most modern states have extensive planning laws because the law of property does not go far enough to satisfy the public interest in controlling the use of land. Similarly, environmental laws are necessary because the common law rules on ownership and nuisance do not provide adequate environmental protection. In such cases, the modern state has had to supplement the traditional laws of property to deal with emerging issues of public importance.

Most lawyers would say that, in relation to property law, the basic principles of the rule of law should allow one to determine the rights of different parties to use, consume, and trade or dispose of an object. The law should be certain, in the sense that it must provide a reasonably clear answer to the questions that arise in property cases: Can I plant crops on this plot of land? Can I photocopy this book? Can I stop you from entering this building? The law must also be transparent, so that the rules

that determine entitlements are open to the public. Finally, it should be reasonably stable, so that entitlements do not change so quickly that they become meaningless and so that individuals can rely on them to plan their futures and make investments.

These principles relate to the form of law. There are also principles of law that lawyers tend to see as part of the foundation of a specific area of law. For example, in the field of family law, most lawyers would agree the best interests of the child must be taken into account in the resolution of disputes that may affect them. In human rights law, there are principles in support of freedom of speech. Such principles are not absolute, but the law should ensure that they carry weight in the resolution of disputes.

PRINCIPLES OF PROPERTY AND IDENTITY

Many of the arguments in support of bringing ideas of cultural identity into the law of private property find their inspiration in Margaret Jane Radin's work on personal development and private property. In her writing, Radin maintained that property law ought to recognise the important connections that exist among objects, places, and the individual's sense of self. As Radin observed, psychological attachments to property can be intense: "One's surroundings – both people and things – can become part of who one is, of the self."[3] For example, most people would say that the theft of a family heirloom or other very personal items would affect them in ways that are not purely economic. Individuals cannot divest themselves of some types of property without damaging themselves in ways that the community may deem unacceptable. We already acknowledge this with our own bodies: a civilised system of law would not allow individuals to sell themselves into slavery or to endanger their own health by selling vital body organs. Radin extends this to external objects that are strongly associated with a sense of personality and identity. Although individuals should be free to enter into exchanges for most types of external objects, exceptions should be made in these limited circumstances.

The idea that identity is worth protecting, and that protection may require limits on alienability (transferability) of property, seems to translate easily to the protection of cultural property. Arguably, as long as participation in a culture is worth fostering, it seems to follow that groups

[3] Radin, "Market-Inalienability." See also Radin, "Property and Personhood," 977: the relationships that a person has with the things she regards as her own "can be very close to a person's center and sanity." For more recent investigations using experimental psychology (which cast some doubt on Radin's intuitions), see Barros, "Legal Questions for the Psychology of Home."

should be able to protect their cultural identity by controlling access to and transfer of those sites and objects that are central to the preservation of their identity as a distinct group. For example, Kristen Carpenter, Sonia Katyal, and Angela Riley argue that the indigenous peoples of the United States ought to have property rights, in the form of powers and duties of stewardship, where control and access are essential for their continued existence as distinct peoples.[4] They also focus on the relationship between identity and property but shift the focus from individual and personhood to peoples and peoplehood. In particular, they argue that the peoplehood of indigenous Americans "dictates that certain lands, resources, and expressions are entitled to legal protection as cultural property because they are integral to the group identity and cultural survival of indigenous peoples."

The question asked in this chapter is whether such principles can become part of the general principles of property law or whether they can be realised only through political processes. The difference is illustrated by examining the language of the UN Declaration on the Rights of Indigenous Peoples.[5] The Preamble to the Declaration refers to the "right of all peoples to be different, to consider themselves different, and to be respected as such."[6] In furtherance of this right to a distinct identity, it recognises rights of indigenous peoples "to maintain, protect and develop the past, present and future manifestations of their cultures, such as archaeological and historical sites, artefacts, designs, ceremonies, technologies and visual and performing arts and literature,"[7] and "to maintain, protect, and have access in privacy to their religious and cultural sites; the right to the use and control of their ceremonial objects; and the right to the repatriation of their human remains."[8]

Plainly, the Declaration identifies a clear link between property and the identity of indigenous peoples. However, the structure of the Declaration also suggests that the link should be made through the political process. The Declaration itself is a product of a political process. States are not obligated to ratify it, and even so, the Declaration does not assert a direct effect on laws of private property. Like most international treaties, it imposes duties on states but leaves it to each state to determine precisely how it will fulfil those duties. A state could argue, for example, that it can fulfil its duties by consulting with indigenous peoples over the use or development of land but without recognising any new property interest that could be enforced against private developers. Or courts and legal professionals could

[4] Carpenter, Katyal, and Riley, "In Defense of Property."
[5] Ibid., 1028. [6] Declaration, preamble.
[7] Declaration, article 11. [8] Declaration, article 12.

(and probably would) decide that the implementation of the Declaration obligations falls to the political process; they may declare, for example, that they would enforce any statute passed in furtherance of the Declaration, but until such statute is passed, there should be no change in property relations. In effect, the Declaration acknowledges the importance of the relationship between property and identity, but it makes no assumptions as to the content of the law of private property. The decisions regarding ratification and implementation are left to the state's political processes and not to the ordinary legal processes that operate within the state.

The language of the Declaration raises a further point concerning Radin's focus on the alienation of property. Her concern is with the loss of property that was once owned. This is, of course, consistent with many claims of indigenous peoples for the restoration of cultural property. Arguments for restoration are often framed in terms of a historical injustice, and specifically in terms of an illegitimate taking of the property. There are numerous examples of property being seized without the thinnest veneer of legality or taken under treaties or contracts that were tainted by coercion or fraud. Restitution of property is important not only for group identity but also for the recognition of a shift in power.

It is therefore interesting to note that the Declaration does not frame its rights in terms of the legitimacy of the original transfer or taking of property. To be sure, there are specific rights regarding restitution of property, repatriation of human remains, and redress for the deprivation of the means of subsistence, and these would turn on proof of historic injustice.[9] However, most of the rights are contingent not on past events but on the present needs of the indigenous group. This avoids questions concerning a lack of continuity in government, which can be important in former colonies. It may also resolve some issues that can arise over the continuity in identity of the indigenous group. For example, in the Kennewick Man–Ancient One dispute, a claim for repatriation of remains failed because no current native American group could establish a sufficiently close relationship with remains that were dated to the earliest periods of human settlement in the United States.[10]

It is therefore worth asking whether Radin's theory is broad enough to protect individual and cultural identity. The framing of rights in the Declaration responds to the needs of indigenous groups: Should this be

[9] See, e.g., Declaration, articles 11(2), 12(2), 20(2), 28.

[10] For a selection of the extensive legal writing on the case, see Dussias, "Kennewick Man, Kinship, and the 'Dying Race'"; Goldberg, "Kennewick Man and the Meaning of Life"; Seidemann, "Time for a Change?"; Seidemann, "The Reason behind the Rules."

the basis for a more general principle for allocating property, or at least for limiting the scope of a property owner's rights? Would it satisfy the general legal criteria for certainty and transparency of property law? In most cases, property entitlements are founded on discrete acts, such as the creation of a new thing; the finding of an unowned object; or the acquisition of property from another by gift, contract, inheritance, or court order. These satisfy the criteria for certainty and transparency because they occur at a defined time and are usually reasonably identifiable from observed events. Human needs are generally thought to provide much less certainty and transparency. At what point, for example, might a homeless person be sufficiently in need to have a claim to enter or use property owned by another? In general, the courts have been very reluctant to recognise principles that regard need as a basis for entitlement. This is not to say that lawyers, as a group, would oppose political action to address human needs, but only that many of them would argue that the courts should not develop principles of property law in response to human needs in advance of political action. Three examples may help to illustrate this point.

Economic Reliance and Property Law

Joseph Singer argued that economic reliance and dependence should be sufficient to create entitlements in some circumstances.[11] Economic reliance would not necessarily be related to the alienation of property: it could evolve over a period of time, without any specific transaction as the source of complaint. Singer took the example of the case of *Local 1330, United Steel Workers v. US Steel Corp.*[12] The dispute arose when US Steel decided to shut down its plants in the Mahoning Valley, near Youngstown, Ohio. The employees' union offered to buy the plants but the company refused, to avoid competition from its former employees. The union then challenged the company's actions in court.

 This was clearly a case of reliance. The judge who heard the case at the preliminary stage put it as follows:

Everything that has happened in the Mahoning Valley has been happening for many years because of steel. Schools have been built[;] roads have been built. Expansion that has taken place is because of steel. And to accommodate that industry, lives and destinies of the inhabitants of that community were based and planned on the basis of that institution: Steel.[13]

[11] Singer, "The Reliance Interest in Property."
[12] *Local 1330, United Steel Workers v. US Steel Corp.*, 631 F.2d 1264 (6th Cir. 1980).
[13] Ibid., quoted at 1265.

It was not a case in which there had been a questionable alienation of property. The union did not have, and had not had, a property interest in the plants. It therefore had to confront the legal principle that a property owner is free to do whatever it wants with the property. It may consume it, destroy it, or in the case of a business shut it down. Indeed, the owner of works of cultural importance may decide to deface or improve them, or simply to shut them away where interested members of the public cannot see them. Others may object, but barring some entitlement of their own, they cannot use the legal process to intervene. Of course, this does not preclude recourse to the political process; for example, it may be possible to persuade the legislature to use its powers to buy a business and transfer it to the employees or to buy cultural objects and put them on public display.

Singer argued that this should not have defeated the union's claim. More generally, he argued that the legal principles of property law ought to incorporate a principle of reliance. In a case such as *Local 1330*, it would lead to a more specific principle:

The corporation should not be allowed to waste property which has been relied upon by members of the common enterprise; such property is held in trust for the benefit of the common enterprise and especially for the benefit of more vulnerable parties to the relationship.[14]

In *Local 1330*, the preliminary ruling went in favour of the union, but US Steel appealed and eventually won its case. The Court felt that the questions belonged in the political realm: the "formulation of public policy on the great issues involved in plant closings and removals is clearly the responsibility of the legislatures of the states or of the Congress of the United States."[15] It did not fall to the courts or legal profession to resolve such questions through the development of general principles of law.

Lying behind this is the concern over the legal process. Keeping a business running involves considerations that are not easily resolved in the narrow confines of a judicial proceeding. A variety of different interest groups will have important concerns, which may not receive a fair hearing. Reaching an appropriate accommodation among these different interest groups is more a matter of careful bargaining and negotiation than searching for neutral principle for application across the country, and through different economic periods.

[14] Singer, "Reliance Interest." 659–60. [15] 631 F.2d 1264.

Belonging and Property Law

Avital Margalit has made an argument on property and community that is similar to Singer's, but in relation to sports teams and their fans.[16] Margalit observed that the fans of a football club form a community (i.e., fandom) that is closer knit and far more socially relevant to its members than the typical group of customers or clients. Being a fan of a club can become so important to one's sense of identity that it becomes as difficult to discard as any other element of identity. Nevertheless, the fans, individually and collectively, have little say in the running of the club. The owners could choose to close the club down or move it to another location without the fans having any direct power to intervene. Of course, a sensible owner would not ignore the wishes of the fans, but this would be a matter of prudent business practice rather than legal obligation.

Issues over fandom bear some similarities with those concerning cultural property; indeed, fandom itself could be regarded as a form of cultural property. In both situations, there is the risk that the titleholder may act in ways that are contrary to the values of the group, thereby damaging community and personal identity. But, as in the *Local 1330* case, it is difficult to construct a legal argument to defend community interests. Indeed, in the United States, even government intervention to prevent the relocation of sports teams has often failed.[17]

Margalit argues that the importance of the community in the lives of the fans is sufficient to warrant giving them some protection of their interests. In her view, the "value of belonging" provides the basis for recognising that the community has a property interest in the club. The community would only have a limited interest, without a direct say in the business and financial decisions of the club. However, it would have a say in decisions that could destroy the club itself (and, by association, the fan community). However, as Margalit implicitly recognises, current property structures do not provide a means for protecting these interests. She calls for new institutional arrangements for managing clubs, involving a modified version of the commercial corporation, in which the social ownership would lie in the hands of the fans but the economic incentives would remain with the ordinary shareholders.

Modifying the corporate form is certainly not inconceivable: it is flexible enough to allow some form of comanagement of a cultural resource. Indeed, some countries require companies to provide unions with representation on the board of directors. In practice, however, the design of

[16] Margalit, "'You'll Never Walk Alone'." [17] Leone, "No Team, No Peace."

such new corporate structures would fall to the legislative branch. It lies outside the existing principles of property, with their emphasis on owner autonomy, exclusivity, and certainty. Indeed, it is no more likely that courts would develop a principle of social belonging than a principle of economic reliance.

Access to Quasi-Public Property[18]

It has also been argued that needs can justify access to privately owned objects or land when necessary for the exercise of human rights. For example, access to specific objects or land may enable followers of a faith to exercise rights to freedom of religion. Similarly, a group may feel that the effective exercise of the right to freedom of expression should give them a right to attend and speak at a public debate. Plainly, if they own the objects or land in question, they have legal rights of access and control. If, however, another private person holds title, they would be faced with the rule of property that a private owner of an object or land has absolute control over it, including the right to exclude others. The situation would be different if the land is owned by the government or a public agency; in such cases, the owner would be accountable for its decisions under the usual principles of public administrative law. The owner would be required to adhere to the terms of the grant of power from the legislature. Some of these terms may relate to the use of the specific property; others may be more general (e.g., all public agencies are subject to the UK's Human Rights Act 1998). This may give the affected group the basis for demanding access. It may be able to show, for example, that the legislative grant of power to the public agency included a responsibility to consider the group's need for access. However, if the property is held by a private person, the potential for gaining access is much lower.

Most of the human rights cases concern quasi-public spaces. These are areas that are privately owned but open to the public on a regular basis. In modern life, the best-known example is the shopping centre. The importance of access to quasi-public spaces to ordinary life should not be underestimated: in some communities, denying access to these spaces could have a serious impact on opportunities for social interaction and employment. For this reason, it is generally acknowledged that the landowner's absolute right of exclusion should not apply. For example, most

[18] See Gray and Gray, "Civil Rights, Civil Wrongs and Quasi-Public Space"; Gray and Gray, "Private Property and Public Propriety."

countries have passed legislation that prohibits businesses from excluding potential customers on the basis of race, gender, religious beliefs, or other discriminatory grounds. Some have also passed legislation to authorise entry to property for other, cultural purposes. In South Africa, for example, it is the cultural tradition of some groups to bury deceased family members near their home. However, in the case of farm labourers who were provided accommodation by the landowner, permission would normally need to be obtained from the landowner before a burial could go ahead. Accordingly, postapartheid legislation provides a right of burial, even if contrary to the wishes of the owner.[19]

In formal terms, this situation raises issues that are similar to those in the cases in which employees or fans seek to stop companies from making decisions contrary to their interests. In this case, however, the claimants have no prior relationship with the property owner. They are not challenging a disposition of property; they argue simply that they cannot exercise their human rights without access to the property. In that respect, their claims are similar to demands of access for cultural reasons.

The question for this chapter is whether the courts and legal profession can develop general principles of property law that would provide similar limitations. There are several interesting cases that suggest that courts are becoming sympathetic to this type of claim. A leading example is the Canadian case *Syndicat Northcrest v. Amselem*,[20] in which the Supreme Court of Canada was asked to restrict rights of private property to enable certain religious practices. The case involved an unusual set of circumstances: owners of flats in a condominium sought to use their balconies to put up temporary shelters for a limited period, as part of a religious practice. This would have interfered with the clear property rights of the building owner, who remained the legal owner of the balconies and had refused to give consent to the erection of the shelters. The circumstances therefore brought up many issues that arise in cases on access to cultural property. Admittedly, the balconies had no cultural value of their own; they were valued only as the most suitable place to engage in the religious practice. The legal grounds of the dispute were clear: the flat owners claimed that denying access would prevent them from exercising their human right to freedom of religion, but the building owner argued that the Court would abrogate its human right to property if it were required to allow access. The Court decided in favour of the flat owners, but only because the shelters

[19] See A. J. van der Walt, *Constitutional Property Law*, 174–5, 344–5.
[20] Supreme Court of Canada, *Syndicat Northcrest v. Amselem*; see Weinrib and Weinrib, "Constitutional Values and Private Law in Canada," 54–61.

were going to be used for a short period, with minimal interference to the building owner's interests. A permanent or more serious intrusion would probably have been rejected. Nevertheless, the case is significant for the willingness of the Court to allow restrictions on private property.

Other courts have accepted the general principle that the exercise of human rights may allow restrictions on private property but are more reluctant to find that the restriction is truly necessary or proportionate. For example, in *Appleby v. United Kingdom*,[21] a group had asked the owners of the Galleries shopping centre in Washington, Tyne & Wear, for access to campaign on local development issues. The owners refused, on the grounds that the centre had a policy of strict neutrality on all political and religious issues. The applicants went to the European Court of Human Rights, to claim that the law that gave owners the absolute right to exclude them from the centre had breached their own human right to freedom of expression. The Court did not entirely rule out the possibility that there may be circumstances in which the right to freedom of expression would require states to enable access to private land. However, it also stated that it would consider doing so only when "the bar on access to property has the effect of preventing any effective exercise of freedom of expression or it can be said that the essence of the right has been destroyed."[22] This would arise only if, for example, "an entire municipality was controlled by a private body."[23] In effect, it accepted the principles of *Syndicat Northcrest v. Amselem*, but whether it would apply them in a specific case seems doubtful.

These cases suggest that there is some room for development of legal principles for claims to cultural property, without further resort to the political process. Against this, it could be argued that these cases still rely on legislative action. The outcome in *Syndicat Northcrest v. Amselem* was justified in terms of the human rights legislation of Quebec. Human rights law is seen as superior and exterior to the law of property rather than as something internal to property law. Arguably, it does not make a real difference: human rights principles are stated at a level of generality that leaves it to the courts to develop principles without waiting for further political action.

However, there is also the more substantial point that the construction of legally enforceable human rights often differentiates a state's negative obligations from its positive obligations. That is, they differentiate the state's obligation not to interfere with human liberties from its obligation

[21] *Appleby v. United Kingdom*, European Court of Human Rights, Appl. No. 44306/98 (6 May 2003).
[22] Ibid., para. 47. [23] Ibid.

to take positive action to respond to human needs. In general, it is much more difficult for private citizens to enforce the positive obligations of their state than its negative obligations. Human needs relating to, for example, subsistence, employment, and education are not generally enforceable by private citizens. For example, the European Convention on Human Rights recognises a right to respect for the family home, but it does not entitle a homeless person to a home, even when it appears necessary to secure basic subsistence. It is only enforceable by those who already have a home (or, in some cases, by victims of discrimination by public housing authorities). Similarly, there is a right to property in the Convention, but it only protects those who already own property. There may be situations, as in *Syndicat Northcrest* and *Appleby*, in which a claimant might be able to use human rights law to restrict someone else's property rights, but the scope for such arguments is fairly limited.

ALIENATION OF PROPERTY

Even if we restrict the inquiry to the alienation of property and leave aside questions regarding human needs as a basis for property entitlements, we are still left with this question: how far can Radin's concern for individual identity be incorporated in property law? Although her theory is based on psychological intuition, she also derived insights from Hegel's theory of property, as expressed in the *Philosophy of Right*.[24] A review of Hegel's theory highlights the difficulty in making the protection of identity a central principle of the law of private property. Hegel begins with an abstract conception of the person as a self-conscious, abstract free will. A person establishes his or her existence in the real world by projecting his or her will into material objects, including his or her own body and mind. This act of projection – which Hegel described as grasping, forming, or marking the object – lays a claim to ownership of objects in the external world. It establishes that the person is an actor in civil society as opposed to an object of the actions of others. An individual without the capacity to own property would have no existence or identity in civil society, except possibly as a slave to be owned by others. Hence, denying individuals the capacity to own property denies the existence and value of their personality. As such, it would violate Hegel's normative imperative that persons should not infringe personality and what personality entails.[25] It is therefore morally

[24] Hegel, *Philosophy of Right*, trans. T. M. Knox; see also Stillman, "Hegel's Analysis of Property in the *Philosophy of Right*."
[25] Hegel, *Philosophy of Right*, paras. 35, 36, 38.

necessary to recognise that others are capable of owning property and to treat them as subjects of a law of property rather than as its objects.

The starting point of his theory is individual freedom, and more specifically the reciprocal recognition of personality. Hence, it is the capacity to own that is important for personality rather than what it is that is owned. Individuals must be able to act on their subjective whims and desires when deciding what to own and when to consume it or transfer it to others,[26] subject to the limit that no person should be able to deny or destroy his or her own existence as a person. Hence, they cannot give up the capacity to acquire, own, and dispose of property, or withdraw their will from their own body and mind; accordingly, the sale of the body and mind should not be permitted or recognised by others.[27]

In this respect, Hegel's theory does not give much to those who would argue that special principles ought to apply to cultural property. Not only is alienation of virtually any kind of external object allowed; the individualist emphasis rules out any argument that groups should have a special claim over cultural property. However, this is only the starting point of his theory. Hegel did not intend to say that limits were always inappropriate, or that the protection of private property, and personal liberty, was the sole objective of the state. The market economy could lead to unacceptable hardship, both for individuals and potentially for society as a whole. The state was therefore under a duty to protect private property (and the personal freedom associated with property), and to enable individuals to transcend it in pursuit of a fulfilling life. Accordingly, it is the responsibility of the state to enact laws that ameliorate the worst effects of the unrestrained market, and to direct individuals into activities that are not self-destructive but fulfilling. This could include laws that limit the owner's otherwise unrestrained control over property, so as to enable access to the property by those individuals or groups whose identity is closely linked to it. However, such laws would be external to the fundamental notions of the person and property.

Radin took issue with Hegel's view of the person, as she felt that it was based on an overly simplified division of the self between external and internal objects. She also raised a number of examples of legal principles that do put limits on autonomy in circumstances in which property is closely related to identity. For instance, home ownership is often treated differently than ownership of other property. Courts generally scrutinise

[26] See Pottage, "Property: Re-Appropriating Hegel."

[27] Hegel, *Philosophy of Right*, paras. 65–6; see also Stillman, "Hegel's Analysis." 1040; Radin, "Market-Inalienability."

the lawfulness of intrusions on the home with great care: a search of a home has long been treated as a more serious matter than a search of an office or business. Mortgages and charges over houses are subject to a variety of rules intended to protect the homeowner, whereas similar security over fungible commercial property is not.

Nevertheless, courts tend to frame these cases in terms of capacity to enter into the transaction rather than the relationship with the type of property. That is, their real concern is whether the person was able to give his or her consent without constraint. If capacity is established, a transaction in external objects normally stands. Moreover, the limits do not usually apply in other cases in which the owner's actions in respect of property might be seen as a type of self-harm. For example, there is no legal principle of property law that allows someone to intervene to prevent an owner from demolishing his or her own home. Similarly, no legal principle prevented the artists Dinos and Jake Chapman from buying and 'rectifying' a set of Francisco Goya's early 19th century engravings by drawing upon them (they entitled the 'new' work *Insult to Injury*).[28] There may be statutory rules: for example, owners of listed buildings are subject to restrictions, but the rules were developed through the political process.

INDIVIDUAL IDENTITY AND GROUP IDENTITY

Radin recognised that "in a given social context certain groups are likely to be constitutive of their members in the sense that the members find self-determination only within the groups."[29] The importance of groups is such that it is worth considering their role, as groups, in claims for cultural property. Indeed, disputes over identity and property are often brought in the name of a group.

The attributes that tie the group together can vary. As Carpenter, Katyal, and Riley observe, a group may be based on "political affiliation, religion, culture, language, race, ethnicity, history, and other factors."[30] Although these factors "inspire individuals to identify with and participate in the collective",[31] they note that membership is not always a free choice. Legal rules and social pressures often constrain personal decisions on joining or leaving groups. Even without external constraints, membership of a group

[28] See P. Shaw (2003). "Abjection Sustained: Goya, the Chapman brothers and the *Disasters of War*." *Art History* 26: 479–504.
[29] Radin, "Property and Personhood," 978.
[30] Carpenter, Katyal, and Riley, "In Defense of Property," 1053.
[31] Ibid., 1054.

can become so important to personal identity that leaving is not a real option.

Looked at this way, there is nothing particularly controversial about extending Radin's argument to say that groups may hold cultural property. It recognises that individuals often pursue their personal interests through groups and that the denial of associational rights and recognition of the group could have a harmful impact on individuals. Indeed, modern human rights instruments protect associational rights. For example, the European Convention on Human Rights requires the state to respect family life and even allows corporate bodies to exercise human rights in most situations. The vast majority of legal systems are quite generous in allowing groups to create artificial legal persons, with the capacity to hold property, bring legal claims, and transact business to the same extent as a natural person. There is no reason such groups cannot establish a separate legal person to hold and administer property that is important to their sense of identity.

At the same time, the possibility of giving a group a separate legal personality does not advance the analysis of cultural property. Separate personality does not dictate what legal persons should own, just as Hegel's theory of property and capacity does not tell us what individuals should own. However, it does demonstrate that arguments based on human needs are of limited value in many circumstances, at least in systems based on European legal models, because the dominant frame for thinking about private property focuses on individual capacity and individual needs. Groups, and the legal structures for facilitating group activity, exist as instruments for individual development. When groups are seen differently, the legal process is unlikely to provide a full hearing to all interested parties. For example, Carpenter, Katyal, and Riley argue that, when American Indians bring legal claims for land or cultural property, they do so to ensure the "continuance of the tribe, its norms, values, and way of life . . . and not solely for their personal fulfillment."[32] The tribe does not exist "merely as a vehicle or context for individual autonomy."[33] This may be true of many other groups, and yet the dominant paradigm for framing property rights does not accord such recognition to the importance of all groups.

CONCLUSION: POLITICAL PROCESSES AND LAWS

The specialised discourse and processes of legal professionals are unlikely to provide an adequate response to the issues of identity and cultural property.

[32] Ibid., 1051. [33] Ibid.

This is not to say that lawyers have no interest in these issues. Indeed, lawyers are more likely to be involved in politics than members of most other professions. Many of them have strong opinions on the issues, and those opinions range across the political spectrum. However, it is in the political realm that these disputes will continue to be resolved.

CHAPTER 14

Monuments versus Moveables
State Restrictions on Cultural Property Rights

David Garrard

If I own something then, other things being equal, I can do what I please with it.[1] But other things frequently aren't equal: the state may opt, through the medium of legislation, to restrict my ownership rights in various ways. Some of these ways make no particular reference to the nature of the item in question: nothing of mine is permitted to become a public nuisance or a fire hazard, regardless of what kind of thing it is. Other forms of restriction, however, are directed quite specifically toward certain categories of goods. One such category is that denoted by the term *cultural property*, a peculiar phrase rarely heard outside academic and regulatory discourse, but intended to suggest the existence of a certain group or common interest that needs to be weighed against the more straightforward property rights of the titular owner.[2] Although legal recognition of these interests has been slow to emerge, most states have now enacted laws restricting what their citizens

[1] On some legal and philosophical theories, this fact forms the bedrock of the very notion of property; see, for example, Waldron's (1993: 188) characterisation of the latter as 'the idea of one person being in charge of a resource and free to use or dispose of it as she pleases'.

[2] In this section I speak of cultural property as the property *of* some group or other, and discuss restrictions on ownership rights as reflecting collective quasi-ownership claims put forward by one such group or another. But this 'nationalistic' approach (see Merryman, 1986) is not the only one, and some of the categories of regulation I discuss here lend themselves to more individualist or more universal models. Some commentators of a very universalist stripe seek to minimise the importance, or even deny the validity, of group-specific claims – for example, King (1989: 199) asserts that 'there can be no such thing as, for example, American Cultural Property since American cultural achievements are the products of worldwide interaction and are the heritage of future generations, worldwide'. This seems to overstate the case: human culture may be a web, but it is not a seamless one, and some of its products relate much more closely, and are of infinitely greater importance, to one group than to another.

An earlier version of this chapter was presented at the Centre for the Ethics of Cultural Heritage at Durham University in July 2009. I am grateful to those who provided comments on that occasion and to those who have read and commented on it since; my particular thanks to Eve Garrard, Geoffrey Scarre, Holly Stout, Hannah Parham, and Janet Ulph for their detailed observations and suggestions.

may do with items construed as cultural property when these fall within their ownership – or, as we are now invited to say, their stewardship.[3]

Such is the general topic of my chapter.[4] I hope to offer both a useful overview of the restrictions currently in force (this forms the first major section below), and (in the second section) some analytical reflections on why different categories of cultural property attract such different regulatory models – my focus being on the treatment of portable artefacts on the one hand and structures and monuments on the other. Finally (in the concluding section), I look beyond the domain of artefacts to examine ways in which cultural property considerations have influenced legislation dealing with the 'natural' environment, and I make some tentative suggestions as to how our achievements in the latter field might in turn guide our approach to the former.

A detailed analysis of the much-theorised concept of cultural property is beyond the scope of this discussion. It is a notion whose scope varies greatly with context, and especially with how strictly or loosely one interprets its two component terms. Hence, in a very broad sense, we may speak of a group's cultural property as comprising everything that is distinctive about its way of life, including its language, customs, institutions, and so on, regardless of whether these could literally be *owned* by anyone. At the opposite extreme are stipulative 'catalogue' definitions that simply list the various categories of goods that are to be counted as cultural property, typically for the purposes of some specific piece of regulation.[5] These have the obvious advantage of clarity and brevity, but just as obviously they lay themselves open to the charge of conceptual bias, especially against non-mainstream cultures whose most valued assets may not be at all like 'ours'. As I do wish to focus on rights of ownership, but do not wish to prejudge what kinds of ownership may properly be subject to constraint,

[3] The stewardship paradigm has deep roots in the discourse of cultural property, and even deeper ones (as the book of Genesis attests) in our understanding of the environment and land ownership in general. For a critique, see Groarke and Warrick (2006).

[4] Thus, I concentrate on state-level restriction rather than the aspirations expressed by the various international agreements (although do I mention the latter when they have a bearing on my main theme), and on legislation and policy rather than what is embodied in the common law (though again I use individual legal cases as illustrations) or in more informal, societal systems of control (for examples of the latter, see Nicholas and Bannister 2004a).

[5] See, for example, the loose-fit inventory laid out in article 1 of UNESCO (1970), where 'cultural property' is defined as 'property which, on religious or secular grounds, is specifically designated by each State as being of importance for archaeology, prehistory, history, literature, art or science', and which also falls into one or more of eleven specified categories ranging from 'original works of statuary art and sculpture in any material' to 'postage, revenue and similar stamps, singly or in collections'. In another context, the same organisation can define the term purely in terms of structural and human-geographical features; see article 1 of UNESCO (1972).

I must attempt to steer a middle course between these two extremes – taking my cue from actual legislation and from an ordinary-language conception of what kinds of things pertain to 'culture', but bearing in mind that some important property types will probably elude conventional classification.[6]

<div align="center">VARIETIES OF REGULATION</div>

Cultural property regulations can be characterised in a variety of ways, for example by the class of items over which control is exercised, by the types of activity that are curtailed, by the nature of the rights and interests in whose name the restrictions are applied, and so on. My aim here is not to provide a full typology, but to pick out the varieties of regulation that appear most salient in the present legal landscape, and to consider how they relate to one another in terms of scope and character.

<div align="center">*Ownership and Export*</div>

Perhaps the highest-profile category of state regulation concerns the ownership, sale, and export of cultural property. Most countries impose some level of restriction on the movement of artworks and antiquities across their borders. This may amount to no more than a requirement to obtain an export licence for works of a certain kind or over a certain value[7] – reinforced in some cases by the state's temporarily withholding the permit in order to give domestic museums the opportunity of buying the work.

Perhaps recognising our relatively modest contribution to the history of the visual arts, and our traditional aptitude for acquiring the artistic riches of other cultures, the UK's export controls are imposed impartially on all works that happen to find themselves in British ownership; they would

[6] For further discussion, see Gerstenblith (1995), characterising cultural property as 'that specific form of property that enhances identity, understanding, and appreciation for the culture that produced [it]' and going on to contrast more and less 'demanding' ways of using the term. On the essential contestedness of the concept, and the political implications of adopting one formulation rather than another, see the discussion of 'de-arting' in Gamboni (1997: chapter 15), and the analysis of copyright and indigenous culture by Nicholas and Bannister (2004a).

[7] The United Kingdom's Export of Objects of Cultural Interest (Control) Order of 2003 – made under the Export Control Act of 2002 – stipulates that a licence is required, with certain exceptions, for 'any objects of cultural interest manufactured or produced more than 50 years before the date of exportation'. The principal exemptions are for items with a strong biographical link to the exporter: her personal papers, letters addressed to her, or artworks she herself has produced. In addition, an open general export licence is granted to items that fall below a certain financial value threshold, ranging from £10,000 for photographs to £180,000 for oil paintings. (The text of the act, and all the other UK legislation referred to in this chapter, can be found at http://www.opsi.gov.uk.)

thus apply as much to a Turner as to a Tiepolo. The regimes of other countries, such as Holland, focus on objects of particular significance to national history – objects that are usually, but not invariably, made on home soil.[8] Such controls apply both to antiquities and to works of fine art, although in the latter case they are usually restricted to works over a certain age. Under the terms laid down by UNESCO (1970), some 'source' countries have sought to establish bilateral agreements with 'destination' countries, whereby the latter agree a blanket ban on imports of certain categories of items from the former.[9]

More robust forms of control go beyond movement restrictions and amount to an outright expropriation of cultural property holders by the state. In many archaeology-rich southern European, Middle Eastern, and South American source countries, antiquities unearthed within national borders automatically belong to the nation and must be surrendered upon discovery: private retention and resale, even on the domestic market, equates to theft of public property.[10] Even the United States, the destination country par excellence, has made similar provisions, albeit that the scope of the Archaeological Resources Protection Act of 1979 is limited to artefacts found on federal and Native lands.[11]

[8] Holland's 1984 Cultural Heritage Preservation Act (*Wet tot behoud cultuurbezit*), discussed by Lubina (2009), imposes government control on the export of privately owned objects deemed to be of special importance within the nation's cultural history. The Dutch system is designation based, not unlike that of Japan (see, *infra*, note 20).

[9] A number of countries have opted to implement the convention by means of a series of bilateral agreements rather than a unilateral application of the UNESCO principles. The United States, for example, has negotiated such agreements with Italy, China and other source nations under the terms of the 1983 Convention on Cultural Property Implementation Act (Fitz Gibbon 2005; Hingston 1989). A separate US law, the Pre-Columbian Art Act of 1972, forbids the importation of items of architectural and monumental sculpture from certain Latin American countries without an appropriate export licence; see 19 USC § 11. (The text of the US Code, in which are embodied the various pieces of US legislation referred to in this chapter, can be found at http://uscode.house.gov/.)

[10] Ownership stipulations of this began as products of late-C19 and early-C20 nationalism; early instances include laws passed by Mexico in 1897, Italy in 1909, Peru in 1929, and Greece in 1932 (Cleere 1984). Given that most illicitly excavated antiquities are destined for sale abroad, these claims have limited meaning if they are not upheld by the legal systems of destination countries – that is, by creating the conditions for such objects to be regarded as stolen property under domestic law. How far they do so remains a moot point, although landmark US rulings such as those in the *McClain* and *Schultz* cases (in 1977 and 2003, respectively), and the United Kingdom's Dealing in Cultural Objects (Offences) Act of 2003, indicate a growing acceptance of the principle; see Gerstenblith (2003); Browne and Valentin (2005).

[11] 16 USC §470 aa–mm. The act forbids unauthorised excavation of sites in federal or Native ownership and asserts federal ownership of all 'archaeological resources' contained therein. Various individual states have enacted similar legislation with respect to state-owned land (see Gerstenblith 1995: 597n171). According to Sax (1999: 183), the state of Alabama is alone in the United States in having, since 1906, asserted state ownership of all archaeological material found within its borders, although the law is said to be 'a dead letter in practice'.

Such statutes are an extension of the ancient law of treasure trove, whereby valuable *objets trouvés* of unknown ownership revert to the state (or its titular head) upon discovery. Historically, the English common law concept of treasure had no built-in bias toward cultural property, treasure being defined in terms of precious metal content (more than 50 percent) and the idea of *animus revocandi* – items that had been hidden with a view to recovery, rather than simply lost, abandoned, or committed to the earth. The Treasure Act of 1996, however, brought specifications as to age (usually at least three hundred years), introduced the category of items of 'outstanding historical, archaeological and cultural importance', and largely disposed of the *animus revocandi* clause, thus extending the law to cover funerary artefacts.[12] State expropriation is discretionary and is usually accompanied by compensation to the finder, owner, or occupier (see section 10(5) of the act). UK government bodies also reserve the right to make compulsory purchase of scheduled ancient monuments and listed buildings,[13] and may carry out excavations in defined 'archaeological areas' without the landowner's consent[14] – although in the latter case the finds, if not deemed to be treasure, are returned to the owners after investigation.

Some states also impose specific restrictions on their own agencies as to how they may dispose of nationally owned cultural property. Under section 4 of the UK Museums and Galleries Act of 1992, the trustees of the national collections (the National Gallery, National Portrait Gallery, Tate Galleries, and Wallace Collection) may dispose of an item only if is so badly damaged as to be unfit for display, is a duplicate of another item in the collection, or else has had its authenticity conclusively disproved. Similar rules apply under section 5 of the British Museum Act of 1963. Where competing claims arise between cultural groups within a country, the state may also bind its institutions to transfer property to the 'originator' community: this

[12] See sections 1.1 and 2.1 of the 1996 act. An item is not deemed to be of 'outstanding importance' unless it belongs to a category so designated by the Secretary of State; the only such designations thus far, made under the Treasure (Designation) Order 2002, relate to prehistoric objects made of gold, silver, or base metal – the latter only in the case of finds containing multiple objects. The first – highly controversial – prosecution under the new law recently took place in Shropshire; see Mills (2010).

[13] See section 9 of the Ancient Monuments and Archaeological Areas Act of 1979, and section 47 of the Planning (Listed Buildings and Conservation Areas) Act of 1990. Listed buildings are subject to compulsory acquisition only when they have been subject to severe neglect and when the owner has first been issued with a repairs notice by the local authority. Buildings and monuments are discussed in more detail later in this chapter.

[14] See the Ancient Monuments and Archaeological Areas Act of 1979, part 2. Landowners must serve an 'operations notice' before carrying out certain kinds of work in defined archaeological areas; when a notice has been served, official representatives may enter and investigate the site 'at any reasonable time' and may subsequently notify the owner of their intent to carry out excavations.

has happened in the United States, where museums must return human remains and grave goods to indigenous groups under the Native American Graves Protection and Repatriation Act of 1990.[15]

Describing the nature of the interests involved in such ownership controversies is not straightforward, and I can only gesture at a complex knot of issues.[16] What is at stake is clearly something public: the views, if any, of the original 'producers' are seldom cited, and often can only be vaguely guessed at. But just how broad that public is depends on the type of arguments being deployed. It is natural to see the matter in terms of purely parochial (usually national or ethnic) interests: access, for one's own public rather than another country's; pride of ownership, with cultural goods regarded as trophies conferring collective glory on their possessors; or the quasi-sacramental value of having certain totemic items kept on home soil, like temple effigies without which the city will fall.[17] (Only the last of these motivations is nationalistic in the fullest sense: the first two can and do apply to foreign as well as homemade goods, as the 2004 campaign to 'save' Raphael's *Madonna of the Pinks* for the (British) gallery-going public testifies.[18]) But the prominence of such interests does not prevent more universalistic considerations from coming into play on both sides of the debate. Hence the contention (at times somewhat disingenuous) that this or that archaeological treasure stands a better chance of physical preservation in its wealthy steward country than in its poorer country of origin; hence, too, the opposing argument (again not always advanced in the best of faith) that such decontextualised fragments as the Elgin Marbles or the Benin Bronzes are stripped of meaning in their current deracinated setting, and will generate a far richer field of cultural experience *for everyone* if returned to the site of their first creation.[19]

[15] 25 USC § 3001–31. Given the nomadic character of the North American tribes, exactly which indigenous group has title to any given set of finds can be a vexed issue; section 3 of the act embodies a complex system of principles including, in rank order, lineal descent, continuity of occupation, and cultural continuity.

[16] Merryman (1986) offers a fuller account of the tension between nationalism and internationalism in cultural policy.

[17] The saga of the Stone of Scone – its capture by Edward I in 1296 and its ceremonial return to Scotland (though to Edinburgh rather than its traditional home in Perthshire) seven hundred years later – provides our superlative intranational instance of the latter two mentalities.

[18] The National Gallery's purchase of the painting from the Duke of Northumberland was made with the help of a multi-million-pound grant from the Heritage Lottery Fund, on condition that the painting be given the widest possible public exposure (Hooper-Greenhill, Dodd, Gibson, and Jones 2007).

[19] For an influential recent attack on the latter position, and on cultural 'restitution' claims more generally, see Cuno (2008).

Creators' Rights

In the case of artworks, antiquities, and other 'middle-sized dry goods', current controls focus almost exclusively on questions of ownership *transfer*; apart from a few remarkable instances such as Japan's Law for the Protection of Cultural Properties, which gives the state ultimate control over ten thousand designated artworks, many of them privately owned,[20] regulation is largely silent on what people may do with objects that remain in their undisputed ownership. To rework a familiar example, the state may prevent you from selling your Praxiteles statue abroad, and may curtail your attempts to dig up another one, but if you want to play skittles with it, that's probably your affair.[21]

A notable exception is found in the various systems of rights developed to protect the interests of cultural creators against those who would exploit or abuse their work. The background assumption is that someone's stake in the fruits of their creative endeavour survives the transfer of ordinary property rights: I may quite legitimately have acquired ownership of your creation, but I still wrong you if I make certain uses of it – even though such uses might be quite acceptable in another context. The key word here is *creation*. If the item in question is one that you simply 'made' (say, by following a set of instructions or a standard routine) or whose existence you merely facilitated (say, by planting a seed), then no such special considerations apply. If you sell me your cupcakes or carrots, my future use of them is unfettered by any authorial prerogatives.

Copyright provides the most familiar instance here, although patents, trademarks, and performing rights laws fall under the same heading. All allow creators to safeguard the conditions of their work's (re)production, essentially to protect their financial interests by maintaining conditions of economically advantageous scarcity. I do not wish to dwell on copyright and its kindred regimes here, as the concerns involved are fairly narrow (in terms both of whose they are and what they involve), and have little to do with the group- or public-interest claims that are normally central to debates about cultural property.

[20] Enacted in 1950, but taking its present form from amendments passed in 1954; see Fitz Gibbon (2005), appendix 1.

[21] See Sax (1999), citing Feldman and Weil (1986), on 'playing darts with a Rembrandt'. The origin of this trope probably lies in Marcel Duchamp's idea for a 'reciprocal Readymade', a work of art transformed into anti-art through Dadaist misuse, expressed in his 1934 injunction to 'use a Rembrandt as an ironing board'; see Gamboni (1997: 261). Ironically enough, your freedom to abuse one of Duchamp's own works would be more closely circumscribed, and would be subject to even tighter control, in the case of a living artist; see my discussion of moral rights herein.

Three things are worth noting, however. The first is that rights of this kind are no more inalienable than are those of ordinary ownership systems: copyright, patents, and the rest are themselves market goods, and capitalising fully on one's creation is often a matter of knowing when to sell these goods, to whom, and at what price. The second is that such provisions treat creative works as collections of data rather than as concretely existing objects: what the exploiter 'misappropriates' is the work as abstract or generic entity[22] – the text, the visual design, the computer program – and not the bit of stuff that is its physical token; instances of the latter, even superlatively important ones like Henry Moore bronzes or Le Corbusier villas, are of the wrong ontological grade to be caught in copyright's net. The third point is that, unlike more traditional forms of theft or fraud, copyright belongs to the domain of civil rather than criminal law: if I've stolen a painting from your studio then the state may prosecute me in the name of the public at large, but if I've merely crept in and illicitly copied it, you must bring (and win) your own individual claim against me before the law will intervene on your behalf.

More germane to our interests here is the legal concept known in French as *droit moral* – which I render here as 'moral rights', although there is no precise equivalence across jurisdictions, and indeed much variety between them as regards how, if at all, such rights are implemented in law. At its broadest, as in France itself,[23] *droit moral* covers a spectrum of 'reputational' rights that all cultural creators have in respect of their work: to be identified as its author in relevant contexts ('paternity'), to decide when and how it shall be made known to the public ('divulgation') and, crucially, to determine whether and how it may be altered by third parties – a 'right of integrity' that enjoins owners not to destroy or modify a work without either obtaining the consent of the artist or else (if this is feasible) allowing the latter to come in and remove it from harm's way.[24] Weaker versions may omit the paternity and divulgation rights, and may also curtail

[22] See the discussion of artworks as 'generic entities' in Wollheim (1980), sections 35–7. In Wollheim's account, this way of talking applies primarily to literary, musical, and other works 'where there is no physical object with which the work...could be plausibly identified'. In discourses like that of copyright, however, we find ourselves speaking of *all* works as if they had a formal 'essence' that does not inhere in any given material realisation.

[23] *Code de la Propriété Intellectuelle*, articles L121–1 to L121-9 ; Berne Convention for the Protection of Literary and Artistic Works, article 6*bis*.

[24] Exactly what constitutes such harm, and what strategies of avoidance and rescue are available, varies considerably between different kinds of work. Particularly heated debate surrounds site-specific works, whose relocation may strike the artist as tantamount to mutilation or even destruction – the removal of Richard Serra's *Tilted Arc* from Federal Plaza in New York in 1989 being the *cause célèbre* in this area (Adler 2009: 274–5). See Sax (1999) for further examples.

the integrity clause in a variety of ways, for example by imposing a quality test whereby protection applies only to works judged to be of genuine merit.[25]

The distinction between moral rights and copyright is a subtle one, and is much sharper in some legal systems than in others. For our purposes, the most important difference is that moral rights law extends copyright's artist-specific prerogatives from designs and other abstract entities into the domain of concrete cultural objects like actual paintings and sculptures. Just as under copyright I can't present a painting whose *design* is a modified version of yours, so moral rights law rules out my producing the same modification by physically altering the *fabric* of your original. In some jurisdictions, the Chapman brothers' two series *Insult to Injury* and *Like a Dog Returns to Its Vomit*, produced by defacing limited-edition prints of Goya etchings, might amount to an unlawful infringement of the original artist's right of integrity (Adler 2009; Jones 2003).

The main thing moral rights and copyright have in common is that both are held by, and enforced in the interests of, cultural creators, thus allowing them to retain some control over their work even after it has passed into another's hands. (Moral rights, unlike copyright, cannot be sold, although in some countries they can be waived.[26]) Some states, their legislators apparently moved by public concerns about the preservation of artworks, have in enacting moral rights provisions invoked what one commentator describes as our shared interest in 'seeing, or preserving the opportunity to see, the work as the artist intended it'.[27] But, as with copyright, it is usually only the individual rights-holder (the artist or, in some cases, her heirs) who may invoke the law. (A rare exception is the state of California, where 'an organisation acting in the public interest may commence an action . . . to preserve or restore the integrity of a work of fine art' even if

[25] Such tests are embodied in US law at both state and federal levels. For example, the California Art Preservation Act of 1979 extends the full range of integrity rights only in the case of works of 'recognised quality', the latter to be determined by appeal to expert witnesses including artists, art dealers, collectors, and curators (California Civil Code §987b; Sax 1999: 23). The Visual Artists Rights Act of 1990 (VARA) protects artworks against mutilation regardless of quality, but restricts the veto over outright destruction to artists 'of recognised stature' (17 USC §106A; Adler 2009: 267).

[26] This is the case in the United States under VARA and in the United Kingdom under the Copyright Designs and Patents Act of 1988, but not in civil law countries such as France, where moral rights are perpetual and inalienable (*Code de la Propriété Intellectuelle*, article L121–1).

[27] Merryman (1976: 1041). See also the various individuals quoted by Sax (1999: 25) in support of VARA, despite the latter's lack of any public recourse option: 'it is paramount to the integrity of our culture that we preserve the integrity of our artworks'; 'society is the ultimate loser when these works are modified or destroyed'.

the artist is unable or unwilling to do so; but this option is unavailable if, as not uncommonly happens, the potential destroyer is the artist herself.[28])

Conceived as a means of protecting cultural property itself, as opposed simply to defending the interests of creators as embodied therein, moral rights law displays many other limitations. For obvious reasons, its terms apply primarily to the work of living artists; in the United States, federal legislation covers only work created after the passing of the Visual Artists Rights Act (VARA) in 1990, and ceases to apply with the artist's death.[29] Typically, only portable items are covered – or rather, as the clause about removal makes clear, items are *treated* as portable for the purposes of legislation: relocation, even of site-specific installations, is permitted under VARA, provided that the work itself is not damaged in the process, thus making it clear that *integrity* means only physical integrity.[30] Furthermore, the 'reputational' character of moral rights tends to restrict their scope to cases involving distortion rather than destruction: in the United Kingdom, an owner who destroys a work so completely as to preclude any further exhibition of it does not infringe the creator's moral rights.[31]

Heritage Protection

For a system of control that applies to works of all periods, covers both destruction and modification, takes account of site specificity, and is explicitly enacted in the public interest, we must turn to the legislative regimes that I lump together under the contestable but convenient heading of 'heritage protection'. The term is borrowed from the English Heritage department[32] responsible (among other things) for maintaining the List of listed buildings, the Schedule of scheduled ancient monuments, and the Register of registered parks and gardens.[33] These national inventories have

[28] California Civil Code § 989. A similar law passed in Massachusetts in 1988 restricts title to 'any bona fide union or other artists' organisation authorised in writing by the artist [of the threatened work]'; see Merryman (1980: 344n25).

[29] 17 USC §106A.

[30] 17 USC §106A: 'the modification of a work of visual art which is the result of... the public presentation, including... placement, of the work is not a destruction, distortion [or] mutilation', and hence does not constitute a breach of the artist's right of integrity.

[31] The UK equivalent of the right of integrity is the 'right to object to derogatory treatment'; 'the treatment of a work is derogatory if it amounts to distortion or mutilation of the work or is otherwise prejudicial to the honour or reputation of the author' (Copyright, Designs and Patents Act of 1988, section 80).

[32] Where I happen to work.

[33] See, respectively, the Town and Country Planning (Listed Buildings and Conservation Areas) Act of 1990, the Ancient Monuments and Archaeological Areas Act of 1979, and the Historic Buildings and Ancient Monuments Act of 1953.

their local equivalent in the council-administered system of conservation areas, and their counterparts abroad in the similar catalogues maintained by many – perhaps most – other countries: national historic landmarks in the United States,[34] *monuments historiques* and *secteurs sauvegardés* in France,[35] and so on.

The primary targets of what I call heritage protection are *structures*, loosely defined as man-made things permanently fixed to, embedded in, or part of the ground – hence items like lampposts and pieces of public sculpture may become listed buildings, whereas earthworks and subterranean features may be scheduled as monuments.[36] As the terminology suggests, the difference between these regimes and those already discussed is in their reliance on item-specific *designation*. Whereas all creative works of the relevant kinds are subject to copyright and give rise to moral rights, and whereas ownership and transfer controls encompass all objects conforming to a certain description, the constraints invoked by heritage protection apply only to properties that have been listed, registered, scheduled, or otherwise identified, individually and officially, as being of importance.[37]

[34] The concept of a national landmark was first adumbrated in the Antiquities Act of 1906 (16 USC §§ 431–433m) and given more concrete specification in the Historic Sites, Buildings, and Antiquities Act of 1935 (16 USC §§ 461–7), which instituted a national list of nationally important properties for statutory oversight (and possible acquisition) by the National Park Service. The subcategory of 'national landmarks' was instituted in 1960, and includes individual buildings, districts, monuments, archaeological sites, and battlefields. The list remains very short by British standards (around 2,500 across the whole of the United States, as compared with around 375,000 nationally listed buildings in England alone), but it is supplemented by the (largely honorific) National Register of Historic Places, established under the National Historic Preservation Act of 1966 (16 USC § 470). On the development of US preservation law, see Rose (1981); Mackintosh (1985).

[35] Heritage protection in the modern sense is to a large extent a French invention, tracing its origins to attempts by appalled antiquaries to curb the Revolutionary iconoclasm of the 1790s (Sax 1990). The first lists of officially protected historic monuments were compiled by Ludovic Vitet and Prosper Mérimée in the 1830s (Jokilehto 1999). *Secteurs sauvegardés*, equivalent to English conservation areas, were created by the '*loi Malraux*' of 1962 (*Code de l'Urbanisme*, articles 313–1 to 313–2–1).

[36] The distinction between what may become a listed building and what may be scheduled as an ancient monument is not a precise one. The latter designation, which is discretionary, was once commonly applied to uninhabitable structures, but as it invokes far more rigorous controls it now tends to be used only for sites of great archaeological sensitivity. Earthworks are not normally listed, but they may be scheduled, and may also form part of conservation areas and registered landscapes. The latter category is a partial exception to my remark about structures, and is in many ways anomalous, being an experimental amalgam of environmental and heritage-based designations – which may explain why the controls that apply here are relatively weak.

[37] Recent shifts in policy may change this, at least in the United Kingdom. Planning Policy Statement 5, issued by the Department for Communities and Local Government in March 2010, employs the (much mocked but increasingly standard) term *historic asset* to refer to a 'building, monument, site, or landscape of historic, archaeological, architectural or artistic interest *whether designated or not*' [my italics]. The designated assets (listed buildings and the rest) continue to enjoy their former privileges, but even their undesignated poor relations, whose 'interest' has not been blessed with official recognition, must henceforth be taken into account in the granting or withholding of

This can have dramatic implications, for example where (as occasionally happens) owners strategically destroy important features of a designation-worthy structure before listing can take effect.

In most other respects, however, heritage protection regimes are more far reaching than any of the equivalent systems for dealing with portable property. Controls apply to modification and destruction alike, with a strong – in some cases, virtually indefeasible – presumption against the latter. Uniquely, provisions also exist to discourage neglect: although in the United Kingdom there is no legal duty to maintain a designated structure, an owner who fails to do so may be served with a repairs notice (enabling the statutory authority to carry out works without his consent, and afterwards recoup costs from him), and in extreme cases the building may be subject to compulsory acquisition.[38] As regards listed structures, no in-principle distinction is made between what is publicly displayed and what goes on behind closed doors: the interiors of remote country houses are in theory as much protected as the river front of the Palace of Westminster. Designated property is conceived of as inseparable from its spatial position: although the owner of a mural need not infringe the artist's moral rights if she moves the work to a new location,[39] the relocation of a listed building, or indeed a mural attached to one, would emphatically require (and would normally not receive) official consent.[40]

The interests enshrined in heritage protection laws are understood to be those of the public at large, and no special regard is paid to the interests of artists or other creators.[41] The state itself operates the regulatory mechanism and initiates proceedings against those who infringe it; someone who carries out unauthorised works to a listed building commits a criminal offence

planning consent. The implications of this seemingly radical shift in emphasis have yet to be tested in the courts. See Planning Policy Statement 5, policy HE9 and Annex 2.

[38] See the Town and Country Planning (Listed Buildings and Conservation Areas) Act of 1990, sections 47–51.

[39] See *supra* note 24 ; VARA in fact includes a specific exception clause for works attached to buildings in such a way that they cannot be removed without mutilation or destruction (17 US Code §113).

[40] A clear statement of this norm is found in ICOMOS (1972), Article 9: 'A building or work should remain in its historical location. The moving of all or part of a building or work is unacceptable unless this is the sole means of ensuring its survival.' An interesting if anomalous test case is that of Islington Green School in London, an architecturally undistinguished building of the 1960s whose only point of interest lay in two large tile and mosaic murals by the noted artist William Mitchell. In 2008, as the building was undergoing demolition, the two murals were put forward for consideration by English Heritage; one was destroyed before an assessment could take place, but the other was duly listed, and will be incorporated – in situ, along with the wall to which it is attached – into the new school complex.

[41] See, among many declarations to this effect, English Heritage (2008), section 1.4: 'Heritage values represent a public interest in places, regardless of ownership. The use of law, public policy and public investment is justified to protect that public interest'.

and is liable to an unlimited fine and/or twelve months' imprisonment.[42] The great majority of designated structures were created by long-dead individuals about whom little or nothing is known; and although some may be the work of famous architects, the designer's actual or projected wishes have no statutory weight in deciding what alterations will be permitted.[43] In contrast with moral rights, there is no creator's veto: Norman Foster, unusually for a living architect, already has two listed buildings to his name, but if (like some well-known artists) he were to become dissatisfied with these early works and seek to destroy them, he would almost certainly not be allowed to do so – even if he had first acquired the freehold.

It should be noted that heritage structures may also fall under the other types of restriction already mentioned. Architects' designs are subject to copyright, and their drawings are protected by moral rights laws against third-party distortion.[44] Earth-bound sculptures, buried antiquities, and architectural fragments are subject to – indeed are some of the primary targets of – art export laws. And as we have seen, ancient monuments and listed buildings are liable to compulsory state purchase. By contrast, portable cultural items will come under the sway of the heritage protection regime only by being physically annexed to a building or other structure, that is, by effectively ceasing to be portable.

WHY STRUCTURES?

So far we have examined several different systems of cultural property legislation, and have noted that one particular system – that which concerns the modification and demolition of structures – appears to incorporate

[42] See the Town and Country Planning (Listed Buildings and Conservation Areas) Act of 1990, section 9.

[43] They may and do, however, influence the judgment of those administering the statutory regime – most obviously in cases where consent is granted for the removal of later additions, themselves perhaps of interest in their own right, in order to return a building to a state representing its architect's original intentions. One such case was the renovation of Augustus Pugin's family home, the Grange at Ramsgate, restored to the master's designs (with the removal of later fabric added by his son Edward, himself no mean architect) in 2004–6: the project is discussed in Stanford (2007).

[44] The same does not apply to the buildings themselves. In the United States, for example, the Architectural Works Copyright Protection Act of 1990 stipulates that copyright in 'an architectural work that has been constructed' specifically excludes control over photography, provided that 'the building in which the work is embodied is located in or ordinarily visible from a public place'; furthermore, a building's owners may alter or destroy their property without breaching the architect's moral rights (17 USC § 120). It is interesting to note, in light of what is said elsewhere in this chapter, that the same practical imperatives that have brought even quite recent architectural works under the protection of heritage legislation have led to their being largely excluded from the moral rights regime.

many of the more robust aspects of the others, and in certain respects goes further than any of them. Why does this disparity exist?

Incentive and Use

The most obvious answer is a purely pragmatic one. By and large, people don't want to destroy or mutilate Greek vases and oil paintings, whereas they frequently do want to demolish or modify buildings, plough up or flatten earthworks, and get rid of unwanted public monuments. The ipso facto immoveability of structures – which are, as the legal phrase has it, 'part of the land' – means that they are apt to get in the way of their owners' purposes in ways that more tractable items will not. The existence of an easel painting presents no obstacle to the creation of a motorway, or even of another painting; that of a mural may be incompatible with either.

We can think of this as a question of resources. Land, space on the earth's crowded surface, is one of the ultimate scarce commodities, and a structure accrues a certain amount to itself simply by existing. The space thus taken up could often be more profitably reallocated to another structure, or handed over to the community at large as a park or a square or (more often) a bypass. By contrast, whatever resource value portable cultural goods represent is usually outweighed, often to an astronomic extent, by their value as unique entities. Nobody ever got rich cutting up old master paintings to reuse the canvas, and times will be desperate indeed when the Victoria and Albert Museum melts down its collection of Spanish reliquaries for the price of the silver bullion; but property speculators in every generation have made fortunes out of liquidating the built heritage to produce reuseable real estate. And redevelopment is only the most spectacularly profitable form of architectural salvage: more modest fortunes, both licit and illicit, have been made out of the trade in architectural fragments, from your local dealer in Victorian fireplaces to Lord Elgin himself.

All this is to put the matter too simply, however. For a start, the unprofitability of art-breaking is in many ways a mere accident of contemporary economics. Europe's first piece of heritage protection law – Pius II's celebrated papal bull of 1462 – forbade the conversion of classical marble statuary into building lime, which the concurrence of a still-sluggish art market and the first great Roman building boom since the fall of the Empire had made very lucrative (Jokilehto 1999: 29). At a less crude level, it sometimes happens that the market value of a complete work is less than the sum of its (dislocated) parts; this is particularly true of the trade

in illuminated manuscripts, where biblioclasm has long been common commercial practice (Stoicheff 2008). Nor does the incentive to destroy necessarily come from outside the artistic or cultural sphere. The very artists and patrons who promoted the 1462 proclamation were, in their own construction projects (some of which resulted in masterpieces of the highest order), quite willing to plunder classical temples for ready-made architectural components so as to save themselves the trouble and expense of manufacturing new ones (Choay 2001: 36–9). And as such productions as the Chapman/Goya series or Robert Rauschenberg's *Erased de Kooning Drawing, 1953* remind us, the avant-garde art of the past hundred years has thematised the act of iconoclasm to such an extent that the destruction of one work may become an inseparable part of the content of another (Adler 2009).

This last instance highlights the fact that objects can 'take up space' in more ways than the merely physical. The historical prevalence of iconoclasm reminds us that an item's portability may not render it any less of an obstacle to those whose purposes are either too personal or too all-embracingly ideological to be tied to a specific location. The leaders and foot soldiers of the English Reformation showed no more indulgence toward moveable items of devotion than they did toward stained glass and architectural statuary,[45] and Savonarola's bonfire was fuelled by treasures carted out of Florentine palazzi, and not (as would be the case in Paris three hundred years later) by the buildings themselves. The very existence, even out of view in the coal cellar, of Graham Sutherland's notoriously unflattering portrait was so intolerable to Winston and Clementine Churchill that the painting was eventually burned – although in this case the bonfire was to sustain vanity rather than to purge it.[46] And the past century's catalogue of 'protest' attacks on art – by traditionalists against the avant-garde and vice versa – testifies to the enduring strength of our impulse toward exemplary destruction.[47] Portable cultural property becomes the target of iconoclasm because, at least in the eyes of the iconoclast, it occupies mental or spiritual 'space' as tenaciously as built property takes up room in the objective realm.[48]

[45] For contemporary reactions to this wholesale liquidation of cultural property, see Aston (1973).

[46] The incident is discussed in Sax (1999: chapter 3). Churchill described the detested portrait as recalling 'an old man on his stool, pressing and pressing'.

[47] The place of iconoclasm in the practice of, and resistance to, contemporary art is discussed by Gamboni (1997: especially chapters 9 and 15).

[48] These and other reflections remind us to be wary about the traditional distinction between the fine and the useful arts. Buildings, unlike easel paintings, are usually built to serve some specific practical

Publicity and Politics

Another apparent reason for our special attitude to the products of the structural arts is their special character of publicity. For elementary functional reasons, buildings usually stand where they can be got at, and monuments where they can be seen; they are features, perhaps the defining features, of the public realm, the common environment that forms the objective setting for many disparate lives. Although they may have insides, they *are* outside, or rather they define the limits of what is outside; and for cultures that combine street life with a strong tendency to conduct personal and business affairs indoors, the outside/inside distinction maps naturally onto the public/private. As with conduct in public, so with the development of the public realm: what goes on out there affects everyone, and thus invites regulation. It has even been argued, in response to building owners disgruntled with heritage protection controls on what they had thought of as their wholly private property, that someone who puts up a building makes an implicit 'dedication' of it to the public at large.[49]

Portable works, by contrast, belong to the more intimate worlds of their owners and consumers: the salon, the private view, at most the semi-public space of the art gallery. They spend most of their time indoors, and – as with people who do the same – what they get up to there is less liable to be offensive to public opinion. Furthermore, being as it were metaphysically 'rootless', having no categorical relation to objective physical space – they may happen to be here or there, but it is no part of their essential character to be anywhere in particular – their relations with the individuals who contemplate them are apt to be mercurial, promiscuous, free-floating. The values they bear are not necessarily 'private' (whatever that would mean),

purpose, and are normally expected to continue to do so (and to suffer modification accordingly) if their prolonged existence is to be justified. The contents of art galleries and museums, by contrast, are there because they are no longer needed for their original use – if indeed they ever had one. But structures like the Taj Mahal or the allegorical garden 'temples' at Stowe and Stourhead may never have been intended to serve any purpose beyond the aesthetic or commemorative; and even the museum culture may come to accept that some portable 'art' objects emphatically do retain their function, and with it their liability to change. An often-cited example of the latter (see, for instance, Lackey 2006) is provided by the wooden war god carvings of the Zuni people in the southwestern United States, which fulfil their ritual purpose only if left out under the sun and rain to decay and ultimately disappear. Numerous Zuni sculptures brought into American museums after being 'found' in the wilderness have, despite their recognised aesthetic and anthropological interest, been given back to their communities of origin, in the knowledge that this will mean their eventual destruction.

[49] See the discussion, in Sax (1999: chapter 4), of Chief Justice Rehnquist's opinion in the 1978 *Penn Central* case, and the 'alternative model' for public art protection put forward in 'Protecting the Public Interest in Art' (1981–2).

but they seem more like the values of personal conversation rather than public, citizenly activity. Any state regulation of gallery art immediately smacks of censorship, oppressive interference in free expression; if we do not feel the same about the built realm, this is partly because the values we see embodied there are less individualised and more – in the Aristotelian sense – political, of the polis.

'Real' property, conferring exclusive rights over a portion of the earth's surface, has often been seen as a problematic institution just because it seems to privatise what we intuitively regard (at least in a certain frame of mind) as inherently public. Rejection of the idea that land may be owned in anything like the same way as goods and chattels has a long history, surfacing repeatedly during episodes such as the enclosures of the early modern period and the access debates of the early twentieth century.[50] The growth of comprehensive planning, which in the developed world now controls almost every aspect of the use of land, shows how this rejection has become politically normative. In the United Kingdom, the legislation that created the modern planning system – the Town and Country Planning Act of 1947 – also instituted the regime of listed building consent, still the single most important element of our heritage protection system. Most decision making about the built heritage rests with the local planning authority, the same body that decides where the new hospital will be built and which part of the town centre is to be zoned for retail. Thus, all structures, and indeed all enduring features of the environment, are subjected to the same range of public concerns, whether the issues at stake are aesthetic or historical or social or commercial.

Partly this is, as we have seen, a matter of resource allocation: the country, or the borough, has only so much land at its disposal, and had better not allow it to be used wastefully.[51] Partly, however, the concern is both more intrinsic and more holistic. A structure makes up place as well as taking up space: it determines and modifies the essential character of its own unique locale, and that of the larger territory of which this forms a part. As even minimally public men and women we have an interest in the character of our immediate environment, our street or village or suburb; as citizens we

[50] See Shoard (1999: 172), quoting an 1892 speech by the member of Parliament and access rights campaigner James Bryce: 'Property in land is of a very different character from every other kind of property. Land is not property for our unlimited and unqualified use. Land is necessary so that we may live upon it and from it, and that people may enjoy it in a variety of ways; and I deny, therefore, that there exists . . . such a thing as an absolute power of exclusion'.

[51] A similar resource-based logic applies in heritage protection when we talk about managing the nation's historic building 'stock', or seek to ensure that a representative 'sample' survives of a once-ubiquitous type like the famous K6 telephone box.

are also apt to care about the overall identity of that portion of the earth's surface that is our homeland, even the parts of it we don't regularly visit; and in our more expansive moods we may experience a more diffuse and cosmopolitan concern for a still greater environmental pattern, of ancient cities and virgin forests (or, for those who prefer them, dizzying skyscrapers and wide-open freeways), none of which perhaps we will ever see but whose image forms the vivid back-cloth to the small parochial dramas of our lives. Moveable cultural property, however great its intrinsic value, is peripheral to this panoptic vision. With regard to artworks in particular, we are inclined to see each item as being a world unto itself, whose relations to the larger one are merely fortuitous; I may care whether or not I am allowed access to it, but there my public concern – as opposed to the personal, subjective history of my inhabitation of that subworld – comes to an end.

Something like this, I think, does underlie our differing legislative approaches to structures and portable property, although to put it thus tends to distort the actual situation in a number of ways. For a start, as we have seen, countries' export and ownership restrictions do not aim solely to ensure their citizens' access to cultural material. The quasi-talismanic urge to retain the national house-gods on the homeland's sacred ground reminds us that the environmental consciousness of place and territory is not solely a feature of our approach to the built heritage. We should remember, too, that the identification of the built environment and the 'public realm' contains a large element of legal fiction. My concern with the world may potentially spread as wide as my imagination; but there is a great difference, as regards any interest we can really call public, between (say) Westminster Abbey and an overgrown family mausoleum in deepest Northamptonshire.

Some of the same anomalies apply to the idea of structures being 'part of the land'. In fact, the degree of annexation can be slight or even nonexistent, and it is seldom that anybody checks. A recent legal battle over the proposed sale of a font by the great Victorian designer William Burges out of a listed church in Somerset (Arlow and Adam 2009) was conducted without either of the parties having any idea as to whether the item in question was fixed down. Vehicles cannot normally be protected, but may – like the *Cutty Sark* or the railway carriages turned squatters' cottages at Dungeness in Kent – occasionally fall into the heritage net simply by being deprived of their means of locomotion. Indeed, the selfsame item can repeatedly pass into and out of the scope of regulation, like George Gilbert Scott's Hereford screen, now displayed (unregulated) in the Victoria and Albert Museum, but until 1967 part of the fittings of Hereford's (grade I listed)

cathedral, and prior to that displayed once more as a museum piece, this time at the Great Exhibition of 1862.

Finally, we should bear in mind that, as we saw in our preceding discussion of iconoclasm, the realm of ordinary three-dimensional space is not the only one in which territorial concerns arise. The creator's interest in the whole body of his work, as recognised by moral rights law, is a microcosm of the broader cultural domain in which we all situate ourselves, whose geography is the whole spread of existing objects and practices, and whose landscape is constituted by our experience of their interrelations. And just as, in one way, the loss of a single painting or sculpture cannot but narrow the universe of art, so, in another – and thinking of the expiatory destructions that, for better or worse, usually accompany moments of great political change – the toppling of a building or a monument may also serve to expand the horizons of a culture.

CULTURE AND ENVIRONMENT

I have suggested that the factors motivating our approach to structures as cultural property are rooted in a sense that these belong to a public world, a fundamentally shared environment whose every feature is a matter of potential concern to all who move through it, and where conventional property rights are everywhere hedged about by common interests. Many of the latter have little or nothing to do with 'culture' – save in the relatively trivial sense of being to some extent conditioned by the milieu in which they are expressed – but the place of the various heritage protection regimes within the machinery of the planning system shows how cultural property claims can be weighed alongside other interests as part of the process of environmental decision making.

So far we have spoken of cultural property as essentially artefactual: as a class of objects, each made at a certain time and for a certain purpose, and all possessed of reasonably clear boundaries. In some of the categories embraced by heritage protection, however – in parks and gardens, for instance, or still more clearly in the small collection of important conflict sites included on the Register of Historic Battlefields[52] – we can see that

[52] Like parks and gardens, registered battlefields are not the subject of primary legislation in the United Kingdom, although Planning Policy Statement 5 includes them on the list of 'designated heritage assets of the highest significance' to which 'substantial harm or loss... should be wholly exceptional'. In the United States, with a more recent history of terrestrial conflict, battlefields from the Revolution to the Civil War were among the first properties to be identified under the Historic Sites Act of 1935, and among the first to be designated as national landmarks in the early 1960s (Mackintosh 1985).

similar interests operate beyond the domain of artefacts. The latest UK policy statement on planning and the heritage identifies as its object something called the 'historic environment', defined as 'all aspects of the environment resulting from the interaction between people and places through time, including all surviving physical remains of past human activity, whether visible, buried or submerged, and landscaped and planted or managed flora'.[53] From its initial focus on a small collection of nationally owned monuments,[54] heritage policy has gradually expanded to become an all-purpose legislative approach to human geography.

But considerations of cultural property have long been central to our regulatory attitude to the environment at large, especially in its humanised guise as 'landscape' or 'scenery'. This is especially true in Britain, where the marks of human influence are almost nowhere absent from the shape of the land, and where our great contribution to the environmental arts is a pictorialist tradition of landscape design that sought to express political meaning through the simulation and enhancement of 'natural' effects. The realm of the mid-eighteenth-century *jardin anglais*, whose celebration of oligarchic enlightenment implied an unconditional right to exclude, was of course anything but public. But half a century later, the English Romantics were giving expression to a more democratic ideal of the landscape as cultural icon, as in Wordsworth's much-quoted plea that mountain scenery be seen as 'a sort of national property in which every man has a right and interest who has an eye to perceive and a heart to enjoy'.[55]

The central chapter of Wordsworth's *Guide to the Lakes*, in which these remarks occur, comprises two equal sections, describing respectively the 'view of the country as formed by nature' and the 'aspect of the country as affected by its inhabitants' (Wordsworth 2004). This dual focus has been characteristic of the British approach to landscape conservation. In the United States, where the first national parks were created in the post–Civil War years, designation focused exclusively on areas of wilderness

[53] See Planning Policy Statement 5, annex 2.

[54] As instituted by the United Kingdom's first piece of bona fide heritage legislation, the Ancient Monuments Protection Act of 1882; see Jokilehto (1999: 156).

[55] These words conclude the main text of Wordsworth's *Guide*, which went through five editions between 1810 and 1835 (see Wordsworth 2004: 93). The qualification turns out to be important: the poet's later opposition to the Kendal and Windermere Railway, which helped to open up the Lake District to mass tourism, was founded in part by concerns about the havoc likely to be wreaked by those 'thousands and tens of thousands' for whom 'a rich meadow, with fat cattle grazing upon it, or the sight of what they would call a heavy crop of corn, is worth all that the Alps and Pyrenees in their utmost grandeur and beauty could show to them' (see Mulvihill 1995: 314).

'untouched' by man,[56] and such purism is still the norm internationally: the International Union for Conservation of Nature defines a national park (category 2, in its classification of protected sites) as a 'large natural or near-natural area set aside to protect large-scale ecological processes'.[57] The UK park system, by contrast, arose out of movements like the National Trust, whose focus was on the thoroughly humanised environments of the English countryside; nearly all the parks include a central hub of semi-wild unfarmed upland, but their borders have been drawn to include the large tracts of cultivated valley floor between and around, with their complement of villages and small towns. Alongside the United Kingdom's fourteen national parks are forty-seven designated areas of outstanding natural beauty, most of which are in densely settled regions devoid of anything resembling wilderness; the Norfolk Broads, a system of wetlands and inland waterways created largely as a result of medieval peat cutting, have enjoyed de facto park status since 1985 (MacEwen and MacEwen 1987). Human contributions to the landscape are recognised as part of what merits protection: the legislation governing national parks has the declared purpose 'of conserving and enhancing the natural beauty, wildlife and cultural heritage of the areas specified',[58] and many of the park authorities have been given responsibility for managing the historic built environment alongside their role in nature conservancy.

But the cultural impetus toward landscape conservation derives from a much wider range of factors illustrating the thorough interpenetration of geography, identity, and the arts. The *Guide to the Lakes*, in many ways a typical product of an already well-established genre, derived its particular authority from Wordsworth's leading role in constituting the Lake District as an object of attention: the author was, in a sense, providing a commentary on his own work. And as the Lake Poets did for Cumbria, so Hardy did for Wessex, the Brontës for the Pennine moors, and so on – a fact of which we are perpetually reminded by regional tourist boards. Constable,

[56] Or at least by European agro-industrial man; the impact of Native systems of land management on such landscapes went largely unrecognised, as did aboriginal claims to continued access to the designated areas (see Nabokov and Loendorf, 2004).

[57] Categories 1a and 1b, comprising 'Strict Nature Reserves' and 'Wilderness Areas', respectively, are perhaps closer to the ecologically purist conception. The UK national parks are not recognised as such by the IUCN, being instead classified as category 5, 'Protected Landscapes', areas 'where the interaction of people and nature over time has produced an area of distinct character with significant ecological, biological, cultural and scenic value' (see International Union for Conservation of Nature 2007).

[58] Environment Act of 1995, section 61(1). The National Parks and Access to Countryside Act of 1949, under which the first UK parks were designated, referred only to 'natural beauty'.

in another medium, gave us the riverine landscapes of Essex and Suffolk ('Constable Country', as the brochure has it), and at a less exalted level we have the distinctive local settings lovingly invoked by various television dramas and subsequently visited by their devotees.[59] What we see and value in landscape is both made available and mediated by a range of cultural productions both high and low. Indeed, it is argued that the very idea of landscape is itself the product of a way of seeing that has its roots in the painting and cartography of the early modern period.[60]

Many cultures have, with the aid of such definitive representations, developed the sense of an 'iconic' landscape or landscapes, which function as touchstones for group identity. The English 'heartland', for example, with its familiar paraphernalia of hedgerows, rolling hills, and spreading oaks, is as important in forming our national self-conception as any class of buildings or artefacts; and this in spite (or, more plausibly, because) of the fact that we have been a predominantly urban society for the past hundred and fifty years. And it is such cherished images that, starting with pioneering measures like the Restriction of Ribbon Development Act of 1935, we have sought ever more legislative power to preserve – generally, as is often pointed out, from the very features of contemporary urban life that made these images so compelling in the first place.[61]

The heartland image has been much decried as a reactionary mystification, an ideological painted veil that masks the realities of contemporary life so as to further the interests of landed property, industrialised agriculture, the metropolitan Establishment, or some unholy alliance of the three.[62] But it has had its would-be radical uses too, in a tradition of agrarian socialism stretching from the Diggers of the seventeenth century through the Chartist colonies and Arts and Crafts cooperatives of the nineteenth to the neo-pastoralist strands in modern-day counterculture. Somewhere at its heart lurks the idea or myth of the commons, of a collection of land rights that once accrued to every free-born Englishman, that were taken from him at some indefinite point in the past, and that he must set out

[59] Detective and medical dramas are particularly productive of such associations, as exploited by the popular tours of 'Inspector Morse's Oxford' and the Richmondshire Museum's elaborate mock-up of the set of *All Creatures Great and Small*. For the impact of this phenomenon on the British tourist industry, see Olsberg SPI (2007).

[60] For this argument, which tends to be expressed somewhat ambiguously as applying to the word *landscape*, or the corresponding concept, or both, see the authors quoted in Muir (1999: 2–6).

[61] Robert Colls (2002: 235–6), discussing 'a certain look of the land' as a component in English national identity, observes that 'the fight to preserve the look of the countryside was suburb-led: front-line, so to speak'.

[62] For some of the ideological abuses of the English rural idyll, see Wright (2009: 70–83), and more generally Williams (1973).

to reclaim. In our leisured age, one standard expression of the Englishman as commoner has been in the protracted campaign for the 'right to roam', that is, for universal recreational access to the countryside as against the landowner's time-honoured right to exclude others from her property.

Securing access rights has thus been a central legislative theme, second only to the preservation of the environment itself.[63] The founders of the National Trust cut their campaigning teeth fighting to uphold commoners' rights in stretches of metropolitan-fringe countryside such as Epping Forest and Wanstead Flats that were important sites of recreation for working-class Londoners (Gaze 1988). Early attempts at legislation, such as James Bryce's Access to Mountains (Scotland) Bills of the 1890s,[64] stalled in the face of entrenched property interests, but the mass trespass movement of the 1930s ensured that access was high on the agenda when the system of national parks was instituted by the postwar Labour government. The National Parks and Access to Countryside Act of 1949 sought to address conservation and public access in the same breath, enjoining local authorities to create definitive maps of public footpaths and other rights of way, and granting them the power to enforce a public access to stretches of 'open country' not already subject to voluntary agreements.[65] When this approach failed, more direct methods were applied, culminating in the Countryside and Rights of Way Act of 2000, which created a general right to roam over most upland and uncultivated areas in England and Wales.

Such access provisions are noticeably lacking from the kinds of legislation surveyed in the first part of this chapter, and for all our talk of universal heritage, the idea of commoners' rights has (apart from the special case of printed, recorded, and digital works) made little headway in the domain of cultural property. Copyright and moral rights law is concerned with restricting rather than enlarging the conditions under which the public may come into contact with a work; and although ownership and transfer regulations usually aim at increasing access, they do so only indirectly and are often criticised as having the opposite effect, ensuring that objects end up buried in domestic museum basements rather than in regional or foreign collections, where they would be far more widely seen. Heritage protection regimes may give owners incentives to offer at least occasional public admission, typically through conditions on grant aid; but these concern only a tiny minority of designated sites, and there is, as yet, no power to compel owners to open their doors.

[63] The account that follows is drawn largely from Shoard (1999) and MacEwen and MacEwen (1987).
[64] See *supra*, note 50.
[65] See the National Parks and Access to Countryside Act of 1949, parts 4–5.

The holders of certain kinds of scenically valuable land thus find their right to exclude others from their property severely curtailed in the public interest, whereas the owners of culturally important artefacts and structures suffer no such constraint. Although this disparity may in most cases be unobjectionable,[66] it is not difficult to think of examples (Titians locked for years in bank vaults, Adam villas mothballed by absentee landlords) where the rationale for compulsory public access would be no less strong than in the case of footpaths and moorland. That no such measure is even on the agenda may reflect a deep respect for proprietorial privacy – or just a failure of nerve. Either way, the measures taken to ensure that land and landscape remain part of our common heritage represent a major legislative achievement – and one from which cultural curators and conservators might learn.

[66] The majority of listed buildings, for example, are in domestic use, and the privacy considerations against general access rights would in most instances be overwhelming. But at present there are no such rights even with respect to listed public buildings, or to open-air sites such as registered landscapes or the majority of scheduled monuments. That there is some connection in the popular mind between designation and access rights is suggested by English Heritage's listed buildings database Images of England (http://www.imagesofengland.org.uk), whose every page carries a disclaimer to the effect that 'the inclusion of a listed building on this website does not mean it is open to the public'.

Looting or Rededication?
Buddhism and the Expropriation of Relics

Robin Coningham and Prishanta Gunawardhana

Recent surveys of archaeological sites in northern Sri Lanka have high-lighted a high level of destruction, in particular at Buddhist monastic sites. Whilst this includes damage resulting from the expansion of agricultural fields and villages or the quarrying of ancient stone slabs and pillars for building materials, most image houses and stupas have been targeted for their Buddhist relics. This is by no means an isolated phenomenon, and scholars have recorded similar levels in the Gandhara region of Pakistan and Afghanistan (Ali and Coningham 2001), as well as in the Kathmandu Valley of Nepal (Schick 1998). Such activities are illegal, as South Asian archaeological and historical sites are protected by strict laws attributing ownership of any materials over one hundred years old to the state. Indeed, although these statutes have been modernised by individual states belonging to the South Asian Association for Regional Cooperation (SAARC), as in the 1998 Sri Lankan Antiquities Ordinance or the 1972 Indian Antiquities and Treasures Act, they all owe much to the original ordinances of the Raj. Thus, Sri Lankan law lays down that "all undiscovered antiquities (other than ancient monuments), whether lying on or hidden beneath the surface of the ground or in any river or lake or within the territorial sea of Sri Lanka, shall be deemed to be the absolute property of the Crown, subject to the provisions of this Ordinance" (1956 Government of Ceylon Antiquities Ordinance I.2). The existence of such clear and precise legislation has enabled many court cases involving looters and treasure hunters to be successfully pursued, resulting in heavy fines and custodial sentences.

Despite the clear legal position as to the modern ownership of ancient relics and antiquities, there is evidence to suggest that the excavation and removal of such material from ancient image houses and stupas was also practised in antiquity. Whilst most early scholars and archaeologists con-demned such activities as treasure hunting or looting, it is possible to develop a series of evidence-based counterarguments. For example, the Mauryan emperor Asoka is said to have reopened stupas to redistribute the

relics of older, established shrines, and such events are also attested by the presence of later Kushan coinage alongside older materials in the Buddhist shrines of Taxila in Pakistan (Marshall 1951). This chapter explores the dynamic interface between legal ordinance and ritual practice in modern Sri Lanka and presents textual and artefactual evidence of past activities. It also reviews the pressures on the Sri Lankan archaeological resource while examining the impact of contemporary communities that are reusing and rededicating relics and antiquities for veneration in new shrines. We conclude by asking whether colonial and postcolonial legal ordinances of southern Asia have appropriated, or rather expropriated, relics and monuments from secular and lay ritual practitioners.

THE ANURADHAPURA SURVEY

Between 2005 and 2009, a team of archaeologists and archaeological scientists launched a project to model the networks between urban and nonurban communities and the environment within the plains surrounding the ancient Sri Lankan capital of Anuradhapura over the course of two millennia. In line with this aim, a methodology consisting of archaeological survey and auger coring was developed to map the nature and location of nonurban sites, soils, and resources, with a sample of sites being later subjected to geophysical survey and excavation. Our sample universe extended for a 50-kilometre radius from trench ASW2 in the Citadel of Anuradhapura (Coningham 1999, 2006), and within this universe we undertook a probabilistic sample of twenty-four transects of 20 kilometres in length randomly generated in the survey zone and a nonprobabilistic survey of the banks of the Malwatu Oya river system and the Yoda Ela and Jaya Ganga canal systems. An intensive microsurvey of a 25-square-kilometre area was then undertaken during the fourth season (Coningham et al. 2005, 2007). A fifth and final season was undertaken in 2009 to apply luminescence dating to a sample of the surveyed brick-built monuments, which were exclusively monastic. Sites identified on all forms of survey had their locations recorded using GPS, were photographed and sketched where appropriate, and diagnostic material was collected for further analysis. Sites were then categorised as follows: landscape feature, ethnographic site, ceramic scatter, metalworking site, monastic site, conical holes, stone bridge or annicut, channel or canal, and undiagnostic site. Of the monastic sites encountered, forty-one were associated with monuments interpreted as stupas. The stupa is one of the three main categories of Buddhist monument and certainly represents "the most recognisable and resilient... comprising a

solid mound of brick, stone or clay usually erected over relics" (Coningham 2010: 935). A monumental category associated with the very earliest phases of Buddhism before the Buddha's iconic representation, the stupa spread widely throughout the Buddhist world. The Pali Buddhist canon records that stupas were to be erected over corporeal relics of the Buddha and his disciples, over objects used by the Buddha, at sites associated with the Buddha's life (and former lives), and votive stupas at sites of pilgrimage for merit (Mitra 1971: 21–2). It is interesting to note that one of the regional trends to develop in Sri Lanka was the construction of gigantic stupas as well as elaborately decorated relic chambers within stupas, apparently designed to represent the universe and the Buddha's centrality in it (Paranavitana 1946: 21).

As well as recording the presence and absence of archaeological categories at individual sites in the survey zone, the team also recorded their degree of preservation. It is extremely significant, therefore, to note that of the 41 stupas recorded at monastic sites, only 16 were undamaged. Cases of damage to monastic sites without stupas were proportionally far lower, with only 29 of a total of 101 targeted. To provide some physical examples of the degree of damage taking place and the types of monuments targeted, five sites have been selected as exemplars. The first site is Veheragala (Site A155), which was identified in the second season of the survey in 2006. Comprising a modern temple complex strung out along a series of granite outcrops, a number of archaeological features indicate the presence of an ancient site, namely a cave with cut drip ledge; a two-phase brick stupa constructed on the summit of the highest outcrop; rock-cut staircases; rock-cut cisterns; rock-cut pillar and post slots; and a number of brick and stone walls, stone pillars, Buddha statues, a sripada or block cut with imprints of the Buddha's footprints and a yantragala or compartmentalised foundation block frequently found under Buddha statues or stupas (Coningham et al. 2006). The brick-built stupa measured 18.6 metres in diameter and 7.8 metres in height, and luminescence dating of the bricks indicated that it was constructed in two phases, the lower 4.8 metres being thought to have been constructed in the middle of the first millennium CE and the smaller 'focal' stupa above it, measuring 4.85 metres in diameter, dating to the eighth century CE (Harriet Lacey 2011, personal communication). What is most striking about this stupa is that there is a robber trench cut some 60 centimetres wide that runs from the centre of its summit to a depth of 4.3 metres. A similar situation was recorded at the site of Parthigala (Site Z00), which is located close to the southern edge of the Nachchaduwa Wewa or tank (Coningham et al. 2006: 59). Defined by

a walled rectangle measuring 480 metres east to west and 440 metres north to south, it contains an inner complex of brick-built stupa, Buddha image house, chapter house, and bodhi-tree shrine. This complex identifies the site clearly as a pabbata vihara, or royal monastery, and as such, it is assumed to have been constructed between the eighth and twelfth centuries CE (Bandaranayake 1974: 81). The results of the luminescence dating of the stupa suggest that the complex was built around an older stupa whose construction appears to date back to the middle of the fifth century CE (Harriet Lacey 2011, personal communication). Whilst this single-phase stupa still stands to a height of 5.05 metres and has a diameter of 41.91 metres, the centre has been recently dug out, exposing a section of brickwork above 2.2 metres of stone foundations.

The third site, Thalaguru (Site A030), was intensely surveyed in 2009 and found to comprise a large brick stupa built on a series of two stone terraces on the summit of a high granite outcrop with the remains of a large monastic complex at its foot on the plain below (Coningham et al. 2006: 59). The stupa itself measured 20.32 metres in diameter and survived to a height of 10.06 metres, and as at Veheragala, it comprised two phases with a large core surmounted by a smaller, focal stupa above. The latter measured 3.26 metres in diameter and survived to a height of 0.7 metres. Luminescence dating of the brickwork indicates that the initial phase dates to the middle of the first millennium CE and that the focal stupa was later constructed in the eighth century CE, in parallel with the sequence at Veheragala (Harriet Lacey 2011, personal communication). Also, as at Veheragala, the stupa had been very badly damaged by the cutting of a slot trench measuring 1 metre wide and some 6.8 metres deep right into its core. Our final site was Etenawatunagala (Site C508), which consists of a series of caves with cut drip ledges, a brick- and stone-built stupa, and Early Brahmi inscriptions on a cluster of granite outcrops. The stupa stands on the highest outcrop and comprises a 1.1-metre-high granite terrace wall surrounding a 3.65-metre-high brick-built stupa. The centre of the stupa has been damaged with a 1.86-metre-deep trench cut into its core all the way to the outcrop beneath.

This well-documented record of destruction in Sri Lanka is by no means unique to the SAARC region, as testified by a number of settlement surveys in the region of ancient Gandhara. There, in the Vale of Peshawar, archaeologists have recorded heavy degrees of damage at monastic sites as illegal collectors of Gandharan Buddhist art have targeted key sites for decades. For example, thirty-five of the seventy-five known monastic sites within Peshawar's Charsadda District have been badly damaged or

completely destroyed, and a similar percentage of affected sites has been recorded within its neighbouring district, Swabi (Ali and Coningham 2001: 27). In the northern valley of Swat, eleven of the seventeen best-preserved Buddhist monasteries have also been damaged, a pattern also found in the neighbouring valleys of Dir and Chitral (Ali and Coningham 2001: 27). This is not a recent phenomenon, as Sir Aurel Stein recorded as early as the 1920s that "much regrettable damage and loss have been caused . . . in tribal territory and elsewhere along the Peshawar border" (Stein 1929: 39). Similar damage has also been reported from Thailand (Byrne 1995) and in Nepal (Schick 1998) and India (Pal 1991).

THE LEGAL FRAMEWORK

As noted in the introduction, there is widespread legislation across South Asia that makes it illegal to damage archaeological sites – legislation that often dates back to the British Raj, as with the Indian Treasure Trove Act of 1878 and the Ancient Monuments Preservation Act of 1904. This is certainly the case of the Antiquities Ordinance of the Democratic Socialist Republic of Sri Lanka, which was first passed by the British governor in 1900 and states clearly that an *antiquity* "shall mean and include any of the following objects, lying or being found in the Island: (a) Statues and Statuary, sculptured or dressed stone and marble of all descriptions, engravings, carvings, inscriptions, paintings, writings, and the material whereon the same appear, all specimens of ceramic, glyptic, metallurgic, and textile art, coins, gems, seals, jewels, jewellery, arms, tools, ornaments, and generally all objects of art and moveable property of antiquarian interest" and "(b) Temples, churches, monuments, tombs, buildings, erections, or structures and immovable property of a like nature or any part of the same" (Government of Ceylon Antiquities Ordinance 1900 I.2).

The ordinance also lays down that "no antiquity shall, by reason merely of its being discovered on land in the ownership of any person, be claimed to be the property of such person" and that the antiquity "shall be deemed to be the absolute property of the Crown" (Government of Ceylon Antiquities Ordinance 1900 I.3). The text continues by making it clear that "no person shall excavate with the object of unearthing or of discovering antiquities, whether on land belonging to himself or otherwise, without permission in that behalf first had and obtained from the Governor in accordance with the provisions of this Ordinance; and every person so excavating in contravention of this section shall be guilty of an offence" (Government of Ceylon Antiquities Ordinance 1900 II.5). The ordinance was amended

in 1998 to increase the fine for offences to Rs 50,000 and imprisonment to not less than two years and not more than five years for any "person who wilfully destroys, injures, defaces or tampers with any antiquity or wilfully damages any part of it" (Antiquities [Amendment] Act No. 24 1998, 15B). Furthermore, the ordinance states that antiquities are those objects that "date from a period prior to annexation of the Kandyan kingdom by the British" (Antiquities Ordinance 1900 I.3) – that is, 2 March 1815.

With such a clear legal framework in place in Sri Lanka and across South Asia as a whole for more than one hundred years, it is quite understandable that professional archaeologists and conservators were frustrated by the degree of damage that had occurred to the numerous sites under their stewardship. For example, when excavating the Dharmarajika stupa of Taxila, Sir John Marshall reported, "A deep broad trench driven right through the heart of the fabric bore witness to the vast labour which some former treasure-seeker or explorer must have undertaken in order to reach the relics, but who this treasure-seeker was is not known to us" (Marshall 1951: 238). This frustration is also evident in the writings of A. H. Longhurst, archaeological commissioner in Ceylon, who lamented, "As all the early structural stupas in India are in ruins, most of them having been destroyed by seekers after treasure, we have to fall back on sculptural representations of them in order to form a correct idea of their appearance when complete.... [W]henever a stupa or a temple fell into disuse, thieves immediately removed these crowning ornaments and stole the offerings placed beneath them" (Longhurst 1936: 14–15). This perspective appears to have been common amongst archaeological commissioners in Sri Lanka, as Professor Senarat Paranavitana commented ten years later, "Ancient stupas at Anuradhapura and elsewhere have been restored, obliterating all original features and destroying beautiful works of art" (Paranavitana 1946: 11). Whilst Lahiri reflects that such accusations are often perceived as part of a colonising message that represents "natives as unworthy of their ancient material past" (Lahiri 2000: 689), it is also worth noting that the intervention of British practitioners was welcomed by the first Sri Lankan archaeological commissioner, who stated, "The stupas which, during the period of about a millennium when Buddhism no longer existed in India ... were undoubtedly much more numerous than those of which some remains have been preserved by chance, till, in the last century, the scientific curiosity of the new rulers from the West was directed to these strange memorials of a forgotten past" (Paranavitana 1946: 2).

This statement has an odd echo of General Sir Alexander Cunningham's poem at the start of his report of the excavations of the Buddhist stupas and

monuments at Sanchi in the mid-nineteenth century, in which he wrote that they had stood "silent . . . and still as cities under magic's wand . . . till curious Saxons, from a distant land, unlock'd the treasure of two thousand years" (Cunningham 1854: 368). Finally, it is very apparent that there was a clear official suspicion of uncertainty or fuzzy boundaries associated with Buddhist sites. This uncertainty pervaded the very highest levels of British authority in India, as illustrated by Lord Curzon's ill-considered and fruitless intervention at Bodhgaya, where legal attempts were made to disassociate it from its hereditary Hindu custodian, the Mahant (Lahiri 2001: 273), or Sir John Marshall's fury at being abused and threatened by "pestilential natives" for walking on a pavement of rough stones surrounding a stone pillar in front of the eastern gate of the Jagannath Temple at Orissa (Sengupta 2010: 168). The latter is particularly enlightening, as Sir John was the newly appointed director general of the Archaeological Survey of India, and he retorted, "If the Government decides that the pavement is sacred and belongs indisputably to the temple, then it should be fenced and a notice warning people not to step on it should be posted up. But if, on the other hand, there is no real sanctity attached to the pavement, and if it is mere perversity and ill-nature on the part of the Hindus that induces them to obstruct Europeans in this way . . . then the rights of the Europeans should be insisted on" (Sengupta 2010: 168). It should be made clear, however, that not all European practitioners in South Asia were so clearly concerned with legal ordinances and regulations, and note should be made of Dr Alois Fuhrer, archaeological surveyor of the North-West Provinces and Oudh, who appears to have purposely fabricated Asokan and pre-Asokan Buddhist relics to sell to pilgrims from Burma and Thailand in the 1890s for personal financial gain (Allen 2008).

Despite the strength and clarity of the legal instruments in the modern nation-states of Sri Lanka, India, and Pakistan, Buddhist monuments continue to be damaged and subject to what is frequently described as robbing, treasure hunting, or looting. Whilst much of the activity is low level and infrequently recorded, there are a number of higher-profile cases, including that of the recent prosecution of retired Major General Parakrama Pannipitiya in Sri Lanka. This highly decorated war veteran was arrested by police on the evening of 7 February 2009 whilst allegedly treasure hunting with the use of explosives at a ruined Buddhist shine complex in the jungle close to Weliweiya (*Lanka Times* 2010). He was charged under the Archaeology Act and remanded in custody for six months, but he was acquitted and released in July 2009. Reports of the involvement of a senior police officer in treasure hunting in the vicinity of Polonnaruva have also appeared,

indicating that some of those entrusted with enforcing the law are also participating in illegal activity (*Lanka Polity* 2010). However, it is not just civilians and officials engaged in this practice in Sri Lanka, but also monks, as illustrated by the case of a Buddhist monk who had been arrested by police while allegedly supervising the illegal excavation of a 4-metre-deep pit at an ancient Buddhist complex at Pooja Nagaraya in the jungle near Anuradhapura on 16 October 2009 (*Colombo Times* 2010). Another newspaper reported that the new incumbent of the Theraputtha Rajamaha Vihara at Ambalantota was arrested by police on 19 October 2009 after excavating in his ancient temple and its surrounding compound (*Sunday Times* 2010). Whilst personal interviews with those involved in damaging Buddhist sites in ancient Gandhara indicated that their involvement was financially motivated, there is some evidence that additional, or alternative, reasons may be associated with some of the Sri Lankan cases. The article reporting the case of Major General Pannipitiya also shed some interesting light into the practices of Sri Lankan treasure hunters when it related that the major general and his associates were arrested in the possession of explosives and trays of flowers. The newspaper suggested that the latter were offerings to placate the guardian deities of the ancient site, which is a common practice amongst treasure hunters, although in this case there was no employment of the "exorcists or kantandiyas who usually offer the necessary pujas to those deities before commencing work on hunting for hidden treasures" (*Lanka Times* 2010). Indeed, the presence of ritual practitioners suggests that treasure hunting is not merely a financial or economic activity but has an important historical ritual and symbolic value as well, as is shown in the following section.

REDEDICATION IN ANTIQUITY

Despite the clear legal position of contemporary SAARC states and their antiquities laws with respect to the modern ownership of relics and antiquities, there is evidence to suggest that the excavation and removal of such material from ancient Buddhist image houses and stupas was also practised in antiquity. Whilst many early scholars condemned such activities as treasure hunting (Longhurst 1936), it is possible to provide counterexamples to this analysis, two of which involve key figures in the establishment and propagation of Buddhism in South Asia, Asoka and Kanishka. Asoka, the Mauryan emperor (r. 274–232 BCE), is one of the best-known monarchs of ancient India on account of the survival of his edicts on stone pillars and edicts across South Asia (Thapar 1963). Ruling an empire that stretched

from Afghanistan in the west to Bangladesh in the east, and from Nepal in the north to the Deccan in the south in the third century BCE, he is also recognised as having played a key role in the establishment of Buddhism in a preeminent position amongst South Asia's various religious traditions. Indeed, his reign is frequently associated with the earliest construction of fired-brick or stone Buddhist structures across northern India, which form a distinct Mauryan horizon (Coningham 2001). Although his own personal affiliation to Buddhism is contested (Coningham and Manuel 2009), his promotion of Buddhism is undisputed, and some see his pilgrimages and patronage as a part of an ongoing process of Mauryanization to cement his authority over newly incorporated territories (Smith 2005.). Part of this process included the incorporation of central India into the Mauryan Empire through the embellishment of the Buddhist cult centre of Sanchi. There, in a landscape never personally visited by the Buddha, two stupas were built around relics of Sariputa and Mahamogalana, both missionaries sent out by the Buddha in "the sixth to fifth century BC" (Willis 2000: 14). However, as Willis notes, "As we have textual accounts of the stupa of Sariputa being constructed at Savatthi (Sravasti) soon after his death, the archaeological record points to the fact that Sariputa's original stupa was broken open so that a portion of his remains could be brought to the Vedisa region" (Willis 2000: 15).

The proposition that Asoka himself was personally engaged in the rebuilding or embellishment of Buddhist monuments is further supported by the text of an inscription on his stone pillar at Niglihawa Sagar in southern Nepal. This inscription, written in early Brahmi script, recorded that Asoka had enlarged a stupa and erected the pillar during his pilgrimage to the site in the twenty-fifth year of his reign. Such practices are also attested by the fourth-century CE Chinese pilgrim Faxian, who recorded that the Emperor Asoka had wished to open all eight original stupas associated with the Buddha, subdivide their relics, and encase them within eighty four thousand new stupas (Rhys Davids 1901: 403). Sir John Marshall, director general of the Archaeological Survey of India and excavator of the site of Taxila, commented on the Dharmarajika stupa, "We have good reason accordingly to infer that Taxila was one of the many cities in the Mauryan Empire which received from Asoka a share of the holy relics, and that the Dharmarajika was the stupa originally erected by him to house that share" (Marshall 1951: 235). As noted earlier, similar traditions are also associated with the Kushan emperor Kanishka (r. 127–151 CE), who is said to have reopened stupas to redistribute the relics of older, established shrines, accounts that are supported by the presence of Kushan coinage in

older monuments (Rosenfield 1967). As in the case of Asoka, there is little evidence to prove that Kanishka, though a powerful patron of Buddhism, was a devotee of this religion alone, as his coinage carries images of a variety of individuals ranging from Buddha to Siva and various Bactrian and Iranian deities (Coningham and Manuel 2009). In this light, it is interesting to note the text of a silver scroll in Chapel G5 close to the Dharmarajika stupa of Taxila, which records the enshrining of "relics of the Holy One (the Buddha)" circa 78 CE "for the bestowal of health upon the great king, king of kings, the son of heaven, the Kushan." This indicates that relics of the Buddha were still in circulation in the Kushan era (Marshall 1951: 256). It is also clear that some of the material enshrined in the vicinity of the Dharmarajika stupa at Taxila had been sourced from earlier monuments; when Marshall identified objects of a Mauryan date in later monuments, he concluded, "It is not unlikely, therefore, that the relic itself may have come originally from a Mauryan stupa and been rededicated in another stupa about the middle of the first century BC" (Marshall 1951: 272). It is believed that this practice of rededication continued in Gandhara for some centuries, as demonstrated by the presence of sculptural plaques dating to the second century CE in a fifth-century CE phase of rebuilding at the Mekha Sanda stupa, and by the presence of coins of the fifth and eighth centuries CE in a number of much earlier stupas (Behrendt 2004: 178, 10).

 This archaeological evidence is strongly supported by a number of Buddhist textual references relating to such practices across South Asia. One of the best known is the sourcing of the relic of the Buddha's collar bone for the city of Anuradhapura in the third century BCE, as recorded in the Pali text known as the *Mahavamasa*, or Great Chronicle. Mahinda, a Buddhist missionary and son of Emperor Asoka, is recorded as having commented to Devanampiya Tissa (r. 250–210 BCE), king of Sri Lanka, that he and his fellow monks were saddened by the absence of relics of the Buddha to venerate (*Mvs.* 17: 1–4). As a result, Devanampiya Tissa commissioned a monk of "great miraculous power" to obtain suitable relics. This individual first journeyed to Asoka to collect a portion of relics and then travelled to the Himalayan kingdom of the king of the gods, where he was presented with the right collarbone of the Buddha (*Mvs.* 17: 16–19). This evidently eligible relic was then transported back to Anuradhapura and enshrined in the Thuparama stupa to the south of the city wall. But not all relics were obtained so easily, or presented so willingly, as Kevin Trainor has noted in highlighting the questionable acquisition of the Buddha's right eyetooth relic by the Brahmin Drona, who hid it in his turban before it was acquired, again questionably, by Sakra, the king of the gods

(Trainor 1997: 123). Another tradition refers to the presence of relics of the Buddha in the stupa of the Koliyas of Ramagrama in Nepal, where they were both venerated and protected by the region's kings of the serpent-deities, or *naga-rajas*. The fourth-century CE Chinese pilgrim Faxian recorded that when Emperor Asoka tried to open the stupa to acquire the relics within, he was confronted by the *naga-rajas*, who prevented him from removing the relics (Beal 1869). A similar role of Buddhist patron, monument builder, and relic circulator is attributed to Emperor Kanishka, who is credited with the construction of the stupa of Shah-ji-ki-dheri at Peshawar in the kingdom of Gandhara over the alms bowl of the Buddha (Rosenfield 1967: 35). These reports and records suggest that the acquisition and circulation of early Buddhist relics was common, and we may conclude by noting that Kanishka is credited as having obtained the alms bowl in lieu of three hundred million gold pieces owed to him as tribute (Behrendt 2004: 64).

CONCLUSION

It is thus apparent that whilst archaeologists, both colonial like Marshall and Longhurst and postcolonial like Paranavitana, denigrated those who damaged stupas and other ancient monuments in pursuit of relics as "treasure-hunters" (Marshall 1951: 238; Longhurst 1936: 11; Paranavitana 1946: 9), such activities were not uncommon practice in the distant South Asian past. Indeed, the work of Marshall at Taxila demonstrated that the recycling of relics – the removal of relics from damaged or dilapidated monuments and the reenshrining of them elsewhere – was as current in the past as it is today (Marshall 1951: 272). If some of the clearest examples are found in the period of Mauryan rule, such as Asoka's inscription at Nigli-hawa Sagar in Nepal, other later cases were identified by Marshall at Taxila (Marshall 1951: 272) and Willis at Sanchi (Willis 2000: 15). It is also useful to reflect that although archaeological commissioners and directors general of archaeology may have criticised the hunting for relics, they themselves were engaged with the redistribution of relics at an official level. Thus, a relic casket excavated by Sir John Marshall and containing ancient coins, gold objects, semiprecious stone and bone beads, and a relic from Stupa S8 at Taxila was presented to the Buddhists of Sri Lanka by the government of India in 1917 and enshrined in the Temple of the Tooth (Marshall 1951: 242). A similar official donation made after India's independence was a gift of Buddhist relics from the government of Pakistan to the government of Sri Lanka in 1958. As recently as 2007 the Bangladesh Buddhist Association donated hair relics to Sri Lanka, though with the warning, "We would

not be able to give any relics to anyone in future as the quantity is very little and might be exhausted" (*Daily Star* 2007). This, the lasting power of relics, is key to understanding why individuals have engaged in relic hunting or treasure hunting, as well as the formal presentation of relics. Indeed, the power and authority of relics should not be underestimated, and there is clear evidence that many generations of monks, nuns, and laity respected relics of the Buddha, because "relics themselves were thought to retain – to be 'infused with', impregnated with – the qualities that animated and defined the living Buddha" (Schopen 1997: 127). Michael Willis puts the point succinctly: "relics are not simple keepsakes or reminders of the Buddha but powerful objects that have a capacity to create new places of religious significance", so that "the presence of relics is equal to the presence of the Buddha" (Willis 2000: 14). This analysis is reinforced by Schopen, who argues that there is strong inscriptional evidence from the first century CE onward to suggest that relics, and the stupa that contained them, were assigned the status of a "legal person" and that damaging them was equated with harming "a living person of rank" (Schopen 1997: 128–30).

In such an environment, the contents of dilapidated or abandoned stupas are liable to "be dispersed . . . whereby old stupas are 'looted' by those seeking amulets and valuables encased therein", as their relics are "sacralised independently of the stupas which contain them. In the discourse of the sacred, their value has little to do with their *in situ* context within stupas" (Byrne 1995: 276). This respect for the power of relics undoubtedly explains why in some regions villagers will avoid climbing or stepping on ruined stupas, such as at That Phanom in Thailand (Byrne 1995: 275), or choose to engage exorcists before hunting for relics in temples and stupas in Sri Lanka (*Lanka Times* 2010). This tension returns us to a number of accounts of relic acquisition in Pali Buddhist literature, where a theft of relics is not necessarily treated as a theft. Kevin Trainor proposes that this is because "the Buddha's relics do not punish those who steal them, and this is in keeping with the benevolent character associated with the Buddha" (Trainor 1992: 20). Byrne also focused on the difficulties of applying western norms of conservation practice to Buddhist stupas in Thailand, arguing that the "Western-derived conservation ethics . . . freeze stupas in their original form" and prevent ordinary Buddhists from personally restoring monuments and gaining merit from empowering the relics encased within (Byrne 1995: 275). Similarly, the application of western-derived monuments and antiquities laws and ordinances criminalises those modern communities of Buddhists who seek to open and redistribute relics from defunct or disused stupas and shrines. These acts also alienate those communities and their own practice of relic acquisition from those individuals, often

highly revered, who were engaged in similar activities in the past. Certainly, John Marshall's excavations at Dharmarajika demonstrated the longevity of both the remodelling of stupas, shrines, and monasteries as well as the reallocation and reenshrining of relics from the time of Emperor Asoka onward until the middle of the first millennium CE (Marshall 1951: 272). These modern legal instruments threaten to put an end to this important element of Buddhist practice, an element that appears to have accompanied and facilitated the development and expansion of the Buddhist tradition beyond the physical landscapes in which the Buddha lived and travelled. Although not justifying the destruction of archaeological sites, this context explains why so many sites with stupas in Sri Lanka have been targeted and will continue to be so. In this environment, it is impossible for police officers, archaeologists, and the courts to differentiate between those individuals motivated by financial gain and those by religious conviction, compelling all those prosecuted to be treated equally.

Two final examples illustrating contemporary ritual practice and behaviour and its interface with criminalization in Sri Lanka are presented from our five seasons of settlement survey in the hinterland of Anuradhapura. The first focuses on a small roadside shrine where villagers were concerned at the impact of road widening close to the village and witnessed the destruction of an archaeological mound with stone pillars. Removing the displaced pillars, they then established a new shrine in the village. They also took one rounded limestone object and placed it in the centre of the shrine, having first painted it with the trunk of the god Ayanayake, lord of the jungle, in a form similar to that of Ganesh. On careful inspection, the object was found to be a badly eroded Buddha head from the ancient shrine that had been misidentified by the villagers as Ayanayake, so demonstrating the multiple processes and interpretations involved. The second example came to light in 2009 when the team returned to a small, dilapidated stupa that had been recorded on the summit of a granite outcrop close to Thalaguru Vihara. On this visit, they found that the ancient brick and stone stupa had been entirely, and illegally, demolished but that its construction materials had been incorporated into a new seated Buddha figure occupying the same location. Reflecting the noticeable trend in the construction of seated Buddha images across the island, the transformation of the stupa into the statue, from aniconic to iconic image, exemplifies how Buddhist practice constitutes an appropriation, or rather expropriation, of relics and monuments. Although both examples represent illegal activities with respect to the 1998 Sri Lankan Antiquities Ordinance, it is clear that the two differ in their degree of criminality, as the first case represents the salvaging of an already badly damaged monument and the second the

wilful destruction of an ancient Buddhist monument. On discussing the irreversible impact of these transformations with those involved, it became clear that all were unaware of the protective legislation surrounding the monuments or of the criminality of their own actions. It is thus clear that rather than seeking to prosecute and imprison hundreds of monks and laity, there is an opportunity for the state to reverse this situation by educating and training these potential custodians through a campaign of microconservation, thus enabling the long-term preservation of the state's cultural heritage to be effected through the localised curation of sites.

Finally, and on a more positive note, it should be noted that the power, or rather the latent authority, of relics is not merely restricted to Buddhist tradition or recognised only by religious authorities. This is illustrated by the well-known case of the Pathar Nataraja from 1988. In an action for restitution brought by the Union of the States of India, it was argued in the High Court that this twelfth-century CE bronze statue of Siva was still a deity, as "once a deity, always a deity. An idol remains a juristic person however long buried or damaged, since the deity and its juristic entity survive the total destruction of its earthly form" (Pal 1991: 118). As a result, it was recognised by the judge, Mr Justice Kennedy, as a plaintiff in its own right in the case (Greenfield 1989: 185) – a stance representing yet another new dynamic in the fuzzy interface between religious practice and tradition and law.

ACKNOWLEDGMENTS

We are extremely grateful to the following individuals for their help, guidance, and assistance during the five research survey seasons in Sri Lanka: Dr Senarath Dissanayake, director general of archaeology; Dr Siran Deraniyagala, former director general of archaeology; Professor M. Jayantha S. Wijeyaratne, vice chancellor of the University of Kelaniya; Professor Y. M. Sunanda Madduma Bandara and Mr Mangala Katugampola, University of Kelaniya; and Gamini Adikhari of the Postgraduate Institute of Archaeology, University of Kelaniya. We also express our thanks to the members of the Universities of Bradford, Durham, Kelaniya, Leicester, Rajarata, and Stirling for their help in the field, and to Dr Mark Manuel and Mr Christopher Davis for making comments on an earlier version of this chapter. The fieldwork and project were generously supported by the Arts and Humanities Research Council.

CHAPTER 16

Partitioning the Past
India's Archaeological Heritage after Independence

Nayanjot Lahiri

This chapter discusses the fate of Indian monuments and antiquities after India gained freedom from British colonial rule on 15 August 1947. Like several contributions to the earlier collection *Ethics and Archaeology* (Scarre and Scarre 2006) of which this volume is a sequel, it offers normative reflections on the dilemmas that are faced by archaeologists, and the resolution of those dilemmas. However, because the story of the fate of monuments and museum collections in the aftermath of 1947, in what is best described as an unprecedented situation of turbulence and trauma, is hardly known, there is a strong historical descriptive narrative that runs through this chapter.

The year 1947 saw a redrawing of the political map, as a consequence of which a united India came to be partitioned into the two nation-states of India and Pakistan. This was accompanied by an unprecedented bloodbath, resulting in more than one million dead, and a two-way mass migration involving several million people. Where and how refugee populations were rehabilitated, the mechanism that was adopted for land compensation, the partitioning of resources and departments, the emotional trauma because of displacement and death in the aftermath of August 1947 – these are issues that have been discussed by many historians, most recently by Ramachandra Guha (2007) in his excellent *India after Gandhi*. What have not been considered are the pressures and problems that India's archaeological past had to face on account of the demographic deluge on the one hand and the division of assets on the other hand.

This is somewhat surprising because an extraordinary irony must have stared everyone in the face. As the two nations came to be divided along religious lines, India became the inheritor of a rich Islamic heritage. The new boundaries had partitioned the archaeological map in such a way that, as Mortimer Wheeler, India's director general of archaeology in 1947, put it, Pakistan was "found to include almost the whole of the known extent of the earliest civilisation of India, that of the Indus valley." Simultaneously,

"almost all the Mohammadan monuments of the first importance" remained in India (Wheeler 1947–8: 1).

How did the massive communal carnage accompanying the birthing of India and Pakistan affect this heritage? How did the Archaeological Survey of India deal with this and other problems posed by the Partition turbulence and trauma? How were conflicts between the archaeological mandate of protection that the organization struggled to fulfil and the problems of relief and rehabilitation resolved? In such situations, are archaeologists at all the arbiters of the fate of monuments?

This chapter looks at some of these challenges as it describes the impact of independence and the Partition on monuments, on museum collections, and on the nature of archaeological research itself. It is, at the outset, necessary to state that it has been written primarily from the Indian perspective and, in the absence of data from Pakistan and Bangladesh (or East Pakistan, as it was called after 1947), has no claims to being a comprehensive exploration. The ethical problems, though, that are highlighted here could not have been unique to India, even if their resolution may have been somewhat different depending on the local and national situations in that exceptionally difficult time of religious polarization and violence.

THE FATE OF ISLAMIC MONUMENTS

Islamic monuments in several parts of India were under siege in 1947, with the Archaeological Survey of India (ASI hereafter) having to combat extraordinary pressures on them from various quarters. These came from looters, from refugee camps, and from the callous acts of omission and commission of various government departments.

Delhi is an example of this. It was India's political capital with a range of impressive Indo-Islamic monuments widely distributed across the city. How many such monuments were attacked is not known, because the relevant files of the Archaeological Survey record only the desecration of those that were protected by it, that is, those monuments that were declared through legislation to be of national importance. What is known is that they began to be systematically attacked from September 1947. The reasons are not far to seek, as it was in September that Delhi became the site of a particularly vicious campaign in which Muslims were butchered by the thousands. Many others would eventually move to camps for safety even as refugees, Hindu and Sikh, from other areas, especially Punjab, poured into the city (Pandey 1997: 2263). It was as a consequence of a larger

anti-Muslim frenzy that descended on the city that symbols of Muslim culture such as monuments were attacked.

The damage inflicted in the case of some protected monuments was severe.[1] The Moti masjid in Mehrauli had its marble minars torn off and smashed – marble chips and shaft pieces were found littered all over the place when it was inspected shortly after the attack. At Wazirabad, the grave of the well-known saint Shahi Alam was completely 'wiped out', the mimbar (the traditional pulpit used by the imam of a mosque) was pulled down, and the inscribed plaster medallions were scraped off from wall facings and destroyed. Sultan Ghari's tomb in south Delhi was also systematically pillaged, numerous graves outside the walled enclosure were dismantled, and four tombs in the crypt were demolished. Before the authorities stepped in and issued prohibitory orders, the demolishers had also planned to convert Sultan Ghari's crypt into a temple by installing a Hindu deity there. That was the intention at Chauburji mosque on the Delhi Ridge as well. A cement effigy of Hanuman, the revered monkey god of India, actually came to be set up there, and it could only eventually be removed with police help.

Although several of the vandalized monuments were protected by the ASI, which by law was mandated to take all steps to preserve them, law enforcement in reality was the responsibility of the Police Department. In such cases, therefore, the ASI promptly brought such acts to the notice of the law enforcers. Simultaneously, it also made a request that the police be posted to guard such monuments. However, as the chief commissioner of Delhi wrote, "with the present shortage in the strength of the Police Force, and the ever increasing demands on its services," it was not possible for him to provide any police to guard the monuments.[2] Evidently, the situation on the ground – a combination of communal tension and carnage along with displaced people pouring in by the thousands – prevented the law enforcement agency and the ASI from following their mandate of monument protection. For the Police Department in particular, the need to protect people was more urgent than the requirement of guarding monuments. Because the scale of displacement and the communal tension accompanying partition were as unexpected as they were unprecedented, the overriding need to protect people above monuments is both understandable and moral.

[1] File 16C/1/47, 1947, Preservation of Pearl Mosque at Mehrauli Damaged during the Communal Upheaval, Archaeological Survey of India, New Delhi (hereafter ASI).

[2] R. Lal to R. E. M. Wheeler, letter dated 19 December 1947, file 16C/1/47, ASI.

If looters targeted Delhi's mosques and tombs, it was the state administration in some states that oversaw more organized campaigns of destruction. This was true, for instance, of the princely states of Alwar and Bharatpur in Rajasthan. 'Princely' India at that point in time was constituted of hundreds of small states and chiefdoms that were ruled by the local royalty. These would soon be amalgamated into the Union of India and the state of Pakistan. But at this point in time, the administrative writ of the Indian government and its archaeological arm, the Archaeological Survey, was relatively tenuous in relation to other parts of India.

Consequently, unlike Delhi, where incidents in which monuments were targeted immediately came to the notice of the government, in states like Alwar and Bharatpur the situation was different. The Indian government managed to confirm reports of destruction only by sending inconspicuous agents to make secret inquiries. One of these was Shankar Das, a superintending archaeologist in the Archaeological Survey, whose enquires revealed systematic monument demolition. Apparently, the profit to be made by grabbing the land on which these stood was the primary motive for demolition. Das's confidential report, extracted here, underlines the mechanism adopted in Alwar:

I visited Alwar on the 10th December 1947, and studied the demolition of the mosques, grave yards and tombs in and around the city. This demolition campaign was launched by the state during the last disturbances and is still going on at some places. The State Ministers after a conference entrusted the task of demolition to one Sardar Joginder Singh, S.D.O. of the Public Works Department. This S.D.O. summoned various contractors and distributed the mosques and tombs for demolition amongst them on the simple conditions that whatever building material was got out of the debris would be appropriated by the contractor and virgin soil over which such a structure stood would be forfeited to the State. The contractors lost no time in razing both old and new mosques as well as grave yards to the ground and the building material thus torn out was removed from the sites and stacked at appreciable distances in quite an unseeming manner.[3]

As a consequence of this, several mosques, graveyards, and tombs were either damaged or demolished, including the singular Gumbad Fateh Jang (tomb of Fateh Jang). The dome's brackets and balcony *chajjas* (projecting eaves) were pulled down, and the mosque situated in its northern enclosure was dismantled. That it happened to survive at all was because refugees came to its rescue. Apparently, the premises were occupied by refugees

[3] S. Das, confidential note, 1947, file 14L/2/48, Report on the (Monuments of) Alwar and Bharatpur, ASI.

from Pakistan who persuaded the contractor that they be allowed to stay there till they got suitable living accommodation elsewhere. As in the case of Alwar, in the princely state of Bharatpur as well, Shankar Das's visit revealed a similar story. Mosques and tombs were broken under the orders of the state with specific contracts for demolition.

Ironically, even as some Islamic monuments came under attack, others provided refugees with much needed shelter. Gyanendra Pandey describes this graphically when he says that Delhi was literally transformed into a 'refugeeistan'. Initially, it was Muslims seeking a safe haven who occupied such places as

the Jama Masjid area itself, Nizamuddin and Okhla, other graveyards and abandoned Muslim monuments, the houses of cabinet ministers Abul Kalam Azad and Rafi Ahmed Qidwai and any other Muslim notable whose dwelling appeared comparatively secure, the Pakistani High Commission, and when these overflowed or (as in the case of the Jama Masjid locality) themselves became insecure, the huge refugee camps that were set up in the Purana Qila and Humayun's tomb. (Pandey 1997: 2263)

Later, tens of thousands of Hindu and Sikh refugees took shelter in such camps, which continued to exist for several years after the Partition. The difficulties of dealing with refugees from Pakistan has been described in the memoir of Dharma Vira (1975: 44–45), who handled the Refugee Section in Prime Minister Nehru's office. "It all seems unimaginable now," he tells us, "but we who have been through these times cannot forget the amount of suffering these refugees had gone through – their distress and privations. Somebody's daughter snatched away; another person's wife dishonoured; their property gone; most of them living an uprooted life; and not knowing what was going to happen the next day. It was not easy to deal with these people. Nevertheless, the job had to be done. They had to be looked after and rehabilitated." So, refugees were allowed to stay on in the refugee camps at monuments till they could be suitably resettled. Even in 1949, there were more than 3,000 refugees in Humayun's tomb, with 450 or so in the main tomb and the rest in tents; 1,400 refugees were housed in Safdarjang's tomb, 250 in the main tomb with the rest in the pavilions; 4,500 people lived in the tents and colonnades of Purana Qila; and 1,500 refugees were accommodated in the tents pitched at Feroz Shah Kotla.

Exceptional times evidently required such exceptional measures. This is perhaps why the Archaeological Survey chose to ignore, for humanitarian reasons, what was stipulated in the act under which the monuments that were protected could not be occupied. Instead, it agreed to a more ethical

option, permitting some of the monuments to be used as temporary refugee camps. Certain conditions were laid down that allowed tents to be pitched in the compounds of monuments for housing refugees, and only minor alterations were to be made that could be removed without in any way damaging the character of the monuments. These conditions, however, could rarely be enforced by officials.

An instance that vividly demonstrates how the Archaeological Survey's views on matters relating to monuments were brushed aside is the case of Sher Shah's mosque in Purana Qila in Delhi. In April 1948, the Women's Section of the Ministry of Relief and Rehabilitation wrote to the rehabilitation commissioner about the need to accommodate a primary school in the mosque for the children of refugees living in Purana Qila.[4] There were roughly seven thousand people living there, and a regular primary school was being planned. This was for the five hundred children who were being taught by the refugees themselves in open-air classes – a situation that, with the summer of 1948 approaching, could not be sustained.

When this letter was forwarded to Mortimer Wheeler, he made it clear that although all other parts of the historic fort could be used, the unique character of the mosque made it impossible to hand it over for a primary school. As he noted:

Please understand that my Department has been only too happy to collaborate to the fullest possible extent in the appalling refugee problem which has confronted the Delhi authorities during the past six months. Certain of the Delhi monuments – buildings of outstanding fame in the architecture of Asia – have been used freely by the refugees in question, and in the Purana Qila no sort of difficulty has been placed in the way even of the erection of new structures for this purpose. I fear, however, that it is quite impossible for my Department to authorise the use of the Sher Shah Mosque as indicated. This mosque is an architectural gem of the highest value, and occupies a particularly high place in the history of Indo-Muslim culture. Whilst all other buildings in the Purana Qila have, as I say, been freely turned over to the refugees, it is essential to maintain the integrity of this mosque.[5]

Wheeler's plea to maintain the integrity of the mosque appears to have fallen on deaf ears. The mosque was occupied, and by August that year, his own officer, Shankar Das, recorded the defacements that he had seen there.[6] He reported that "a number of stones inside Sher Shah's Mosque at Purana

[4] Director to rehabilitation commissioner, letter dated 3 April 1948, file 15B/3/48, ASI.

[5] R. E. M. Wheeler to relief and rehabilitation commissioner, letter dated 10 April 1948, file 15B/3/48, ASI.

[6] S. Das to D.G.A., note dated 25 August 1948, file 15B/8/48, Protection of Humayun's Tomb Jang and Pir Gaib Occupied by Refugees, ASI.

Qila have been broken by the refugees intentionally. Out of this damaged lot unique pieces of carved marble in the Mihrab have been mutilated. Attempts were also made to rake out black marble ornaments from the geometrical pattern incised in the splays adjoining the Mihrab. Some of the Refugees have started sleeping on the 'Charpois' inside the Prayer Chamber and shoes are freely moved about." During his inspection, he also found the prayer chamber of the mosque littered with bricks and pebbles, obviously used to cause injuries to the structure. He therefore requested that "the Ministry of Relief and Rehabilitation may please be sounded so that this lovely mosque is saved from further acts of vandalism." No action appears to have been taken. In December 1949, another ASI officer, K. N. Puri, once again wrote to the chief commissioner about what he had observed during his inspection:

I was shocked to see some brick marks on the central Mehrab of the Sher Shah's Mosque. Brickbats were also seen piled at one corner. Somebody appeared to have worked for its mutilation. Fortunately the bricks themselves being of war quality could not achieve the purpose for which they were used, as the injuries inflicted were not very serious. This was obviously the task of school children who could not administer sound blows to the marble ornamentation. The school was on and the students as well as the teachers were moving in the mosque with shoes on. Chairs were found spread up both in the Lawn and the outer court. It is a pity that in spite of various letters having been issued to responsible quarters due sympathy and cooperation should not have been invoked to save this gem in the history of Indian Architecture.[7]

This episode, in retrospect, compels us to recall that protected monuments that had become refugee camps after 1947, for all practical purposes, were not under the ASI's custody. Under these circumstances, all it could do was inspect monuments and prepare notes of strong protest – which it did – about how its suggestions were being completely disregarded by those in charge of relief and rehabilitation. Unfortunately, because the primary intention of the Ministry of Relief and Rehabilitation was to house as many refugees with no concerns at all for the historical surroundings that housed them, the damage caused to some of the monuments was appalling.

To create usable spaces, the camp commandants themselves, working under the ministry, carried out mindless mutilations. For instance, around Arab Sarai, where a vocational training centre was to be set up, ruthless removal and renovation was the order of the day. Shankar Das, again

[7] K. N. Puri to chief commissioner of rehabilitation, letter dated 8 December 1949, file 15B/5/49, Occupation of Archaeological Monuments in Delhi by Refugees, ASI.

acting as the ASI's watchdog, filed the following report, after inspecting the site:

> Having been informed that the authorities of vocational Training Centre at Arab Sarai were still continuing with their activities of making additions and alterations to the ancient structures within the enclosures of Arab Sarai, I inspected the monument last evening and was wonder struck at the amazing speed with which the acts of vandalism were being perpetrated on the silent edifices belonging to the early Moghul period. The walls of the mosque known as Afsar Wala were being demolished according to their pre-planned designs. The historic northern enclosure between the Bu-Halima's Gate and the western entrance to the Humayun's Mausoleum was being bored through at various sections with heavy blows of jimpers and pick-axes. The demolitions and the new constructions were going on simultaneously and that too at a top speed. Even the magnificent gate in this wall which once stood over the highway winding its way from Purana Qila down into the Sarai and opening through the Jaghangiri Gate was not spared. Perforations were made in its wall and wooden frames for doors and windows fitted.[8]

Rather than seeking ways to undo this damage, the minister of relief and rehabilitation, Mohan Lal Saksena, suggested that Arab-ki-Sarai should simply cease to be a monument protected under the Monuments Act. The ASI appears to have been outraged at the suggestion, and the monument was visited by Maulana Azad, minister of education (the ASI was a department under the Ministry of Education). He very clearly articulated his views that the demolitions and alterations there showed that the Ministry of Relief and Rehabilitation had not kept to its promise when a training school was decided to be set up.[9] What such instances demonstrate is that when the task of protecting monuments was in conflict with relief and rehabilitation work, monument protection inevitably lost out. In this case, the vocational training school never came to be removed from Arab Sarai. It continues to exist there, even though Arab Sarai lies within the precinct of the World Heritage Site of Humayun's Tomb.

If monuments were defaced by the Relief and Rehabilitation Ministry in Delhi, a similar damage was inflicted by the Indian Army on the Gol Gumbad monumental complex in western India.[10] Here too, the ASI was not consulted. The occupation of the monument was the result of an unusual situation in the adjacent princely state of Hyderabad, whose

[8] S. Das, note dated 29 October 1948, file 15B/5/49, Occupation of Archaeological Monuments in Delhi by Refugees, ASI.

[9] M. N. Masud, note dated 25 April 1949, file 15B/5/49, Occupation of Archaeological Monuments in Delhi by Refugees, ASI.

[10] For details, see file 159/5/48, 1948, Housing of Refugees in Protected Ancient Monuments at Bijapur, ASI.

recalcitrant ruler was unwilling to politically integrate with India. The Indian Army was asked to take control of the state, and in preparation for this, army detachments had moved into the border areas around the state of Hyderabad, with Bijapur being one such border district.

In Bijapur, without getting prior permission from the Archaeological Survey, parts of the seventeenth-century Gol Gumbad complex were taken over. This tomb is located in the heart of the city and, with one of the largest dome structures in the world, is Bijapur's most splendid monumental complex. There are large, open garden stretches around the tomb. Rather than pitching tents in the open spaces, historical buildings came to be occupied by the army. A particularly jarring instance was the occupation for residential purposes of the mosque attached to the Gumbad. Latrines were built behind the mosque, and compound walls were broken at places for the entry of lorries. As the ASI pointed out, this amounted to nothing short of sacrilege.[11] The saving grace was that when this matter was taken up by the director general of the ASI with the Defence Department, the buildings were immediately vacated by the troops.

Unsurprisingly, these measures attracted adverse publicity in Pakistan and internationally. Enquires about various Muslim shrines were regularly made by the Pakistan government.[12] On many occasions, photographs appeared to show how the government of India was treating its Muslim monuments. Ruined gardens, gaps in fortifications made for egress and ingress of refugees, soot-blackened tombs, bulldozer operations levelling mounds that contained foundations of old habitations inside monument compounds – these figure frequently in the letters and memos of the ASI, and surely they must have figured in media reports.

Yet by the early 1950s, as refugees moved out, as always it was the Archaeological Survey that, as the institutional guardian of protected monuments, immediately got down to the business of repairing and restoring them. These repairs also find mention in the ASI's annual publication although in a somewhat low-key way, quite unlike the vivid details about mistreated monuments that are recorded in its files. So, for instance, when the repairs to Kotla Firoz Shah at Delhi are discussed, the ASI recorded that "like many other monuments in Delhi, this citadel, occupied by refugees for about two years, was cleared of all squatters. The roads were properly repaired; low sections of the walls were raised on the old lines to check

[11] M. N. Deshpande, letter dated 12 July 1948, file 159/5/48, Housing of Refugees in Protected Ancient Monuments at Bijapur, ASI.
[12] For details, see file 15C/2/48, 1948, Enquiries by Pakistan Govt. Regarding the Condition of Dargah Hazrat Salim Chisti at Fatehpur Sikri, ASI.

trespass; joints where mortar had fallen out were filled and pointed, and the rough rubble-stone paving near the main entrance was repaired" (*Indian Archaeology* 1953–4: 16). Such repairs were carried out with commendable speed and so thoroughly that hardly anyone who visits those monuments is aware of the tribulations and travails undergone by them more than six decades ago. These rusted incidents recounted here have simply been hauled away into the dust heap of forgotten histories.

By way of comparison, what is known about the fate of monuments in India after the Partition is quite different from the documentation that exists on looted war art and the collateral damage to Europe's monuments during World War II (for references, see Moorhead 1995). The work of the Monuments, Fine Arts and Archives group that came behind the Allied armies, for instance, as it reported on the state of artistic monuments and attempted to stop Allied forces, often unsuccessfully, from billeting in historic buildings, is well researched. In India, in contrast, there is no public record of what was destroyed or desecrated during the Partition. Such details have simply remained buried in the archives of government departments.

In the aftermath of 1947, the state clearly straddled a fine ethical line between a thorough presentation of the enormity of the trauma that accompanied the Partition and a selective rendering of India's liberation and independence. A public articulation of the damage that Islamic monuments had suffered, for instance, might have exacerbated the fresh wounds of communal riots and displacement. Moreover, in a situation in which India was coping with the loss of property and life of close to eight million people who had poured in after independence, the primary focus was on the successful settlement of refugees.

What is less defensible in moral terms, though, is that this silence continued in the following decades. In fact, a selective amnesia about the Partition horrors extended from historical writings on 1947 to public representations of that period. Consequently, 1947 came to be more often seen as a moment of liberation and less as a "tormenting history of displacement" (Pandey 1997: 2271). A scholarly recovery of the suppressed history and memories of the Partition has been systematically pursued only from the 1990s. Why this happened is not entirely clear. A possible reason may be that the pogroms and riots following the assassination of Prime Minister Indira Gandhi in 1984 and the destruction of the Babri Masjid in 1992 made communal terror part of the lived reality of many middle-class Indians (which include historians) (Pandey 1997: 2261). This

is likely to have made scholars more receptive to the task of documenting and understanding memories – of a generation that had experienced it and was still alive – of similar events at the time of independence. Whatever the reasons, cameo histories of rousing speeches and national celebration at independence have given way to writings that are woven around the anger, hardships, and scars of citizens and dispossessed refugees.

If more inclusive historical narratives have since been produced by integrating Partition memories and traumas into the story of the birthing of India and Pakistan, government recognition continues to lag. There is no memorial to the victims of the Partition. Nor has the state thought it necessary to create a museum around the wealth of photographs, documents, oral histories, memorabilia, and archaeological exhibits of that era. Evidently, making generations of Indians aware of what they had not experienced directly in their own lives does not extend to the landscape of partition.

But coming back to the damage and destruction that Islamic monuments suffered, how would an explicit recognition of this have helped in policy making? Perhaps such a recognition could have become the starting point for putting institutional mechanisms and legislation in place for protecting monuments and cultural markers in situations of strife and conflict. Laws and decrees in themselves, though, are never sufficient. The nonapplication of the framework for the protection of cultural property in the Hague Convention in cases of armed conflict is well known. Croatia in the 1990s is one example that demonstrates that even with preventive measures, where the government of Croatia specifically directed the protection of its cultural heritage, because of what has been described as "an unexpected and undeclared war," enormous damage was sustained (Šulc 2001: 160). At the same time, the task of assessing this damage and the scale of losses to movable and fixed cultural heritage was seen there as a state responsibility, according to instructions on the implementation of the Law on Ascertaining War Damage, which was passed in 1993.

A similar stocktaking, though, of the violence done to its people and its cultural heritage, was never done in India. This, and the lack of any commemoration or representation of the scars that accompanied independence, has meant that there simply has been no public confrontation of that pain and destruction. It is only now, more than sixty years later, that for the first time, a bill aimed at specifically ensuring accountability of public authorities for the prevention and control of communal and sectarian violence is being drafted. Hopefully, it will lead to legislation that explicitly

recognizes the threats to cultural security, along with physical and social security.

PARTITIONING MUSEUMS AND ARCHAEOLOGICAL COLLECTIONS

If monuments in 1947 became part of the heritage of either India or Pakistan depending on where they were located, how were antiquities and museum collections divided? On the face of it, this could have been a fairly straightforward exercise, as the division could be done either by sharing the antiquities or on the basis of where the sites were located. As things turned out, however, the negotiations were prolonged and twisted. Ultimately, the solution that was arrived at was based more on goodwill and compromise than on the legal principles on the basis of which they were supposed to be partitioned. As we shall see, though, in searching for a solution that was equitable to both nations, what was crucially sacrificed was the principle of preserving the integrity of some of the antiquities themselves.

The Partition Council in October 1947 had resolved that museums would be divided on a territorial basis.[13] This council had been set up to deal with the administrative consequences of Partition and decided on a wide range of issues, from revenue and domicile to records and museums. With regard to its decision on a territorial division of museums, the council stipulated that when the territory of a province was partitioned, the museum exhibits of the provincial museums would also be physically divided. A subcommittee made up of officials from India and Pakistan was set up to recommend the procedure for the division of museum exhibits in accordance with the decision of the Partition Council. On this basis, the exhibits in the Lahore Museum, which belonged to the United Province of Punjab before Partition, were to be split between East Punjab (in India) and West Punjab (in Pakistan). This was straightforward enough.

More complicated was the fate of objects that had been sent on temporary loan to places that, on 15 August 1947, happened to be on the wrong side of the border, far away from the original museums to which they belonged. On that date, there were objects in India from Harappa and Mohenjodaro, the earliest Bronze Age cities of the Indian subcontinent. There were also objects from Taxila in India and an important collection of antiquities in London. The antiquities in London were on loan to the Royal Academy of Arts. In its wisdom, therefore, the Partition Council

[13] Minutes of the proceedings of the Museum Committee set up by the Inter-Dominion conference to discuss the division of museum exhibits between India and Pakistan, 5 January 1949, no file no., ASI.

ruled that all objects that had been removed for temporary display after 1 January 1947 were to be returned to the original museums.

For Pakistan, this did not pose any problems in relation to most museums, where nothing had been removed from their precincts after 1 January. At Harappa, some antiquities had been taken out of its site museum in July and September 1946, and these Pakistan was willing to treat as belonging to India. Similarly, there were more than two thousand antiquities, as well as notebooks, drawings, and maps from the Excavations Branch from Taxila that had been taken to New Delhi in July and August 1947, some a little earlier. These were to be made over to Pakistan.[14]

The real problem, though, revolved around the antiquities of Mohenjodaro. This is because, on the day of Partition, as many as twelve thousand objects from Mohenjodaro were in Delhi. Because Mohenjodaro fell within the territory of Pakistan, the objects should have fallen to its share. However, India's negotiators maintained that these rightfully belonged to India because they had not been removed after 1 January 1947 from the original museum (which was at Mohenjodaro) but came from Lahore. Similarly, they had not been removed for the purposes of temporary display but because, as early as 1944, the director general of archaeology, Mortimer Wheeler, had wanted to concentrate all the best Indus objects in a central national museum.[15] It was in the absence of such a museum that it had been decided that Lahore Museum would act as a substitute, pending the establishment of a central national museum. Wheeler had continued to reiterate that "all objects from Mohenjodaro now on exhibition at Lahore are deposited by the Central Government on loan, and the Punjab Government has no lien upon them." Pakistani officials, however, put forth the argument that the bulk of the antiquities were intended for Lahore and only a representative collection for a central national museum.[16] Some emphasis was placed by them on the words in Wheeler's letter of May 1944, in which he had made clear that the Mohenjodaro objects were on "long loan" (which was the same they believed as "indefinite loan") to the Lahore Museum. The same letter, though, had also mentioned that it was in the absence of a central national museum that the most "suitable repository" would be the Lahore Museum.[17]

[14] V. S. Agrawala, letter dated 5 July 1949, file 33/21/49, Division of Antiquities between the Two Dominions, ASI.

[15] Minutes of the proceedings of the Museum Committee set up by the Inter-Dominion conference to discuss the division of museum exhibits between India and Pakistan, 5 January 1949, no file no., ASI.

[16] Ibid. [17] Ibid., annex 6.

It was this – the question of intention about the future disposal of the objects in a central national museum – that was central to the contentious dispute around how the antiquities were to be divided. Several formulae were suggested and rejected; pressure tactics were used by both parties. To make things difficult, the West Punjab government postponed the actual handing over of East Punjab's share of the Lahore Museum holdings till such time as India had handed over to Pakistan its share from the central museums. And a final decision on the central museums remained pending till the Mohenjodaro matter was sorted out.

That India considered Indus objects to be an integral part of its own heritage was equally an issue. N. P. Chakravarti, who succeeded Wheeler as director general in 1948, said it in so many words when he declared, "The Indus Valley Civilisation as such does not merely represent the civilisation of Pakistan but has a direct bearing on the civilisation of the whole of India and Pakistan and certainly the 300 million in India have quite a large interest in that civilisation, particularly as India has no longer any jurisdiction over these sites."[18] By then, in fact, because major Indus sites were "lost" to India, finding forgotten Indus cities in India was considered a priority area of research.

Even before negotiations around Mohenjodaro's collection had begun, as early as March 1948, K. M. Panikkar – a scholar-administrator who had served as one of the most senior ministers in the princely state of Bikaner – had written to Prime Minister Jawaharlal Nehru, about the necessity of a survey of Bikaner and Jaisalmer. As he put it, "with the separation of the Pakistan Provinces, the main sites of what was known as the Indus Valley Civilisation have gone to Pakistan. It is clearly of the utmost importance that archaeological work in connection with this early period of Indian history must be continued in India. A preliminary examination has shown that the centre of the early civilisation was not Sind or the Indus valley but the desert area in Bikaner and Jaisalmer through which the ancient river Saraswati flowed into the gulf of Kutch at one time."[19] Nehru promptly agreed with the suggestion that was conveyed to the ASI, and, with his support, money was also allocated for it. Consequently, in 1950, Amalananda Ghosh of the Archaeological Survey began an exploration of Bikaner, and within a couple of months had found as many as seventy sites, fifteen of which

[18] N. P. Chakravarti, note 'Division of Antiquities between India and Pakistan', 1949, file 33/21/49, Division of Antiquities between Two Dominions, ASI.

[19] S. Panikkar to the prime minister, note dated 29 March 1948, file 19/8/48, Ground Survey of the Desert Area in Bikaner and Jaisalmer: Proposal by Sardar Panikkar, ASI.

yielded the same types of antiquities that had been found at Harappa and Mohenjodaro.

So, as it turned out, Chakravarti's observation about the Indus civilization being part of the civilization of India and Pakistan was prescient. When Chakravarti wrote, though, such sites could be counted on the fingers of one hand. Gujarat has more than a hundred Harappan sites today; around 1947, Rangpur was perhaps the only site that had been reported and studied. It was this paucity of sites that Chakravarti had in mind as he presided over a partitioning of museum collections that would help India keep some of the Harappan material from Indus cities in Pakistan.

Eventually, after many rounds of negotiations and a massive exchange of correspondence, the Museum Committee in 1949 agreed to a division down the middle. As the note 'Division of Antiquities between India and Pakistan' put it, "India wishes that a decision shall be made upon a basis which provides a firm foundation for future good-will and collaboration between the Archaeological Departments of the two Dominions. Pakistan is actuated by the same consideration, and, with this end in view, both Dominions agree to accept a 50/50 division of the Mohenjodaro and Chanhu-daro collections".[20] More than fourteen thousand antiquities from the Indus sites were divided in this way.[21] This physical division, as it came to be implemented, covered all kinds of Indus objects ranging from seals and statuary to ordinary artefacts of stone, clay, and metal. Even potsherds were equally apportioned, although Pakistan waived all claims to any share in the skeletal material from Mohenjodaro and Harappa. Pakistan was also expected to give India as comprehensive a duplicate collection as possible from Taxila.

The suggestion to divide the Indus collections into two equal parts came from Mortimer Wheeler, who, after completing his term as director general of archaeology in India, had become archaeological adviser to the government of Pakistan. Wheeler's letter containing this suggestion also proposed a way of dealing with unique articles that could be divided as, for instance, jewellery made up of beads and spacers.[22] Here too, he suggested absolute equity.

That this suggestion was accepted (with the division being eventually done by Wheeler himself), in retrospect, was a tragic decision. Four articles

[20] Division of Antiquities between India and Pakistan, 1949, file 33/21/49, Division of Antiquities between Two Dominions, ASI.

[21] Deputy Director General, note 'Department of Archaeology' dated 22 April 1949, file 33/21/49, Division of Antiquities between Two Dominions, ASI.

[22] R. E. M. Wheeler to Fazal Ahmad Khan, letter dated 26 March 1949, file 33/21/49, Division of Antiquities between Two Dominions, ASI.

were fragmented 'equitably' because this formula was foisted unthinkingly on them – that too by an archaeologist who, above all, should have known that he was severely compromising the integrity of the objects. These were two gold necklaces from Taxila; a carnelian and copper girdle of Mohenjodaro; and a magnificent Mohenjodaro necklace of jade beads, gold discs, and semiprecious stones. They were broken up and divided down the middle. An office note describes this division:

The exhibits are to be divided as follows:
India and Pakistan should receive equal share of the two terminals, 42 elongated carnelian beads, 72 small globular beads and six spacers of the copper and carnelian girdle from Mohenjodaro (item 8 of list IA, Royal Academy Catalogue No. 29). The Mohenjodaro necklace (item No. 9 of list IA, Royal Academy Catalogue No. 23) consists of 10 jade beads, 55 spacers of gold disk, 7 pendants, and 10 semi-precious stones. Out of it India's share should consist of 5 jade beads, 27 spacers of gold disk, 4 pendants and 5 semi-precious stones. India should be allotted 4 pendants out of 7, since in dividing Taxila gold necklace No. 8885 Sirkap only 12 beads and a terminal were given to India as against 13 beads and one terminal to Pakistan. The two gold necklaces from Taxila (Items 5 and 15 of List II) are to be divided equally.[23]

Oddly enough, nowhere in the correspondence is there a sense that the character of the objects was being permanently destroyed. There is, instead, an overriding anxiety about carefully adhering to the arithmetic of division. Once this was completed, again, there was only a sense of relief that the work of division had been completed successfully. Mortimer Wheeler's letter from London to the director general of archaeology captures this:

On Tuesday, the 14th, we completed the partitioning of the Royal Academy collections and on Wednesday squared everything with the customs authorities.

Mitra turned up on behalf of India, and everything went very smoothly and easily. As usual, India won the toss on the two occasions when we had to toss for odd things. You seem to have won down the line.[24]

Situations like this, with the benefit of retrospective appraisal, surely raise a larger issue about the desirability of equity as the overriding principle on which museum collections and antiquities are to be divided. In the case of India and Pakistan, the destruction of the integrity of monuments had been an important area of concern since the latter part of the nineteenth century,

[23] Director General of Archaeology's Office, note dated 9 November 1949, file 33/21/49, Division of Antiquities between Two Dominions, ASI.
[24] R. E. M. Wheeler, letter dated 18 November 1949, file 33/21/49, Division of Antiquities between Two Dominions, ASI.

and it is somewhat amazing that such concerns were not articulated post-independence with reference to the previously mentioned artefacts. This is especially surprising because in 1947 itself, the relics of two of the Buddha's disciples that had been taken away from Sanchi in the nineteenth century were being brought back to be enshrined at Sanchi. However, in the case of collections that were the subject of dispute, archaeologists and negotiators, in their anxiety to adhere to what was politic, ignored the more ethical option. In the bargain, the past came to be partitioned in this unfortunate way.

Now, many decades later, is there a way in which this can be undone? Surely, India and Pakistan can take heed from the experience of the two pieces of a bronze sculpture that was originally attributed to Bartolomeo Bellano but is now recognized as the work of Severo Calzetta da Ravenna, one of which was in the National Gallery of Washington and the other at the Louvre in Paris. While these are not from India, what followed when the two pieces were revealed to be parts of a single sculpture – *St Christopher Carrying the Christ Child with the Globe of the World* – may be a useful solution for the partitioned objects of the Indian subcontinent. Apparently, the National Gallery gave its part of the sculpture on permanent loan to the Louvre. Since 1973, the sculpture has been there on the principle that the aesthetic value of the reunited sculpture is greater than the value of dismembered parts. The Louvre, in turn, has, on occasion, loaned the sculpture to the National Gallery for display.

In much the same way, with a modicum of good faith on both sides, the Mohenjodaro and Taxila beads and terminals can be reunited. Although this would not change the principles on which the pasts of India and Pakistan were partitioned, it would certainly restore some integrity to those objects and collections. In the process, such an arrangement would also underline that these form part of the common heritage of both nation-states. The question remains, however, whether ethics and an apolitical historical consciousness will be able to overcome political rifts to reunite a fractured heritage.

References

Adler, A. 2009. 'Against Moral Rights'. *California Law Review* 97: 263.

Agbe-Davies, A. S. 2010. 'Social Aspects of the Tobacco Pipe Trade in Early Colonial Virginia'. In A. A. Bauer and A. S. Agbe-Davies (eds.), *Social Archaeologies of Trade and Exchange*, 69–98. Walnut Creek, CA: Left Coast Press.

Aldenderfer, M. 2011. 'Envisioning a Pragmatic Approach to the Study of Religion'. In Y. Rowan (ed.), *Beyond Belief: The Archaeology of Religion and Ritual*. Arlington, VA: American Anthropological Association.

Aldred, L. 2000. 'Plastic Shamans and Astroturf Sun Dances: New Age Commercialization of Native American Spirituality'. *American Indian Quarterly* 24(3): 329–52.

Algie, J. 2006. 'The Peaks and Pitfalls of Eco-Tourism in Thailand'. *Things Asian*. http://www.thingsasian.com/stories-photos/20251.

Ali, I., and Coningham, R. A. E. 2001. 'Recording and Preserving Gandhara's Cultural Heritage'. In N. Brodie, J. Doole, and A. C. Renfrew (eds.), *Trade in Illicit Antiquities and the Destruction of the World's Archaeological Heritage*, 25–33. Cambridge, UK: McDonald Institute for Archaeological Research.

Allen, C. 2008. *The Buddha and Dr Führer: An Archaeological Scandal*. London: Haus Publishing.

Altrock, U., Bertram, G., Horni, H., and Asendorf, O. 2010. 'Positionen zum Wiederaufbau verlorener Bauten und Räume'. *Forschungen*, vol. 143, Bundesministerium für Verkehr, Bau und Stadtentwicklung. Bonn, Germany: Bundesamt für Bauwesen und Raumforschung.

Anderson, D., Pearson, M., Fisher, A., and Zieglowsky, D. 1980. *Planning Seminar on Ancient Burial Grounds*. Iowa City, IA: Office of the State Archaeologist.

Anderson, J. 2005. 'The Making of Indigenous Knowledge in Intellectual Property Law in Australia'. *International Journal of Cultural Property* 12: 347–373.

Anscombe, E. 2000. *Intention*. Cambridge, MA: Harvard University Press.

Aoki, K., Boyle, J., and Jenkins, J. 2008. *Bound by Law: Tales from the Public Domain*. http://www.law.duke.edu/cspd/comics/.

Appiah, K. A. 2006a. 'The Case for Contamination'. *New York Times Magazine*, January 1. http://www.nytimes.com/2006/01/01/magazine/01cosmopolitan.html.

Appiah, K. A. 2006b. *Cosmopolitanism: Ethics in a World of Strangers*. New York: W.W. Norton.

Appleby, J., Covington, E., Hoyt, D., Latham, M., and Sneider A. 1996. 'The Scientific Revolution and Enlightenment Thought: Introduction'. In J. Appleby, E. Covington, D. Hoyt, M. Latham, and A. Sneider (eds.), *Knowledge and Postmodernism in Historical Perspective*, 23–28. London: Routledge.

Archuleta, E. 2008. 'Gym Shoes, Maps, and Passports, Oh My! Creating Community or Creating Chaos at the National Museum of the American Indian?' In A. Lonetree and A. J. Cobb (eds.), *The National Museum of the American Indian: Critical Conversations*, 181–207. Lincoln: University of Nebraska Press.

Arlow, R., and Adam, W. 2009. 'Re St Peter Draycott'. *Ecclesiastical Law Journal* 11: 365–6.

Ashley, S. 2005. 'State Authority and the Public Sphere: Ideas on the Changing Role of the Museum as a Canadian Social Institution'. *Museum and Society* 3(1): 5–17.

Aston, M. 1973. 'English Ruins and English Antiquity: The Dissolution and the Sense of the Past'. *Journal of the Warburg and Courtauld Institute* 36: 231–55.

Atalay, S. 2006. 'Indigenous Archaeology as Decolonizing Practice'. *American Indian Quarterly* 30(3): 280–310.

Atalay, S. 2008. 'No Sense of the Struggle: Creating a Context for Survivance at the National Museum of the American Indian'. In A. Lonetree and A. J. Cobb (eds.), *The National Museum of the American Indian: Critical Conversations*, 267–89. Lincoln: University of Nebraska Press.

Atalay, S. 2010. '"We don't talk about Catalhoyuk, we live it": Sustainable Archaeological Practice through Community-Based Participatory Research'. *World Archaeology* 42(3): 418–29.

Atalay, S. In press. *Community-Based Archaeology: Research with, by and for Indigenous and Local Communities*. Los Angeles: University of California Press.

Atalay, S., Ziibiwing, S. M., and Johnson, W. 2008. *Education, Protection and Management of Ezhibiigaadek Asin (Sanilac Petroglyph Site)*. IPinCH case-study proposal, Simon Fraser University, Burnaby, BC, Canada.

Bakhtin, M. M. 1981. *The Dialogic Imagination: Four Essays*. Austin: University of Texas Press.

Bakhtin, M. M. 1984. *Problems of Dostoevsky's Poetics*. Minneapolis: University of Minnesota Press.

Bandaranayake, S. 1974. Sinhalese Monastic Architecture. Leiden: E.J. Brill.

Bannister, K. 2000. 'Chemistry Rooted in Cultural Knowledge: Unearthing the Links between Antimicrobial Properties and Traditional Knowledge in Food and Medicinal Plant Resources of the Secwepemc (Shuswap) Aboriginal Nation'. PhD diss., Department of Botany, University of British Columbia.

Bannister, K., and Barrett, K. 2006. 'Harm and Alternatives: Cultures under Siege'. In N. Myers and C. Raffensperger (eds.), *Precautionary Tools for Reshaping Environmental Policy*, 215–39. Cambridge, MA: MIT Press.

Barkan, E. 2002. 'Amending Historical Injustices: The Restitution of Cultural Property – An Overview.' In E. Barkan and R. Bush (eds.), *Claiming the Stones,*

Naming the Bones: Cultural Property and the Negotiation of National Ethnic Identity, 16–46. Los Angeles: Getty Publications.

Barkan, E., and Bush, R. (eds.). 2002. *Claiming the Stones, Naming the Bones: Cultural Property and the Negotiation of National and Ethnic Identity*. Los Angeles: Getty Publications.

Barros, D. B. 2008–9. 'Legal Questions for the Psychology of Home'. *Tulane Law Review* 83: 645–60.

Barthes, R. 1975. *S/Z*. London: Jonathan Cape.

Bauer, A. A. 2002. 'Is What You See All You Get? Recognizing Meaning in Archaeology'. *Journal of Social Archaeology* 2: 37–52.

Bauer, A. A., and Preucel, R. W. 2000. 'The Meaning of Meaning: A Semiotic Approach to Archaeological Interpretation'. Paper presented at the annual meeting of the European Association of Archaeologists, Lisbon.

Beal, S. 1869. *Travels of Fah-Hian and Sung-Yun*. London: Trubner & Co.

Beattie, O., Apland, B., Blake, E. W., Cosgrove, J. A. Gaunt, S., Greer, S., Mackie, A. P., Mackie, K. E., Straathof, D., Thorp, V., and Troffe, P. M. 2000. 'The Kwäday Dän Ts'ìnchi Discovery from a Glacier in British Columbia'. *Canadian Journal of Archaeology* 24: 129–47.

Behrendt, K. A. 2004. *The Buddhist Architecture of Gandhara*. Leiden, the Netherlands: Brill.

Bell, C., and Napoleon, V. (eds.). 2008. *First Nations Cultural Heritage and Law: Case Studies, Voices and Perspectives*. Vancouver: University of British Columbia Press.

Bell, C., and Paterson, R. K. (eds.). 2009. *Protection of First Nations Cultural Heritage: Laws, Policy, and Reform*. Vancouver: University of British Columbia Press.

Bell, D. 1998. *Ngarrindjeri Wurruwarrin: A World That Is, Was, and Will Be*. North Melbourne, Australia: Spinafex.

Bender, B. 1998. *Stonehenge: Making Space*. Oxford, UK: Berg.

Bendremer, J. C., and Richman, K. A. 2006. 'Human Subjects Review and Archaeology: A View from Indian Country'. In C. Scarre and G. Scarre (eds.), *The Ethics of Archaeology: Philosophical Perspectives on Archaeological Practice*, 97–114. Cambridge, UK: Cambridge University Press.

Benhabib, S. 2002. *The Claims of Culture: Equality and Diversity in the Global Era*. Princeton, NJ: Princeton University Press.

Bennett, T. 1995. *The Birth of the Museum: History, Theory, Politics*. London: Routledge.

Bennett, T. 2004. *Pasts beyond Memory: Evolution, Museums, Colonialism*. London: Routledge.

Bergson, H. 1960. *Time and Free Will: An Essay on the Immediate Data of Consciousness*, trans. F. L. Pogson. New York: Harper and Row. (Originally published 1889.)

Bernstein, R. J. 1985. 'Introduction'. In R. J. Bernstein (ed.), *Habermas and Modernity*, pp. 1–32. Cambridge, MA: MIT Press.

Bickel A. M. 1962. *The Least Dangerous Branch: The Supreme Court at the Bar of Politics*. Indianapolis, IN: Bobbs-Merrill.

Bielawski, E. 1994. 'Dual Perceptions of the Past: Archaeology and Inuit Culture'. In R. Layton (ed.), *Conflict in the Archaeology of Living Traditions*, 228–36. London: Routledge.

Bienkowski, P. 2007. 'Authority over Human Remains: Genealogy, Relationship, Attachment'. *Archaeological Review from Cambridge* 22(2): 113–30.

Bienkowski, P. 2012. 'Archaeological Knowledge, Animist Knowledge, and Appropriation of the Ancient Dead'. In. I. Robertson (ed.), *Heritage from Below*, 29–58. Farnham, UK: Ashgate.

Binford, L. R. 1981. *Bones: Ancient Men and Modern Myths*. New York: Academic Press.

Bird-David, N. 1999. '"Animism" Revisited: Personhood, Environment, and Relational Epistemology'. *Current Anthropology* 40: S67–S91.

Bourdieu, P., and Darbel, A. 1991. *The Love of Art: European Art Museums and Their Public*, trans. C. Beattie and N. Merriman. Cambridge, UK: Polity Press.

Bowie, F., 2006. 'The Anthropology of Religion'. In R. A. Segal (ed.) *Blackwell Companion to the Study of Religion*. Malden, MA: Blackwell Publishing.

Bowie, F. 2009. 'Anthropology of Religion'. In R. A. Segal (ed.), *The Blackwell Companion to the Study of Religion*, 3–24. Oxford, UK: Wiley-Blackwell.

Boyle, J. 1996. *Shamans, Software and Spleens: Law and the Construction of the Information Society*. Cambridge, MA: Harvard University Press.

Brady, E. 2003. *Aesthetics of the Natural Environment*. Edinburgh, UK: Edinburgh University Press.

Bray, T. L. (ed.). 2001. *The Future of the Past: Archaeologists, Native Americans and Repatriation*. New York: Garland Publishing.

Bray, T. L., and Killion, T. W. (eds.). 1994. *Reckoning with the Dead: The Larsen Bay Repatriation and the Smithsonian Institution*. Washington, DC: Smithsonian Institution Press.

Brent, J. 1998. *Charles Sanders Peirce: A Life*. Bloomington: Indiana University Press.

British Museum. 'The Druids'. http://www.britishmuseum.org/explore/highlights/article_index/d/the_druids.aspx.

Broadbent, G. 1980. 'Building Design as an Iconic Sign System'. In G. Broadbent, R. Bunt, and C. Jencks (eds.), *Signs, Symbols and Architecture*, 311–31. Chichester, UK: John Wiley and Sons.

Broadbent, G. 1994. 'Recent Developments in Architectural Semiotics'. *Semiotica* 101: 73–101.

Brown, D., and Nicholas, G. 2010. 'Protecting Canadian First Nations and Maori Heritage through Conventional Legal Means'. http://www.sfu.ca/ipinch/sites/default/files/project_papers/presentations/Brown-Nicholas_Canada_NZ_presentation_paper_Feb_2010.pdf.

Brown, M. 2004. *Who Owns Native Culture?* Cambridge, MA: Harvard University Press.

Brown, M. F. 2005. 'Heritage Trouble: Recent Work on the Protection of Intangible Cultural Heritage'. *International Journal of Cultural Property* 12: 40–61.

Brown, P. 2011. Us and Them: Who Benefits From Experimental Exhibition Making? *Museum Management and Curatorship* 26/2: 129–48.

Browne, A., and Valentin, P. 2005. 'The Art Market in the United Kingdom and Recent Developments in British Cultural Policy'. In K. Fitz Gibbon (ed.), *Who Owns the Past?*, 97–107. New Brunswick, NJ: Rutgers University Press.

Browning, R. 2008. 'The Parthenon in History'. In C. Hitchens (ed.), *The Parthenon Marbles: The Case for Reunification*, 1–16. London: Verso.

Bsumek, E. M. 2008. *Indian-Made: Navajo Culture in the Marketplace, 1868–1940*. Lawrence: University Press of Kansas.

Burke, H., Smith, C., Lippert, D., Watkins, J., and Zimmerman, L. (eds.). 2008. *The Ancient One: Perspectives on Kennewick Man*. Walnut Creek, CA: Left Coast Press.

Burström, M., Elfström, B., and Johansen, B. 2004. 'Serving the Public: Ethics in Heritage Management'. In H. Karlsson (ed.), *Swedish Archaeologists on Ethics*, 135–47. Lindome, Sweden: Bricoleur Press.

Bush, R., and Barkan, E. (eds.). 2002. *Claiming the Stones, Naming the Bones: Cultural Property and the Negotiation of National and Ethnic Identity*. Los Angeles: Getty Publications.

Butler, R. W. 1990. 'Alternative Tourism: Pious Hope or Trojan Horse?' *Journal of Travel Research* 28: 40–5.

Butler, S. R. 1999. *Contested Representations: Revisiting into the Heart of Africa*. Amsterdam: Overseas Publishers Association.

Byrne, D. 1995. Buddhist Stupa and Thai Social Practice. *World Archaeology* 27(2): 266–81.

Byrne, D. 2007. *Surface Collection: Archaeological Travels in Southeast Asia*. Plymouth, UK: AltaMira Press.

Byrne, D. 2009. 'Archaeology and the Fortress of Rationality'. In L. Meskell (ed.), *Cosmopolitan Archaeologies*, 68–88. Durham, NC: Duke University Press.

Canadian Broadcasting Corporation. 2010. 'Olympic Inukshuks Net Proceeds for Nunavut Cavers'. CBC News – North, 29 January 2010. http://www.cbc.ca/news/canada/north/story/2010/01/28/north-oly-inukshuks.html.

Carpenter K. A., Katyal, S. K., and Riley, A. R. 2009. 'In Defense of Property'. *Yale Law Journal* 118: 1022–1125.

Carson, C. 1995. 'Mirror, Mirror, on the Wall, Whose History Is the Fairest of Them All?' *Public Historian* 71(4): 61–7.

Center for the Study of the First Americans. 2009. 'History of the Center'. http://www.centerfirstamericans.com/about.php.

Charlesworth, M. 2005. 'Aboriginal Religions: New Readings'. *Sophia* 44(2): 1–5.

Chavez Lamar, C. 2008. 'Collaborative Exhibit Development at the Smithsonian's National Museum of the American Indian'. In A. Lonetree and A. J. Cobb (eds.), *The National Museum of the American Indian: Critical Conversations*, 144–64. Lincoln: University of Nebraska Press.

Childs, S. T. 1995. 'The Curation Crisis: What's Being Done?' *Federal Archeology* 7(4): 11–15.

Childs, S. T. (ed.). 2004. *Our Collective Responsibility: The Ethics and Practice of Archaeological Collections Stewardship*. Washington, DC: Society for American Archaeology.

Choay, F. 2001. *The Invention of the Historic Monument*, trans. L. M. O'Connell. Cambridge, UK: Cambridge University Press.

Chok, S., Macbeth, J., and Warren, C. 2007. 'Tourism as a Tool for Poverty Alleviation: A Critical Analysis of "Pro-Poor Tourism" and Implications for Sustainability'. In C. Hall and C. Michael (eds.), *Pro-Poor Tourism: Who Benefits? Perspectives on Tourism and Poverty Reduction*, 34–55. Clevedon, UK: Channel View Publications.

Cipolla, C. N. 2008. 'Signs of Identity, Signs of Memory'. *Archaeological Dialogues* 15: 196–215.

Churchill, W. 1998. *Fantasies of the Master Race: Literature, Cinema and the Colonization of the American Indian*. San Francisco, CA: City Lights Books.

Clark, G. A. 1996. 'NAGPRA and the Demon-Haunted World'. *Society for American Archaeology Bulletin* 14(5): 3.

Clarke, A. 2002. 'The Ideal and the Real: Cultural Transformations of Archaeological Research on Groote Eylandt, Northern Australia'. *World Archaeology* 34(2): 249–64.

Cleere, H. (ed.). 1984. *Approaches to the Archaeological Heritage*. Cambridge, UK: Cambridge University Press.

Clifford, J. 1997a. 'Museums as Contact Zones'. In J. Clifford (ed.), *Routes: Travel and Translation in the Late Twentieth Century*, 186–219. Cambridge, MA: Harvard University Press.

Clifford, J. 1997b. *Routes: Travel and Translation in the Late Twentieth Century*. Cambridge, MA: Harvard University Press.

Cobb, A. J. 2008. 'The National Museum of the American Indian as Cultural Sovereignty'. In A. Lonetree and A. J. Cobb (eds.), *The National Museum of the American Indian: Critical Conversations*, 331–52. Lincoln: University of Nebraska Press.

Cobb, L. 2009. 'Study of Vandalism Survival Times', *Wikipedia Signpost*, 22 June 2009. http://en.wikipedia.org/wiki/Wikipedia:Wikipedia_Signpost/2009–06–22/Vandalism (accessed 3 July 2010).

Colani, M. 1935. *Mégalithes du Haut-Laos (Hua Pan, Tran Ninh) I–II*, vols. 25–26. Paris: Publications de l'École Française d'Extrême-Orient.

Cole, D. 1985. *Captured Heritage: The Scramble for Northwest Coast Artifacts*. Vancouver, BC: Douglas & McIntyre.

Cole, D., and Chaikin, I. 1990. *An Iron Hand upon the People: The Law against the Potlatch on the Northwest Coast*. Vancouver, BC: Douglas & McIntyre.

Coleman, E. 2005. *Aboriginal Art, Identity and Appropriation.* Aldershot, UK: Ashgate.

Coleman E. B. 2008. 'The Disneyland of Cultural Rights to Intellectual Property: Anthropological and Philosophical Perspectives'. In C. Beat Graber and M. Burri-Nenova (eds.), *Intellectual Property and Traditional Cultural Expression in a Digital Environment,* 49–72. Cheltenham, UK: Edward Elgar.

Coleman E. B. 2010. 'Repatriation and Inalienable Property'. In H. Morphy and M. Pickering (eds.), *The Meanings and Values of Repatriation,* 82–95. Oxford and New York: Berghahns Publishing.

Coleman E. B., and Coombe, R. J. 2009. 'Broken Records: Subjecting "Music" to Cultural Right'. In C. Brunk and J. O. Young (eds.), *The Ethics of Cultural Appropriation,* 173–210. Malden, MA: Wiley-Blackwell.

Colls, Robert. 2002. *Identity of England.* Oxford: Oxford University Press.

Colombo Times. 2010. http://www.thecolombotimes.com/political-news/9210 viewed 05/09/2010.

Colwell-Chanthaphonh, C. 2009. *Inheriting the Past: The Making of Arthur C. Parker and Indigenous Archaeology.* Tucson: University of Arizona Press.

Colwell-Chanthaphonh, C. 2010. 'The Archaeologist as a World Citizen: On the Morals of Heritage Preservation'. In Lynn Meskell (ed.), *Cosmopolitan Archaeologies,* 140–65. Durham, NC: Duke University Press.

Colwell-Chanthaphonh, C., and Ferguson, T. J. 2004. 'Virtue Ethics and the Practice of History: Native Americans and Archaeologists along the San Pedro Valley of Arizona'. *Journal of Social Archaeology* 4: 5–27.

Colwell-Chanthaphonh, C., and Ferguson T. J. 2006. 'Trust and Archaeological Practice: Towards a Framework of Virtue Ethics'. In C. Scarre and G. Scarre (eds.), *The Ethics of Archaeology: Philosophical Perspectives on Archaeological Practice,* 115–30. Cambridge, UK: Cambridge University Press.

Colwell-Chanthaphonh, C., and Ferguson, T. J. 2008. 'Introduction' *Collaboration in Archaeological Practice: Engaging Descendant Communities,* in Chip Colwell-Chanthaphonh and T. J. Ferguson (eds.), 1–32. Lanham, MD: Altamira Press.

Colwell-Chanthaphonh, C., Ferguson, T. J., Lippert, D., McGuire, R. H., Nicholas, G. P., Watkins, J. E., and Zimmerman, L. J. 2010. 'The Premise and Promise of Indigenous Archaeology'. *American Antiquity* 75(2): 228–38.

Comaroff, J. L., and Comaroff, J. 2009. *Ethnicity, Inc.* Chicago: University of Chicago Press.

Coningham, R. A. E. 1999. *Anuradhapura: The British–Sri Lankan Excavations at Anuradhapura Salgaha Watta.* Vol. 1, *The Site.* Oxford, UK: Archaeopress for the Society for South Asian Studies (British Academy).

Coningham, R. A. E. 2001. 'The Archaeology of Buddhism'. In T. Insoll (ed.), *Archaeology and World Religion,* 61–95. London: Routledge.

Coningham, R. A. E. 2006. *Anuradhapura: The British–Sri Lankan Excavations at Anuradhapura Salgaha Watta.* Vol. 2, *The Artefacts.* Oxford, UK: Archaeopress for the Society for South Asian Studies (British Academy).

Coningham, R. A. E. 2010. 'The Archaeology of Buddhism'. In T. Insoll (ed.), *The Oxford Handbook of the Archaeology of Ritual and Religion*, 932–45. Oxford: Oxford University Press.

Coningham, R., Cooper, R., and Pollard, M. 2006. 'What Value a Unicorn's Horn? A Study of Archaeological Uniqueness and Value'. In C. Scarre and G. Scarre (eds.), *The Ethics of Archaeology: Philosophical Perspectives on Archaeological Practice*, 260–72. Cambridge, UK: Cambridge University Press.

Coningham, R. A. E., Gunawardhana, P., Adikhari, G., Katugampola, M., Simpson, I., and Young, R. 2006. 'The Anuradhapura (Sri Lanka) Project: The Hinterland (Phase II), Preliminary Report of the First Season 2005'. *South Asian Studies* 22: 53–64.

Coningham, R. A. E., Gunawardhana, P., Manuel, M. J., Adikari, G., Katugampola, M., Young, R. L., Schmidt, A., Krishnan, K., Simpson, I., McDonnell, G., and Batt, C. 2007. 'The State of Theocracy: Defining an Early Medieval Hinterland in Sri Lanka'. *Antiquity* 81: 699–719.

Coningham, R. A. E., and Manuel, M. J. 2009. 'The Early Empires of South Asia: 323 BC–500 AD'. In T. Harrison (ed.), *The World's Greatest Empires*, 42–63. London: Thames & Hudson.

Cooper, D. E. 2010. 'Edification and the Experience of Beauty'. *International Association of Aesthetics Yearbook* 4: 61–80.

Cooper, N. 2001. *France in Indochina: Colonial Encounters*. Oxford, UK: Berg.

Corum, T. 2009. 'Giving Up Control – How Banksy Helped Us Let Go'. *Museums Journal* (October): 17.

Cove, J. J. 1995. *What the Bones Say: Tasmanian Aborigines, Science, and Domination*. Ottawa: Carleton University Press.

Crawford, D. 1983. 'Nature and Art: Some Dialectical Relationships'. *Journal of Aesthetics and Art Criticism* 42(1): 49–58.

Crossland, Z. 2009. 'Of Clues and Signs: The Dead Body and Its Evidential Traces'. *American Anthropologist* 111: 69–80.

Crouch, D., and McCabe, S. 2003. 'Culture, Consumption and Ecotourism Policies'. In D. A. Fennell and R. Dowling (eds.), *Ecotourism Policy and Planning*, 77–98. Cambridge, MA: CABI Publishing.

Cunningham, A. 1854. *The Bhilsa Topes or Buddhist Monuments of Central India*. London: Smith & Elder.

Cuno, J. 2008. *Who Owns Antiquity?* Princeton, NJ: Princeton University Press.

Cutright-Smith, E., Murray W. F., and Hollenback K. 2010. 'Twenty Years Later: A Quantitative Assessment of NAGPRA's Impacts on American Archaeology'. Paper presented at the seventy-fifth annual meeting of the Society for American Archaeology, 'NAGPRA in 20/20 Vision: Reviewing 20 Years of Repatriation and Looking Ahead to the Next 20', St. Louis, MO.

Cybulski, J. 2001. 'Current Challenges to Traditional Anthropological Applications of Human Osteology in Canada'. https://tspace.library.utoronto.ca/citd/Osteology/cybulski.html.

Daily Star. 2007. http://www.buddhistchannel.tv.

Dalton, R. 2010. 'Audit Picks a Bone with US Relics Office: Congressional Watchdog Unearths Shortcomings at Agency in Charge of Repatriating Ancient Tribal Remains'. *Nature* 466: 422. http://www.nature.com/news/2010/100721/full/466422a.html#comments.

Darvill, T. 1995. 'Value Systems in Archaeology'. In M. A. Cooper, A. Firth, J. Carman, and D. Wheatley (eds.), *Ethics and Values in Archaeology*, 13–21. New York: Free Press.

Darvill, T. 2004. 'Public Archaeology: A European Perspective'. In J. Bintliff (ed.), *A Companion to Archaeology*, 409–34. Oxford, UK: Blackwell.

Davie, G. 2009. 'Sociology of Religion'. In R. A. Segal (ed.), *The Blackwell Companion to the Study of Religion*, 171–92. Oxford, UK: Wiley-Blackwell.

Davies, M. 2008. 'Pluralism in Law and Religion'. In P. Cane, C. Evans, and Z. Robinson (eds.), *Law and Religion in Theoretical and Historical Context*, 186–213. Cambridge, UK: Cambridge University Press.

Davis, J. L., Heginbottom, J. A., Annan, A. P., Daniels, R. S., Berdal, B. P., Bergan, T., Duncan, K. E., Lewin, P. K., Oxford, J. S., Roberts, N., Skehel, J. J., and Smith, C. R. 2000. 'Ground Penetrating Radar Surveys to Locate 1918 Spanish Flu Victims in Permafrost'. *Journal of Forensic Science* 45: 68–76.

Deakin, R. 2008. *Wildwood: A Journey through Trees*. London: Penguin.

Deakin, R. 2009. *Walnut Tree Farm*. London: Penguin.

Deckers, M. 2000. *The Way of All Flesh: A Celebration of Decay*, trans. S. Marx-Macdonald. London: Harvill.

Delgado, R., and Stefancic, J. 2001. *Critical Race Theory: An Introduction*. New York: New York University Press.

Deloria, P. J. 1998. *Playing Indian*. New Haven, CT: Yale University Press.

Deloria, V. 1973. *God is Red*. New York: Grosset and Dunlap.

Deloria, V. 1995. *Red Earth, White Lies: Native Americans and the Myth of Scientific Fact*. New York: Scribner.

Denzin, N. K., Lincoln, Y. S., and Tuhawi Smith, L. (eds.). 2008. *Handbook of Critical and Indigenous Methodologies*. Thousand Oaks, CA: Sage.

Department of Culture, Media, and Sport. 2005. *Guidance for the Care of Human Remains in Museums*. London: Department of Culture, Media, and Sport.

Department of Interior. 2010. '43 CFR Part 10: Native American Graves Protection and Repatriation Act Regulations–Disposition of Culturally Unidentifiable Human Remains; Final Rule'. http://edocket.access.gpo.gov/2010/2010–5283.htm.

Dexter, M. R., and Mair, V. H. 2010. *Sacred Display: Divine and Magical Female Figures of Eurasia*. Amherst, NY: Cambria Press.

Dingli, S. 2006. 'A Plea for the Responsibility towards the Common Heritage of Mankind'. In C. Scarre and G. Scarre (eds.), *The Ethics of Archaeology: Philosophical Perspectives on Archaeological Practice*, 219–41. Cambridge, UK: Cambridge University Press.

Downs, J. F. 1971. *Cultures in Crisis*. Beverly Hills, CA: Glencoe Press.

Driver, J. 2007. *Ethics: The Fundamentals*. Oxford, UK: Blackwell Publishing.

Dryzek, J. 1990. *Discursive Democracy: Politics, Policy, and Political Science*. Cambridge, UK: Cambridge University Press.

Dryzek, J. 2000. *Deliberative Democracy and Beyond: Liberals, Critics, Contestations.* Oxford, UK: Oxford University Press.

Duffy, R. 2002. *A Trip Too Far: Ecotourism, Politics and Exploitation.* London: Earthscan.

Duin, J. 2003. 'Tribes Veto Southwest Mural'. *Washington Times*, 18 February 2003. http://www.nathpo.org/News/NAGPRA/News-NAGPRA29.htm (accessed 16 May 2010).

Dummett, M. 1973. *Truth and Other Enigmas.* Cambridge, MA: Harvard University Press.

Dummett, M. 1977. *Elements of Intuitionism.* Oxford, UK: Clarendon Press.

Dummett, M. 1991. *The Logical Basis of Metaphysics.* Cambridge, MA: Harvard University Press.

Dussias, A. M. 2005–6. 'Kennewick Man, Kinship, and the "Dying Race": The Ninth Circuit's Assimilationist Assault on the Native American Graves Protection and Repatriation Act'. *Nebraska Law Review* 84: 55–161.

Easlea, B. 1980. *Witch Hunting, Magic and the New Philosophy: An Introduction to Debates of the Scientific Revolution, 1450–1750.* Sussex, UK: Harvester Press and Humanities Press.

Eaton, A., and Gaskell, I. 2009. 'Do Subaltern Artifacts Belong in Art Museums?' In J. O. Young and C. Brunk (eds.), *The Ethics of Cultural Appropriation*, 235–67. Malden, MA: Wiley-Blackwell.

Eco, E. 1980. 'Function and Sign: The Semiotics of Architecture'. In G. Broadbent, R. Bunt, and C. Jencks (eds.), *Signs, Symbols and Architecture*, 11–69. Chichester, UK: John Wiley and Sons.

Edwards, E., Gosden, C., and Phillips, R. B. (eds.). 2006. *Sensible Objects: Colonialism, Museums and Material Culture.* Oxford, UK: Berg.

Ellis, G. 2004. 'Ellis Acceptance of the Templeton Prize, March 17, 2004'. *Global Spiral.* http://www.metanexus.net/magazine/tabid/68/id/8765/Default.aspx.

Engelberg-Dočkal, E. von. 2007. 'Rekonstruktion als Architektur der Gegenwart? Historisierendes Bauen im Kontext der Denkmalpflege'. March 2007. http://edoc.hu-berlin.de/kunsttexte/2007–3/engelberg-dockal-eva-von-8/PDF/engelberg-dockal.pdf.

English, P. 2002. 'Disputing Stonehenge: Law and Access to a National Symbol'. *Entertainment Law* 1(2): 1–22.

English Heritage. 2008. *Conservation Principles: Policies and Guidance for the Sustainable Management of the Historic Environment.* http://www.english-heritage.org.uk/professional/advice/conservation-principles.

Erikson, P. P. 2008. 'Decolonizing the "Nation's Attic": The National Museum of the American Indian and the Politics of Knowledge-Making in a National Space'. In A. Lonetree and A. J. Cobb (eds.), *The National Museum of the American Indian: Critical Conversations*, 43–83. Lincoln: University of Nebraska Press.

European Council. 1992. *Council Regulation (EEC) No 3911/92 of 9 December 1992 on the Export of Cultural Goods.* http://eur-lex.europa.eu/LexUriServ/LexUriServ.do?uri=CELEX:31992R3911:EN:HTML.

Fabian, J. 1983. *Time and the Other: How Anthropology Makes Its Object.* New York: Columbia University Press.

Feinberg, J. 1988. *The Moral Limits of the Criminal Law.* Vol. 2, *Offense to Others.* New York: Oxford University Press.

Feldman, F., and Weil, S. E. 1986. *Art Law.* Boston: Little, Brown.

Ferré, F. 1970. 'The Definition of Religion'. *Journal of the American Academy of Religion* 38(1): 3–16.

Feyerabend, P. 1977. 'Rationalism, Relativism, and Scientific Method'. *Philosophy in Context,* suppl., 6(1): 7–19.

Feyerabend, P. 1978. *Science in a Free Society.* London: New Left Books.

Feyerabend, P. 1987. *Farewell to Reason.* London: Verso.

Fforde, C. 2004. *Collecting the Dead: Archaeology and the Reburial Issue.* London: Duckworth.

Fforde, C., Hubert, J., and Turnbull, P. 2002. *The Dead and Their Possessions: Repatriation in Principle, Policy and Practice.* London: Routledge.

Fisch, M.H. 1978. 'Peirce's General Theory of Signs'. In T. Sebeok (ed.), *Sight, Sound, and Sense,* 31–70. Bloomington, IN: Indiana University Press.

Fisher, A., and Ramsay, Hayden. 2000. 'Of Art and Blasphemy'. *Ethical Theory and Moral Practice* 3(2): 137–67.

Fitzgerald, M. O. 1991. *Yellowtail: Crow Medicine Man and Sun Dance Chief.* Norman, Oklahoma: University of Oklahoma Press.

Fitz Gibbon, K. (ed.) 2005. *Who Owns the Past?* New Brunswick, NJ: Rutgers University Press.

Fojut, N. 2009. 'The Philosophical, Political and Pragmatic Roots of the Convention'. In *Heritage and Beyond,* 13–21. Strasbourg: Council of Europe. http://www.coe.int/t/dg4/cultureheritage/heritage/identities/PatrimoineBD_en.pdf.

Foucault, M. 1970. *The Order of Things: An Archaeology of the Human Sciences.* London: Routledge Classics. (Originally published as *Les mots et les choses,* 1966.)

Foucault, M. 1995. *Discipline and Punish: The Birth of the Prison,* trans. A. Sheridan. New York: Vintage Books. (Originally published 1977.)

Fogelin, L. 2007. 'Inference to the Best Explanation: A Common and Effective Form of Archaeological Reasoning'. *American Antiquity* 72: 603–25.

Francaviglia, R. 1995. 'History after Disney: The Significance of "Imagineered" Historical Places'. *Public Historian* 17(4): 69–74.

Fricker, M. 2007. *Epistemic Injustice: Power and the Ethics of Knowing.* New York: Oxford University Press.

Fung, A. 2006. *Empowered Participation: Reinventing Urban Democracy.* Princeton, NJ: Princeton University Press.

Fung, A., and Wright, E. O. 2003. *Deepening Democracy: Institutional Innovations in Empowered Participatory Governance.* London: Verso.

Gabriel, Mille. 2010. 'Objects on the Move: The Role of Repatriation in Postcolonial Imageries'. PhD diss., Department of Anthropology, University of Copenhagen.

Gamboni, D. 1997. *The Destruction of Art: Iconoclasm and Vandalism since the French Revolution.* London: Reaktion Books.

Gardin, J.-C. 1980. *Archaeological Constructs*. Cambridge, UK: Cambridge University Press.

Galtung, J. 1967. 'Scientific Colonialism'. *Transition* 30: 10–15.

Gaylor, B. (writer and dir.). 2009. *Rip! A Remixer's Manifesto* (86 mins.). New York: Eyesteelfilm and National Film Board of Canada, Disinformation. http://www.nfb.ca/film/rip_a_remix_manifesto/.

Gaze, John. 1998. Figures in a Landscape: A History of the National Trust. London: Barrie and Jenkins.

Gendron, D., Partridge, T., and Palliser, N. 2010. *Cultural Tourism in Nunavut*. IPinCH case-study proposal, Simon Fraser University, Burnaby, BC, Canada.

Gerstenblith, P. 1995. 'Identity and Cultural Property: The Protection of Cultural Property in the United States'. *Boston University Law Review* 75: 559–688.

Gerstenblith, P. 2002. 'Cultural Significance and the Kennewick Skeleton: Some Thoughts on the Resolution of Cultural Heritage Disputes'. In E. Barkan and R. Bush (eds.), *Claiming the Stones, Naming the Bones: Cultural Property and the Negotiation of National and Ethnic Identity*, 162–97. Los Angeles: Getty Publications.

Gerstenblith, P. 2003. 'The McClain/Schultz Doctrine: Another Step against Trade in Stolen Antiquities'. *Culture without Context* 13. http://www.mcdonald.cam. ac.uk/projects/iarc/culturewithoutcontext/issue%2013/gerstenblith.htm.

Giles, J. 2005. 'Internet Encyclopaedias Go Head to Head'. *Nature* 438: 900–1.

Gimbutas, M. 2001. *The Living Goddesses*. Berkeley: University of California Press.

Glatz, J. 2008. 'Die Rekonstruktion der Rekonstruktion. Fallbeispiel Mainzer Markt'. *Die Denkmalpflege* 1: 28–33.

Goldberg S. 2006. 'Kennewick Man and the Meaning of Life'. *University of Chicago Legal Forum* (2006): 275–87.

Gottdeiner, M. 1995. *Postmodern Semiotics: Material Culture and the Forms of Postmodern Life*. Oxford, UK: Blackwell.

Graber, C. B. 2009. 'Aboriginal Self-Determination vs. the Propertisation of Traditional Culture: The Case of Sacred Wanjina Sites'. *Australian Indigenous Law Review* 13(2): 18–34.

Greenfield, J. 1989. *The Return of Cultural Treasures*. Cambridge, UK: Cambridge University Press.

Greenfield, J. 1996. *The Return of Cultural Treasures*, 2nd ed. Cambridge, UK: Cambridge University Press.

Gregg, J. B., and Zimmerman, L. J. 1986. 'Malnutrition in 14th Century South Dakota: Osteopathological Manifestations'. *North American Archaeologist* 7(3): 191–214.

Gray, K., and Gray, S. F., 1999. 'Civil Rights, Civil Wrongs and Quasi-Public Space'. *European Human Rights Law Review* 1: 46–102.

Gray, K., and Gray, S. F. 1999. 'Private Property and Public Propriety'. In J. McLean (ed.), *Property and the Constitution*, 11–39. Oxford, UK: Hart Publishing.

Grinsell, L. V. 1976. 'The Legendary History and Folklore of Stonehenge'. *Folklore* 87(1): 5–20.

Groarke, L., and Warrick, G. 2006. 'Stewardship Gone Astray: Ethics and the SAA'. In C. Scarre and G. Scarre (eds.), *The Ethics of Archaeology: Philosophical Perspectives on Archaeological Practice*, 163–77. Cambridge, UK: Cambridge University Press.

Guerlac, S. 2006. *Thinking in Time: An Introduction to Henri Bergson*. Ithaca, NY: Cornell University Press.

Guha. R. 2007. *India after Gandhi: The History of the World's Largest Democracy*. Delhi: Picador Macmillan.

Guilfoyle, D., Bennell, B., Webb, W., Gillies, V., and Strickland, J. 2009. 'Integrating Natural Resource Management and Indigenous Cultural Heritage: A Model and Case Study from South-Western Australia'. *Heritage Management* 2(2): 149–75.

Habermas, J. 1984. *The Theory of Communicative Action*. Vol. 1, *Reason and the Rationalization of Society*. Boston: Beacon Press.

Habermas, J. 1996. *Between Facts and Norms: Contribution to a Discourse Theory of Law and Democracy*. Cambridge, MA: MIT Press.

Hall, C. M. (ed.). 2007. *Pro-Poor Tourism: Who Benefits? Perspectives on Tourism and Poverty Reduction*. Clevedon, UK: Channel View Publications.

Hall, S. 2008. 'Whose Heritage?' In G. Fairclough, R. Harrison, J. Schofield, and K. Jameson Jr. (eds.), *The Heritage Reader*. London: Routledge.

Hanen, M. P., and Kelley, J. H. 1989. 'Inference to the Best Explanation in Archaeology'. In V. Pinsky and A. Wylie (eds.), *Critical Traditions in Contemporary Archaeology*, 14–17. Cambridge, UK: Cambridge University Press.

Hansen, A. 2008. 'Die Frankfurter Altstadtdebatte. Zur Rekonstruktion eines "gefühlten" Denkmals.' *Die Denkmalpflege* 1: 5–17.

Hanson, F. A. 1975. *Meaning in Culture*. London: Routledge.

Haraway, D. 1988. 'Situated Knowledges: The Science Question in Feminism and the Privilege of Partial Perspective'. *Feminist Studies* 14: 575–99.

Harris, L. J. (1989). 'From the Collector's Perspective: The Legality of Importing Pre-Columbian Art and Artifacts'. In P. M. Messenger (ed.), *The Ethics of Collecting Cultural Property: Whose Culture? Whose Property?*, 155–75. Albuquerque: University of New Mexico Press.

Harris, N. 1995. 'Museums and Controversy: Some Introductory Reflections'. *Journal of American History* 82(3): 1102–10.

Harrison, R. 2010. 'Exorcising the "Plague of Fantasies": Mass Media and Archaeology's Role in the Present; or, Why We Need an Archaeology of "Now".' *World Archaeology* 42: 328–40.

Harvey, D. C. 2003. '"National" Identities and the Politics of Ancient Heritage: Continuity and Change at Ancient Monuments in Britain and Ireland c 1675–1850'. *Transactions of the Institute of British Geographers* 28(4): 473–87.

Harvey, G. 2005. *Animism: Respecting the Living World*. London: Hurst and Company.

Haworth, A. 2008. 'Let's Take Free Speech Seriously'. Paper presented at the 'Self-Censorship Conference', Morrell Centre for Tolerance, University of York, UK.

Héeleetaalawe, I. B. 1987. *A Dictionary of Everyday Crow*. Crow Agency, MT: Bilingual Materials Development Center.

Hegel, G. 1942. *Philosophy of Right*, trans. T. M. Knox. Oxford, UK: Clarendon Press.

Held, J. 1968. 'Alteration and Mutilation of Works of Art'. *South Atlantic Quarterly* 14(1): 1–28.

Hell, J., and Schonle, A. (eds.). 2010. *Ruins of Modernity: Politics, History and Culture*, Durham, NC: Duke University Press.

Hemming, S. 1996. 'Inventing Ethnography'. *Journal of Australian Studies* 20(48): 25–39.

Herbrechtsmeier, W., 1993. 'Buddhism and the Definition of Religion: One More Time'. *Journal for the Scientific Study of Religion* 32: 1–18.

Herz, R. 1993. 'Legal Protection for Indigenous Cultures: Sacred Sites and Communal Rights'. *Virginia Law Review* 79(30): 691–716.

Hetzer, N. D. 1965. 'Environment, Tourism, Culture'. *Links* 1(2): 1–3.

Hewison, R. 1987. *The Heritage Industry: Britain in a Climate of Decline*. London: Methuen.

Higham, J. (ed.). 2007. *Critical Issues in Ecotourism: Understanding a Complex Tourism Phenomenon*. Oxford, UK: Elsevier.

Hildreth, P., and Kimble, C. 2004. *Knowledge Networks: Innovation through Communities of Practice*. London: Idea Group Publishing.

Hingston, A. G. 1989. 'US Implementation of the UNESCO Cultural Property Convention'. In P. M. Messenger (ed.), *The Ethics of Collecting Cultural Property: Whose Culture? Whose Property?*, 129–47. Albuquerque: University of New Mexico Press.

Hitchens, C. 2008. *The Parthenon Marbles: The Case for Reunification*. London: Verso.

Hodder, I. 1990. *The Domestication of Europe: Structure and Contingency in Neolithic Societies*. Oxford, UK: Blackwell.

Hodder, I. 1999. *The Archaeological Process: An Introduction*. Oxford, UK: Blackwell.

Hodder, I. 2000. *Towards a Reflexive Method in Archaeology: The Example at Çatalhöyük*. Cambridge, UK: McDonald Institute for Archaeological Research.

Hodder, I. (ed.). 2005. *Çatalhöyük Perspectives: Reports from the 1995–99 Seasons*. Cambridge, UK: McDonald Institute for Archaeological Research.

Hodder, I. 2008. 'Multivocality and Social Archaeology'. In J. Habu, C. Fawcett, and J. M. Matsunaga (eds.), *Evaluating Multiple Narratives: Beyond Nationalist, Colonialist, Imperialist Archaeologies*, 196–200. New York: Springer.

Hodder, I. 2009. 'Mavili's Voice'. In L. Meskell (ed.), *Cosmopolitan Archaeologies*, 184–204. Durham, NC: Duke University Press.

Hoffmann-Axthelm, D. 2000. *Kann die Denkmalpflege entstaatlicht werden?* Gutachten für die Bundestagsfraktion von Bündnis 90/Die Grünen, March 2000. http://www.antje-vollmer.de/cms/default/dok/4/4358.kann_die_denkmalpflege_entstaatlicht_wer.pdf.

Högberg, A. 2007. 'The Past Is the Present – Prehistory and Preservation from a Children's Point of View'. *Public Archaeology* 6(1): 28–46.

Hollowell, J., and Carr, G. 2009. 'Bibliography of Community-Based Participatory Research and Ethics'. IPinCH Workshop on Community-Based Participatory and Research Ethics at the Prindle Institute for Ethics, DePauw University. http://www.sfu.ca/ipinch/node/484.

Hollowell, J., and Nicholas, G. 2009. 'Using Ethnographic Methods to Articulate Community-Based Conceptions of Cultural Heritage Management'. *Public Archaeology* 8(2–3): 141–60.

Hollowell, J., and Nicholas, G. (eds.). 2009. 'Decoding Implications of the Genographic Project for Archaeology and Cultural Heritage'. *International Journal of Cultural Property* 16(2): 131–220.

Holman, N. 1996. 'Photography as Social and Economic Exchange: Understanding the Challenges Posed by Photography of Zuni Religious Ceremonies'. *American Indian Culture and Research Journal* 20(3): 93–110.

Holtorf, C. 2000–8. *Monumental Past: The Life-Histories of Megalithic Monuments in Mecklenburg-Vorpommern (Germany)*. Toronto: University of Toronto, Centre for Instructional Technology Development. http://hdl.handle.net/1807/245.

Holtorf, C. 2004. *From Stonehenge to Las Vegas: Archaeology as Popular Culture*. Walnut Creek, CA: Altamira Press.

Holtorf, C. 2007a. *Archaeology Is a Brand! The Meaning of Archaeology in Contemporary Popular Culture*. Oxford, UK: Archaeopress.

Holtorf, C. 2007b. 'What Does Not Move Any Hearts – Why Should It Be Saved? The *Denkmalpflegediskussion* in Germany'. *International Journal of Cultural Property* 14(1): 33–55.

Holtorf, C. 2010a. 'Meta-Stories of Archaeology'. *World Archaeology* 42(3): 381–93.

Holtorf, C. 2010b. 'On the Possibility of Time Travel'. *Lund Archaeological Review* 15: 31–42.

Holtorf, C. 2010c. *Search the Past – Find the Present: The Value of Archaeology for Present-Day Society*. Amsterdam: Erfgoed Nederland.

Holtorf, C., and Högberg, A. 2005–6. 'Talking People: From Community to Popular Archaeologies'. *Lund Archaeological Review* 11–12: 79–88.

Hooper-Greenhill, E. 1992. *Museums and the Shaping of Knowledge*. London: Routledge.

Hooper-Greenhill, E. 1997. 'Towards Plural Perspectives'. In E. Hooper-Greenhill (ed.), *Cultural Diversity: Developing Museum Audiences in Britain*, 1–14. London: Leicester University Press.

Hooper-Greenhill, E., Dodd, J., Gibson, L., and Jones, C. 2007. *The Madonna of the Pinks: Evaluation of the Education and Community Strategy for the Madonna of the Pinks, 2004–2007*. Leicester: University of Leicester, Department of Museum Studies.

Howes, D. 1995. 'Combating Cultural Appropriation in the American Southwest: Lessons from the Hopi Experience Concerning the Uses of Law'. *Canadian Journal of Law and Society* 10: 129–54.

Hoxie, F. 1997. *Parading through History: The Making of the Crow Nation in America, 1805–1935.* Cambridge: Cambridge University Press.

Hubert, J., Turnbull, P., and Fforde, C. (eds.). 2002. *The Dead and Their Possessions: Reparation in Principle, Policy and Practice.* London: Routledge.

Huyssen, A. 1995. *Twilight Memories: Marking Time in a Culture of Amnesia.* London: Routledge.

Hviding, E. 1996. 'Nature, Culture, Magic, Science: On Meta-Language for Comparison in Cultural Ecology'. In P. Descola and G. Pálsson (eds.), *Nature and Society: Anthropological Perspectives*, 165–84. London: Routledge.

ICOMOS 1964. *International Charter for the Conservation and Restoration of Monuments and Sites (The Venice Charter 1964).* Paris: International Council of Monuments and Sites. Available at http://www.icomos.org/charters/venice_e.pdf

ICOMOS. 1972. *The Australia ICOMOS Charter for the Conservation of Places of Cultural Significance.* http://www.icomos.org/burra_charter.html.

Indian Archaeology: A Review. 1953–4. 'Preservation of Monuments': 16–28.

InfoHub. N.d. 'Indiana Jones Adventure Tour'. http://www.infohub.com/TRAVEL/SIT/sit_pages/2694.html.

Ingold, T. 2000. *Totemism, Animism and the Depiction of Animals in the Perception of the Environment: Essays on Livelihood, Dwelling and Skill.* London: Routledge.

Inwood, D. 2009. 'Native Businessman Upset at VANOCs Outsourcing of Aboriginal Products'. *Province* (Vancouver, BC), 20 December.

Irwin, L. (ed.). 2000. *Native American Spirituality: A Critical Reader.* Lincoln: University of Nebraska Press.

Isaac, G. 2011. 'Whose Idea Was This? Museums, Replicas, and the Reproduction of Knowledge'. *Current Anthropology* 52(2): 211–33.

Isaacs, J. 1992. *Desert Crafts: Anangu Maruku Punu.* Sydney: Doubleday.

James, J. 2004. 'Recovering the German Nation: Heritage Restoration and the Search for Unity'. In Y. Rowan & U. Baram (eds.), *Marketing Heritage: Archaeology and the Consumption of the Past*, 143–65. Lanham, MD: Altamira Press.

James, N. 2008. 'Repatriation, Display and Interpretation'. *Antiquity* 82: 770–7.

Janca, A. and Bullen, C. 2003. The Aboriginal Concept of Time and Its Mental Health Implications. *Australasian Psychiatry* 11: S40–S44. DOI: 10.1046/j.1038-5282.2003.02009.x

Janke, T. 2003. *Minding Culture: Case Studies on Intellectual Property and Traditional Cultural Expressions.* Geneva: World Intellectual Property Organization.

Janke, T., and Quiggin, R. 2005. 'Indigenous Cultural and Intellectual Law and Customary Law' (Background Paper No. 12). Law Reform Commission of Western Australia, Perth.

Jocks, C. R. 2000. 'Spirituality for Sale: Sacred Knowledge in the Consumer Age'. In L. Irwin (ed.), *Native American Spirituality: A Critical Reader*, 61–77. Lincoln: University of Nebraska Press.

Johnson, V. 1996. *Copyrites: Aboriginal Art in the Age of Reproductive Technologies. Catalogue for a Touring Exhibition.* Sydney: National Indigenous Arts Advocacy Association and Macquarie University.

Johnston, D. 1989. 'Native Rights as Collective Rights: A Question of Self Preservation'. *Canadian Journal of Law and Jurisprudence* 2(1): 19–34.

Jokilehto, J. 1999. *A History of Architectural Conservation*. Oxford, UK: Butterworth-Heinemann.

Jokilehto, J. 2008. *What Is OUV? Defining the Outstanding Universal Value of Cultural World Heritage Properties*. Monuments and Sites 16, International Council on Monuments and Sites (ICOMOS). Berlin: Bässler. http://openarchive.icomos.org/435/.

Jones, J. 2003. 'Look What We Did'. *Guardian* (UK), 31 March.

Jones, S. 2005. 'Making Place, Resisting Displacement: Conflicting National and Local Identities in Scotland'. In J. Littler and R. Naidoo (eds.), *The Politics of Heritage: 'Race', Identity and National Stories*, 94–114. London: Routledge.

Jonaitis, A., and Berlo, J. C. 2008. '"Indian Country" on the National Mall: The Mainstream Press versus the National Museum of the American Indian'. In A. Lonetree and A. J. Cobb (eds.), *The National Museum of the American Indian: Critical Conversations*, 208–40. Lincoln: University of Nebraska Press.

Joyce, R. A. 2002. *The Languages of Archaeology: Dialogue, Narrative, and Writing*. Oxford, UK: Blackwell.

Joyce, R. A. Guyer, C., and Joyce, M. 2002. 'Voices Carry Outside the Discipline'. In R. A. Joyce (ed.), *The Language of Archaeology: Dialogue, Narrative, and Writing*, 100–32. Oxford, UK: Blackwell.

Joyce, R. A. 2007. 'Figurines, Meaning, and Meaning-Making in Early Mesoamerica'. In A. C. Renfrew and I. Morley (eds.), *Material Beginnings: A Global Prehistory of Figurative Representation*, 107–16. Cambridge, UK: McDonald Institute for Archaeological Research.

Kaestle, F. A., and Horsburgh, K. A. 2002. 'Ancient DNA in Anthropology: Methods, Applications, and Ethics'. *Yearbook of Physical Anthropology* 45: 92–130.

Kalinowski, K. 1993. 'Der Wiederaufbau der historischen Stadtzentren in Polen – Theoretische Voraussetzungen und Realisation am Beispiel Danzigs'. In W. Lipp (ed.), *Denkmal – Werte – Gesellschaft: zur Pluralität des Denkmalbegriffs*, 322–46. Frankfurt: Campus.

Källén, A. 2004a. *And through Flows the River: Archaeology and the Pasts of Lao Pako*. Studies in Global Archaeology 6. Uppsala, Sweden: Uppsala University.

Källén, A. 2004b. 'Elusive Spirits and/or Precious Phosphates: On Archaeological Knowledge Production at Lao Pako'. In Håkan Karlsson (ed.), *Swedish Archaeologists on Ethics*, 99–116. Gothenburg, Sweden: Bricoleur Press.

Karlström, A. 2005. 'Spiritual Materiality: Heritage Preservation in a Buddhist World? *Journal of Social Archaeology* 5: 338–55.

Karn, G. P. 2008. 'Geschichte im Rückwärtsgang. Eine Fotodokumentation der Nordzeile des Mainzer Marktplatzes von 1978 bus 2008'. *Die Denkmalpflege* 1: 34–8.

Karp, I. 1992. 'On Civil Society and Social Identity'. In I. Karp, C. M. Kreamer, and S. D. Lavine (eds.), *Museums and Communities: The Politics of Public Culture*, 19–33. Washington, DC: Smithsonian Institution Press.

Keen, I. 1992. 'Undermining Credibility: Advocacy and Objectivity in the Coronation Hill Debate'. *Anthropology Today* 8(2): 6–9.

Kelly, L., Cook, C., and Gordon, P. 2006. 'Building Relationships through Communities of Practice: Museums and Indigenous People'. *Curator* 49(2): 217–34.

Kelly, L., and Gordon, P. 2002. 'Developing a Community of Practice: Museums and Reconciliation in Australia'. In R. Sandell (ed.), *Museums, Society, Inequality*, 153–74. London: Routledge.

Kelly, W. 1971. 'Pogo'. http://en.wikipedia.org/wiki/Pogo_(comics).

Kenny, C. 1996. *It Would Be Nice If There Was Some Women's Business*. Pots Point, Australia: Duffy and Snellgrove.

Keosopha, K., and Källén, A. 2008. 'Hintang – Standing Stones of Hua Phan'. English-Lao booklet. Vientiane: Institute of Historical Research.

Kerkhoff, U. 2008. 'Das Prinzip Rekonstruktion. Skizzen einer Zürcher Tagung'. *Die Denkmalpflege* 1: 47–53.

Killion, T. (ed.). 2008. *Opening Archaeology: Repatriation's Impact on Method and Theory*. Santa Fe, NM: School for Advanced Research.

King, Jaime Litvak. 1989. 'Cultural Property and National Sovereignty'. In P. M. Messenger (ed.), *The Ethics of Collecting Cultural Property: Whose Culture? Whose Property?* Albuquerque: University of New Mexico Press.

Klettner, Andrea. 2012. 'Roman Marble Sale Could Set "Dangerous Precedent"'. *Building Design*, 4 January.

Kohl, P. L. 2004. 'Making the Past Profitable in an Age of Globalization and National Ownership: Contradictions and Considerations'. In U. Baram and Y. Rowan (eds.), *Marketing Heritage: Archaeology and the Consumption of the Past*, 295–301. Walnut Creek, CA: Altamira.

Kosso, P. 1991. 'Method in Archaeology: Middle-Range Theory as Hermeneutics'. *American Antiquity* 56: 621–7.

Kreps, C. 2003. *Liberating Culture: Cross-Cultural Perspectives on Museums, Curation and Heritage Preservation*. London: Routledge.

Lackey, D. P. 2006. 'Ethics and Native American Reburials'. In C. Scarre and G. Scarre (eds.), *The Ethics of Archaeology*, 46–62. Cambridge, UK: Cambridge University Press.

Ladd, E. J. 2001. 'A Zuni Perspective on Repatriation'. In T. L. Bray (ed.), *The Future of the Past: Archaeologists, Native Americans and Repatriation*, 107–15. New York: Garland Publishing.

Lagerkvist, C. 2006. 'Empowerment and Anger: Learning How to Share Ownership of the Museum'. *Museum and Society* 4(2): 52–68.

Lahiri, N. 2000. 'Archaeology and Identity in Colonial India'. *Antiquity* 74: 687–92.

Lahiri, N. 2001. 'Monument Policy in British India, 1899–1905'. In R. Layton, J. Thomas, and P. G. Stone (eds.), *Destruction and Conservation of Cultural Property*, 264–76. London: Routledge.

Landow, G. P. 1997. *Hypertext 2.0: The Convergence of Contemporary Critical Theory and Technology*. Baltimore, MD: Johns Hopkins University Press.

Lanka Polity. 2010. http://lankapolity.blogspot.com/2010/09/sri-lankas-cultural-custodians-blast.html.

Lanka Times. 2010. http://www.lankatimes.com/fullstory.php?id=15004.

Lao National Tourism Administration. N.d. *National Ecotourism Strategy and Action Plan 2005–2010: Summary.* Vientiane: Lao National Tourism Administration.

Lave, J., and Wenger, E. 1991. *Situated Learning: Legitimate Peripheral Participation.* Cambridge, UK: Cambridge University Press.

Layton, R., and Wallace, G. 2006. 'Is Culture a Commodity?' In G. Scarre and C. Scarre (eds.), *The Ethics of Archaeology: Philosophical Perspectives on Archaeological Practice*, 46–68. Cambridge, UK: Cambridge University Press.

Lear, J. 2006. *Radical Hope: Ethics in the Face of Cultural Devastation.* Cambridge, MA: Harvard University Press.

Lee, B. 1997. *Talking Heads: Language, Metalanguage, and the Semiotics of Subjectivity.* Durham, NC: Duke University Press.

Leone, K. C. 1997. 'No Team, No Peace: Franchise Free Agency in the National Football League'. *Columbia Law Review* 97: 473–523.

Lilley, I. 2009. 'Strangers and Brothers? Heritage, Human Rights, and Cosmopolitan Archaeology in Oceania'. In L. Meskell (ed.), *Cosmopolitan Archaeologies*, 48–67. Durham, NC: Duke University Press.

Lindeman, F. B. 1962. *Plenty Coups, Chief of the Crows.* Lincoln: University of Nebraska Press.

Linenthal, E. T., and Englehardt, T. (eds.). 1996. *History Wars: The Enola Gay and Other Battles for the American Past.* New York: Metropolitan Books.

Lippert, D. 1997. 'In Front of the Mirror: Native Americans and Academic Archaeology'. In N. K. Swidler, K. E. Dongoske, R. Anyon, and A. S. Downer (eds.), *Native Americans and Archaeologists: Stepping Stones to Common Ground*, 120–7. Walnut Creek, CA: Altamira Press.

Livy. 1919. *Livy in Fourteen Volumes*, vol. 1., trans. B. O. Foster. Cambridge, MA: Harvard University Press.

Löfgren, O. 1999. *On Holiday: A History of Vacationing.* Berkley: University of California Press.

Logan, M. 2003. 'Global Systems Selling Out Indigenous Knowledge'. Inter Press Service News Agency. http://ips- news.net/interna.asp?idnewsp21517.

Lonetree, A. 2008. '"Acknowledging the Truth of History": Missed Opportunities at the National Museum of the American Indian'. In A. Lonetree and A. J. Cobb (eds.), *The National Museum of the American Indian: Critical Conversations*, 305–27. Lincoln: University of Nebraska Press.

Longhurst, A. H. 1936. *The Story of the Stupa.* Colombo: Ceylon Government Press.

Lopiparo, J. 2002. 'A Second Voice': *Crafting Cosmos'*. In R. A. Joyce (ed.), *The Language of Archaeology: Dialogue, Narrative, and Writing*, 68–99. Oxford, UK: Blackwell.

Lowell, S., Hill, J., Rodríguez, J. Q., Parks, W., and Wisner, M. 1999. *The Many Faces of Mata Ortiz.* Tucson, AZ: Rio Nuevo Publishers.

Lowenthal, D. 1985. *The Past Is a Foreign Country*. Cambridge, UK: Cambridge University Press.

Lowenthal, D. 1998. *The Heritage Crusade and the Spoils of History*. Cambridge, UK: Cambridge University Press.

Lubina, K. 2009. 'Protection and Preservation of Cultural Heritage in the Netherlands in the 21st Century'. *Electronic Journal of Comparative Law* 13(2). http:www.ejcl.org.

Lydon, J. 2009. 'Young and Free: The Australian Past in a Global Future'. In L. Meskell (ed.), *Cosmopolitan Archaeologies*, 28–47. Durham, NC: Duke University Press.

Lynch, B. T. 2011. Custom-Made Reflective Practice: Can Museums Realise Their Capabilities in Helping Others Realise Theirs? *Museum Management and Curatorship* 26(5) 441–58.

Lynch, B. T., and Alberti, S. J. M. M. 2010. 'Legacies of Prejudice: Racism, Co-Production and Radical Trust in the Museum'. *Museum Management and Curatorship* 25(1): 13–35.

Lynott, M. 2003. 'The Development of Ethics in Archaeology'. In L. Zimmerman, K. Vitelli, and J. Hollowell-Zimmer (eds.), *Ethical Issues in Archaeology*, 17–27. Walnut Creek, CA: Altamira Press.

Macaulay, R. 1966. *Pleasure of Ruins*. London: Thames & Hudson. (Originally published in 1953.)

Maccallum S. H. 1978. 'Ceramic Revival in the Casas Grande Valley'. *Masterkey* 52(2): 44–53.

MacEwen, A., and MacEwen, M. (1987). *Greenprints for the Countryside? The Story of Britain's National Parks*. London: Allen & Unwin.

Mackintosh, Barry. 1985. 'The Historic Sites Survey and National Historic Landmarks Program'. Washington, DC: National Parks Service.

Magirius, H. 2010. 'Rekonstruktion in der Denkmalpflege'. In W. Nerdinger (ed.), *Geschichte der Rekonstruktion – Konstruktion der Geschichte*, 148–55. Munich: Prestel.

Mahavamsa 1989. Trans. W. W. P. Guruge. Colombo: Lake House.

Margalit A. 2009. '"You'll Never Walk Alone": On Property, Community and Football Fans'. *Theoretical Inquiries in Law* 10: 217–40.

Margalit A., and Raz, J. 1995. 'National Self Determination'. In W. Kymlicka (ed.), *The Rights of Minority Cultures*, 79–92. Oxford, UK: Oxford University Press.

Marks, J. 2010. 'Science, Samples and People'. *Anthropology Today* 26(3): 3–4.

Marling, K. A. (ed.). 1997. *Designing Disney's Theme Parks: the Architecture of Reassurance*. Paris: Flammarion.

Marshall, J. H. 1951. *Taxila: An Illustrated Account of Archaeological Excavations*. Cambridge, UK: Cambridge University Press.

Marshall, Y. 2002. 'What Is Community Archaeology?' *World Archaeology* 34: 211–19.

Mathews, F. 2009. 'Why Has the West Failed to Embrace Panpsychism?' In D. Skrbina (ed.), *Mind That Abides: Panpsychism in the New Millennium*, 341–60. Amsterdam: John Benjamins.

Mayr, O. 1998. 'The 'Enola Gay' Fiasco: History, Politics, and the Museum'. *Technology and Culture* 39(3): 462–73.

McClintock, A. 1995. *Imperial Leather: Race, Gender and Sexuality in the Colonial Conquest*. New York: Routledge.

McDavid, C. 2000. 'Archaeology as Cultural Critique: Pragmatism and the Archaeology of a Southern United States Plantation'. In C. Holtorf and H. Karlsson (eds.), *Philosophy and Archaeological Practice: Perspectives for the 21st Century*, 221–40. Lindome, Sweden: Bricoleur Press.

McDavid, C. 2002a. 'Archaeologies That Hurt; Descendents That Matter: A Pragmatic Approach to Collaboration in the Public Interpretation of African-American Archaeology'. *World Archaeology* 34: 303–14.

McDavid, C. 2002b. 'From Real Space to Cyberspace: The Internet and Public Archaeological Practice'. PhD diss., University of Cambridge, UK.

McDavid, C. 2004a. 'From "Traditional" Archaeology to Public Archaeology to Community Action: The Levi Jordan Plantation Project'. In P. A. Shackel and E. J. Chambers (eds.), *Places in Mind: Archaeology as Applied Anthropology*, 35–56. New York: Routledge.

McDavid, C. 2004b. 'Towards a More Democratic Archaeology? The Internet and Public Archaeological Practice'. In N. Merriman (ed.), *Public Archaeology*, 159–87. London: Routledge.

McDonald, J. D., Zimmerman, Tall Bull, L. J. W., and Rising Sun, T. 1991. 'The Cheyenne Outbreak of 1879: Using Archaeology to Document Northern Cheyenne Oral History'. In R. Paynter and R. McGuire (eds.), *The Archaeology of Inequality*, 64–78. Oxford, UK: Basil Blackwell.

McGhee, R. 2008. 'Aboriginalism and the Problems of Indigenous Archaeology'. *American Antiquity* 73: 579–97.

McGuire, R. 2003. 'Foreword'. In L. Zimmerman, K. Vitelli, and J. Hollowell-Zimmer (eds.), *Ethical Issues in Archaeology* vii–ix. Walnut Creek, CA: Altamira Press.

McGuire, R. H. 2008. *Archaeology as Political Action*. Berkeley: University of California Press.

McLaren, D. 2003. *Rethinking Tourism and Ecotravel*, 2nd rev. ed. Bloomfield, CT: Kumarian Press.

McLeod, J. 2007a. 'Ecotourism in Lao PDR'. New Zealand Agency for International Development Media & Publications, article 7, 5 June 2007. http://www.nzaid.govt.nz/library/articles/archives/eco-lao.html.

McLeod, K. 2007a. *Freedom of Expression: Resistance and Repression in the Age of Intellectual Property*. Minneapolis: University of Minnesota Press.

Medicine Crow, J. 2006. *Counting Coup: Becoming a Chief on the Reservation and Beyond*. Washington, DC: National Geographic.

Medina, J. F. 2008. 'The Globalization of Indigenous Art: The Case of Mata Ortiz Pottery'. http://ciede.mgt.unm.edu/fibeamanaus/papers/IndigenousEntrpreneurshipAndGlobalization/medinadelossantospaper.pdf.

Menand, L. 2001. *The Metaphysical Club*. New York: Farrar, Straus, and Giroux.

Merryman, J. 1976. 'The Refrigerator of Bernard Buffet'. *Hastings Law Journal* 27: 1023–8.

Merryman, J. 1980. 'The Public Interest in Cultural Property'. *California Law Review* 77(2): 339–64.

Merryman, J. 1985. 'Thinking about the Elgin Marbles'. *Michigan Law Review* 83: 1881–923.

Merryman, J. 1986. 'Two Ways of Thinking About Cultural Property'. *American Journal of International Law* 80: 831.

Merryman, J. H. 1994. 'The Nation and the Object'. *International Journal of Cultural Property* 3: 61–76.

Meskell, L. 2009. 'Introduction: Cosmopolitan Heritage Ethics'. In L. Meskell (ed.), *Cosmopolitan Archaeologies*, 1–27. Durham, NC: Duke University Press.

Meurer, D. M., and Coombe, R. 2009. 'Digital Media and the Informational Politics of Appropriation'. In Atopia Projects (ed.), *Lifting: Theft in Art*, 20–27. Aberdeen, UK: Peacock Visual Arts. http://www.artmob.ca/files/Lifting-Meurer-Coombe.pdf.

Meyer, C. J., and Royer, D. (eds.). 2001. *Selling the Indian: Commercializing and Appropriating American Indian Cultures*. Tucson: University of Arizona Press.

Midgley, M. 1992. *Science as Salvation: A Modern Myth and its Meaning*. London: Routledge.

Mills, A. 2010. 'Fresh Look at Landmark Coin Case'. *Shropshire Star* (UK), 20 May.

Mitra, D. 1971. *Buddhist Monuments*. Calcutta: Sahitya Samsad.

Moore, G. E. 1903. *Principia Ethica*. Cambridge, UK: Cambridge University Press.

Moorehead, C. 1995. *The Lost Treasures of Troy*. London: Phoenix.

Morgan-Olsen, B. 2010. 'Conceptual Exclusion and Public Reason'. *Philosophy of the Social Sciences* 40: 213–43.

Morley, D., and Robins, K. 1995. *Spaces of Identity: Global Media, Electronic Landscapes and Cultural Boundaries*. London: Routledge.

Mortensen, L., and G. Nicholas. 2010. 'Riding the Tourism Train? Navigating Intellectual Property, Heritage and Community-Based Approaches to Cultural Tourism'. *Anthropology News* (November): 11–12.

Morton, P. A. 2000. *Hybrid Modernities: Architecture and Representation at the 1931 Colonial Exposition, Paris*. Cambridge, MA: MIT Press.

Muir, K. 1996. 'Media Representations of Ngarrindjeri Women'. *Journal of Australian Studies* 20(48): 73–8.

Muir, R. 1999. *Approaches to Landscape*. London: Macmillan.

Mullin, M. 2001. *Culture in the Marketplace: Gender, Art, and Value in the American Southwest*. Durham, NC: Duke University Press.

Mulvihill, J. 1995. 'Wordsworth and the Kendal and Windermere Railway Controversy'. *Modern Language Quarterly* 56(3): 305–26.

Muñoz Viñas, S. 2004. *Contemporary Theory of Conservation*. Oxford, UK: Butterworth-Heinemann.

Nabokov, P. 1967. *Two Leggings: The Making of a Crow Warrior*. Lincoln: University of Nebraska Press.

Nabokov, P., and Loendorf, L. 2004. *Restoring a Presence: American Indians and Yellowstone National Park*. Norman: University of Oklahoma Press.

National NAGPRA. 2010. 'National NAGPRA Frequently Asked Questions'. http://www.nps.gov/nagpra/FAQ/INDEX.HTM#How_many.

Neidhardt, H. J. 1999. 'What We Want: Gesellschaft Historischer Neumarkt Dresden e.V'. http://www.avoe.org/dresdenwhat.html (accessed 23 August 2010).

Nelson, R. M. 2001. 'Rewriting Ethnography: The Embedded Texts in Leslie Silko's Ceremony'. In E. H. Nelson and R. M. Nelson (eds.), *Telling the Stories: Essays on American Indian Literatures and Culture*. New York: Peter Lang.

Nelson, T. H. 1993. *Literary Machines 93.1*. Sausalito, CA: Mindful Press.

Nerdinger, W. (ed.). 2010. *Geschichte der Rekonstruktion – Konstruktion der Geschichte*. Munich: Prestel.

Netanel, N. W. 1996. Copyright and a Democratic Civil Society. *Yale Law Journal* 106: 283.

Nicholas, G. (ed.). 2010. *Being and Becoming Indigenous Archaeologists*. Walnut Creek, CA: Left Coast Press.

Nicholas, G. P. 2008. 'Native Peoples and Archaeology'. In D. Pearsall (ed.), *The Encyclopedia of Archaeology*, vol. 3, 1660–1669. Oxford, UK: Elsevier.

Nicholas, G. P. 2010. 'Seeking the End of Indigenous Archaeology'. In H. Allen and C. Phillips (eds.), *Bridging the Divide: Indigenous Communities and Archaeology into the 21st Century*, 233–52. Walnut Creek, CA: Left Coast Press. http://www.lcoastpress.com/book.php?id=285.

Nicholas, G. P. In press. 'Indigenous Cultural Heritage in the Age of Technological Reproducibility: Towards a Postcolonial Ethic of the Public Domain'. In R. J. Coombe and D. Wershler (eds.), *Dynamic Fair Dealing: Creating Canadian Culture Online*.

Nicholas, G. P., and Bannister, K. P. 2004a. 'Copyrighting the Past? Emerging Intellectual Property Rights Issues in Anthropology'. *Current Anthropology* 45(3): 327–50.

Nicholas, G. P., and Bannister, K. 2004b. 'Intellectual Property Rights and Indigenous Cultural Heritage in Archaeology'. In M. Riley (ed.), *Indigenous Intellectual Property Rights: Legal Obstacles and Innovative Solutions*, 309–40. Walnut Grove, CA: Altamira Press.

Nicholas, G., Bell, C., Bannister, K. Ouzman, S., and Anderson, J. 2009. 'Intellectual Property Issues in Heritage Management – Part 1: Challenges and Opportunities Relating to Appropriation, Information Access, Bioarchaeology, and Cultural Tourism'. *Heritage Management* 2(1): 261–86.

Nicholas, G., Bell, C., Coombe, R., Welch, J., Noble, B., Anderson, J., Bannister, K., and Watkins, J. 2010. 'Intellectual Property Issues in Heritage Management. Part 2: Legal Dimensions, Ethical Considerations, and Collaborative Research Practices'. *Heritage Management* 3(1): 117–47.

Nicholas, G. P., and Hollowell, J. 2006. 'Intellectual Property Issues in Archaeology: Addressing the Needs of a Changing World through Negotiated Practice'. Plenary address at the 'Cultural Heritage and Indigenous Cultural and Intellectual Property Rights Conference', fifth World Archaeological Intercongress, Burra, Australia.

Nicholas, G., and Hollowell, J. 2007. 'Ethical Challenges to a Postcolonial Archae-ology'. In Y. Hamilakas and P. Duke (eds.), *Archaeology and Capitalism: From Ethics to Politics*, 59–82. Walnut Creek, CA: Left Coast Press.

Nicholas, G., Julies, J., and Dan, C. 2008. 'Moving beyond Kennewick: Alterna-tive Native American Perspectives on Bioarchaeological Data and Intellectual Property Rights'. In C. Smith, L. Zimmerman, D. Lippert, and J. Watkins (eds.), *Kennewick Man: Perspectives on the Ancient One*, 233–43. Walnut Creek, CA: Left Coast Press.

Nicholas, G., and Wylie, A. 2009. 'Archaeological Finds: Legacies of Appropria-tion, Modes of Response'. In C. Brunk and J. O. Young (eds.), *The Ethics of Cultural Appropriation*, 11–54. Malden, MA: Wiley-Blackwell.

Norindr, P. 1996. *Phantasmatic Indochina: French Colonial Ideology in Architecture, Film, and Literature*. Durham, NC: Duke University Press.

O'Bonawain, C. M. 2006. 'The Conundrum of "Ilanaaq" – First Nations Repre-sentation and the 2010 Vancouver Winter Olympics'. In *Cultural Imperialism in Action: Critiques in the Global Olympics, Eighth International Symposium of Olympic Research*, 387–94. London, ON: International Centre for Olympic Studies, University of Western Ontario.

Olivier, M. (ed.). 1932–4. *Exposition Coloniale Internationale et des Pays d'Outre-Mer, Paris 1931: Rapport Général*. 7 vols. Paris: Imprimerie Nationale.

Olsberg SPI. 2007. UK Film Council. http://www.ukfilmcouncil.org.uk/media/ pdf/a/6/Final_Stately_Attraction_Report_to_UKFC_and_Partners_20.08.07. pdf.

O'Reilly, T. 2005. 'What Is Web 2.0: Design Patterns and Business Models for the Next Generation of Software'. O'Reilly Media, 14 May 2010. http://oreilly. com/web2/archive/what-is-web-20.html.

Ostrowitz, J. 2008. 'Concourse and Periphery: Planning the National Museum of the American Indian'. In A. Lonetree and A. J. Cobb (eds.), *The National Museum of the American Indian: Critical Conversations*, 84–127. Lincoln: Uni-versity of Nebraska Press.

Owen, S. 2008. *The Appropriation of Native American Spirituality*. London: Con-tinuum.

Owsley, D. W., and Jantz, R. L. 2002. 'Kennewick Man – A Kin? Too Distant'. In E. Barkan and R. Bush (eds.), *Claiming the Stones, Naming the Bones: Cultural Property and the Negotiation of National and Ethnic Identity*, 141–61. Los Angeles: Getty Publications.

Pal, H. B. 1991. *The Plunder of Art*. New Delhi: Abhinav Publishers.

Pandey, G. 1997. 'Partition and Independence in Delhi: 1947–48'. *Economic and Political Weekly* 32(36): 2261–72.

Paranavitana, S. 1946. *The Stupa in Ceylon*. Colombo: Archaeological Survey of Ceylon.

Parekh, B. 2002. *Rethinking Multiculturalism: Cultural Diversity and Political The-ory*. Cambridge, MA: Harvard University Press.

Parezo, N. 1983. *Navajo Sandpainting: From Religious Act to Commercial Art*. Tucson: University of Arizona Press.

Parker Pearson, M. 1999. *The Archaeology of Death and Burial.* Stroud, UK: Alan Sutton.

Parmentier, R. J. 1994. *Signs in Society: Studies in Semiotic Anthropology.* Bloomington: Indiana University Press.

Parmentier, R. J. 1997. 'The Pragmatic Semiotics of Cultures'. *Semiotica* 116: 1–115.

Paul, J. 1979. 'Das Knochenhaueramtshaus in Hildesheim – post mortem: Vom Nachleben einer Architektur als Bedeutungsträger'. *Niederdeutsche Beiträge zur Kunstgeschichte* 18: 129–48. http://denkmaldebatten.denkmalschutz.de/fileadmin/dateien/Download-Materialien/J._Paul_Hildesheim.pdf.

Pearce, S. M. 1994. 'Objects as Meaning: Or Narrating the Past'. In S. M. Pearce (ed.), *Interpreting Objects and Collections*, 19–29. London: Routledge.

Pearlstone, Zena. 2000. 'Mail-Order "Katsinam" and the Issue of Authenticity'. *Journal of the Southwest* 42: 801–32.

Pearson, K. A., and Mullarkey, J. 2002. Introduction to *Henri Bergson: Key Writings*, ed. K. A. Pearson and J. Mullarkey, 1–45. New York: Continuum.

Peirce, C. S. 1992. *The Essential Peirce: Selected Philosophical Writings.* Vol. 1, *1867–1893.* Bloomington: Indiana University Press.

Peirce, C. S. 1998. *The Essential Peirce: Selected Philosophical Writings.* Vol. 2, *1893–1913.* Bloomington: Indiana University Press.

Porcheddu, F. 2007. 'Otto F Ege: Teacher, Collector, Biblioclast'. *Art Documentation* 26 (1): 4–15.

Pottage A. 1990. 'Property: Re-Appropriating Hegel'. *Modern Law Review* 53: 259–70.

Provincial Tourism Office Houaphanh 2007. 'Tourism Development Strategy 2007–2020 Houaphanh Province: Prepared by Provincial Tourism Office Houaphanh, with the support and assistance of SNV', June.

Preucel, R. W. 2006. *Archaeological Semiotics.* Oxford, UK: Blackwell.

Preucel, R. W., and Bauer, A. A. 2001. 'Archaeological Pragmatics' *Norwegian Archaeological Review* 34: 85–96.

Preucel, R. W., and Mrozowski, S. A. (eds.). 2010. *Contemporary Archaeology in Theory: The New Pragmatism.* Oxford, UK: Wiley-Blackwell.

'Protecting the Public Interest in Art'. 1981–2. *Yale Law Journal* 91: 121–43.

Pullar, G. L. 1994. 'The Qikertarmiut and the Scientist: Fifty Years of Clashing World Views'. In T. L. Bray and T. W. Killion (eds.), *Reckoning with the Dead: The Larsen Bay Repatriation and the Smithsonian Institution*, 15–25. Washington, DC: Smithsonian Institution Press.

Radin M. J. 1982. 'Property and Personhood'. *Stanford Law Review* 34: 957–1015.

Radin M. J. 1987. 'Market-Inalienability'. *Harvard Law Review* 100: 1849–1937.

Reardon, J. 2005. *Race to the Finish: Identity and Governance in an Age of Genomics.* Princeton, NJ: Princeton University Press.

Rees Leahy, H. 2008. 'Under the Skin'. *Museum Practice* 43: 36–40.

Rhys Davids, T. W. 1901. 'Asoka and the Buddha Relics'. *Journal of the Royal Asiatic Society*: 397–410.

Rizvi, U. Z., and Lydon, J. (eds.). 2010. *Handbook of Postcolonial Archaeology.* Walnut Creek, CA: Left Coast Press.

Robertson, I. J. M. (ed.) 2012. *Heritage from Below.* Farnham: Ashgate.

Robson, D. 2008. *Bawa: The Sri Lankan Gardens.* London: Thames & Hudson.

Rödl, S. 2007. *Self-Consciousness.* Cambridge, MA: Harvard University Press.

Rorty, R. 1986. 'On Ethnocentrism: A Reply to Clifford Geertz'. *Michigan Quarterly Review* 25: 525–34.

Rose, C. 1981. 'Preservation and Community: New Directions in the Law of Historic Preservation'. *Stanford Law Review* 33(3): 473–534.

Rose, W. 1992. 'The Great Pretenders: Further Reflections on Whiteshamanism'. In M. A. Jaimes (ed.), *The State of Native America: Genocide, Colonization, and Resistance*, 403–22. Boston: South Bend Press.

Rosenfield, J. M. 1967. *The Dynastic Arts of the Kushans.* Berkeley: University of California Press.

Rowan, Y., and Baram, U. (eds.). 2004. *Marketing Heritage: Archaeology and the Consumption of the Past.* Walnut Creek, CA: Altamira Press.

Sadurski, W. 1994. 'Racial Vilification, Psychic Harm and Affirmative Action'. In T. Campbell and W. Sadurski (eds.), *Freedom of Communication*, 77–94. Aldershot, UK: Dartmouth.

Saitta, D. J. 2003. 'Archaeology and the Problems of Men'. In T. Van Pool and C. Van Pool (eds.), *Essential Tensions in Archaeological Method and Theory*, 11–15. Salt Lake City: University of Utah Press.

Samuel, R. 1996. *Theatres of Memory.* London: Verso.

Sax, J. L. 1990. 'Heritage Preservation as a Public Duty: The Abbé Grégoire and the Origins of an Idea'. *Michigan Law Review* 88: 1142–69.

Sax, J. L. 1999. *Playing Darts with a Rembrandt.* Ann Arbor: University of Michigan Press.

Scanlon, T. M. 1998. *What We Owe to Each Other.* Cambridge, MA: Belknap Press of Harvard University Press.

Scarre, G. 2006. 'Can Archaeology Harm the Dead?' In C. Scarre and G. Scarre (eds.), *The Ethics of Archaeology: Philosophical Perspectives on Archaeological Practice*, 181–98. Cambridge, UK: Cambridge University Press.

Scarre, C., and Scarre, G. (eds.). 2006. *The Ethics of Archaeology: Philosophical Perspectives on Archaeological Practice.* Cambridge, UK: Cambridge University Press.

Schick, J. 1998. *The Gods Are Leaving the Country: Art Theft from Nepal.* Bangkok: White Orchid Press.

Schmidt, L. 2008. *Einführung in die Denkmalpflege.* Stuttgart: Theiss. (English version published as *Architectural Conservation: An Introduction*). Bad Münstereifel: Westkreuz.

Schopen, G. 1997. *Bones, Stones and Buddhist Monks: Collected Papers on the Archaeology, Epigraphy and Texts of Monastic Buddhism in India.* Honolulu: University of Hawai'i Press.

Schopenhauer, A. 1969. *The World as Will and Representation*, vol. 1, trans. E. F. J. Payne. New York: Dover. (Originally published in 1819.)

Scott, N., and Seglow, J. 2007. *Altruism: Concepts in the Social Sciences.* Maidenhead, UK: Open University Press.

Sebald, W. G. 2002. *The Rings of Saturn*, trans. M. Hulse. London: Vintage.

Sebastian, T. 2001. 'Alternative Archaeology: Has It Happened?'. In R. J. Wallis and K. Lymer (eds.), *A Permeability of Boundaries? New Approaches to the Archaeology of Art, Religion and Folklore*, 125–35. Oxford: British Archaeological Reports International Series 936.

Sebeok, T. A. (ed.). 1978. *Sight, Sound, and Sense*. Bloomington: Indiana University Press.

Seidemann R. M. 2003–4. 'Time for a Change? The Kennewick Man Case and Its Implications for the Future of the Native American Graves Protection and Repatriation Act'. *West Virginia Law Review* 106: 149–76.

Seidemann R. M. 2007. 'The Reason behind the Rules: The Archaeological Resources Protection Act of 1979 and Scientific Study'. *Boston University Journal of Science and Technology Law* 13: 193–217.

Sengupta, I. 2010. 'Sacred Space and the Making of Monuments in Colonial Orissa in the Early Twentieth Century'. In H. P. Ray (ed.), *Archaeology and Text: The Temple in South Asia*, 168–88. New Delhi: Oxford University Press.

Shanks, M. and Tilley, C. 1987. *Social Theory and Archaeology*. Albuquerque: University of New Mexico Press.

Shaw, P. 2003. 'Abjection Sustained: Goya, the Chapman Brothers and the *Disasters of War*'. *Art History* 26: 479–504.

Shoard, M. 1999. *A Right to Roam*. Oxford, UK: Oxford University Press.

Silk, J. A. 2008. *Managing Monks: Administrators and Administrative Roles in Indian Buddhist Monasticism*. Oxford, UK: Oxford University Press.

Silliman, S. W. 2010. 'The Value and Diversity of Indigenous Archaeology: A Response to McGhee'. *American Antiquity* 75(2): 217–20.

Simms, S. C. 1903. *Traditions of the Crows*. Chicago: Field Columbian Museum.

Simpson, M. 2001. *Making Representations: Museums in the Post-Colonial Era*. New York: Routledge.

Singer, J. W. 1988. 'The Reliance Interest in Property'. *Stanford Law Review* 40: 611–751.

Smith, C., and Wobst, H. M. (eds.). 2005a. 'Decolonizing Archaeological Theory and Practice.' In C. Smith and H. M. Wobst (eds.), *Indigenous Archaeologies: Decolonizing Theory and Practice*, 4–14. New York: Routledge.

Smith, C., and Wobst, H. M. (eds.). 2005b. *Indigenous Archaeologies: Decolonizing Theory and Practice*. New York: Routledge.

Smith, L. 2004. *Archaeological Theory and the Politics of Cultural Heritage*. London: Routledge.

Smith, L. 2006. *Uses of Heritage*. London: Routledge.

Smith, L. T. 1999. *Decolonizing Methodologies: Research and Indigenous Peoples*. London: Zed Books.

Smith, M. 2005. 'Networks, Territories and the Cartography of Ancient States'. *Annals of the Association of American Geographers* 95(4): 832–49.

Snell, A. H. 2000. *Grandmother's Grandchild: My Crow Indian Life*. Lincoln: University of Nebraska Press.

Society for American Archaeology. 1996. *Principles of Archaeological Ethics*, 10 April. http://www.saa.org/AbouttheSociety/PrinciplesofArchaeologicalEthics/tabid/203/Default.aspx.

Society for American Archaeology. 2008. 'Comments on 2007 Proposed Rule Relating to Culturally Unidentifiable Human Remains under the Native American Graves Protection and Repatriation Act (79 Federal Register 58582, Published Tuesday October 16, 2007)'. http://www.saa.org/Portals/0/SAA/repatriation/SAA_CUHR_comments_2008_01_14.pdf.

Spivak, G. 1998. 'Can the Subaltern Speak?'. In C. Nelson and L. Grossberg (eds.), *Marxism and the Interpretation of Culture*, 271–313. Urbana: University of Illinois Press.

Stanford, C. 2007. 'Saving the Grange'. *Building Conservation Directory* 2007. http://www.buildingconservation.com/articles/grange/grange.htm.

Starn, R. 2002. 'Authenticity and Historic Preservation: Towards an Authentic History'. *History of the Human Sciences* 15(1): 1–16.

Stead, I. M., Bourke, J., and Brothwell, D. 1986. *Lindow Man: The Body in the Bog*. London: British Museum Press.

Stein, M. A. 1929. On Alexander's Track to the Indus. London: Macmillan.

Stillman P. G. 1989. 'Hegel's Analysis of Property in the *Philosophy of Right*'. *Cardozo Law Review* 10: 1030–72.

Stoicheff, P. 2008. 'Putting Humpty Together Again: Otto Ege's Scattered Leaves'. Computing in the Humanities Working Papers. http://www.chass.utoronto.ca/epc/chwp/CHC2007/Stoicheff/Stoicheff.htm.

Stutt, A., and Shennan, S. 1990. 'The Nature of Archaeological Arguments'. *Antiquity* 64: 766–77.

Šulc, B. 2001. 'The Protection of Croatia's Cultural Heritage during War 1991–95'. In R. Layton, P. G. Stone, and J. Thomas (eds.), *Destruction and Conservation of Cultural Property*, 157–67. London: Routledge.

Sunday Times. 2010. http://sundaytimes.lk/cms/article1.php?id=4218.

Tarlow, S. 2006. 'Archaeological Ethics and the People of the Past'. In C. Scarre and G. Scarre (eds.), *The Ethics of Archaeology: Philosophical Perspectives on Archaeological Practice*, 199–216. Cambridge, UK: Cambridge University Press.

Taylor, C. 2007. *A Secular Age*. Cambridge, MA: Harvard University Press.

Thapar, R. 1963. *Asoka and the Decline of the Mauryans*. New Delhi: Oxford University Press.

Thomas, J. 2004. *Archaeology and Modernity*. London: Routledge.

Thompson, V. 1937. *French Indo-China*. London: Allen & Unwin.

Tierney, P. 2000. *Darkness in El Dorado: How Scientists and Journalists Devastated the Amazon*. New York: Norton.

Tilley, C. 1991. *Material Culture and Text: The Art of Ambiguity*. London: Routledge.

Tillich, P., 1958. *Dynamics of Faith*. New York: Harper Torchbooks.

Townsend, R. F. (ed.). 2005. Casas Grandes and the Ceramic Art of the Ancient Southwest. *Chicago: Art Institute of Chicago*; New Haven, CT: Yale University Press.

Trainor, K. 1992. 'When Is a Theft Not a Theft? Relic Theft and the Cult of the Buddha's Relics in Sri Lanka'. *Numen* 39: 185–90.

Trainor, K. 1997. *Relics, Ritual and Representation in Buddhism: Rematerializing the Sri Lankan Theravada Tradition.* Cambridge, UK: Cambridge University Press.

Trigger, B. 2006. *A History of Archaeological Thought.* Cambridge, UK: Cambridge University Press.

Tully, J. 1995. *Strange Multiplicity: Constitutionalism in an Age of Diversity.* Cambridge, UK: Cambridge University Press.

Turnbull, P. 2002. 'Indigenous Australian People, Their Defence of the Dead and Native Title'. In C. Fforde, J. Hubert, and P. Turnbull, (eds.), *The Dead and Their Possessions: Reparation in Principle, Policy and Practice,* 63–86. London: Routledge.

Ubelaker, D., and Grant, L. 1989. 'Human Skeletal Remains: Preservation or Reburial?' *American Journal of Physical Anthropology* 32: 249–87.

UK Department of Culture, Media and Sport. 2002. Circular on Changes to Export of Works of Art, 31 October.

UNESCO. 1970. *Convention on the Means of Prohibiting and Preventing the Illicit Import, Export and Transfer of Ownership of Cultural Property.* http://portal.unesco.org/en/ev.php URL_ID=13039&URL_DO=DO_TOPIC&URL_SECTION=201.html.

UNESCO. 1972. *Convention Concerning the Protection of the World Cultural and Natural Heritage.* http://whc.unesco.org/en/conventiontext

Valadez, J. M. 2001. *Deliberative Democracy, Political Legitimacy, and Self-Determination in Multicultural Societies.* Boulder, CO: Westview Press.

Van der Walt, A. J. 2005. *Constitutional Property Law.* Cape Town: Juta & Co.

Vira, D. 1975. *Memoirs of a Civil Servant.* Delhi: Vikas Publishing House.

Voget, F. W. 1984. *The Shoshoni-Crow Sun Dance.* Norman: University of Oklahoma Press.

Wadsworth, Y. 1998. 'What Is Participatory Action Research?' Action Research International Paper No. 2. http://www.scu.edu.au/schools/gcm/ar/ari/p-ywadsworth98.html.

Waldron, J. 1992. 'Superseding Historical Injustice'. *Ethics* 103: 4–28.

Waldron, J. 1993. 'Property, Justification and Need'. *Canadian Journal of Law and Jurisprudence* 6: 185–215.

Walker, P. L. 2000. 'Bioarchaeological Ethics: A Historical Perspective on the Value of Human Remains'. In M. A. Katzenberg and S. R. Saunders (eds.), *Biological Archaeology of the Human Skeleton,* 3–39. New York: Wiley.

Wallis, R. J. 2003. *Shamans/Neo-Shamans: Ecstasy, Alternative Archaeologies and Contemporary Pagans.* London: Routledge.

Wallis, R. J., and Blain, J. 2002. 'Contemporary Paganism and Archaeology: Irreconcilable?' *Archeology in the Public Domain.* http://www.sacredsites.org.uk/papers/aypublic.html.

Wallis, R. J., and Blain, J., 2003. 'Sites, Sacredness, and Stories: Interactions of Archaeology and Contemporary Paganism'. *Folklore,* 114 (3): 307–21.

Walsh, A. N., and Lopes, D. M. 2009. 'Objects of Appropriation'. In J. O. Young and C. Brunk (eds.), 211–34. Malden, MA: Wiley-Blackwell.

Watkins, J. 2000. *Indigenous Archaeology: American Indian Values and Scientific Practice*. Walnut Creek, CA: Altamira.

Watts, C. M. 2008. 'On Mediation and Material Agency in the Peircean Semeiotic'. In C. Knappet and L. Malafouris (eds.), *Material Agency: Towards a Non-Anthropocentric Approach*, 187–207. New York: Springer.

Waxman, S. 2008. *Loot! The Battle over Stolen Art Treasures of the Ancient World*. London: Times Books.

Webber, J. 2008. 'Understanding the Religion in Freedom of Religion'. In P. Cane, C. Evan, and Z. Robinson (eds.), *Law and Religion in Theoretical and Historical Context*, 26–43. Cambridge, UK: Cambridge University Press.

Webmoor, T. 2007. 'Reconfiguring the Archaeological Sensibility: Mediating Heritage at Teotihuacan, Mexico'. PhD diss., Stanford University.

Webmoor, T. 2008. 'From Silicon Valley to the Valley of Teotihuacan: The "Yahoo!'s" of New Media and Digital Heritage'. *Visual Anthropology Review* 24: 183–200.

Weinrib, L. E., and Weinrib, E. J. 2002. 'Constitutional Values and Private Law in Canada'. In D. Friedmann and D. Barak-Erez (eds.), *Human Rights in Private Law*, 43–72. Oxford, UK: Hart Publishing.

Weiss, E. 2001. 'Kennewick Man's Funeral: The Burying of Scientific Evidence'. *Politics and the Life Sciences* 20(1): 13–18.

Weiss, E. 2008. *Reburying the Past: The Effects of Repatriation and Reburial on Scientific Inquiry*. Hauppauge, NY: Nova Science Publishers.

West, P., and Carrier, J. G. 2004. 'Ecotourism and Authenticity: Getting Away from It All?' *Current Anthropology* 45(4): 483–98.

Wetzel, A. 1988. 'Reconstructing Carthage: Archeology and the Historical Novel'. *Mosaic* 21(1): 13–23.

Wheeler, R. E. M. 1947–8. 'Notes'. *Ancient India* 4: 1–3.

White, S. K. 1988. *The Recent Work of Jürgen Habermas: Reason, Justice and Modernity*. Cambridge, UK: Cambridge University Press.

Whitt, L. A. 1998. 'Indigenous Peoples, Intellectual Property & the New Imperial Science New Directions in Native American Law: Part One: Interdisciplinary Perspectives: Literary and Philosophical Perspectives'. *Oklahoma City University Law Review* 24(1–2): 211–59.

Whitt, L. A. 1999. 'Value-Bifurcation in Bioscience: The Rhetoric of Research Justification'. *Perspectives in Science* 7(4): 413–46.

Willheim, E. 2008. 'Australian Legal Procedures and the Protection of Secret Aboriginal Spiritual Beliefs: A Fundamental Conflict'. In P. Cane, C. Evan, and Z. Robinson (eds.), *Law and Religion in Theoretical and Historical Context*, 214–42. Cambridge, UK: Cambridge University Press.

Williams, R. 1973. *The Country and the City*. Oxford, UK: Oxford University Press.

Williams, Terri-Lynn (gii-dahl-guud-sliiaay). 1995. 'Cultural Perpetuation: Reparation of First Nations Cultural Heritage'. *University of British Colombia Law Review* 29: 183–201.

Willis, M. 2000. *Buddhist Reliquaries from Ancient India*. London: British Museum Press.

Winter, T. 2006. 'When Ancient Glory Meets Modern Tragedy: Angkor and the Khmer Rouge in Contemporary Tourism'. In L.-C.-P. Ollier and T. Winter (eds.), *Expressions of Cambodia: The Politics of Tradition, Identity and Change*, 37–53. London: Routledge.

Winter, T. 2007. *Post-Conflict Heritage, Postcolonial Tourism. Culture, Politics and Development at Angkor*. London: Routledge.

Wisnewski, J. 2009. 'What We Owe the Dead'. *Journal of Applied Philosophy* 26(1): 54–70.

Witmore, C. L. 2007. 'Symmetrical Archaeology: Excerpts of a Manifesto'. *World Archaeology* 39: 546–62.

Wollheim, Richard. 1980. *Art and Its Objects*. Cambridge, UK: Cambridge University Press.

Wong, A. 2011. 'Museums and Social Media: Ethical Issues of the Emerging Media Landscape'. *Museum Management and Curatorship* 26: 97–112.

Wood, M. 2007. *Possession, Power and the New Age: Ambiguities of Authority in Neoliberal Societies*. Aldershot, UK: Ashgate.

Woodhead, L., and Heelas P. (eds.). 2000. *Religion in Modern Times: An Interpretive Anthology*. Oxford, UK: Blackwell.

Woodhead, L. and Heelas, P., 2000. Religions of Spirituality. In L. Woodhead and P. Heelas (eds.), *Religion in Modern times: An Interpretive Anthology*. Oxford, UK: Blackwell.

Woodward, C. 2002. *In Ruins*. London: Vintage.

Wordsworth, W. 2004. *Guide to the Lakes*. London: Frances Lincoln.

World Archaeological Congress. 2007. 'WAC Ethics'. http://humanitieslab .stanford.edu/174/11.

World Intellectual Property Organization. 2006. 'Bioethics and Patent Law: The Cases of Moore and the Hagahai People'. *WIPO Magazine*. http://www.wipo. int/wipo_magazine/en/2006/05/article_0008.html.

Wright, P. 2009. *On Living in an Old Country*. Oxford, UK: Oxford University Press.

Wylie, A. 1993. 'A Proliferation of New Archaeologies: "Beyond Objectivism and Relativism"'. In N. Yoffee and A. Sherratt (eds.), *Archaeological Theory: Who Sets the Agenda?*, 20–26. Cambridge, UK: Cambridge University Press.

Wylie, A. 2003. 'On Ethics'. In L. J. Zimmerman, K. D. Vitelli, and J. Hollowell-Zimmer (eds.), *Ethical Issues in Archaeology*, 3–16. Walnut Creek, CA: Altamira Press.

Wylie, A. 2005. 'The Promise and Perils of an Ethic of Stewardship'. In L. Meskell and P. Pells (eds.), *Embedding Ethics*, 47–68. London: Berg Press.

Wylie, A. 2008a. 'The Integrity of Narratives: Deliberative Practice, Pluralism, and Multivocality'. In J. Habu, C. Fawcett, and J. M. Matsunaga (eds.), *Evaluating Multiple Narratives: Beyond Nationalist, Colonialist, Imperialist Archaeologies*, 201–12. New York: Springer.

Wylie, A. 2008b. 'A More Social Epistemology: Decision Vectors, Epistemic Fairness, and Consensus in Solomon's Social Empiricism'. *Perspectives on Science* 16: 237–40.

Wylie, A. 2009. 'Legacies of Collaboration: Transformative Criticism in Archaeology'. Manuscript in possession of the author; originally presented as the Patty Jo Watson Distinguished Lecture, Archaeology Division, American Anthropological Association, San Francisco, 2008.

Wylie, A. 2011. 'Epistemic Justice, Ignorance, and Procedural Objectivity'. *Hypatia* 26(2): 233–35.

Young, J. 2005. 'Profound Offense and Cultural Appropriation'. *Journal of Aesthetics and Art Criticism* 63(2): 135–46.

Young, J. O. 2006. 'Cultures and the Ownership of Archaeological Finds'. In C. Scarre and G. Scarre (eds.), *The Ethics of Archaeology: Philosophical Perspectives on Archaeological Practice*, 15–31. Cambridge, UK: Cambridge University Press.

Young, J. O. 2008. *Cultural Appropriation and the Arts*. Malden, MA: Blackwell Publishing.

Young, J. O., and Brunk, C. G. (eds.). 2009. *The Ethics of Cultural Appropriation*. Malden, MA: Wiley-Blackwell.

Young, J. O., and Haley, S. 2009. 'Nothing Comes from Nowhere: Reflections on Cultural Appropriation as the Representation of Other Cultures'. In J. O. Young and C. Brunk (eds.), *The Ethics of Cultural Appropriation,* 268–89. Malden, MA: Wiley-Blackwell.

Zhao, W., and Ritchie, J. R. B. 2007. 'Tourism and Poverty Alleviation: An Integrative Research Framework'. In C .M. Hall (ed.), *Pro-Poor Tourism: Who Benefits? Perspectives on Tourism and Poverty Reduction*, 9–33. Clevedon, UK: Channel View Publications.

Zimmerman, L. J. 1989. 'Human Bones as Symbols of Power: Native American Views of "Grave-Robbing" Archaeologists'. In R. Layton (ed.), *Conflict in the Archaeology of Living Traditions*, 211–16. London: Unwin Hyman.

Zimmerman, L. J. 1992. 'Archaeology, Reburial, and the Tactics of a Discipline's Self-Delusion'. *American Indian Culture and Research Journal* 16(2): 37–56.

Zimmerman, L. J. 1994a. 'Made Radical by My Own: An Archaeologist Learns to Accept Reburial'. In R. Layton (ed.), in *Conflict in the Archaeology of Living Traditions*, 60–7. London: Routledge.

Zimmerman, L. J. 1994b. 'Sharing Control of the Past'. *Archaeology* 65: 67–8.

Zimmerman, L. J. 1995. 'Regaining Our Nerve: Ethics, Values, and the Transformation of Archaeology'. In M. Lynott and A. Wylie (eds.), *Ethics in American Archaeology: Challenges for the 1990s,* 64–70. Washington, DC: Society for American Archaeology.

Zimmerman, L. J. 1996. 'Epilogue: A New and Different Archaeology?' *American Indian Quarterly* 20(2): 297–307.

Zimmerman, L. J. 1997a. 'Anthropology and Responses to the Reburial Issue'. In T. Biolsi and L. J. Zimmerman (eds.), *Indians and Anthropologists: Vine Deloria, Jr., and the Critique of Anthropology*, 92–112. Tucson: University of Arizona Press.

Zimmerman, L. J. 1997b. 'Remythologizing the Relationship between Archaeologists and Indians'. In N. Swidler, K. Dongoske, R. Anyon, and A. Downer (eds.), *Native Americans and Archaeologists: Stepping Stones to Common Ground*, 44–56. Walnut Creek, CA: Altamira Press.

Zimmerman, L. J. 2005. 'Public Heritage, a Desire for a "White" History for America, and Some Impacts of the *Kennewick Man/Ancient One* Decision'. *International Journal of Cultural Property* 12: 265–74.

Zimmerman, L. J. 2008. 'Multi-Vocality, Descendant Communities, and Some Epistemological Shifts Forced by Repatriation'. In T. Killion (ed.), *Opening Archaeology: Repatriation's Impact on Method and Theory*, 91–108. Santa Fe, NM: School for Advanced Research.

Zimmerman, L. J., and Makes Strong Move, D. 2008. 'Archaeological Taxonomy, Native Americans, and Scientific Landscapes of Clearance: A Case Study from Northeastern Iowa'. In A. Gazin-Schwartz and A. P. Smith (eds.), *Landscapes of Clearance*, 190–211. Walnut Creek, CA: Left Coast Press.

Zimmerman, M. J. 2007. 'Intrinsic vs. Extrinsic Value'. In Edward N. Zalta (ed.), *Stanford Encyclopedia of Philosophy* (Spring). http://plato.stanford.edu/archives/spr2007/entries/value-intrinsic-extrinsic/.

STATUTES

Council of Europe, Convention on the Protection of the Archaeological Heritage of Europe, European Treat Series 143.

Council of Europe. 2005. Council of Europe Framework Convention on the Value of Cultural Heritage for Society (The Faro Convention). Available at http://conventions.coe.int/Treaty/EN/Treaties/Html/199.htm .

Government of Canada. 1885. An Act Further to Amend 'The Indian Act, 1880', S.C. 1884 (47 Vict.), chap. 27, sec. 3.

Government of Canada. 1895. An Act to Further Amend 'The Indian Act, 1880', S.C. 1895, chap. 35, sec. 6.

UK Statutory Instrument 2003 No. 2759: Export of Objects of Cultural Interest (Control) Order 2003.

UN Declaration on the Rights of Indigenous Peoples, G.A. Res. 61/295, UN Doc. A/RES/61/295 (13 September 2007).

US Native American Graves Protection and Repatriation Act, 25 USC §§ 3001–13 (16 November 1990).

CASES

Appleby v. United Kingdom, European Court of Human Rights, Appl. No. 44306/98 (6 May 2003).

Local 1330, United Steel Workers v. US Steel Corp., 631 F.2d 1264 (6th Cir. 1980).

Syndicat Northcrest v. Amselem, Supreme Court of Canada, *Canada Supreme Court Reports* 2004(2), 551.

Index